Figure Drawing for Men's Fashion

A book is not just a book; it is a living part of an existence
that wants to be at the service of not only its own growth,
but that of others. If this wish is granted, it will be one of
the greatest gifts ever offered in a lifetime.
To our loved ones, friends, colleagues and pupils, with
immeasurable affection.

Tiziana - Elisabetta

Hoaki Books, S.L.
C/ Ausiàs March, 128
08013 Barcelona, Spain
T. 0034 935 952 283
F. 0034 932 654 883
info@hoaki.com
www.hoaki.com

hoaki_books

Figure Drawing for Men's Fashion

ISBN: 978-84-17412-83-8

Copyright © 2021 Promopress, Hoaki Books, S.L.
Copyright © 2021 Ikon Editrice srl
Original title: *Disegnare la figura maschile nella moda*

Authors: Tiziana Paci and Elisabetta Kuky Drudi
Translation: Emma Sayers
Layout: Wendy Moreira
Cover design: spread

D.L.: B 20490-2020
Printed in Turkey

Figure Drawing for Men's Fashion

Elisabetta Kuky Drudi
Tiziana Paci

PROMOPRESS 11

Elisabetta Kuky Drudi

lives and works in Cattolica as an illustrator and fashion, textile and knitwear designer. From a family of artists, she eagerly immerses herself into the artistic gymnastics of her household, growing up surrounded by classical music and Sex Pistols. A creative nonconformist, and ingenious re-builder of forms and structures, she loves to customise objects, clothes and accessories, to expunge the monotony of seriality. These passions would soon morph into creative collaborations with boutiques and design studios. She began her artistic studies, obtaining the Diploma di Maturità Artistica (Art School Graduation Diploma) at the Mengaroni Art School in Pesaro, working simultaneously as an illustrator and *fashion designer* in Italian and foreign companies, including Iki and Torras Barcelona. After a brief period in Milan and passing the entrance exam to the Marangoni Fashion Institute with flying colours, she obtains a Professional Master's Degree in Independent Company Management, an experience that would in five years give her in-depth knowledge of every useful design and production phase for the creation of women's fashion collections, as a company owner, designer, *fitting model* and marketing partner. The need to nourish herself with new experiences and enrich her emotional and cultural background takes her away from the methodical, business side of the work and leads her into freelance collaborations with various companies, which enables her to intersperse her projects between fantastic trips around the world. In her thirty-year career, she has collaborated in the creation of knitwear collections and garments for the following brands: Fuzzi, MSGM, Mary Katrantzou, Pucci, Jean Paul Gaultier, Custo Barcelona, Hugo Boss, HB Sport, Baldessarini, and Joop.
The mutual friendship and respect she shares with her former teacher, Tiziana, would lead her to enrich her curriculum with a series of publications aimed at the fashion & design sector.
Her first international bestseller was published in 1996: "La figura nella moda".

Tiziana Paci

lives and works in Pesaro as a Fashion Design teacher at the Mengaroni Art School.
Over her career spanning thirty years, she has devised original methods for designing and perfecting her fashion figurine drawing and painting techniques. All of this material has been organised into various guidebooks that combine didactic, artistic and professional topics in an evocative way. Innovative, effective and complemented by rich imagery, these books – which have been developed together with Elisabetta Drudi – have been translated into several languages and are used in all kinds of schools in Italy and internationally. As an artist, she loves to express herself in many areas: in painting with solo and group exhibitions held in Pesaro, Urbino, Milan, Bologna and Rome. She has worked as a costume designer in the theatre world for many years, designing costumes for plays, operas and dance shows directed by Gabbris Ferrari; as a set designer and costume coordinator, she curated the ten "Lo specchio" theatrical shows for all kinds of schools and age groups. She has participated in Italian television events, including "Alla ricerca dell'Arca", directed by Mino Damato, with the "Concetto Moda" dresses, a magnificent representation of femininity. She has worked as a freelancer with fashion houses such as Laurana Gioielli, Angel Fashion, Equipe Style and Alberta Ferretti. For the humanitarian association "Peace Games Uisp", she created a crafts program for Palestinian associations.
She taught university courses in Fashion Design at the Faculty of Design and Fashion Discipline at the University of Urbino and the Poliarte Accademia di Belle Arti Design in Ancona.
Publications:
"La figura nella moda", Paci-Drudi - Ikon Editrice. The English version will be published by Promopress.
"Dipingere la moda", Paci T. - Ikon Editrice. English version: "Colour in Fashion Illustration", Promopress, Barcelona, 2018.

INTRODUCTION

A decade after its appearance, the professional graphic design manual *Figure Drawing for Men's Fashion*, appreciated worldwide, knows its second edition with an essential update.

The text that we present pursues the same didactic objectives and preserves the same background structure as the preceding book, since its objective is to provide an adequate method of study. Starting from the analysis of the canon, the manual analyzes the body in various ways: as a mannequin, it translates anatomical masses into geometric shapes; as a proportional scheme, it examines the parts, inserted in a grid of eight modules, and studies their morphological characteristics; and as a stylization, it lengthens the body one or two modules with respect to the classical canon. The second and third parts of the book develop the dress of the figurine in various ways: in transparency, to understand the wearability in relation to the body underneath; in graphic form, in order to correctly visualize the garments drawn on the figurines and easily reproduce them, in copying exercises in which the plastic style with which they have been created is also imitated; in color, with the use of Photoshop and other pictorial media. In the profession of designer, and also in that of illustrator, it is essential to use artistic software that, in addition to saving time, facilitates the realization of visual projects and allows unthinkable and aesthetically valid creative elaborations. Indeed, after being created freehand, many images in this book come from transformations with specific programs to correct the drawing, polish it, adjust it, alter its proportions, insert colors, fabrics and other things. Digital art is undoubtedly a third hand for professionals and artists and its use is considered today an integral part of the creative process and is also necessary for students.

The fourth part is dedicated to fashion design itself, with illustrations of various outfits characteristic of contemporary clothing and the creation of some capsule collections inspired by various themes. Classic and sporty lines alternate with the most extreme forms, because clothing, with its content, expresses adherence to a common thought and concrete belonging to a social group. So many different styles show the extreme freedom of aesthetic expression of contemporary man.

The last part deals with flat drawing, fundamental in the profession of fashion designer, who must translate his own creations into technical sheets, effective and irreplaceable in the study of prototypes. The knowledge, competence and skills that will be acquired in the different modules are essential in preparation for studying *fashion design*. This new edition is also characterized by greater teaching efficiency, thanks to the insertion of many color pages, the studied and revised selection of the figures from the previous book and the creation of new and fantastic male silhouettes with a youthful, slim and multi-ethnic physique, taken in various poses and perfect to wear any garment. Special attention has been paid to the beautiful faces and the coolest hairstyles on the current scene, as a primary resource to increase the fascination of any image figurine. As for the wardrobe, we present new outfits in line with current international fashion proposals and as an orientation on the most fashionable styles.

But, although it includes many contemporary looks, this new manual does not want to and cannot be a trend book: the garments have been designed for educational purposes oriented towards the acquisition of a solid method of dressing the costume and the aesthetic interpretation of contemporary brands. We consider this new publication as a valuable, useful and unique tool in the current publishing scene, due to the quantity and originality of the drawings, due to the gradual learning method and due to the analysis and deepening of the arguments, which are presented exhaustively and of course.

Stimulated by this fundamental learning, students will better develop their capacities for reflection and reproduction, gradually overcome dependence on copying, and conquer a free and creative dimension in which their own stylistic language will emerge naturally.

We can only say hello and thank all our loyal readers, the fashion teachers who have followed us for many years in different publications and so many students who passionately exercise our manuals and who we remember that to learn this profession you need talent, time, culture and a lot of tenacity.

Tiziana Paci - Elisabetta Kuky Drudi

First module
THE RULES OF DRAWING

THE BODY

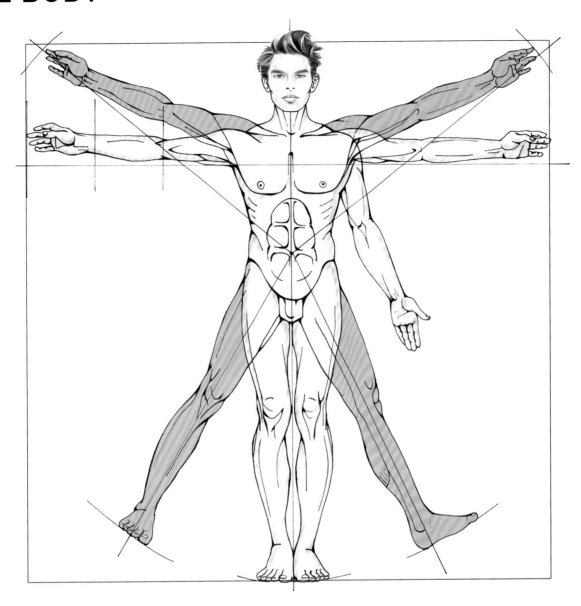

HISTORICAL CANONS OF PROPORTIONS

Since ancient times, the body has attracted the attention of artists who have sought to represent it, first instinctively and later with increasing understanding, leading to each civilisation devising its own canon based on mathematical rules to express the latest concept of proportions. The canon, or norm, is a rule that establishes the ideal proportions of the human body by dividing it into sections called *modules.* The ancient Egyptians, for example, enclosed the figure in a modular grid whose unit of measurement was the *ulna*, which is equivalent to the distance between the elbow and the tip of the thumb. In classical Greece, painters made

a great discovery: foreshortening. For the first time in history, artists painted feet seen from the front. The discovery of depth was a great qualitative leap in the study of reality. With the development of the concept, "beauty in art", the male body was interpreted according to a higher order and harmony, in search of an ideal of absolute perfection. At the end of the 5th century BC, the sculptor Polykleitos, with the statue of the Doryphoros, established a proportional canon that was so perfect that it was taken as a rule by the artists of the time. During the Renaissance, a time of great geniuses such as those of classical Greece, the canon of the human body was

scientifically determined. Studies on the body appear in many architectural treatises, among which we will cite **De Architectura**, by Vitruvius (1st century AD), **De Prospectiva Pingendi** by Piero Della Francesca, **De Divina proporzione**, by Luca Pacioli, **Della simmetria dei corpi umani**, by Dürer, and the many studies of proportions carried out by Leonardo Da Vinci and Michelangelo, up to the most recent **Canon** by Theodor Fritsch (1895) and **Modulor** by Le Corbusier. Presented in the various treatises on the following pages are some of the most important diagrams, which we have included by way of illustration as well as to suggest and guide eventual searches.

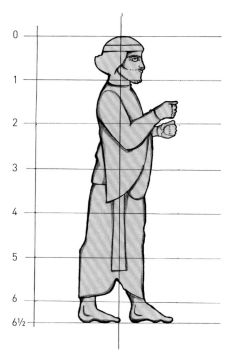

Persian canon

The figure's height is six and a half times the size of its head.
The image obtained is squat and very schematic.
1st millennium BC

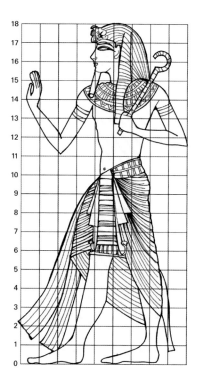

Square Grid Egyptian Canon (New Empire)

The figure is drawn in a modular grid, eighteen squares high and nine squares wide. The unit of measurement is the ulna and corresponds to the distance between the elbow and the tip of the thumb; the ulna is in turn divided into four fists.

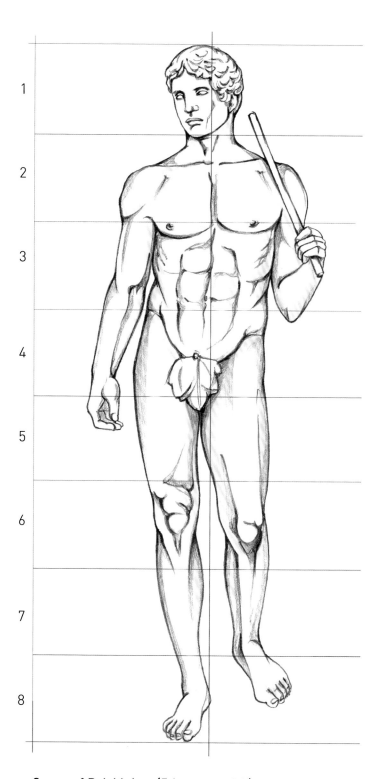

Canon of Polykleitos (5th century BC)

Based on a systematic study of the anatomical measurements of several Olympic athletes, Polykleitos wrote the first, now lost, treatise on the beauty and symmetry of human anatomy, where he shows the perfect proportions of each of its parts in relation to the harmony of the whole. Polykleitos formulated his Canon by dividing the body into seven and a half modules, using the height of the head as the main unit of measurement. A later revision increased the rule to include eight modules. Polykleitos applied his theory to his sculptures, the most famous of which is the Doryphoros, or spear-bearer. This has been passed down to us in the form of a Roman copy, in which the balanced and opposing rhythm of the arms and legs can be seen in the classical position, or chiastic structure, where rest and movement occur at the same time.

The sheer perfection and extreme beauty of this canon would transform Greek sculpture, making it a template that would inspire artists in all subsequent eras.

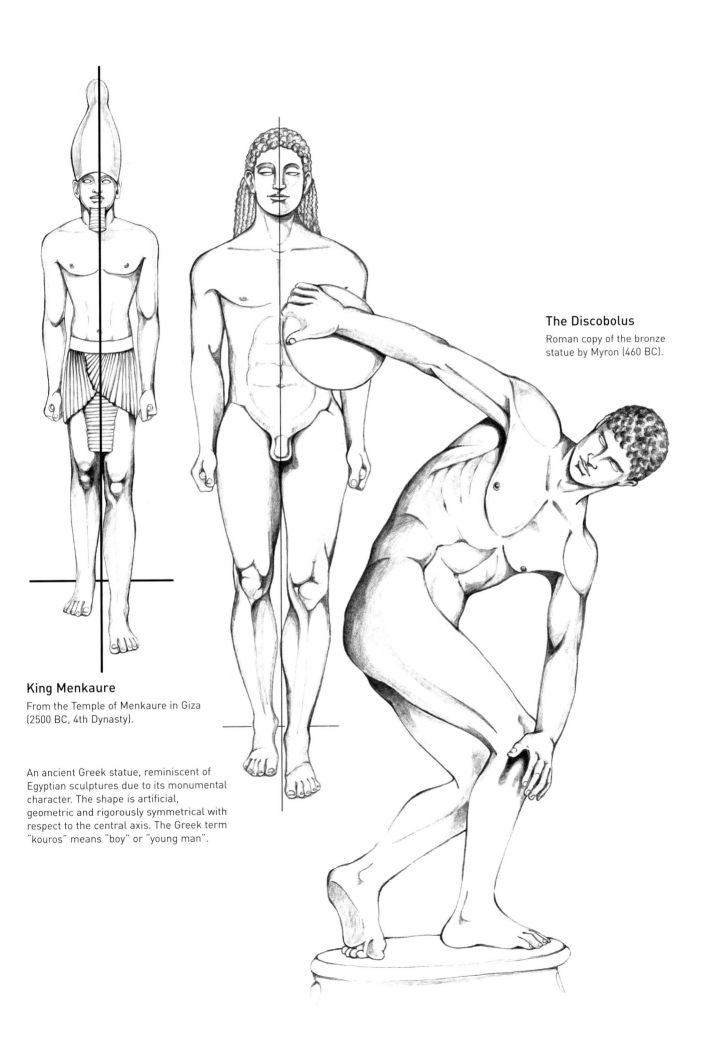

The Discobolus

Roman copy of the bronze statue by Myron (460 BC).

King Menkaure

From the Temple of Menkaure in Giza (2500 BC, 4th Dynasty).

An ancient Greek statue, reminiscent of Egyptian sculptures due to its monumental character. The shape is artificial, geometric and rigorously symmetrical with respect to the central axis. The Greek term "kouros" means "boy" or "young man".

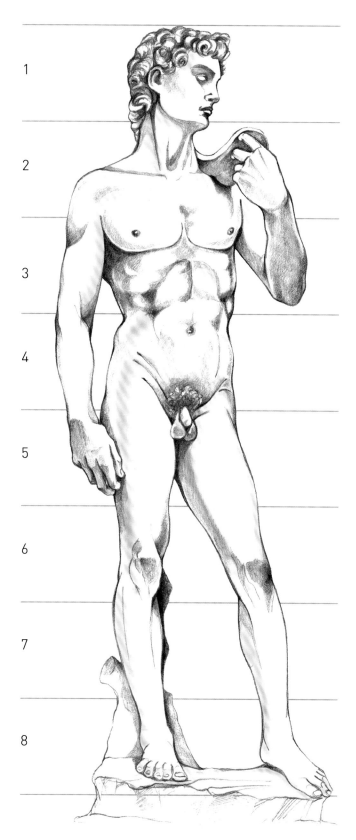

1
2
3
4
5
6
7
8

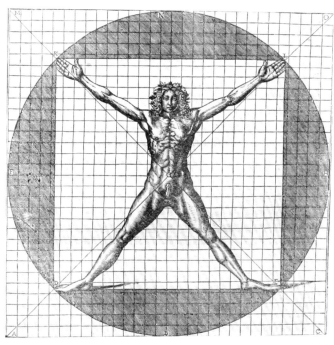

Vitruvian Man (27 BC).

Vitruvius, a Roman architect, studied the canons of Greek art and created his own canon of proportions by drawing the human body in a square and a circle. In his treatise, **De Architectura**, he states that the human body is a model of perfection and harmony because, with the arms and legs stretched out, it fits the circle and square perfectly.

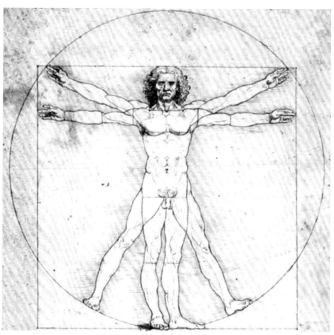

Vitruvian man, reproduced and perfected by Leonardo Da Vinci (1452-1519).

David by Michelangelo (1501-1504)

During the Renaissance, as in classical Greece, the human body was recognised as a universal aesthetic model. Sculptors were inspired by the canon devised by Polykleitos to make statues of perfect proportions.

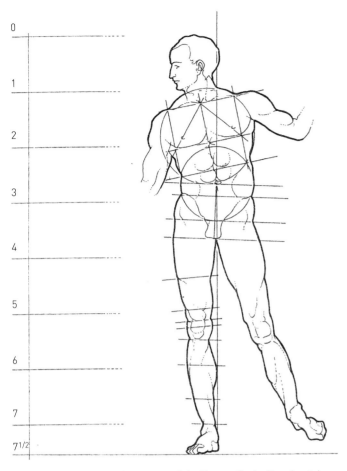

Albrecht Dürer, **On the Symmetry of the Human Body**. Drawing taken from the weighty, four-part treatise on the harmonious proportions of the body, published after his death in 1528.

Anthropologist and physiologist Gustav Theodor Fritsch investigated the similarities between the structure and functions of the human body and, in 1895, created his **Anatomical Canon** inspired by Schmidt, 1849, and took the basic module of the length of the spine from the base of the nose to the symphysis pubis as his measurement.

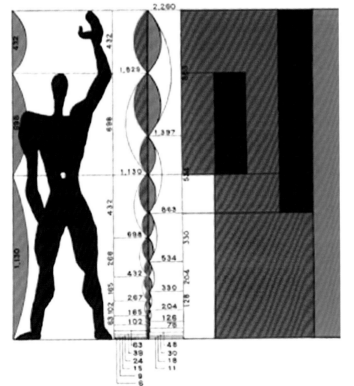

More recently, in 1946, we find **"Modulor"** (a word composed of "*module*" and "*section d'or*", meaning "gold section" in French), by esteemed architect, Le Corbusier. He developed a proportional grid using a measurement scale based on the golden rule, which was already known to the ancient Greeks, and Fibonacci numbers.
The canons looked at in this chapter constitute a brief overview of the many treatises that have been formulated over the centuries, accompanied by brief notes that aim to pique the interest of students wishing to delve further into the subject.

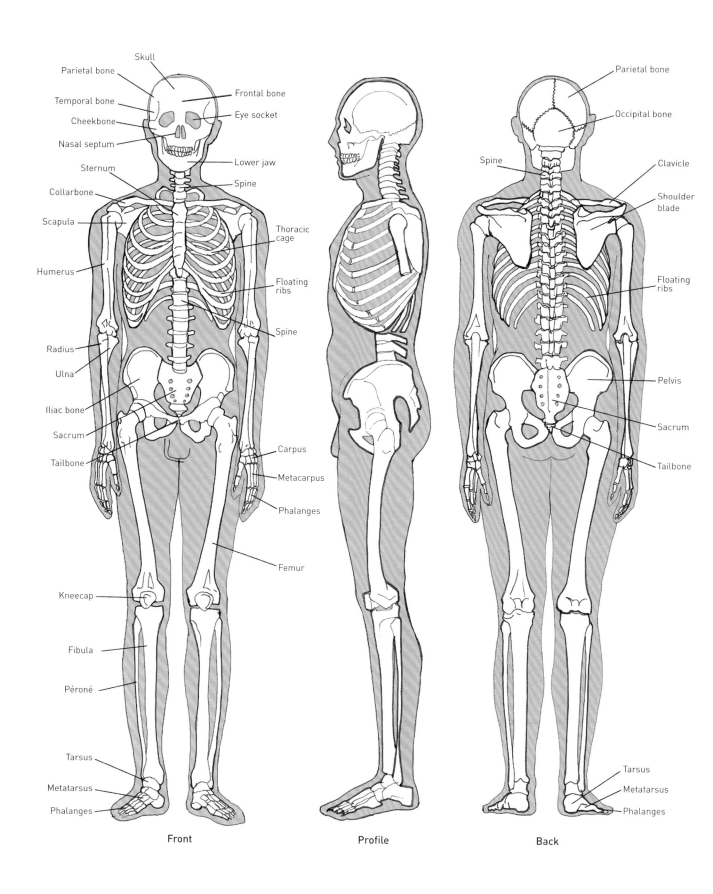

Skull
Parietal bone
Temporal bone
Cheekbone
Nasal septum
Sternum
Collarbone
Scapula
Humerus
Radius
Ulna
Iliac bone
Sacrum
Tailbone
Kneecap
Fibula
Péroné
Tarsus
Metatarsus
Phalanges

Frontal bone
Eye socket
Lower jaw
Spine
Thoracic cage
Floating ribs
Spine
Carpus
Metacarpus
Phalanges
Femur

Parietal bone
Occipital bone
Spine
Clavicle
Shoulder blade
Floating ribs
Pelvis
Sacrum
Tailbone
Tarsus
Metatarsus
Phalanges

Front

Profile

Back

THE HUMAN SKELETON

The skeleton is the supporting structure inside the body; it is made up of a series of bones and cartilaginous tissue. The masculine skeleton is larger than its feminine counterpart, which can be seen by looking at the head, chest, spine and hips.

DRAWING PREPARATIONS

Tools, techniques and secrets

The best way to learn a good technique is to first familiarise yourself with the medium you are going to be using. The first of these being the pencil, whose ductility allows us to draw lines of various thickness. In artistic drawing, soft graphite pencils are used: medium soft pencils such as F, HB, 2B, and very soft, from 3B onwards. In our drawings, we have mainly used HB and 2B pencils and mechanical pencils with very fine leads. For rubbing out, a putty rubber is best, since it is less messy and can easily be divided into smaller pieces as required. Markers of various thicknesses, from 005 to 06, and different kinds of black markers are used to go over the pencil lines. For colouring in by hand, I recommend using brand-name pencils and watercolours as well as normal and professional felt-tip pens. The second important thing is the substrate: you will need to use paper that is suitable for the various inks and pens you will be using.

If you use this book as a basic manual, you won't need special paper with particular characteristics; just use good quality paper. For the final figurines, however, you will have to use one of the following: smooth drawing paper, white wrapping paper that is suitable for pencil sketches and very cheap, and other papers of various weights and qualities. The third thing is a light table or an LED tablet for drawing and tracing, a good computer with art software, printer-scanner and a graphics tablet. Some of these materials are shown on this page.

Quick pencil sketch.

Detailed figurine finished off with 0.6 marker.

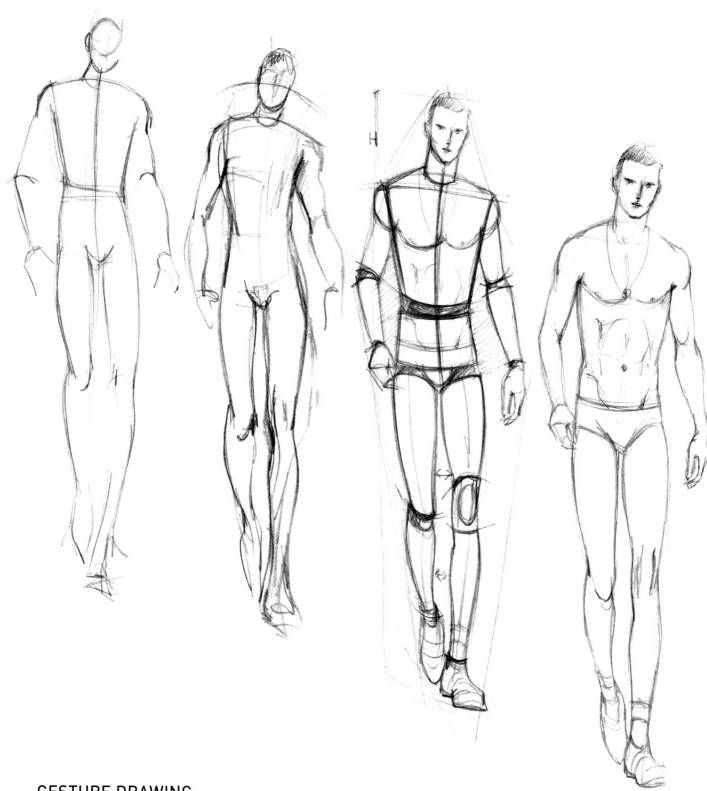

GESTURE DRAWING

When you are getting started in drawing, it is useful to make free sketches, without thinking about it being pretty or worrying about the result. Having fun moving the pencil freely, repeating each stroke to gain agility and improve ease of handling, is a very good way to overcome stiffness in a hand that is frozen by the fear of not doing it well. Gestural drawing quickly captures the essence of the subject. It is also good to try not to separate the pencil from the paper at any time, and to draw an exaggerated scribble that roughly marks out the shape and main movements of the body.

You learn by copying

Lots of people think that copying doesn't help you to develop your own style and that inventing is much more instructive. But how can you invent if you don't know how to draw? All painters have learnt to draw by copying, either from life or from reproductions, and they have often copied each other. So, copying is necessary, but it must be done consciously and without any feelings of guilt. Soon there will be time enough for personal experimentation and developing your own style.

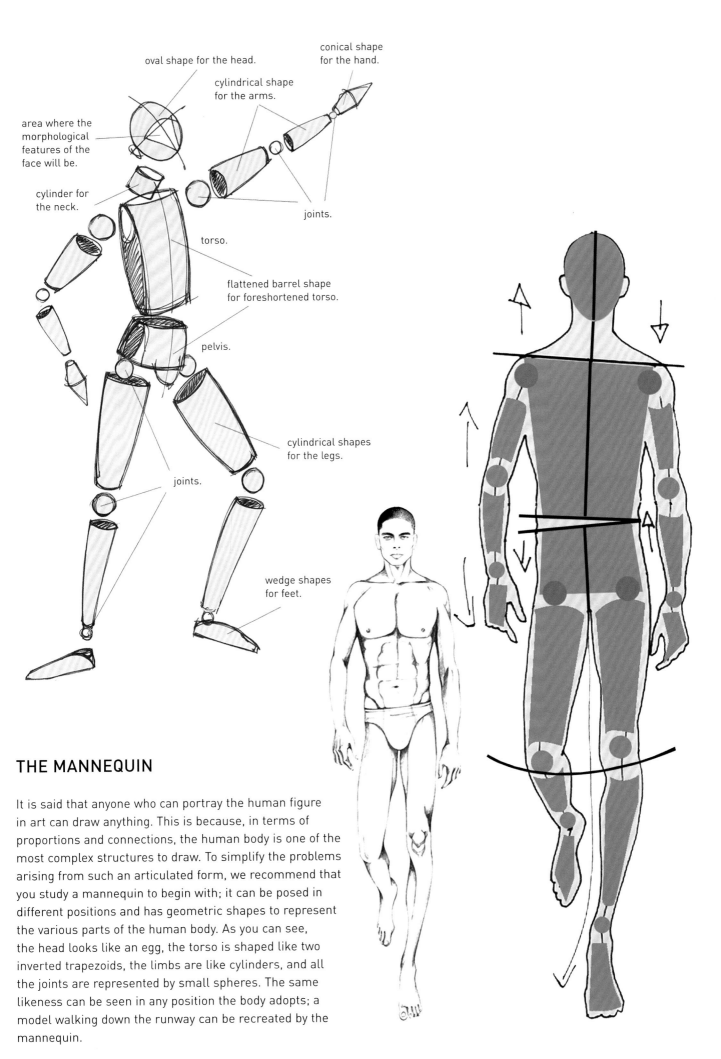

oval shape for the head.

conical shape for the hand.

cylindrical shape for the arms.

area where the morphological features of the face will be.

cylinder for the neck.

joints.

torso.

flattened barrel shape for foreshortened torso.

pelvis.

cylindrical shapes for the legs.

joints.

wedge shapes for feet.

THE MANNEQUIN

It is said that anyone who can portray the human figure in art can draw anything. This is because, in terms of proportions and connections, the human body is one of the most complex structures to draw. To simplify the problems arising from such an articulated form, we recommend that you study a mannequin to begin with; it can be posed in different positions and has geometric shapes to represent the various parts of the human body. As you can see, the head looks like an egg, the torso is shaped like two inverted trapezoids, the limbs are like cylinders, and all the joints are represented by small spheres. The same likeness can be seen in any position the body adopts; a model walking down the runway can be recreated by the mannequin.

MANNEQUINS IN VARIOUS POSES

The male figure is larger than its female counterpart and its muscle masses are more pronounced and energetic. The volume of the rib cage dominates over the other parts of the body and, as the mannequins demonstrate, both the torso and the abdomen look like a trapezium from the side and a flattened barrel from the front, while the limbs look like elongated cylinders. All joints are represented as jointed curves. As you draw, pay attention to the proportions of all parts of the body and the harmony of the whole figure. It is a good idea to draw each picture several times, making improvements each time. It is also useful to draw them onto the modular grid.

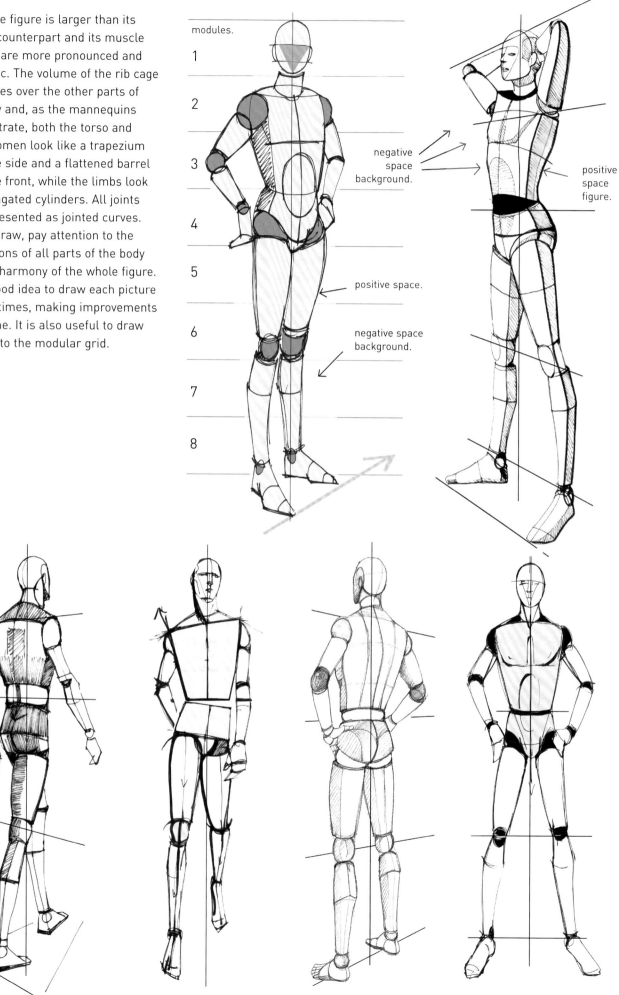

modules.

1
2
3
4
5
6
7
8

negative space background.

positive space figure.

positive space.

negative space background.

STATIC MANNEQUIN FROM FOUR ANGLES

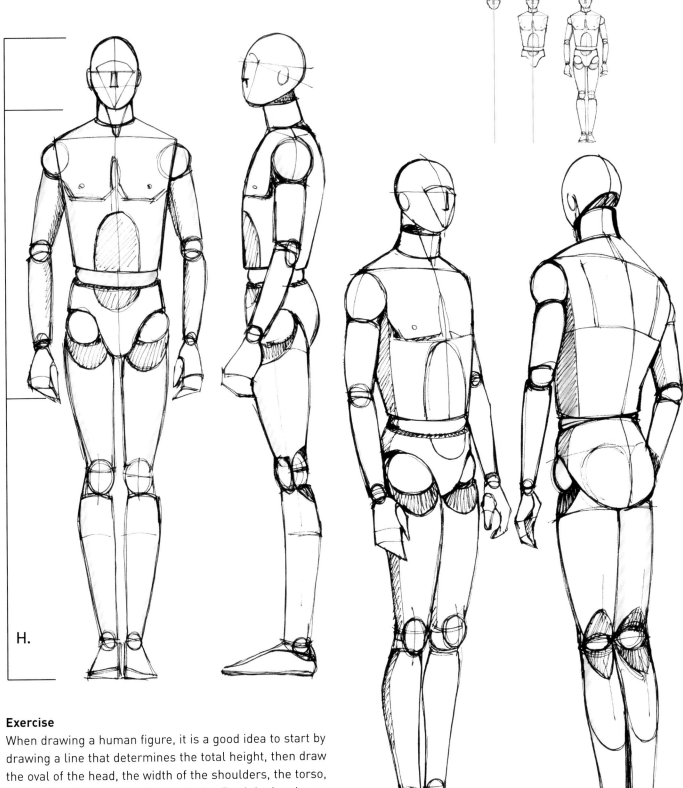

H.

Exercise

When drawing a human figure, it is a good idea to start by drawing a line that determines the total height, then draw the oval of the head, the width of the shoulders, the torso, and finally, the upper and lower limbs. Don't be in a hurry to finish it; rather, get better and better at it by repeating the same pose several times until you can reproduce it from memory. Try to avoid using the rubber and don't be afraid of making mistakes. Draw lightly, allowing the lines to overlap each other, then make a slightly stronger line to draw the right shape. Once the sketch is finished, if you want to obtain a clean drawing, you can use the LED table to trace over your work, or scan it onto the computer to make further colour variations.

BALANCE LINE

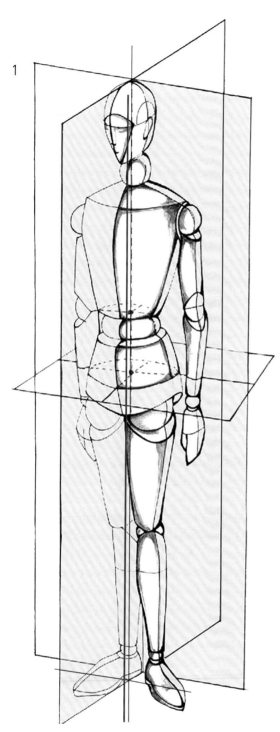

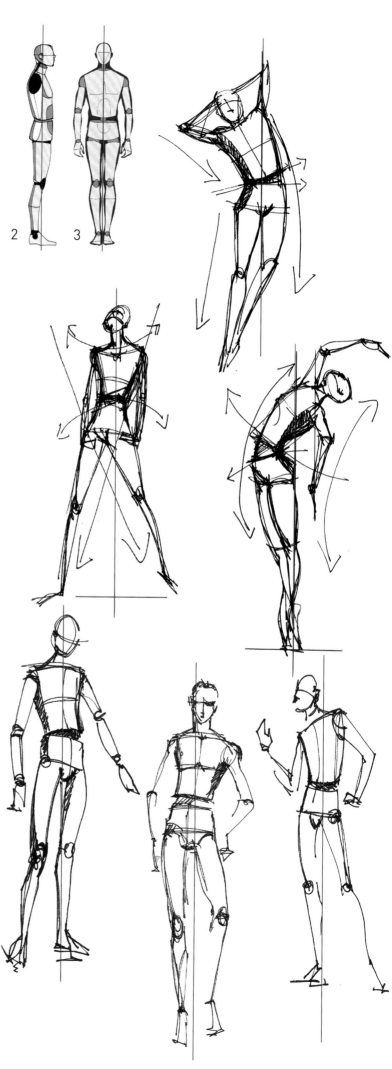

Whether at rest or in motion, the body maintains its balance thanks to the force of gravity. With a figure standing perfectly straight, the balance line overlaps the height line, and is drawn along the central axis and passes through the middle of the body (figs. 1-2-3). Conversely, with a figure that is moving or bending over, a new vertical line is created. This line is determined by the opposite balances of each body part (see diagrams on the right). To visualise the axis, several perpendicular, horizontal, and transverse planes have been added, since the area where the planes intersect determines the balance line.

LIMB ROTATION

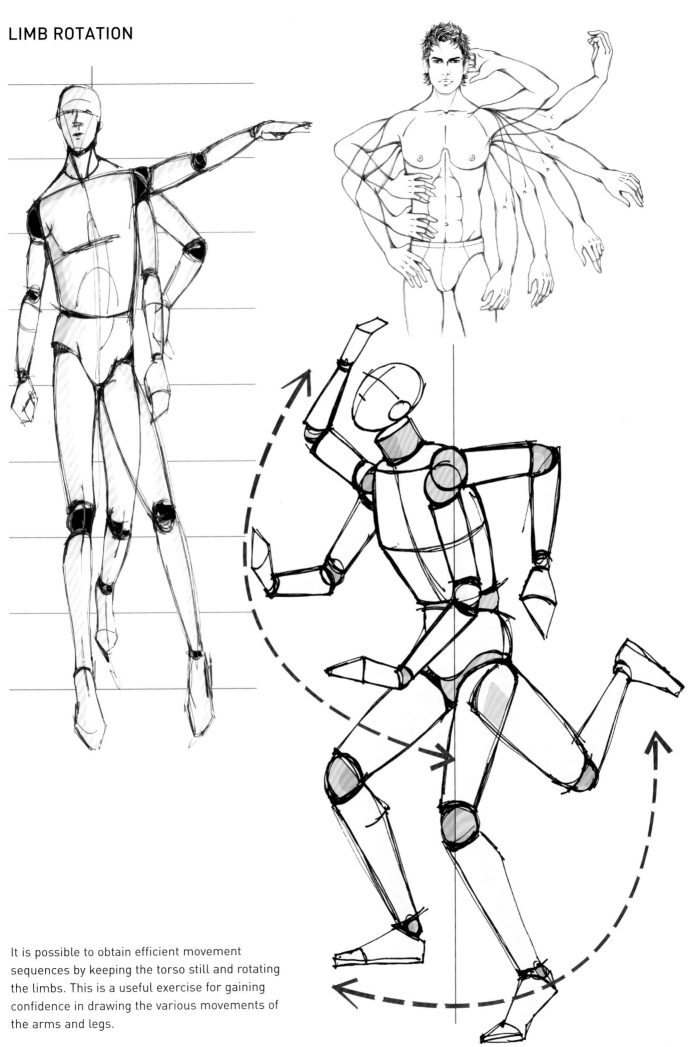

It is possible to obtain efficient movement sequences by keeping the torso still and rotating the limbs. This is a useful exercise for gaining confidence in drawing the various movements of the arms and legs.

FIGURE AND BACKGROUND

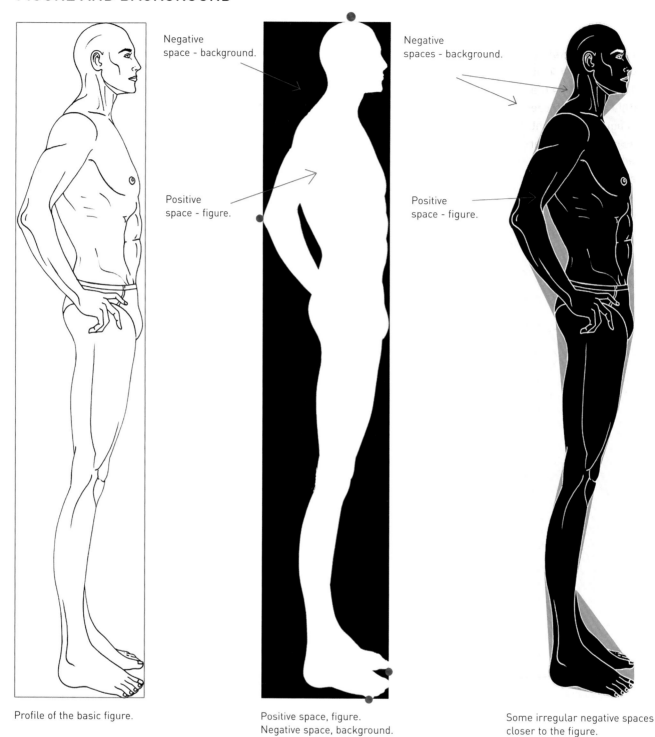

Negative space - background.

Positive space - figure.

Negative spaces - background.

Positive space - figure.

Profile of the basic figure.

Positive space, figure.
Negative space, background.

Some irregular negative spaces closer to the figure.

Positive space and negative space

- The positive space is the area occupied by the figure.
- Negative space refers to the background area around the subject. When you draw a figure, don't just look at its shape; look at the space it takes up, too, that is, the empty space around it. The problem, apart from our inexperience, is that our perceptual system contemplates only what it considers to be full

and therefore positive, concrete, ie the figure, while it understands the background or empty space as something negative, marginal and not really relevant. However, both the figure and the background are of equal importance and are essential, since they coincide perfectly with each other and every positive shape or space corresponds to a single negative space.

Drawing the negative shapes puts a boundary on the space they take up, which therefore controls the exact proportions of everything that is depicted. An understanding of lengths, widths, depths, alignments and triangulations helps to improve the drawing's plausibility. When it comes to the human body, learning to visualise negative space is one of the best drawing lessons you can get.

VARIOUS WAYS TO STUDY A FIGURE

The human body is a very complex and articulated structure, and it takes a lot of attention and concentration to reproduce it. For this reason, these diagrams demonstrate how to proceed in examining and then drawing a figure from sight by combining the outline that represents its body parts with two studies of the articulated form – the full and empty spaces – and their relationship as a whole. Once these notions are understood and reproduced, we can move on to copying the basic figure. The same rules also apply to drawing the details of the body, such as the head, hands, etc.

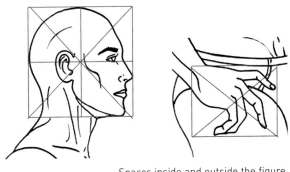

Spaces inside and outside the figure.

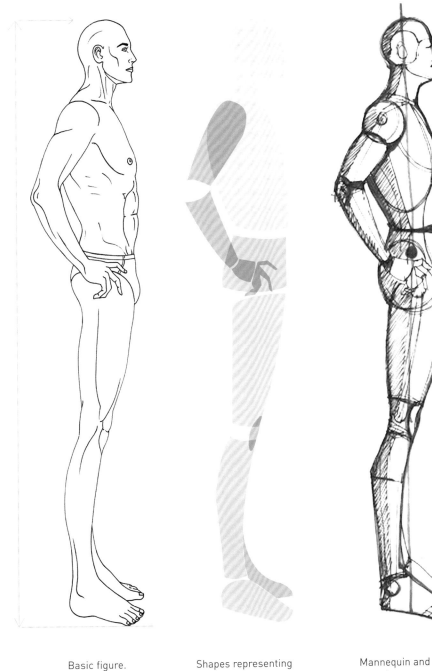

H

Basic figure.

Shapes representing the main body parts.

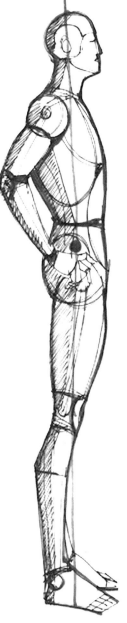

Mannequin and negative space.

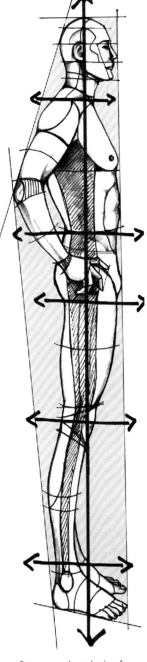

Spaces and analysis of structures and alignments.

THE MALE FIGURE IN THE GREEK CANON

BASIC FRONTAL POSE

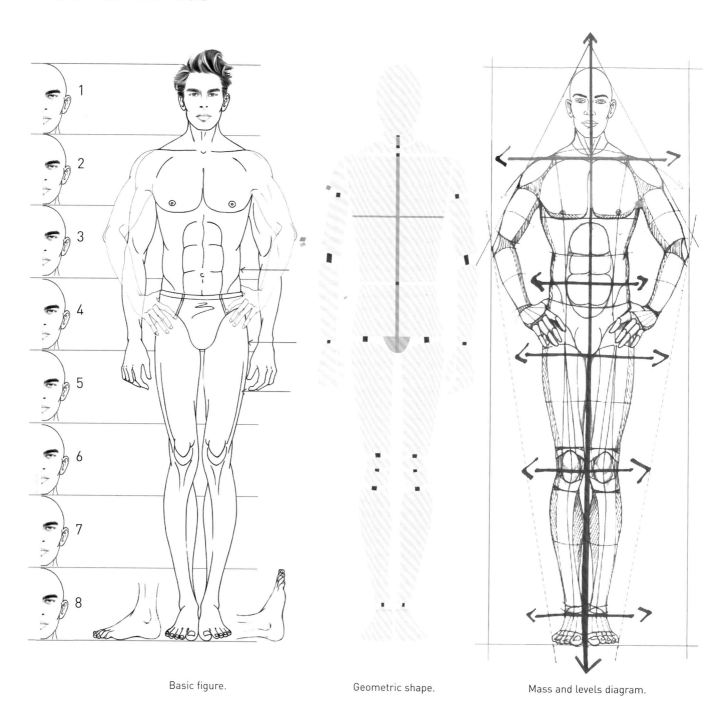

Basic figure.

Geometric shape.

Mass and levels diagram.

Among the many canons defined in the ancient world, the classical Greek one was chosen because it was considered perfect in its proportions. According to this codex, the height of the head represents the unit of measurement that splits the subsequent subdivisions of the body into eight modules: 1) the head; 2) the neck, shoulders and upper part of the chest; 3) the chest

and the lower part of the torso to the waist; 4) the hip and pubis; 5) the middle of the thighs 6) the lower part of the thighs and knees; 7) the central part of the leg and the calf; 8) the ankle and the foot.
Other rules: the foot, in profile, is equal to one module. The elbow lines up with the waist, the fist with the pubis, and the fingertips with the middle of the thigh.

The first drawing shows what the real body looks like, with diagrams shown next to it. The blue silhouette shows the main volumes, while the figure on the right represents the muscle masses and various alignments. Draw the grid with the various modules and remember to analyse the pose in all the different angles explained on this and the previous pages.

BASIC PROFILE POSE

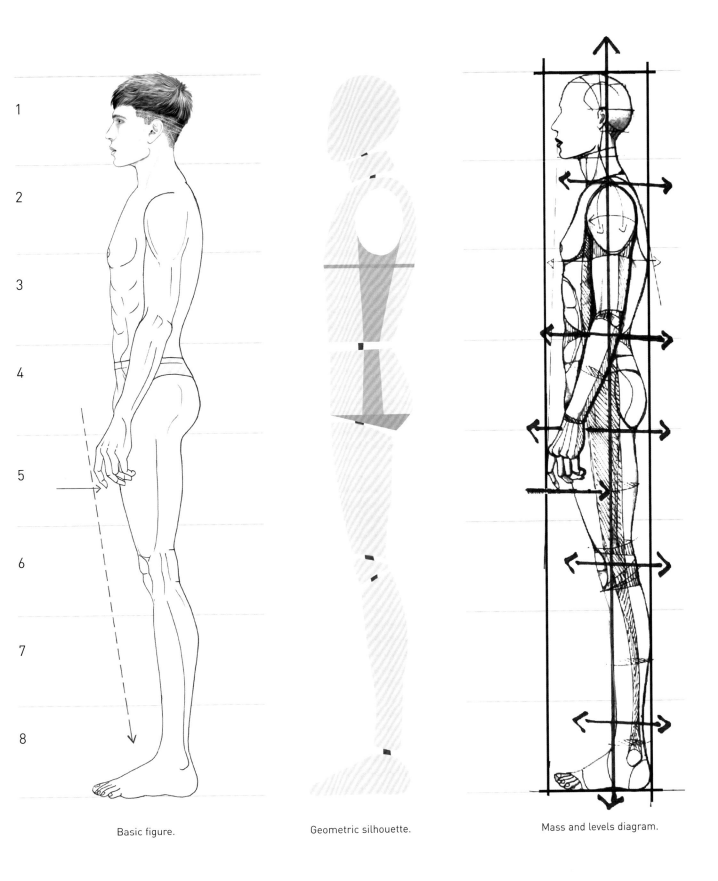

1

2

3

4

5

6

7

8

Basic figure.

Geometric silhouette.

Mass and levels diagram.

In the profile pose, the torso and the curve of the back stand out clearly, as do the buttocks and the inward sloping line of the lower limbs.

The head reveals the roundness of the skull and the details of the facial profile with its morphological characteristics.

NOTE When doing life drawings, while you must take the study of proportions into account, these are indicative and ideal; in reality, all bodies differ from the canon in some way.

BASIC REAR POSE

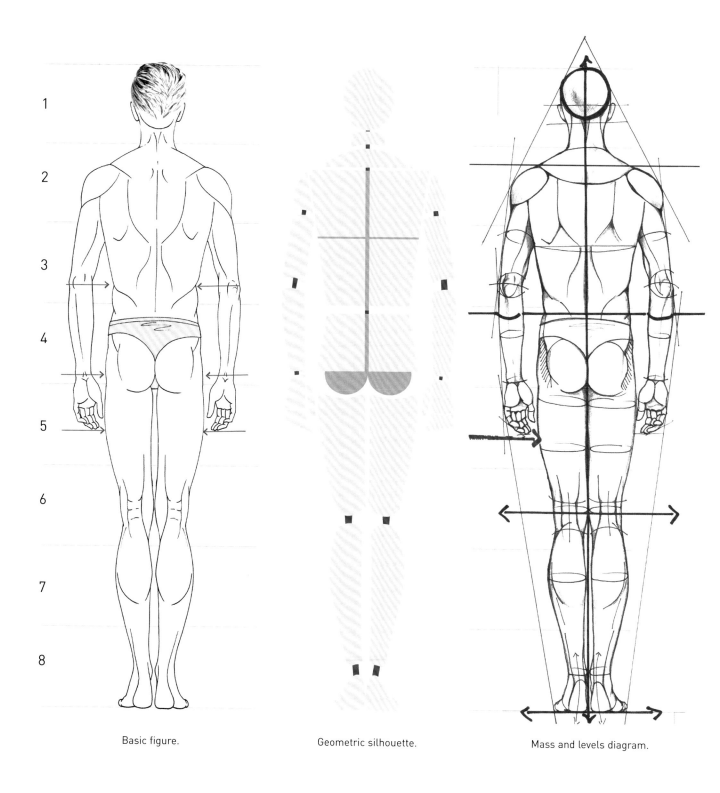

1
2
3
4
5
6
7
8

Basic figure.

Geometric silhouette.

Mass and levels diagram.

Seen from behind, this pose shows the broadness of the back, the line of the spine and the shape of the buttocks, as well as the proportions of the upper and lower limbs. The diagram in the middle shows the main masses of the body as they are seen on a mannequin, while the drawing on the right exhibits the muscle masses and shows where the limbs align with the other parts of the body.

THREE-QUARTER REFLECTED POSE WITH LEGS TOGETHER

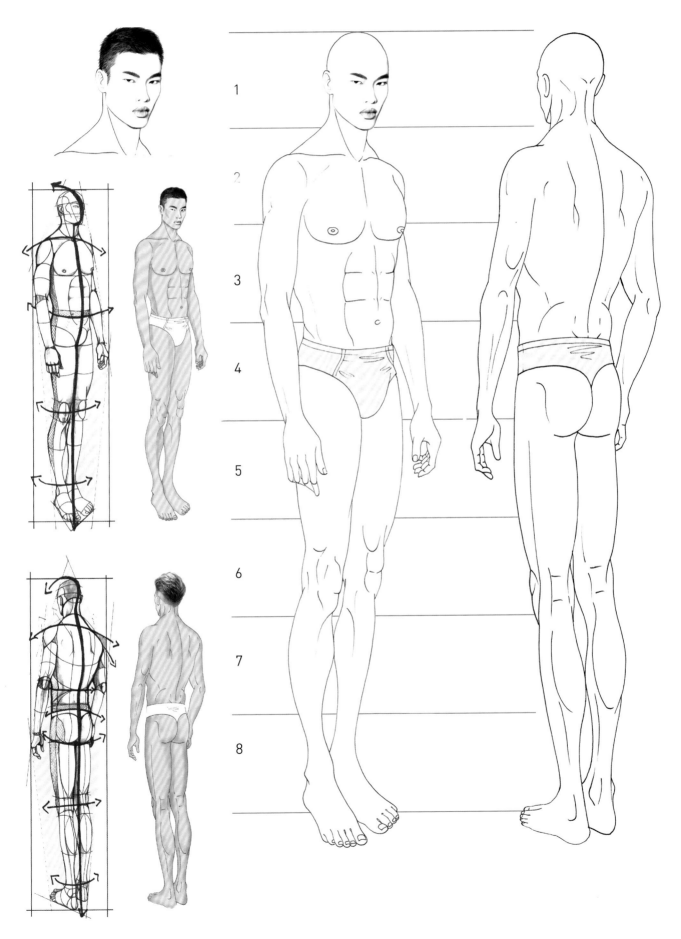

STRUCTURAL ANALYSIS OF A POSE FROM THREE ANGLES

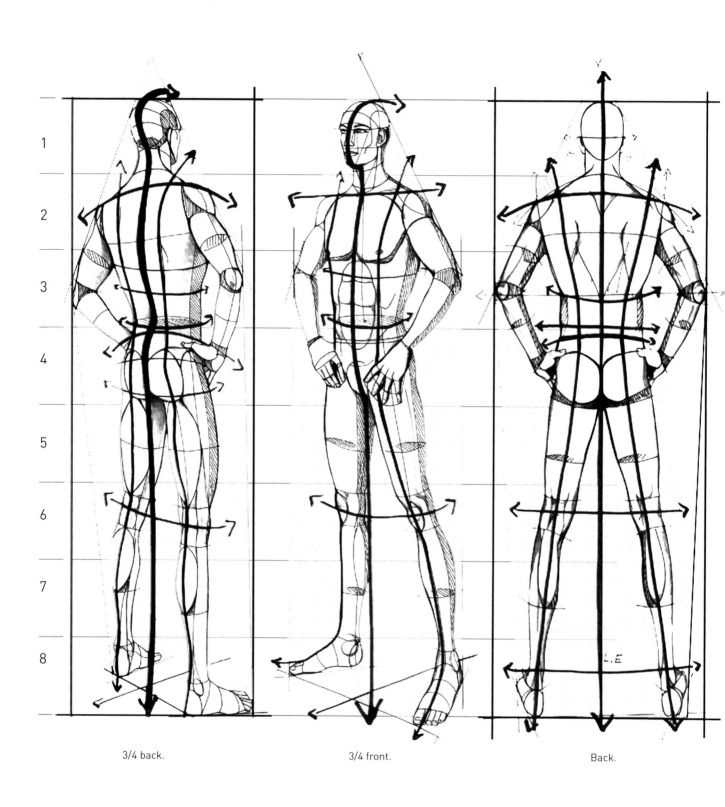

3/4 back.

3/4 front.

Back.

These three images pertain to the poses on the following pages. The diagrams analyse negative and positive spaces, and the various anatomical and structural relationships. Start off by drawing the modular grid and carefully study one diagram at a time until you can draw them by heart.

SAME POSE SHOWN FROM THREE ANGLES, LEGS APART AND HANDS ON HIPS

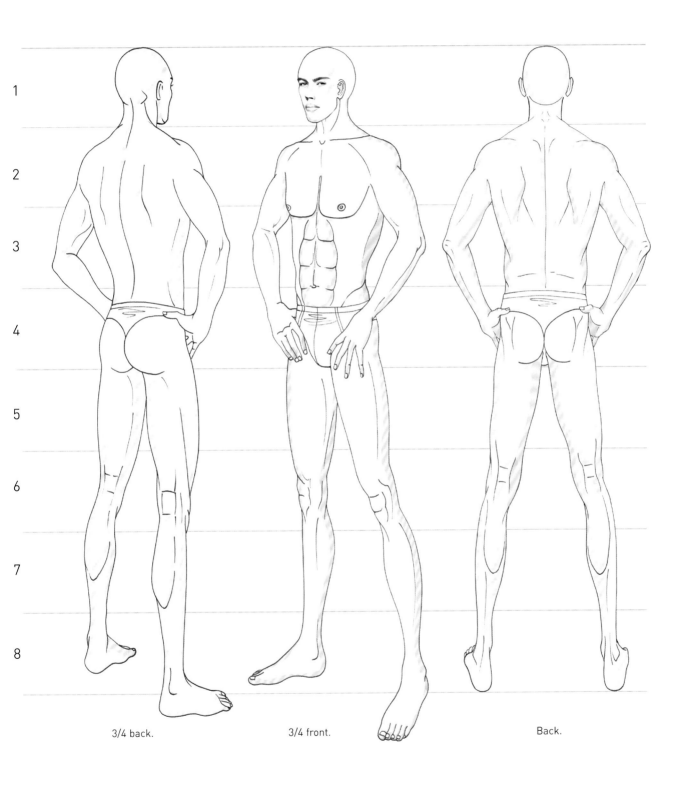

3/4 back.

3/4 front.

Back.

Drawn from the three basic perspectives, this pose can be useful for visualising a piece of clothing, whereby you can see all its characteristics from all angles. When drawing figures, always pay attention to the proportions of the whole and make sure that all the anatomical parts are distributed between the various modules. If the previous exercise is done carefully, you should have no difficulty reproducing the figure on the page.

FIGURE SEEN FROM THE BACK, WALKING

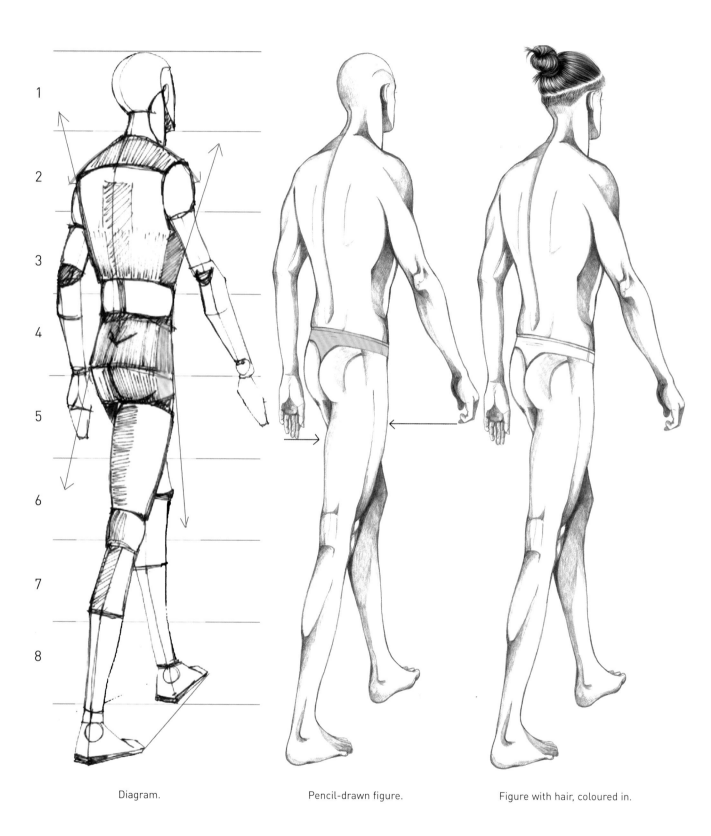

1

2

3

4

5

6

7

8

Diagram.

Pencil-drawn figure.

Figure with hair, coloured in.

POSE WITH BENT LEG, SEEN FROM BEHIND

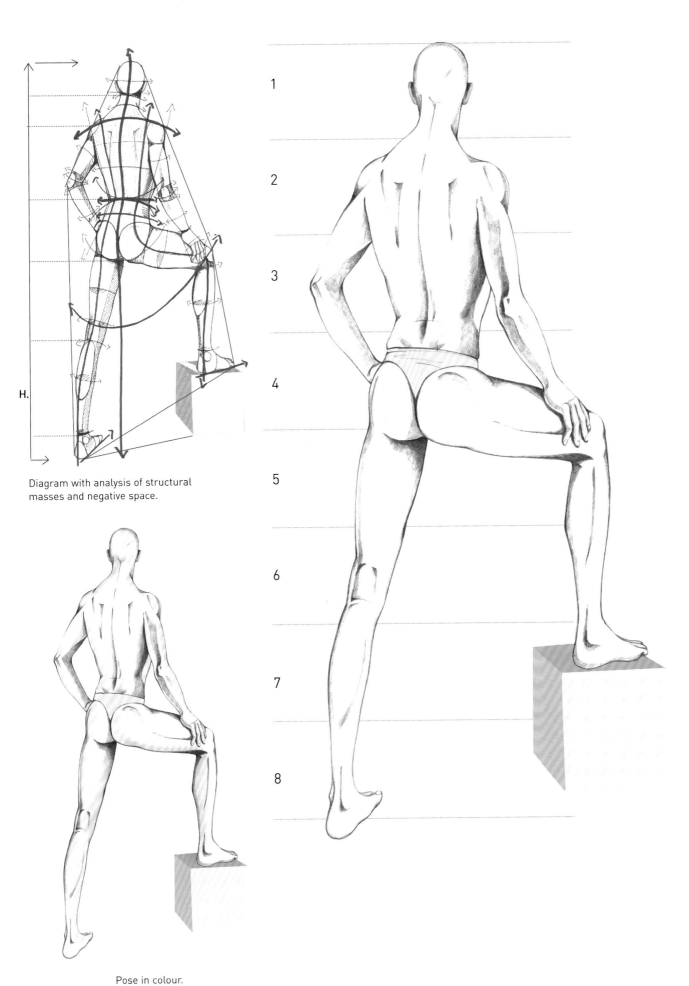

Diagram with analysis of structural
masses and negative space.

Pose in colour.

ANALOGIES

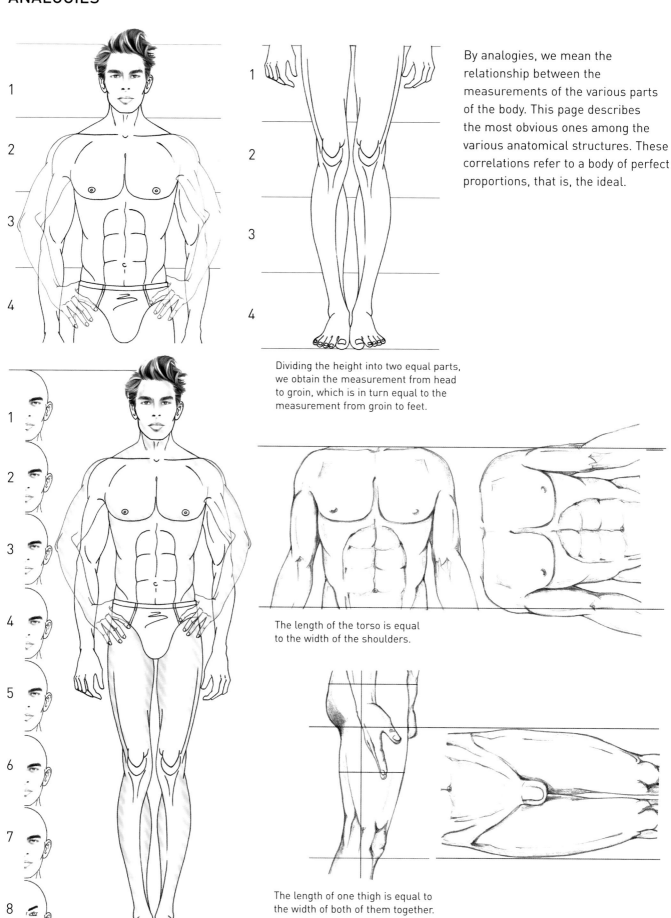

By analogies, we mean the relationship between the measurements of the various parts of the body. This page describes the most obvious ones among the various anatomical structures. These correlations refer to a body of perfect proportions, that is, the ideal.

Dividing the height into two equal parts, we obtain the measurement from head to groin, which is in turn equal to the measurement from groin to feet.

The length of the torso is equal to the width of the shoulders.

The length of one thigh is equal to the width of both of them together.

The head is the size of one module and is equal to an eighth of the standing body.

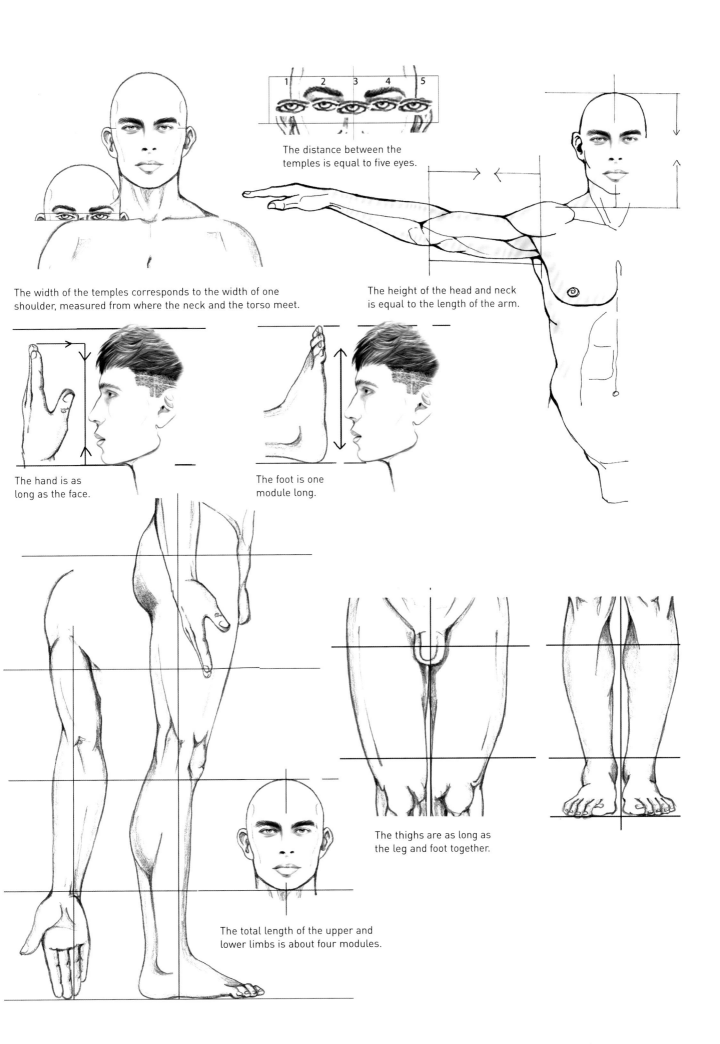

The distance between the temples is equal to five eyes.

The width of the temples corresponds to the width of one shoulder, measured from where the neck and the torso meet.

The height of the head and neck is equal to the length of the arm.

The hand is as long as the face.

The foot is one module long.

The total length of the upper and lower limbs is about four modules.

The thighs are as long as the leg and foot together.

LIMB ROTATION AND NEW POSES

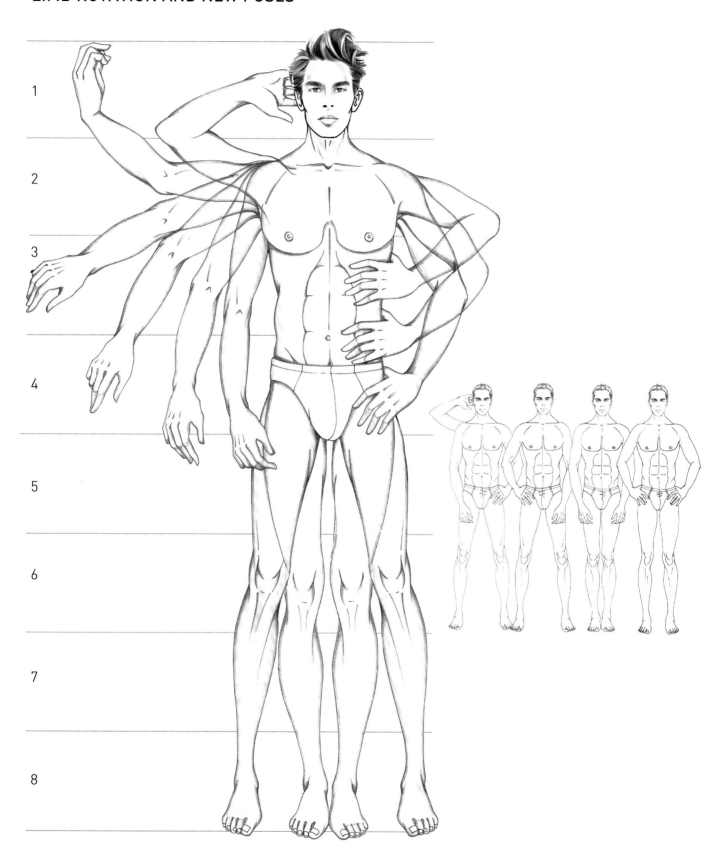

If you want to have a new pose without having to make a new figurine each time, just change the position of the limbs, and head if you wish, leaving the torso unaltered. This figure demonstrates how by simultaneously rotating and bending the arms and legs, you can create another image with little effort and in a short amount of time. In the copying exercise, the shoulder joint gradually moves closer to the neck as the arm is raised. The lower limbs also retract slightly. Carefully examine the content of each module, without losing sight of the proportions; draw using an ordinary or mechanical HB pencil. When you have finished, trace over the drawing using the LED table, and upload it to your computer to make colour and costume variations.

SIMULTANEOUS MOVEMENTS IN PROFILE AND THREE-QUARTERS, AS SEEN FROM THE BACK

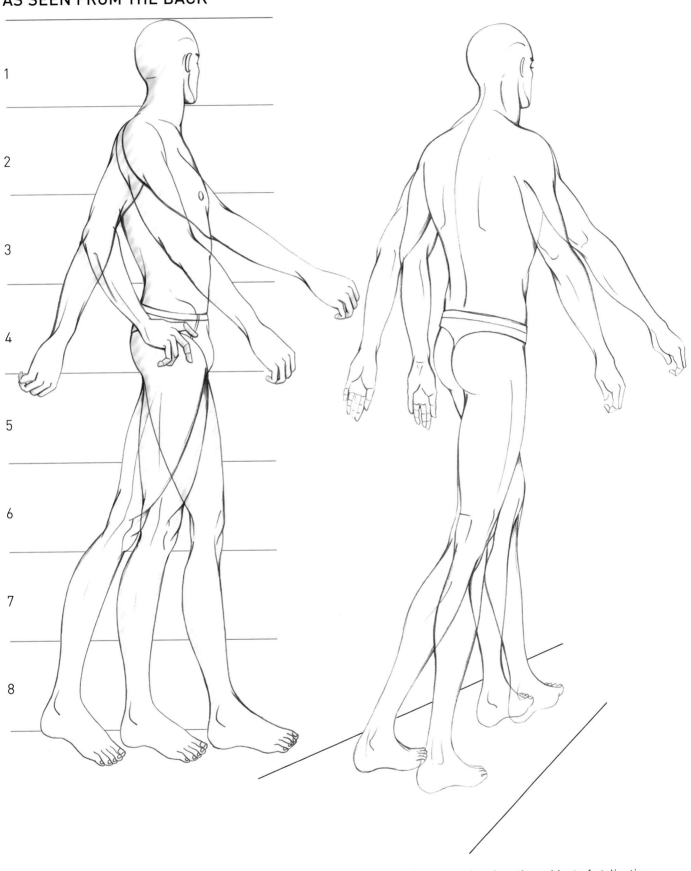

The two poses in simultaneous movement suggest at least six other positions that can be extrapolated and saved in your archive, so that you can apply them to future outfits. These last drawings, with many topics covered and several suggested exercises, conclude the part dedicated to the human body of classical proportions.

Now we are ready to tackle a lovely topic that is more akin to fashion drawing: the subject of stylisation, which is the transformation of a body with real proportions to another more pertinent and suitable figure for fashion design.

FASHION CANON

STYLISATION

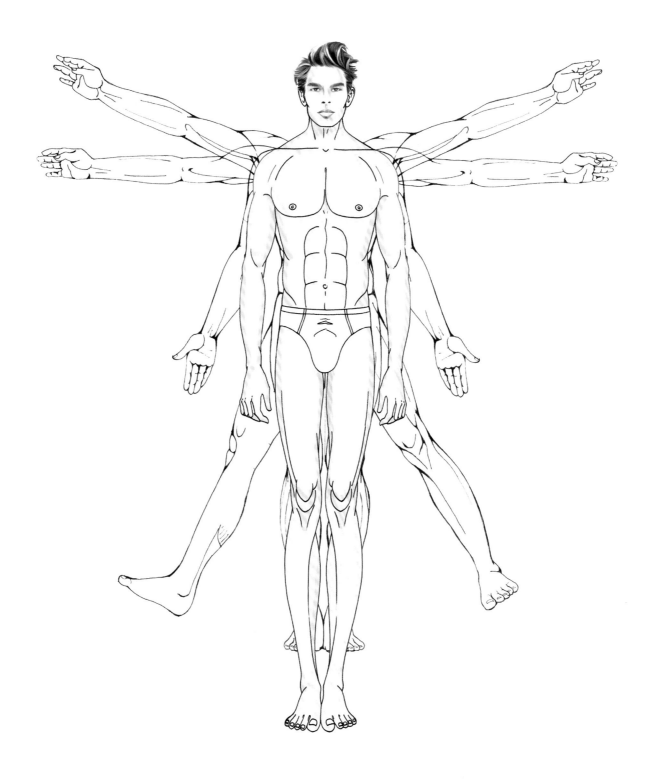

By *stylisation* we mean the simplification and gist of the structure of the body, which is reduced to a few essential features or simply lengthened by one or two modules, with respect to the Greek canon. Fashion calls for perfect, tall, athletic bodies, so fashion figurines should spotlight the wearers' proportions by showcasing their most attractive features, such as height, beauty and elegance of movement.

This chapter analyses and develops the technique of transforming the Greek canon into the fashion canon, using nude poses and diagrams of the body reduced to a mannequin. To make the modifications simpler and neater, the figures are drawn over the grid base, and are elongated by one module. The male body is depicted in basic positions, without artistic license, so as not to influence the style that students will develop by the end of the course, once the complete methodological process has been acquired.

IMAGINED FIGURINES

Figure with essential colours.

Drawn figure.

Realistic figure.

By "imagined figurine" we mean the depiction of a person wearing the outfit while posing or walking freely in an imaginary space. There are several ways to draw this, as long as it is not too stylised and features the most important details of the clothing, since its function is none other than to clearly showcase the clothes being worn. You will find many examples of imagined figurines in the chapter dedicated to clothing and trends.

The ones we see here have been included in order to demonstrate what can be achieved by following the explanations one step at a time, before moving on to develop one's own artistic language.

STYLISATION OF THE BASIC FRONTAL FIGURE

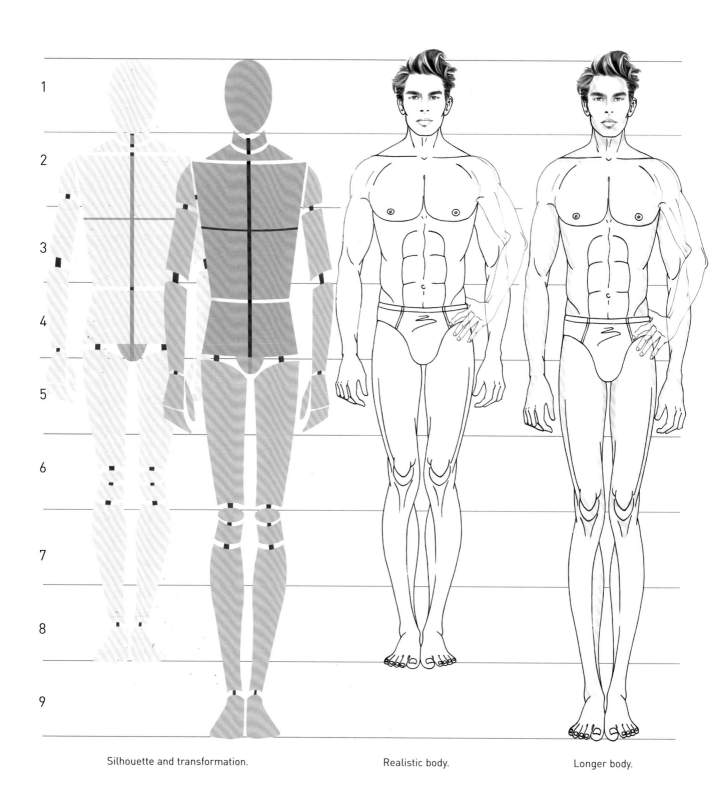

Silhouette and transformation.

Realistic body.

Longer body.

In the diagram, the pose is illustrated as a silhouette and as an anatomical version of the body, and clearly schematises the modifications. In the stylisation, the figure on the right has been lengthened by one module and has nine modules in total: the neck and torso have been relatively lengthened, the upper and lower limbs have undergone the greatest extension, while the head remains with the first module. The basic alignments remain proportionate: the elbow is still at waist height, the fist is level with the pubis and the hands are level with the middle of the thigh. The entire figure has been narrowed slightly, so it looks even slimmer.

BASIC PROFILE FIGURINE

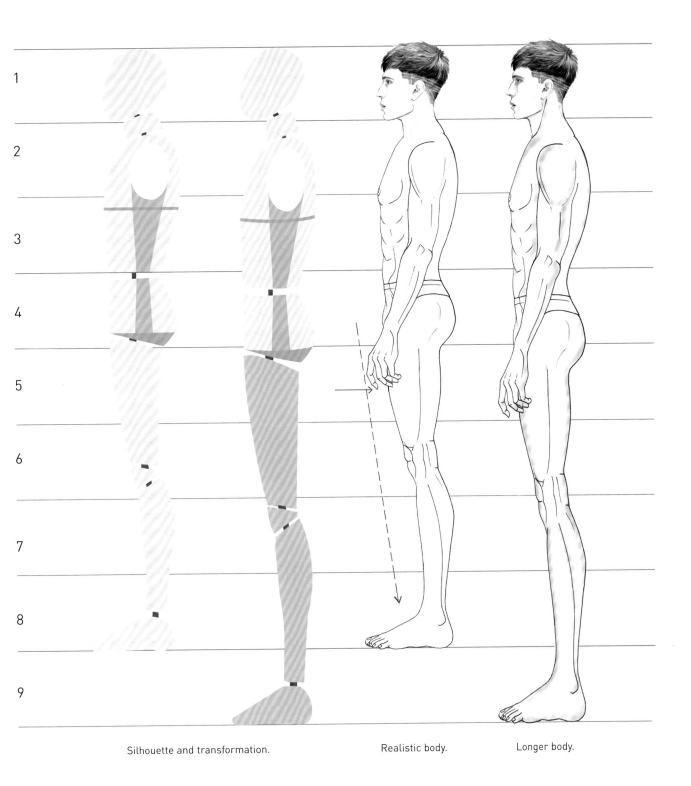

1

2

3

4

5

6

7

8

9

Silhouette and transformation. Realistic body. Longer body.

The same modifications have also been made in this basic profile pose, transforming the body with real proportions into a more stylised one in accordance with the language of fashion design. Adding the silhouette and figure to the modular grid assists the learning and analysis stage, and is also useful for copying exercises.

BASIC FIGURINE FROM BEHIND

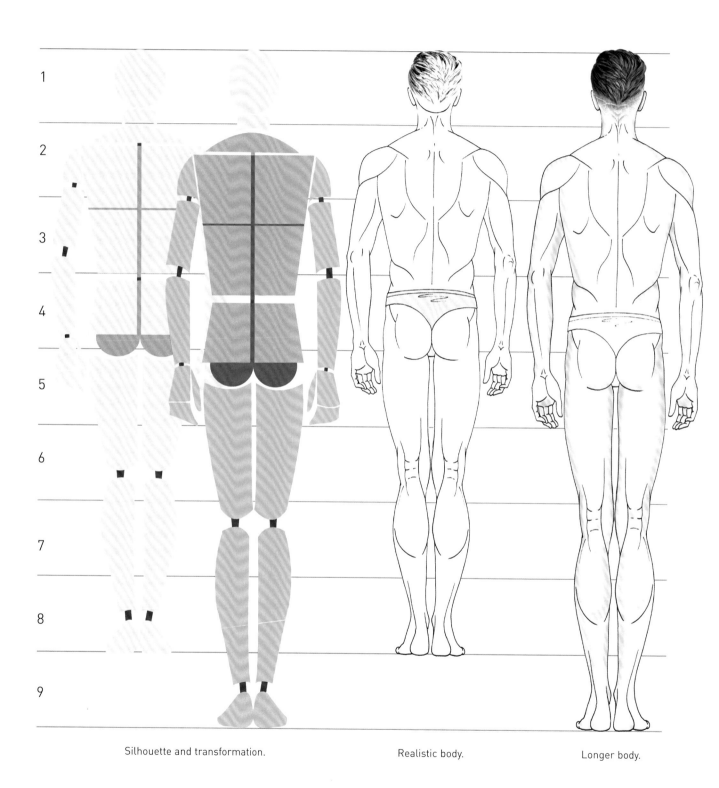

Silhouette and transformation.

Realistic body.

Longer body.

When reproducing the images, pay attention to every detail: the anatomical proportions, the muscular masses and the correct arrangement of the limbs within the various modules. The modifications made to the figure on the right are the same as those applied to the two previous poses and their malleability makes them a perfect accompaniment to the flat drawings used in the pattern-making workshop. Depending on requirements, the arms and legs can be lengthened so that the armholes and trouser crotch can be seen better.

OTHER WAYS TO DRAW A FASHION FIGURINE

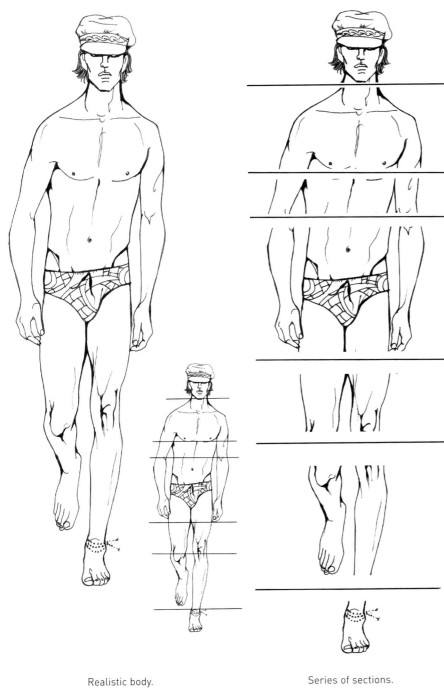

Realistic body.

Series of sections.

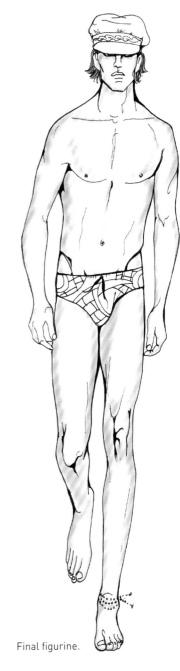

Final figurine.

The first drawing is a figure traced from a photo shoot but, due to an optical effect, the body is stocky and short, despite the fact that the real model is very tall and long. To obtain the appropriate stylisation, just cut the drawing of the real body horizontally into several sections (as shown in the central drawing), separate the parts according to how tall you want the final figurine to be and then trace everything to make a good copy. The system is so practical and fast that you only have to match up the sections at the end, and then the new pose will be ready to wear clothes.

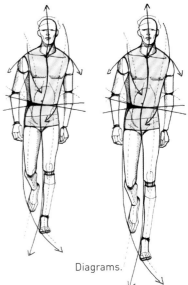

Diagrams.

STYLISING A WALKING MODEL

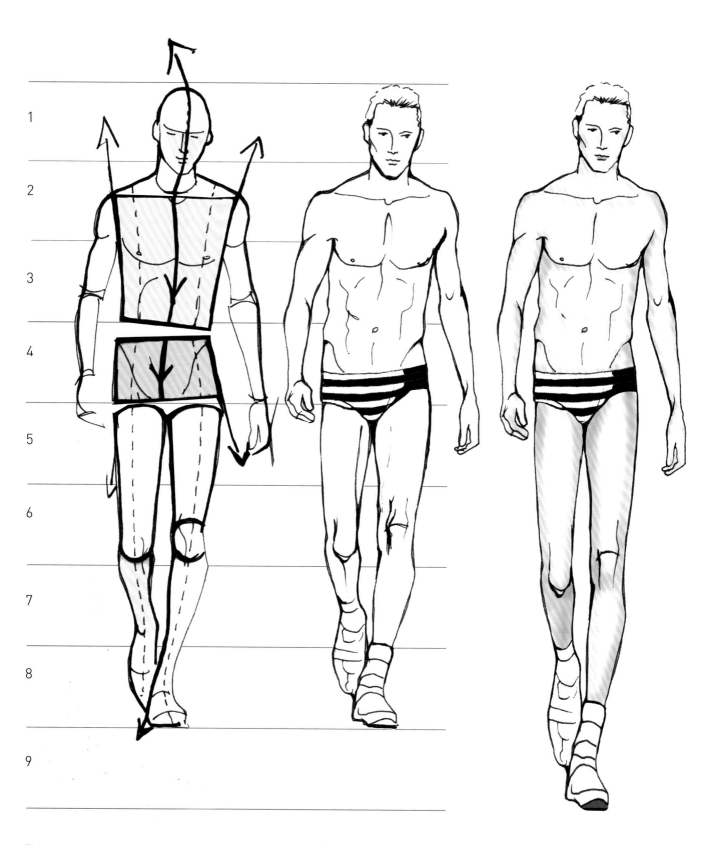

This drawing captures the most common attitude embodied by models as they catwalk down the runway. The mannequin demonstrates the movement of the main parts of the body and its posture when walking. The most elongation was applied to the limbs, and the entire figure has also been slightly slimmed down.

10-MODULE FASHION FIGURINE

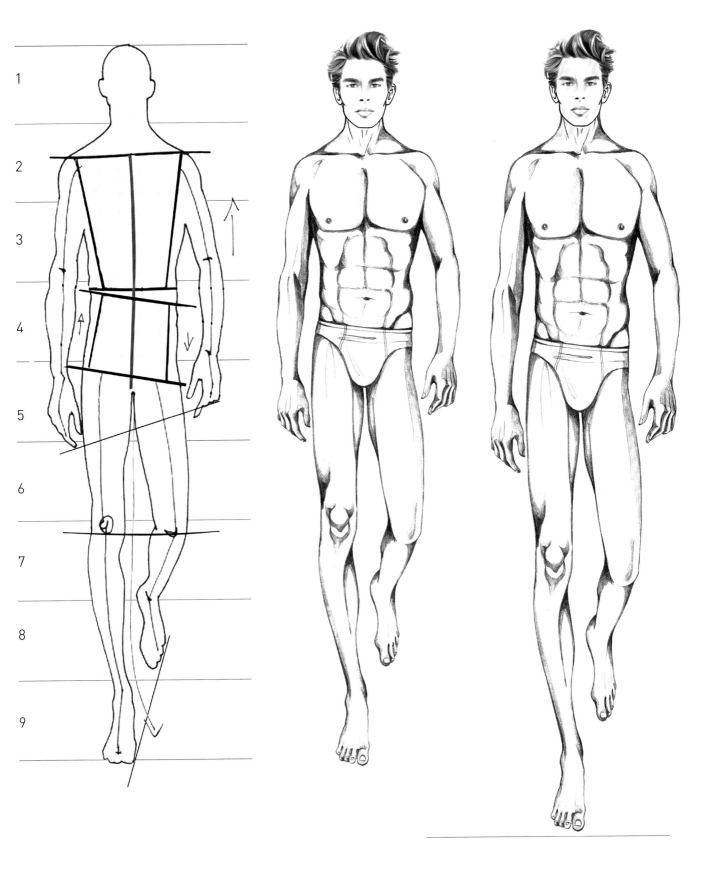

The further lengthening of the fashion figurine, which already spanned nine modules, was done in just a few moments using Photoshop.
The head has retained its basic proportions, but the body has been extended by one module, making ten in all. If you stray too far from the real measurements of the body with extreme stylisation or excessive elongation, you may run the risk that the proportions of the garments will be misinterpreted. It is therefore advisable that you describe very elongated figures with exhaustive technical notes, so that the technicians in the prototyping lab understand the proportions and cuts you envisage.

THREE FIGURINES IN FASHION POSES

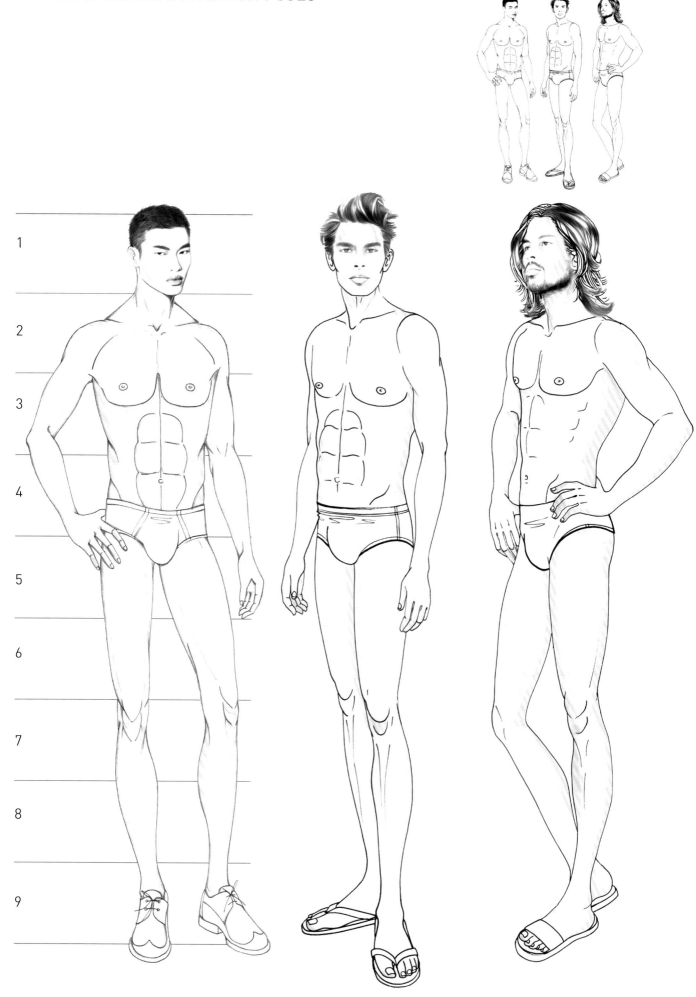

1

2

3

4

5

6

7

8

9

LENGTHENING A POSE WITH PHOTOSHOP

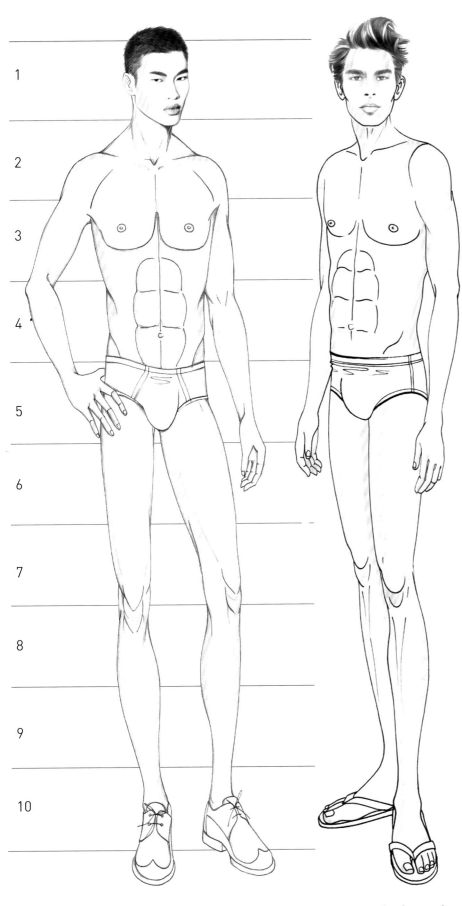

1

2

3

4

5

6

7

8

9

10

Using Photoshop, it is very easy to lengthen or modify the proportions of an image. If you prefer a taller, slimmer pose, just select the image from the neck to the feet and lengthen it by one module. The head will keep the same dimensions, so as not to make its length disproportional. Knowing how to use various art software programs is essential for future fashion designers.

Second module
THE PARTS OF THE BODY

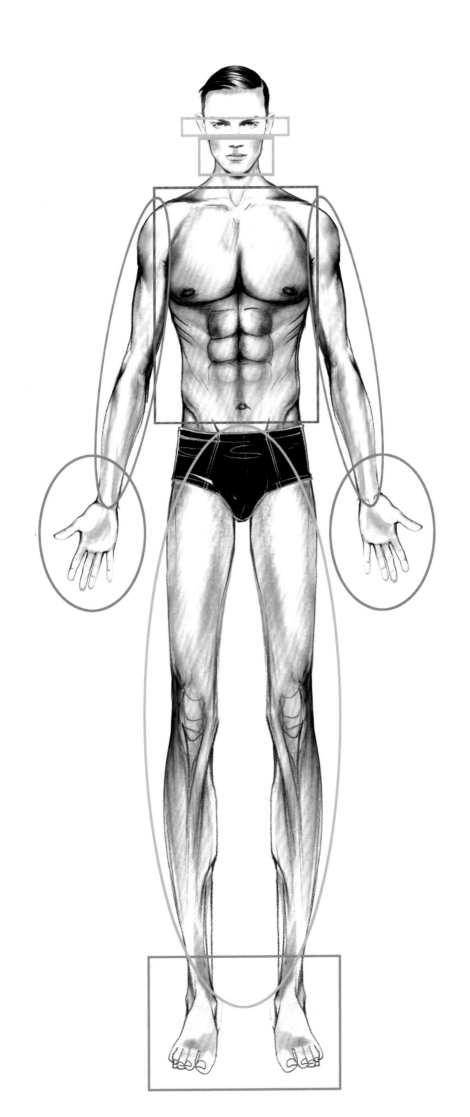

THE HEAD

ANALYSIS AND STRUCTURE

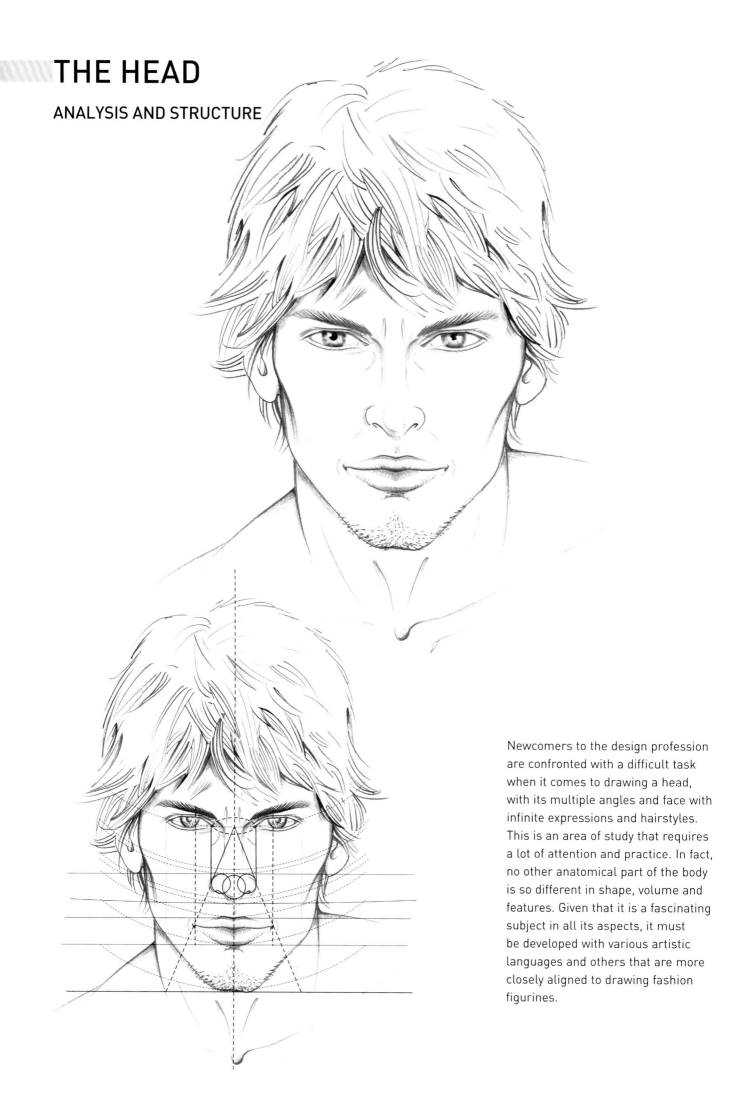

Newcomers to the design profession are confronted with a difficult task when it comes to drawing a head, with its multiple angles and face with infinite expressions and hairstyles. This is an area of study that requires a lot of attention and practice. In fact, no other anatomical part of the body is so different in shape, volume and features. Given that it is a fascinating subject in all its aspects, it must be developed with various artistic languages and others that are more closely aligned to drawing fashion figurines.

THE HEAD SEEN AS AN EGG

The overall structure of the head is similar to that of an egg: the upper part is formed by the cranial mass (CM) and the lower part by the mass of the face (FM), which includes the facial features and the jaw. These simplified diagrams of the volume of the head have been drawn with horizontal and vertical axes that divide the two main masses. When the head rotates or tilts, the axes turn into curved lines.

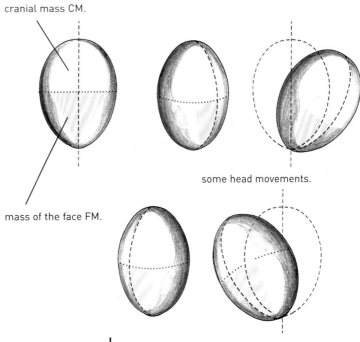

cranial mass CM.

mass of the face FM.

some head movements.

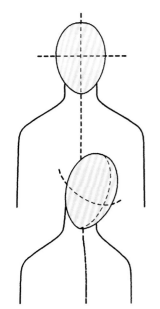

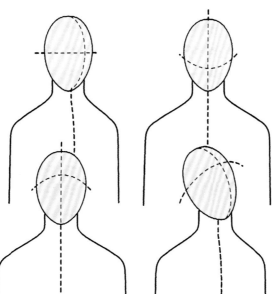

Exercise
Take an egg and draw the main axes outlining the main features of the face on it; rotate it in various ways and copy the obtained positions.

The face, drawn inside an egg.

The face drawn on the egg can be subdivided into three equal sections: the first, from the hairline to the superciliary area; the second, from the superciliary area to the tip of the nose, and the third from the tip of the nose to the chin. We can observe that the horizontal lines curve when the head is tilted and they always remain parallel to each other.

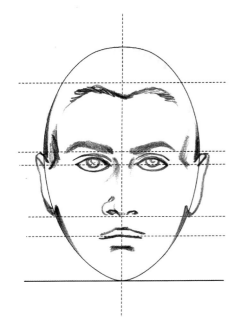

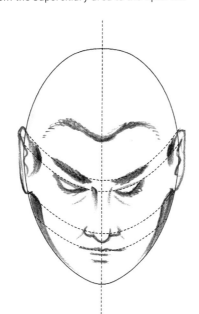

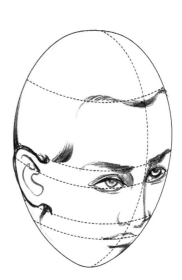

47

FROM THE SKULL TO THE HEAD

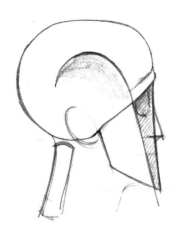

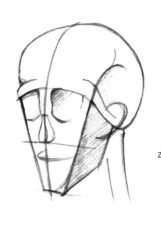

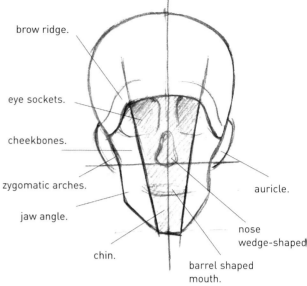

brow ridge.

eye sockets.

cheekbones.

zygomatic arches.

jaw angle.

chin.

auricle.

nose
wedge-shaped

barrel shaped
mouth.

The skull shows the two large masses CM and FM,
and the new secondary masses of the face.

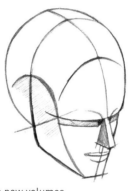

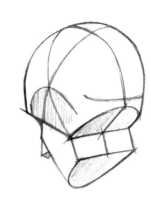

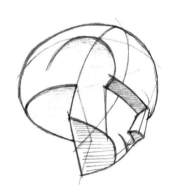

Head rotation. Each position corresponds to new volumes
and alignments of the main and secondary masses.

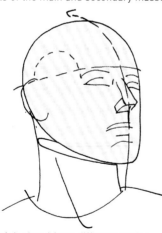

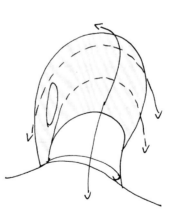

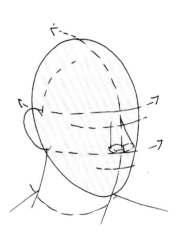

Six diagrams of the head from different angles.

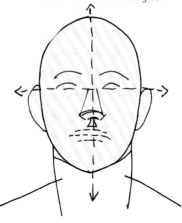

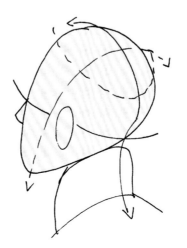

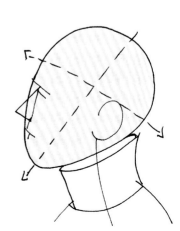

HEAD CANON

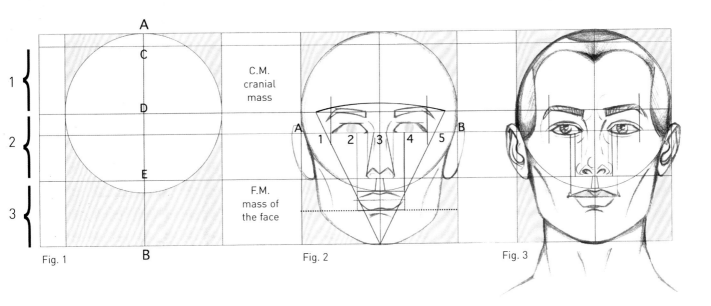

Fig. 1 Fig. 2 Fig. 3

C.M. cranial mass

F.M. mass of the face

Fig.1 Use a vertical segment to determine the height of the face (A-B) and the hairline C. Divide the C-B segment into three equal segments, then draw a circle with a radius equal to A-D, and the rectangle containing the face.

Fig. 2 Eyes and nose: draw the oval of the nose by lengthening the jaw a little. Divide the width of the temples (AB) into five equal segments and draw the shape of the eyes and superciliary arch in the second and fourth spaces. We can see that the width between each temple is equal to five eyes. Draw the schematic and elongated shape of the septum and nasal wings as wide as one eye.

Mouth and ears: divide the third section in half, to determine where the bottom of the lower lip should be. Draw a smaller upper lip and a fuller lower lip. The width of the lips is one third of an eye. Between the nose and the mouth is the *trapezoidal* philtrum. Next, draw the ears slightly above the nose.

Fig. 3 The whole head. Define the facial features by slightly lowering the hairline. A man's neck is thicker than a woman's, so it must be drawn from under the jaw.

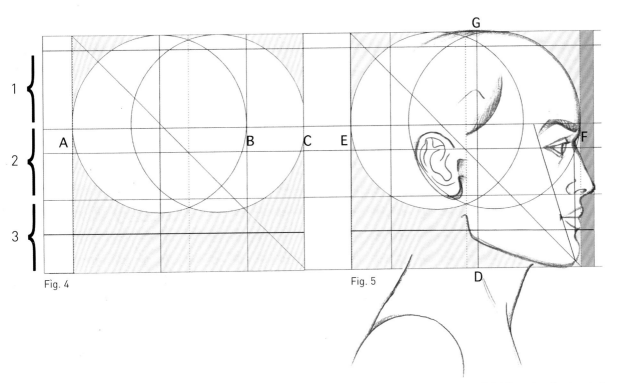

Fig. 4 Fig. 5

Fig. 4 The head in profile
Draw a circle with a diameter (A-B) that is equal to the one we drew for the cranial mass (fig. 1). Outwardly extend a third of the diameter and draw a second circle of the same size, overlapping the first. Draw a square with side A-C tangent to the circumference. Translate all the building segments from fig. 1 into the square.

Fig. 5 Morphology
Draw the profile, using illustration as a guide; note that the root of the nose is aligned with the inward curve of the mouth. The ear is oblique in the third sector, displaced slightly backwards from the central G-D axis of the square. The largest diameter of the intuitive ellipse (E-F) determines the distance between the skull and the forehead.

NOTE When drawing heads from life, recall the proportions studied here, but remember that they are ideal and so only meant as a guide; in reality, all heads feature characteristics that differ from the canon.

ANALYSIS AND ROTATION OF THE HEAD

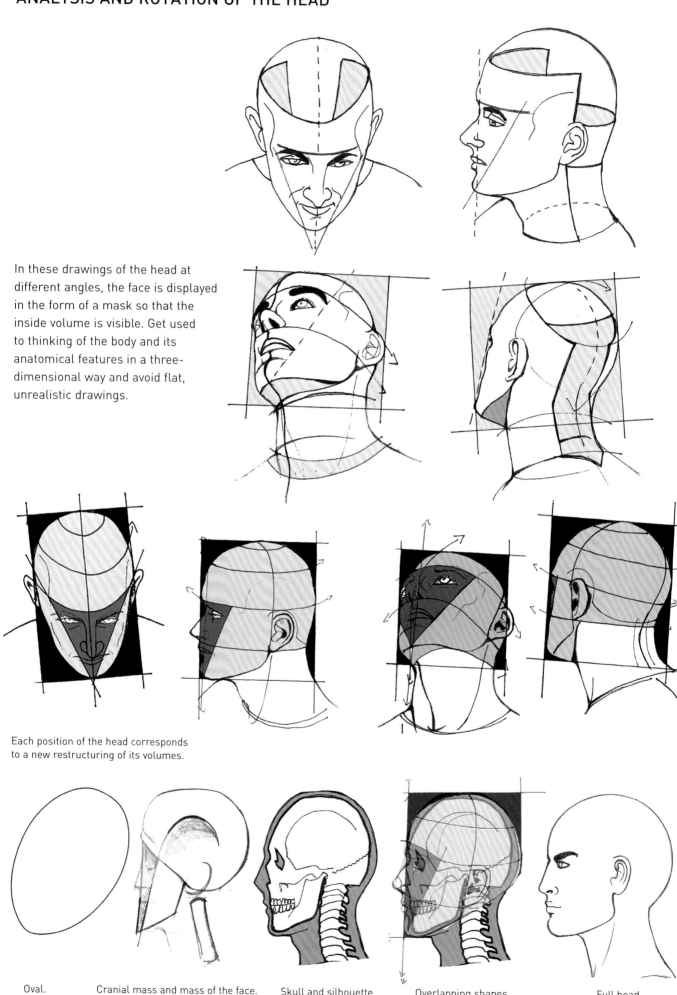

In these drawings of the head at different angles, the face is displayed in the form of a mask so that the inside volume is visible. Get used to thinking of the body and its anatomical features in a three-dimensional way and avoid flat, unrealistic drawings.

Each position of the head corresponds to a new restructuring of its volumes.

Oval.　　　Cranial mass and mass of the face.　　　Skull and silhouette.　　　Overlapping shapes.　　　Full head.

ANALYSIS OF VARIOUS ANGLES OF THE HEAD

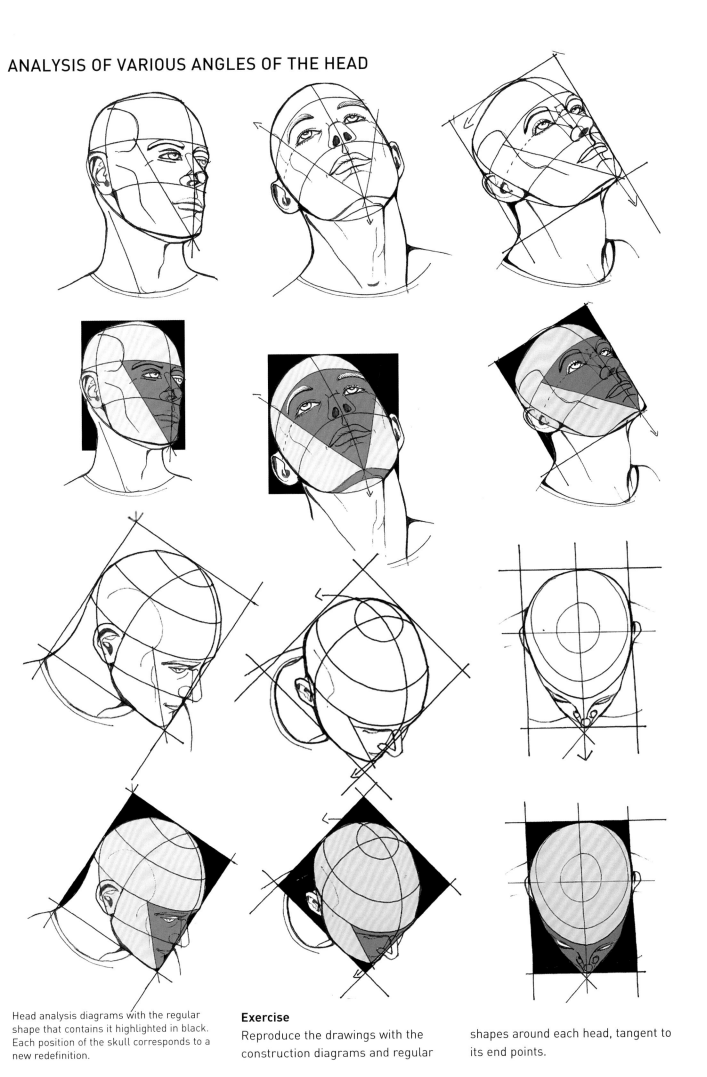

Head analysis diagrams with the regular shape that contains it highlighted in black. Each position of the skull corresponds to a new redefinition.

Exercise

Reproduce the drawings with the construction diagrams and regular shapes around each head, tangent to its end points.

HEAD ROTATION IN FIVE MOVEMENTS

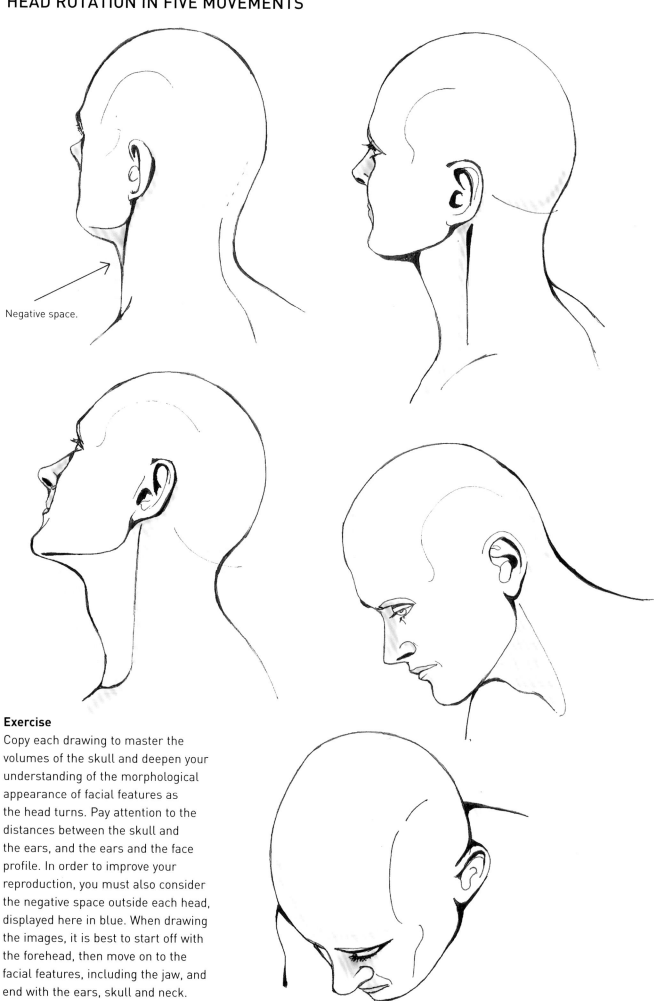

Negative space.

Exercise

Copy each drawing to master the volumes of the skull and deepen your understanding of the morphological appearance of facial features as the head turns. Pay attention to the distances between the skull and the ears, and the ears and the face profile. In order to improve your reproduction, you must also consider the negative space outside each head, displayed here in blue. When drawing the images, it is best to start off with the forehead, then move on to the facial features, including the jaw, and end with the ears, skull and neck.

HEAD ROTATION IN FOUR MOVEMENTS

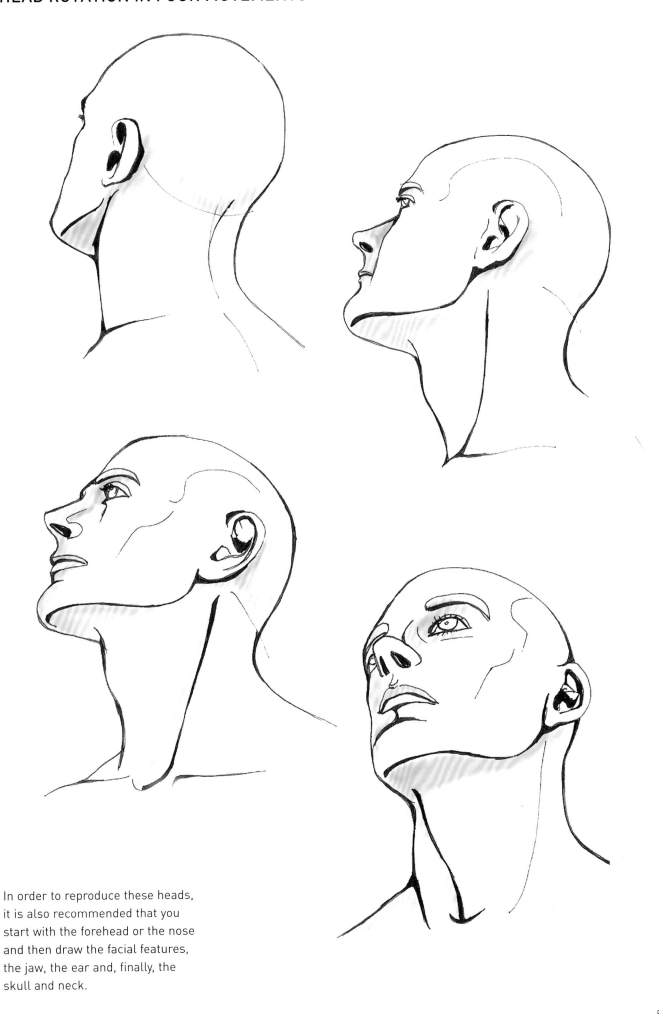

In order to reproduce these heads, it is also recommended that you start with the forehead or the nose and then draw the facial features, the jaw, the ear and, finally, the skull and neck.

MANY HAIRSTYLES FOR ONE FACE

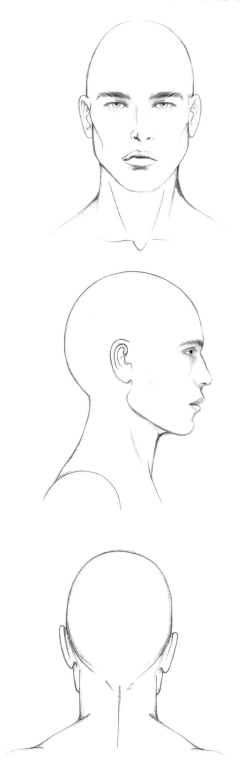

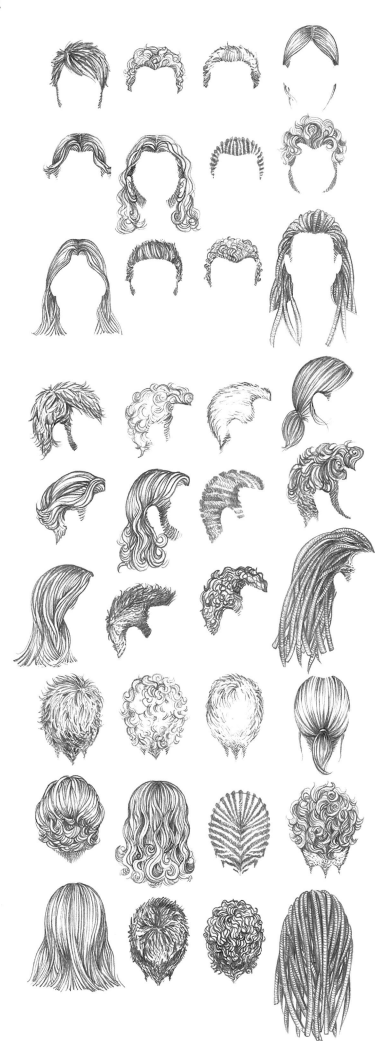

You don't need to draw a different head each time you want to give a particular style or character to the face of a figurine: you can just modify the hairstyle. This page includes drawings of various hairstyles that are suitable for the three heads. You can use them in the copy exercise or select them on the screen and place them directly on the head.

COMBINATIONS

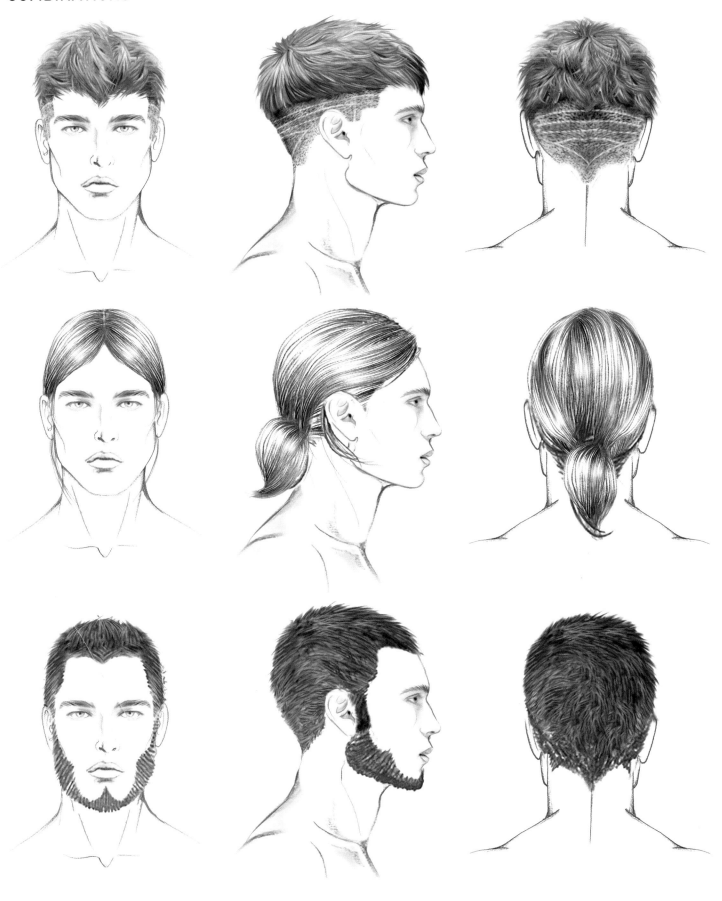

On this and the following pages, we can see how the same face changes with a bald head or full head of hair. The procedure was carried out directly on the computer after drawing the different hairstyles freehand. The range of hairstyles displayed here is a reflection of various fashion trends. **Drawing technique:** the hair mass is expressed using strokes that are close together and further apart, according to the movement of the strands. The linear and three-dimensional styles are achieved using a 2B pencil or 02-05 fineline markers.

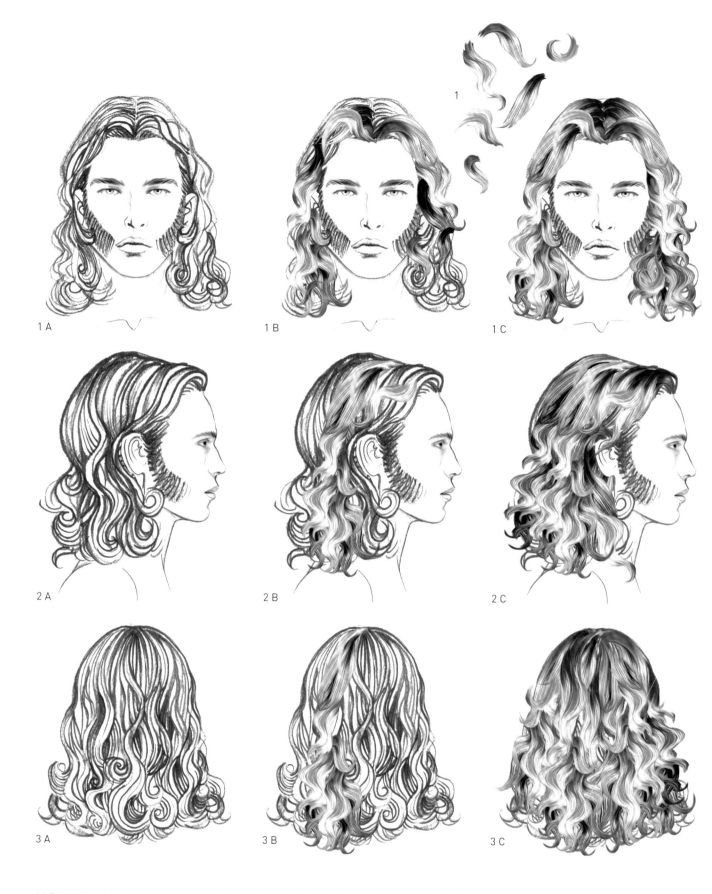

1 A 1 B 1 C

2 A 2 B 2 C

3 A 3 B 3 C

USING A COMPUTER TO ADD COLOUR TO A HAIRSTYLE

These images show the same hairstyle, which was drawn by hand with a 2B pencil and coloured in on the computer, seen from a regular angle. The first step was to use a graphics card to create several meshes with various different movements and shapes. Figures

1B, 2B and 3B demonstrate the first steps of hair application and assembly, using the classic cut and paste system to position the strands directly, and using tools for small touches and to create movement. In order to give the hair a more realistic appearance, some areas have been darkened and

others lightened. Figures 1C, 2C and 3C show the complete head with its new hairstyle. To change the colour of the face pencil, just go to *Image-Settings-Colour Balance* and turn the black of the pencil to a beige that is similar to natural blonde hair and blend it into the hairstyle.

DREADLOCKS

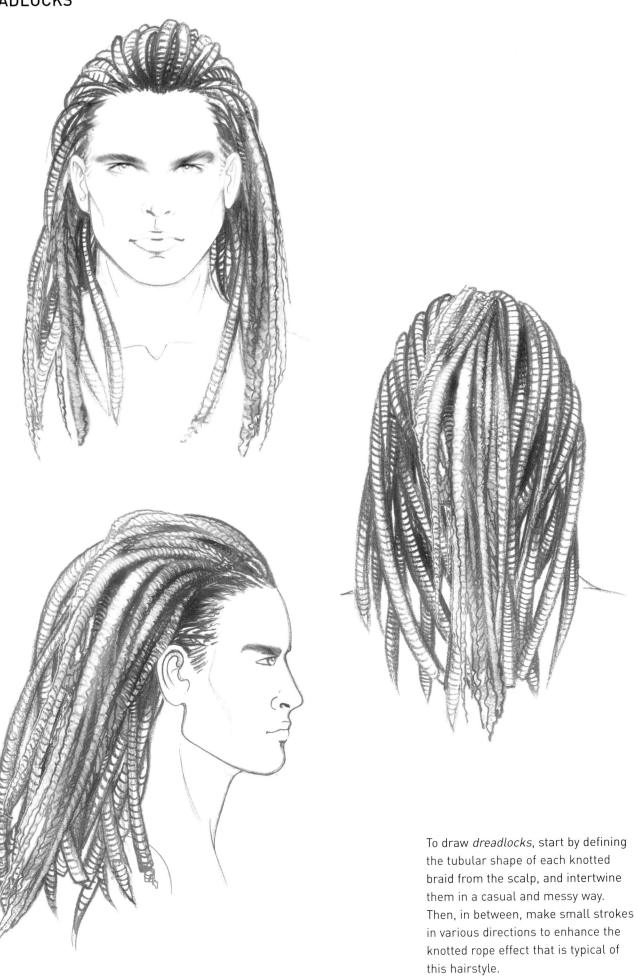

To draw *dreadlocks*, start by defining the tubular shape of each knotted braid from the scalp, and intertwine them in a casual and messy way. Then, in between, make small strokes in various directions to enhance the knotted rope effect that is typical of this hairstyle.

OTHER COMBINATIONS

If you want to depict the characteristics of hair correctly, avoid the *spaghetti* effect.

To avoid hardening the lines or having to draw each hair at a time, it is advisable to draw the entire hair mass with a light hand, using soft strokes, gradually darkening and thickening the movement of the hairstyle as you go. Don't be discouraged if you don't get great results immediately, because it's just a matter of practice.

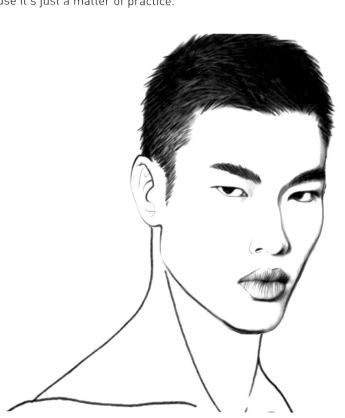

NOTE The lines are drawn closer together where the hair thickens or is gathered; where there is no movement, however, it is enough to draw a single line that is more pronounced in the shaded areas and thinner against lighter areas.

HEADS WITH HAIR

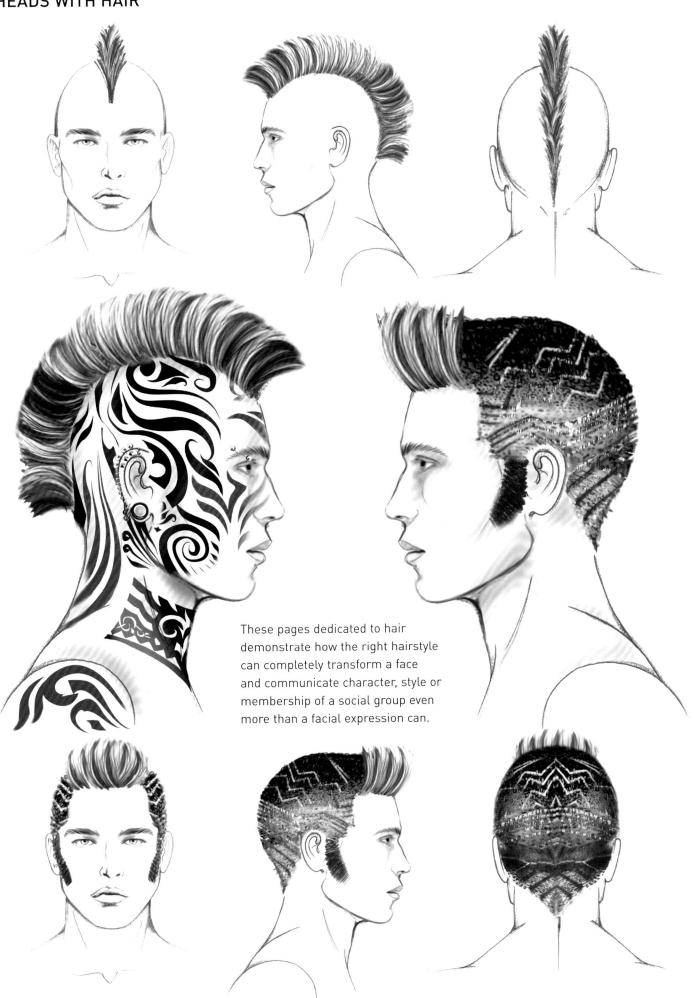

These pages dedicated to hair demonstrate how the right hairstyle can completely transform a face and communicate character, style or membership of a social group even more than a facial expression can.

DRAWING HEADS WEARING HEADGEAR

Drawn with n.º 02 to n.º 08 fineliners, these drawings are characterised by a more graphic technique, giving them an almost comic-book style. Drawing hats on top of any outfit adds life and character to the proposed look; just took how many celebrities wear them.

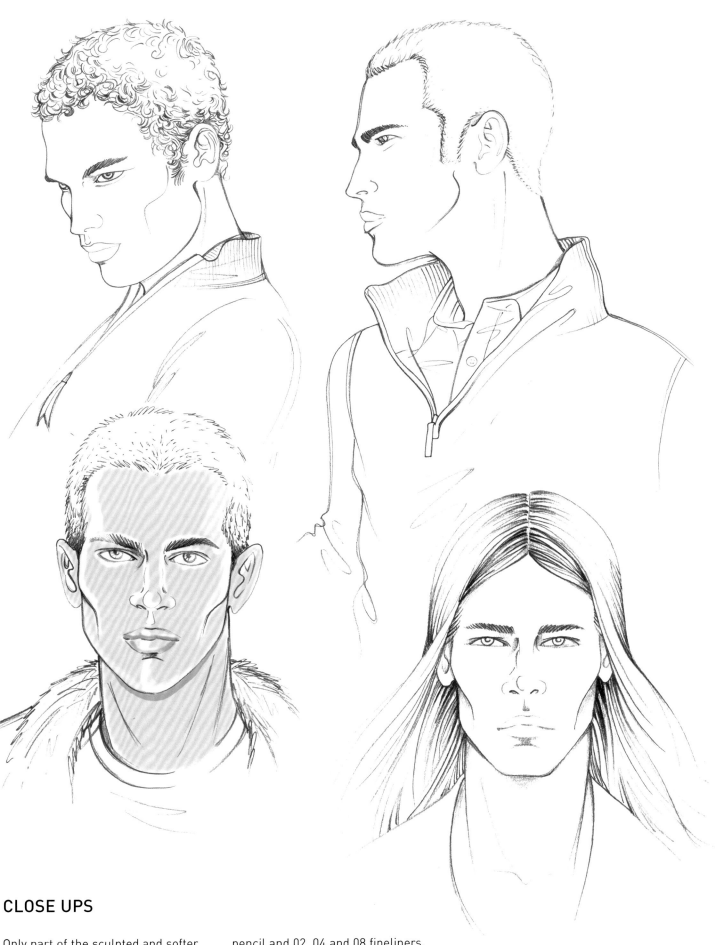

CLOSE UPS

Only part of the sculpted and softer hairstyles are drawn here, just enough to get the idea of the full volume and style. The drawings were made using a well-sharpened 2B pencil and 02, 04 and 08 fineliners. To copy them, keep your hand light: sketch the whole and then gradually build up the volume of the hair over the thickest strands.

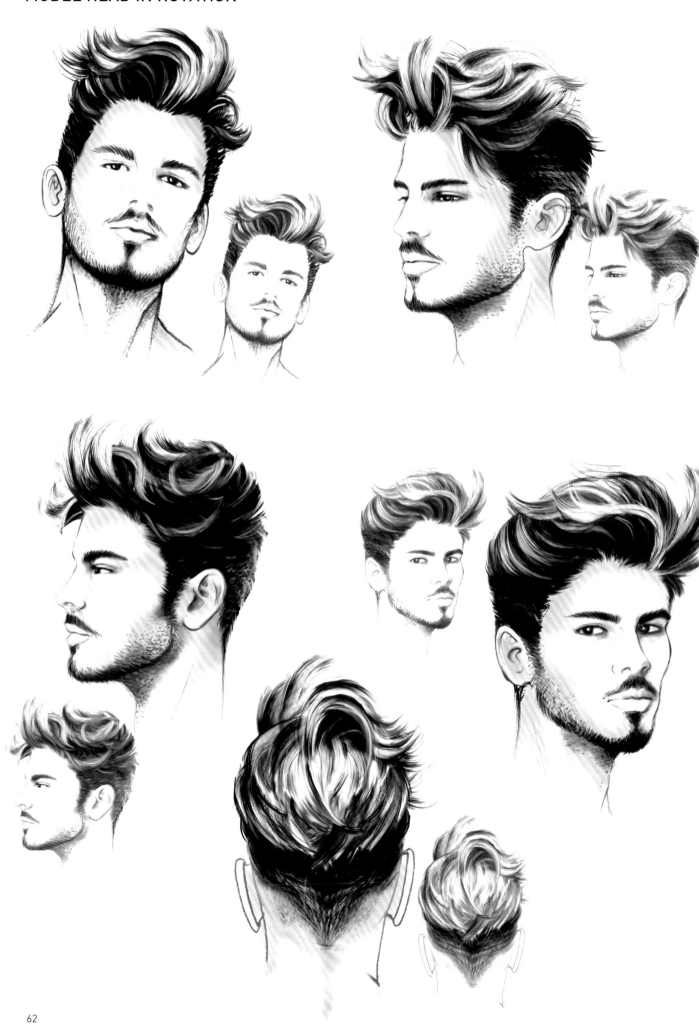

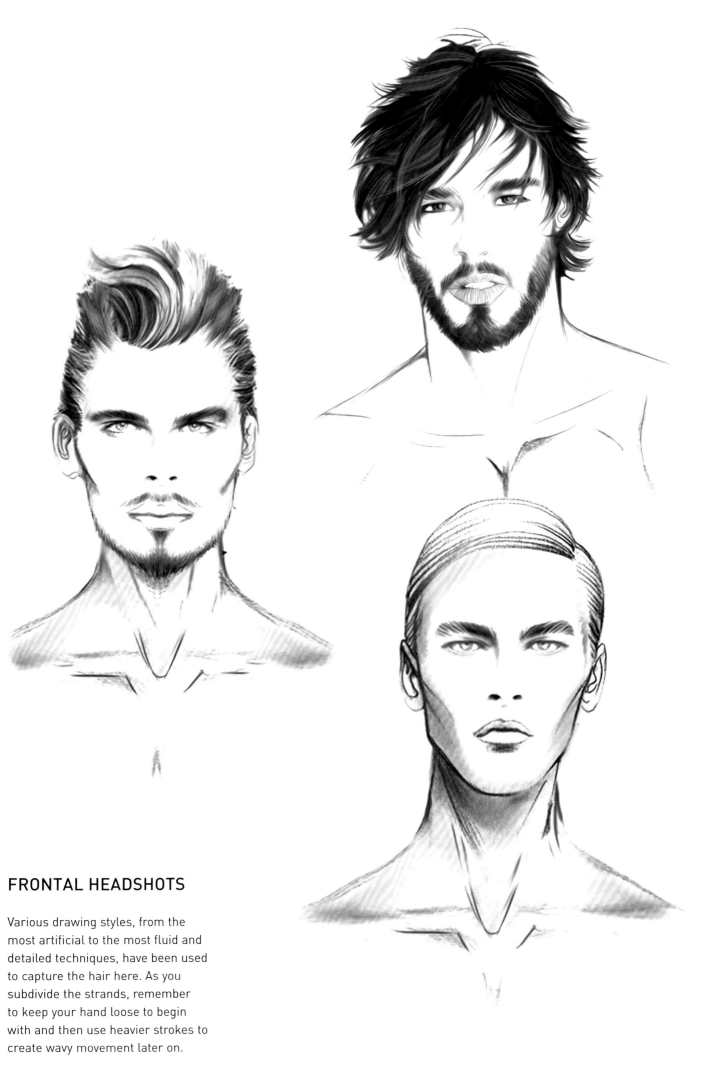

FRONTAL HEADSHOTS

Various drawing styles, from the most artificial to the most fluid and detailed techniques, have been used to capture the hair here. As you subdivide the strands, remember to keep your hand loose to begin with and then use heavier strokes to create wavy movement later on.

PENCIL PORTRAIT IN CHIAROSCURO GRADIENT

On this last page, we analyse the faded chiaroscuro technique which, unlike the comic book graphics in the previous chapters, depicts the heads in a more truthful and three-dimensional way. Faded chiaroscuro is a technique whereby you draw very small circles that are alternated with very fine lines that cross over each other, to produce a light and delicate effect. Draw a wiggly line to depict the concave and convex waves of the hair. The procedure takes time, but it is very helpful in *keeping the hand loose* and developing your attention to the most delicate nuances. Place a protective sheet of paper between your hand and the sheet you are drawing on, to stop you from dirtying the drawing by leaning on or rubbing it with the palm of your hand.

Procedure

Start by using a HB pencil to draw a light, linear outline of the silhouette of the head; then, gradually add the shadows using very sharp HB, 2B and 3B pencils, starting from the medium tones; finally, very gradually intensify the shades, pressing harder on the shaded areas, as explained in the sequential drawing. To rub out, gently dab the putty rubber on the area you want to lighten. This rubber is also good for accentuating lighter areas by removing excess shadow.

FACE ALIGNMENTS - EYES

The eyes are the most expressive part of the face, because they communicate the full range of human emotions. Their most interesting feature, besides their shape, is the colour of the iris, which creates captivating headshots.

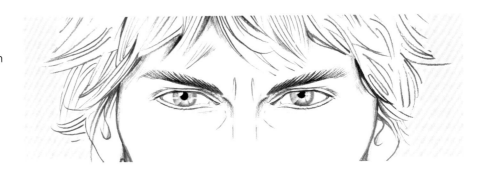

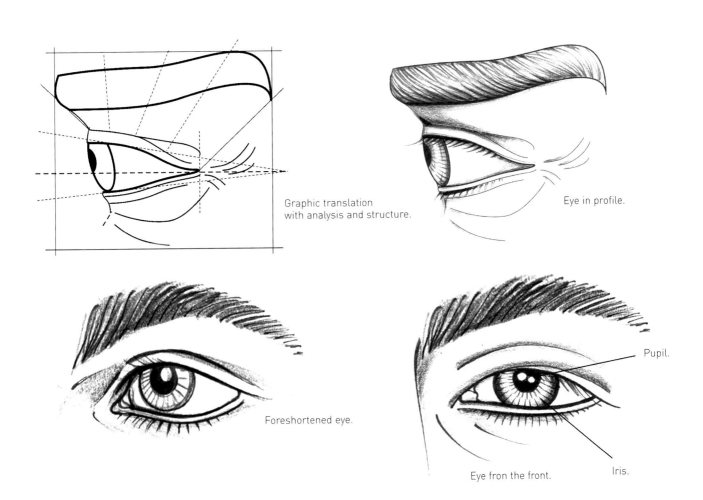

Graphic translation with analysis and structure.

Eye in profile.

Foreshortened eye.

Eye fron the front.

Pupil.

Iris.

SHAPE AND STRUCTURE

Seen from the front, the eye is shaped like an almond, while in profile it is triangular. It is protected by the upper eyelid, which is thicker and wider, and by the lower eyelid, which is thinner. Eyebrows and eyelashes are important eye adornments and must be drawn with care. Technically, the light effect of the pupil is obtained by leaving one or two small white circles inside it; to give depth to the look, darken the inner line of the upper eyelids, accentuating the shadow cast by the eyelashes inside the eye. Practice copying the drawings from the chapter, starting with a sketch, studying the shape and the chiaroscuro effect.

ANALYSIS

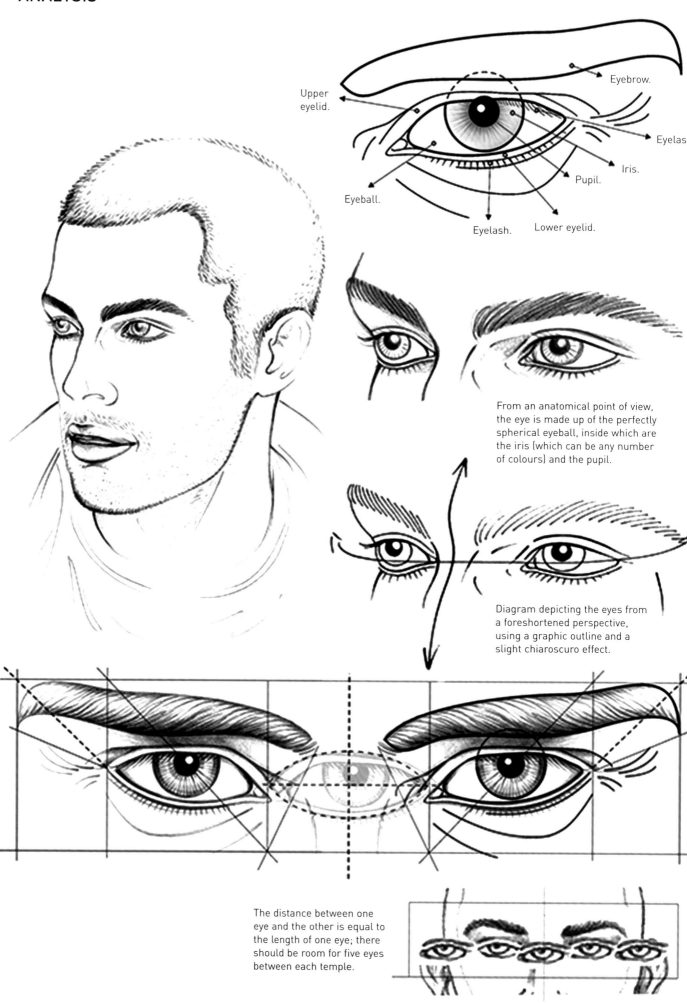

Upper eyelid.

Eyebrow.

Eyelash

Iris.

Pupil.

Eyeball.

Eyelash.

Lower eyelid.

From an anatomical point of view, the eye is made up of the perfectly spherical eyeball, inside which are the iris (which can be any number of colours) and the pupil.

Diagram depicting the eyes from a foreshortened perspective, using a graphic outline and a slight chiaroscuro effect.

The distance between one eye and the other is equal to the length of one eye; there should be room for five eyes between each temple.

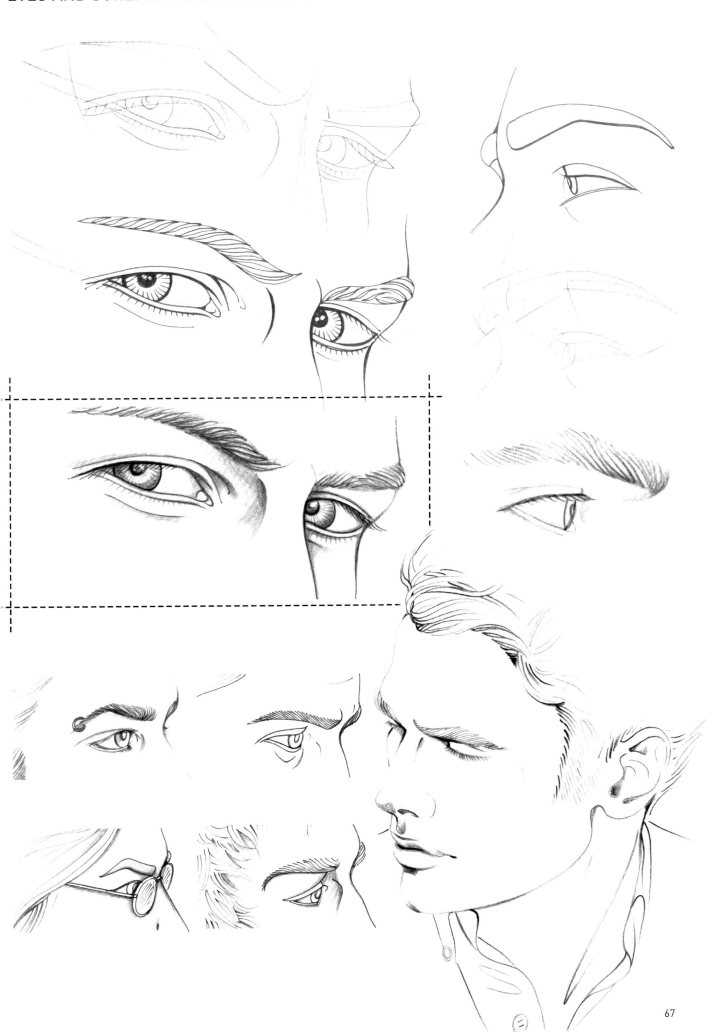

EYES AND FACE

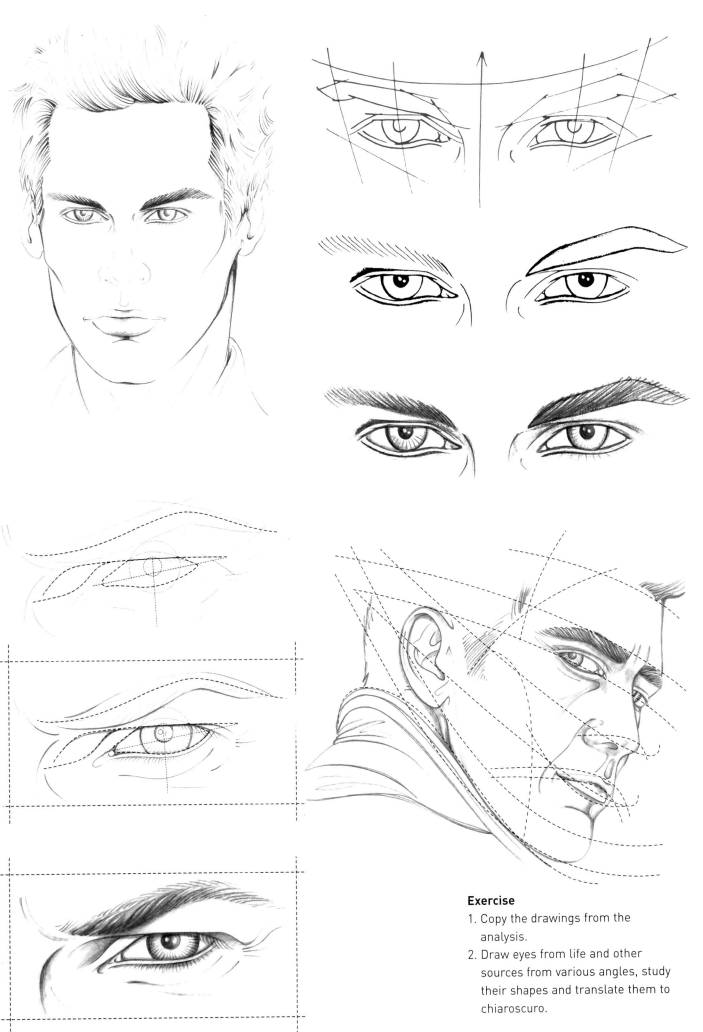

Exercise

1. Copy the drawings from the analysis.
2. Draw eyes from life and other sources from various angles, study their shapes and translate them to chiaroscuro.

THE NOSE

PROPORTION ANALYSIS

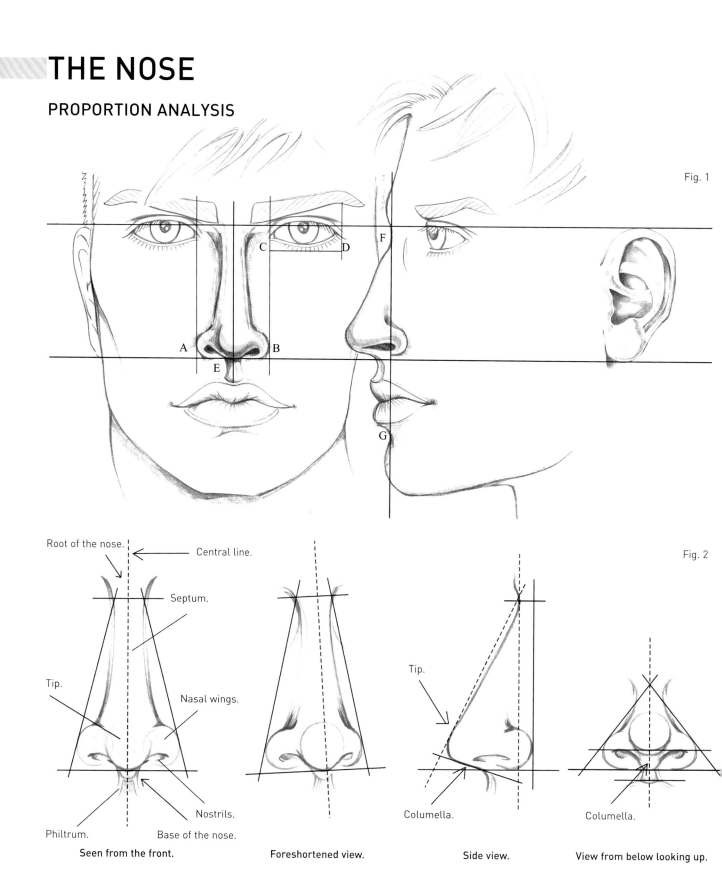

Fig. 1

Fig. 2

Root of the nose.
Central line.
Septum.
Tip.
Nasal wings.
Nostrils.
Philtrum.
Base of the nose.

Seen from the front.

Foreshortened view.

Tip.
Columella.

Side view.

Columella.

View from below looking up.

Positioned in the middle of the face, the nose is the head's most protruding anatomical feature and is the first organ of the respiratory system. Its shape, which is different for each person, helps to give the face a unique appearance. In this chapter, the nose is analysed according to the classic canon of proportions, which is perfect in every respect. The nose is predominantly made up of the

septum, tip, nasal wings, and the nostrils (Fig. 1 and 2) and is attached to the mouth by the philtrum or nasal sulcus which, seen in profile, lines up with the groove at the base of the nose. (E). The nose's length, from root to base, lines up roughly with the length of the ears, and the distance between the nasal wings is equal to the width of one eye (AB = CD). The root of the nose and the recess under

the lips are on the same line (GF). The profile is characterised by the back of the columella, that is, the curve under the tip. In terms of structure, the shape of the nose seen from the front can be enclosed in an elongated trapezoid whose base is made up of three spheres: a central, larger one, corresponding to the tip, and two smaller lateral ones that determine the dimensions of the nostrils (fig. 2).

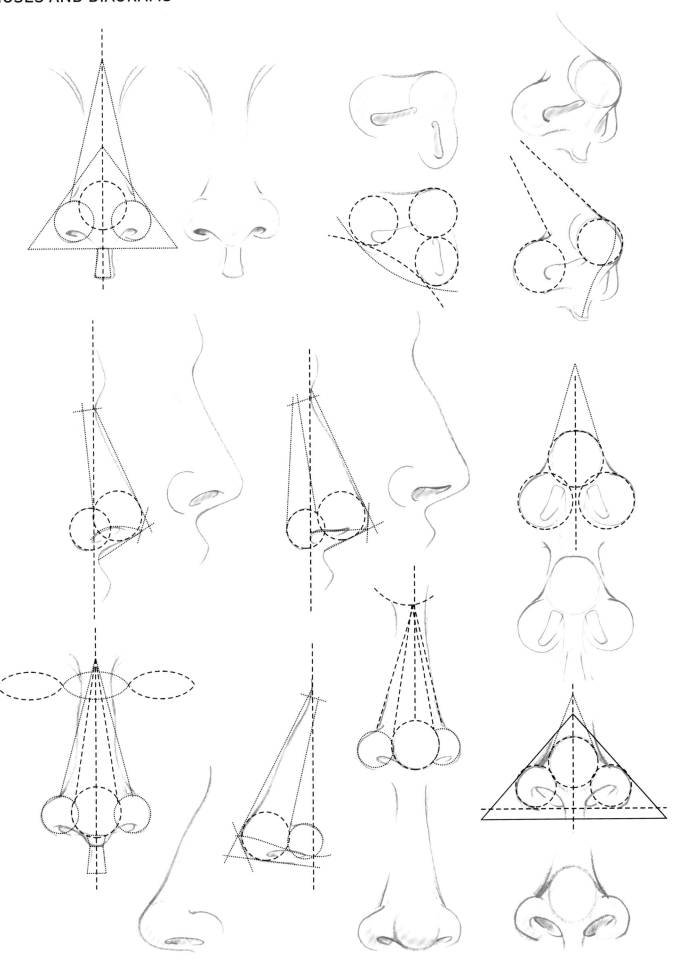

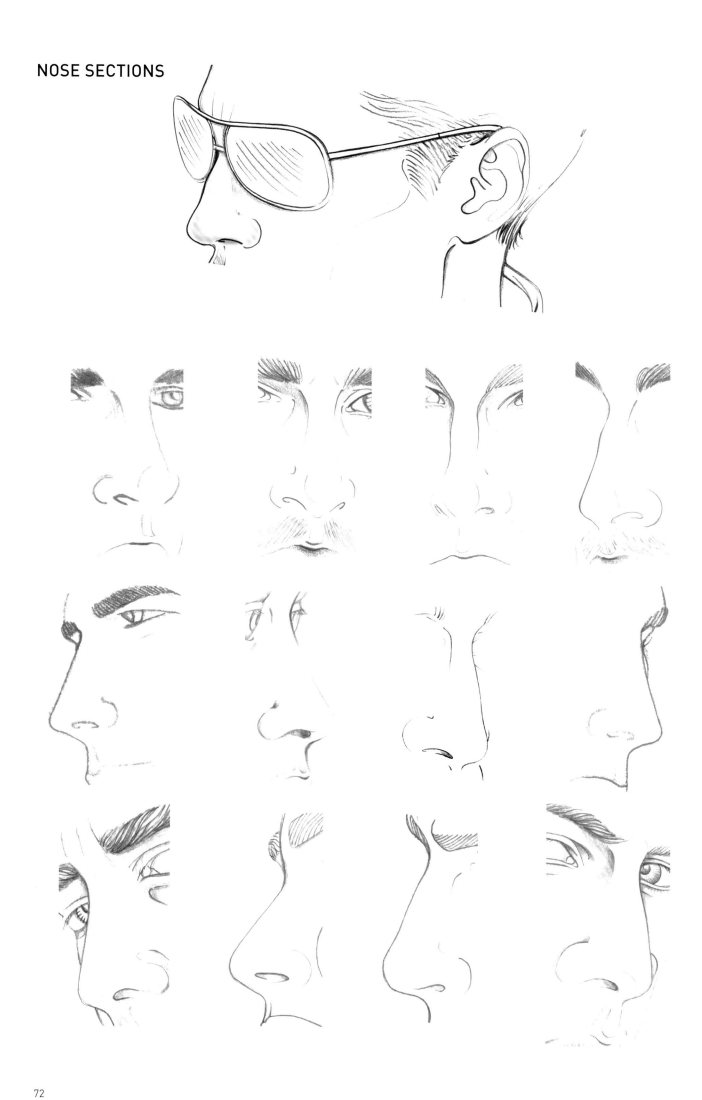

THE MOUTH

ANALYSIS AND STRUCTURE

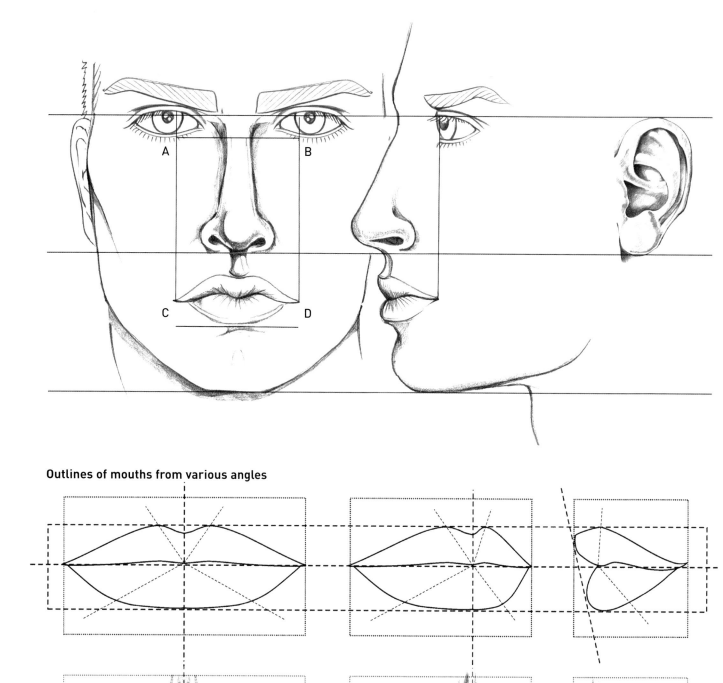

Outlines of mouths from various angles

Seen from the front.

Foreshortened view.

Side view.

The external part of the mouth is made up of two moving parts: the upper lip, which is smaller and long, and the lower lip, which is larger and fuller. The outer points of the mouth, where the lips meet, is equal to one third of each eye (AB - CD). Between the nose and the mouth is the philtrum, which is trapezoidal in shape, and whose axis divides the lips into two equal parts.

MOUTHS FROM THE FRONT AND ANALYSIS

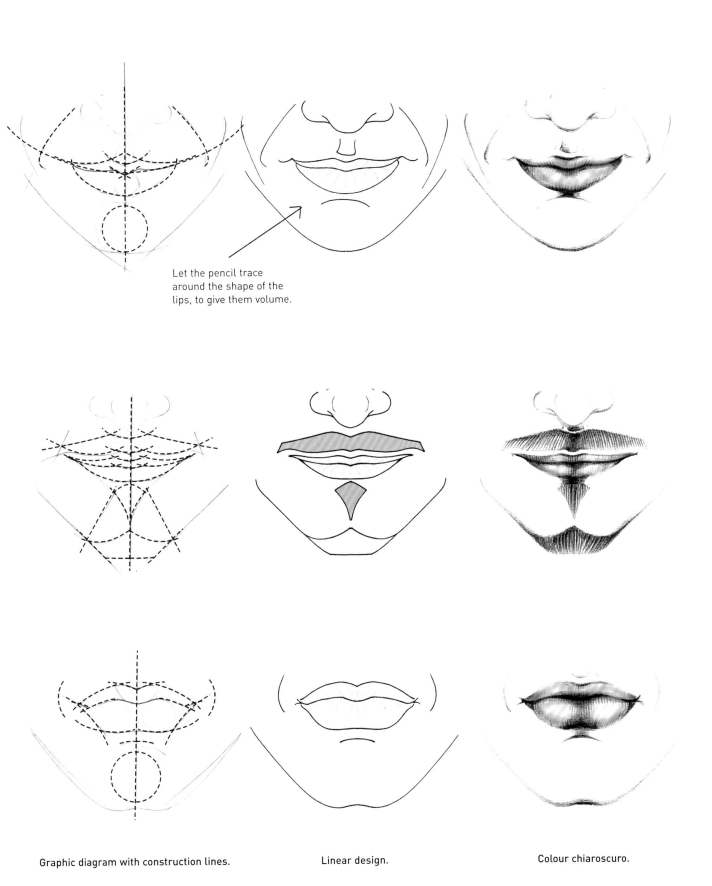

Let the pencil trace around the shape of the lips, to give them volume.

Graphic diagram with construction lines.

Linear design.

Colour chiaroscuro.

DIAGRAMS OF MOUTHS SEEN FROM VARIOUS ANGLES

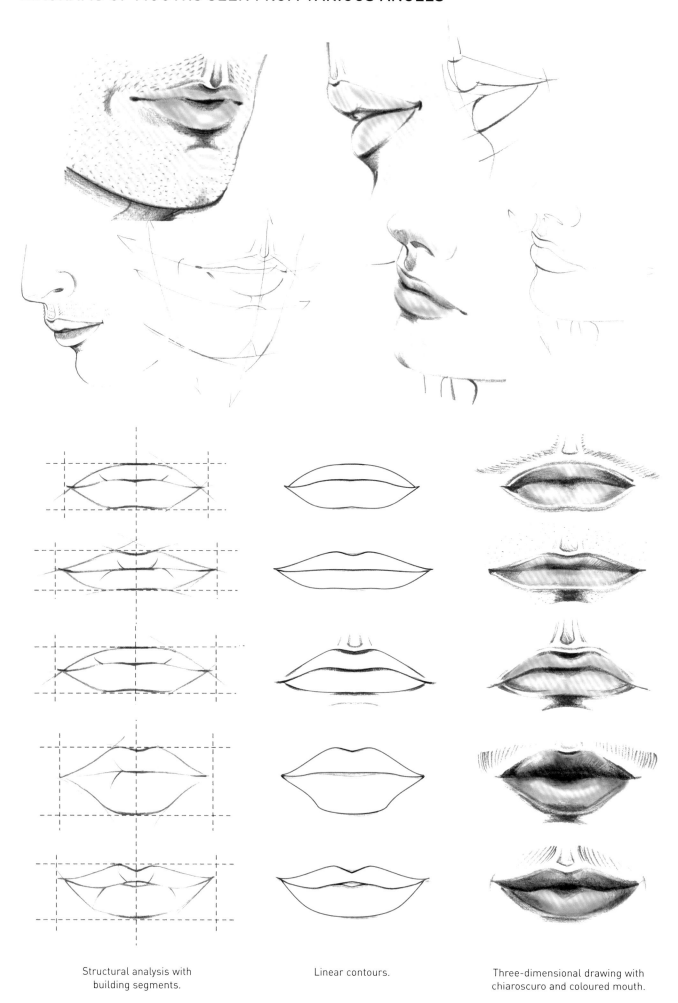

Structural analysis with
building segments.

Linear contours.

Three-dimensional drawing with
chiaroscuro and coloured mouth.

DETAILS OF SMILING MOUTHS

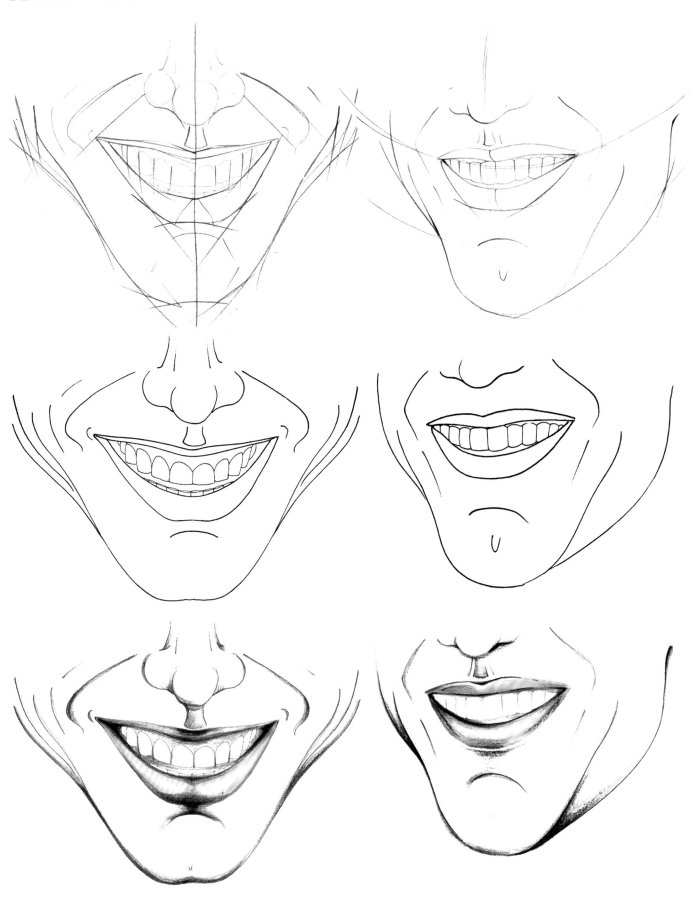

Exercise

1. Following the instructions in the book, copy the drawings featured so far, complete with structure lines.

2. Using the chiaroscuro technique in pencil, draw mouths from life and from magazines, seen from various angles.

3. On a new piece of paper, use a 04 fineliner to trace over the mouths you have drawn.

EXPRESSIONS OF THE LIPS

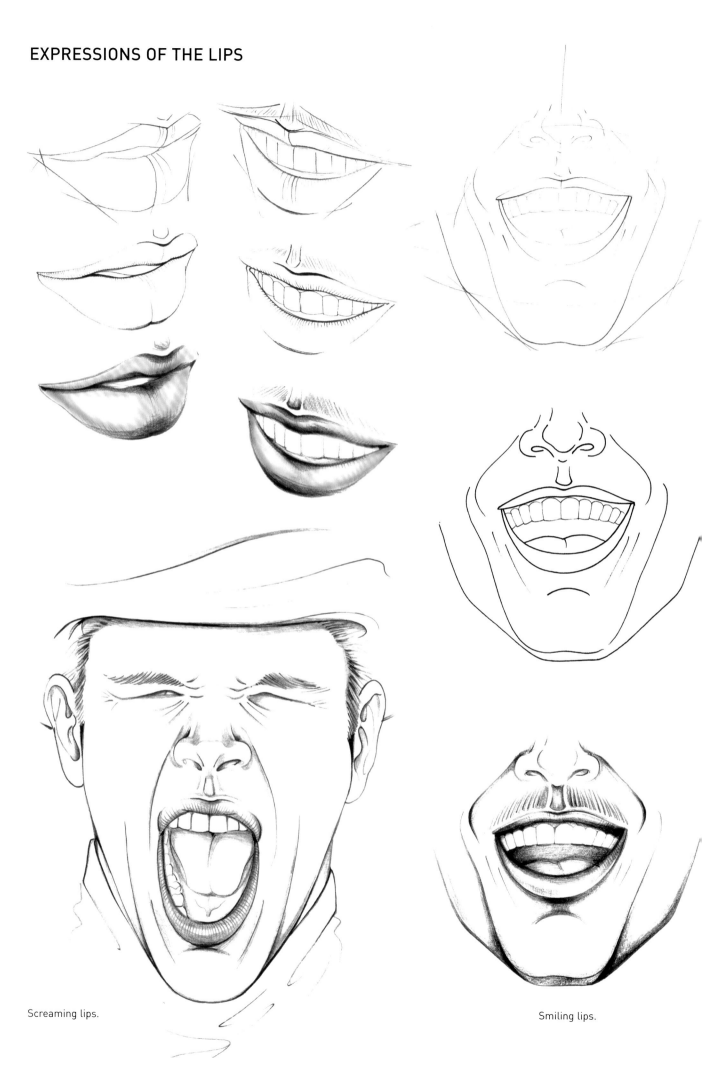

Screaming lips.

Smiling lips.

THE EAR

ANALYSIS AND STRUCTURE

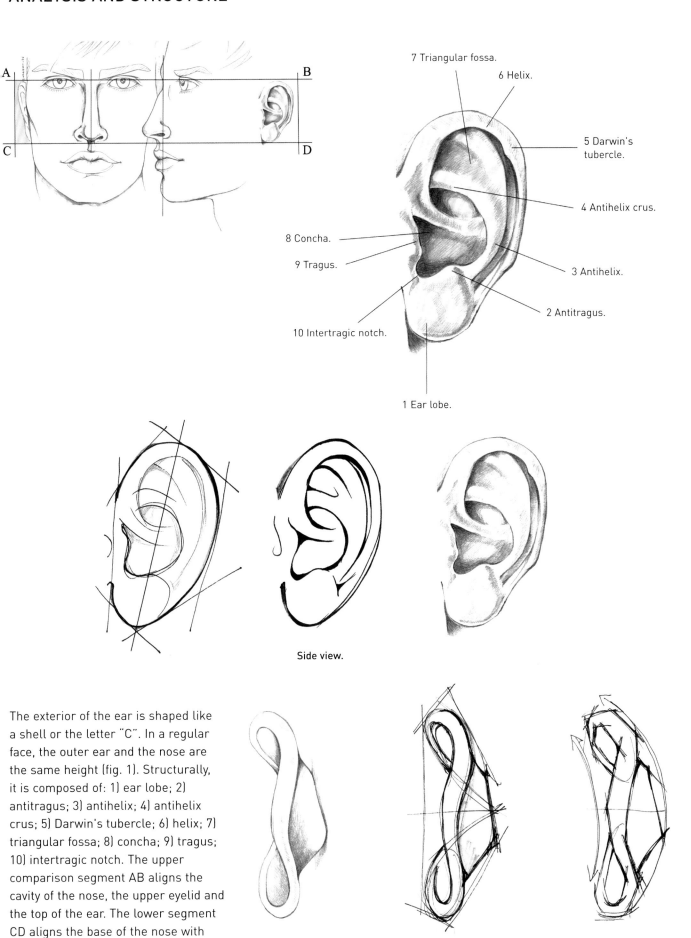

7 Triangular fossa.

6 Helix.

5 Darwin's tubercle.

4 Antihelix crus.

8 Concha.

9 Tragus.

3 Antihelix.

2 Antitragus.

10 Intertragic notch.

1 Ear lobe.

Side view.

The exterior of the ear is shaped like a shell or the letter "C". In a regular face, the outer ear and the nose are the same height (fig. 1). Structurally, it is composed of: 1) ear lobe; 2) antitragus; 3) antihelix; 4) antihelix crus; 5) Darwin's tubercle; 6) helix; 7) triangular fossa; 8) concha; 9) tragus; 10) intertragic notch. The upper comparison segment AB aligns the cavity of the nose, the upper eyelid and the top of the ear. The lower segment CD aligns the base of the nose with the bottom of the ear (fig. 1).

Seen from behind.

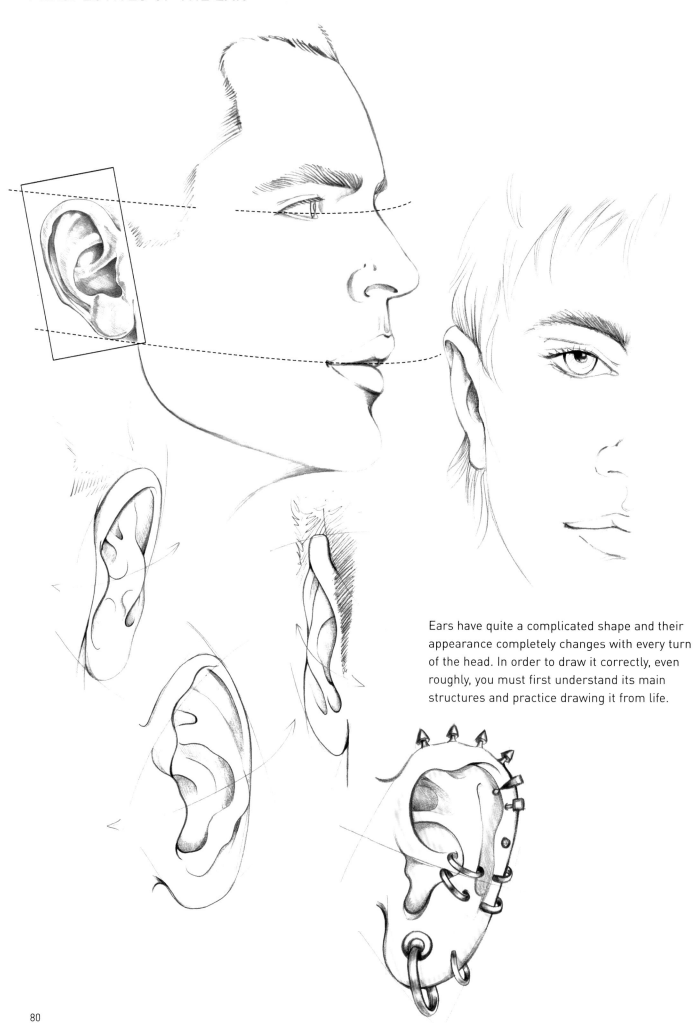

Ears have quite a complicated shape and their appearance completely changes with every turn of the head. In order to draw it correctly, even roughly, you must first understand its main structures and practice drawing it from life.

THE TORSO

The torso, or trunk, is undoubtedly one of the most aesthetically beautiful parts of the male body. Used in a vast array of advertising images as a symbol of virility, strength, protection and security, it has been drawn in a plethora of poses that highlight its powerful and perfect forms. During the summer, no magazine misses the opportunity to dedicate eye-catching covers in its honour, and the most famous bodies in the world line up to be photographed in the most athletic and sensual poses. Many actors, models, and athletes owe a lot of their success to their extraordinary physiques. In terms of how it is presented, the torso is the central part of the body and its distinctive shape allows fashion designers to create garments in the most diverse styles; being able to expertly reproduce the body is synonymous with great skill.

ANALOGIES

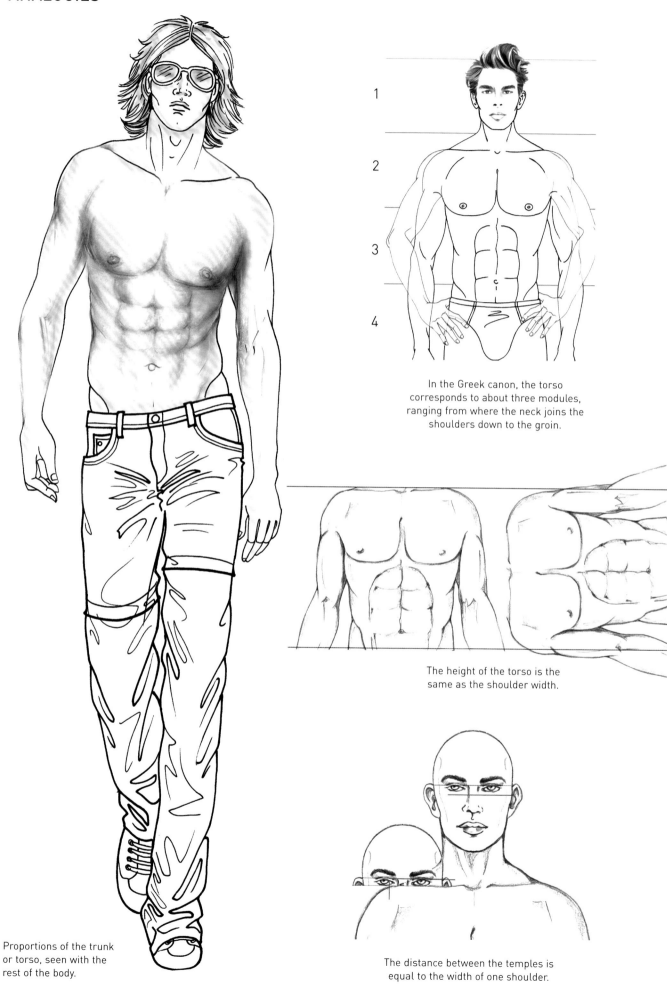

1
2
3
4

In the Greek canon, the torso corresponds to about three modules, ranging from where the neck joins the shoulders down to the groin.

The height of the torso is the same as the shoulder width.

Proportions of the trunk or torso, seen with the rest of the body.

The distance between the temples is equal to the width of one shoulder.

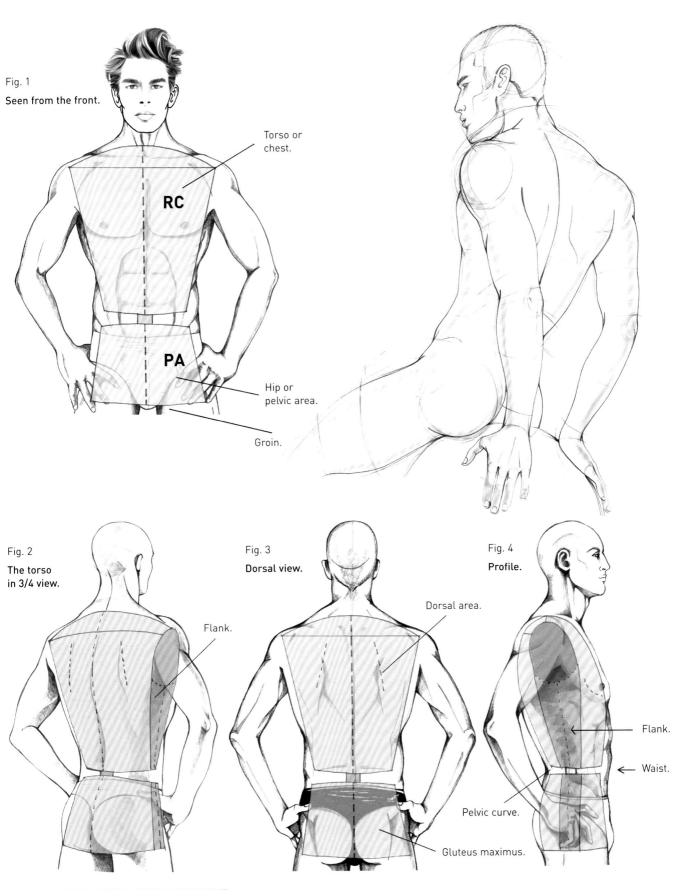

Fig. 1
Seen from the front.

Torso or chest.

RC

PA

Hip or pelvic area.

Groin.

Fig. 2
The torso in 3/4 view.

Flank.

Fig. 3
Dorsal view.

Dorsal area.

Gluteus maximus.

Fig. 4
Profile.

Flank.

Waist.

Pelvic curve.

ANALYSIS AND STRUCTURE

The torso is the largest part of the body. It is made up of two moving parts: the bust and the hip, also called the rib cage RC and the pelvic area PA. The pelvic or hip area is made up of the abdomen, with the slightly sunken navel, the sides and the groin (Fig. 1), while the posterior is made up of the dorsal area and the buttocks (Fig. 3).

Viewed from the front, the torso is wedge-shaped, wider at the clavicles and narrower at the base; seen from a three-quarter view, we can see the thickness of the flank (fig. 2); in profile, its structure resembles that of a flattened barrel, with the chest protruding forward and the hip extending along the inside of the pelvic curve (Fig. 4).

THE SKELETON AND MUSCULAR SYSTEM

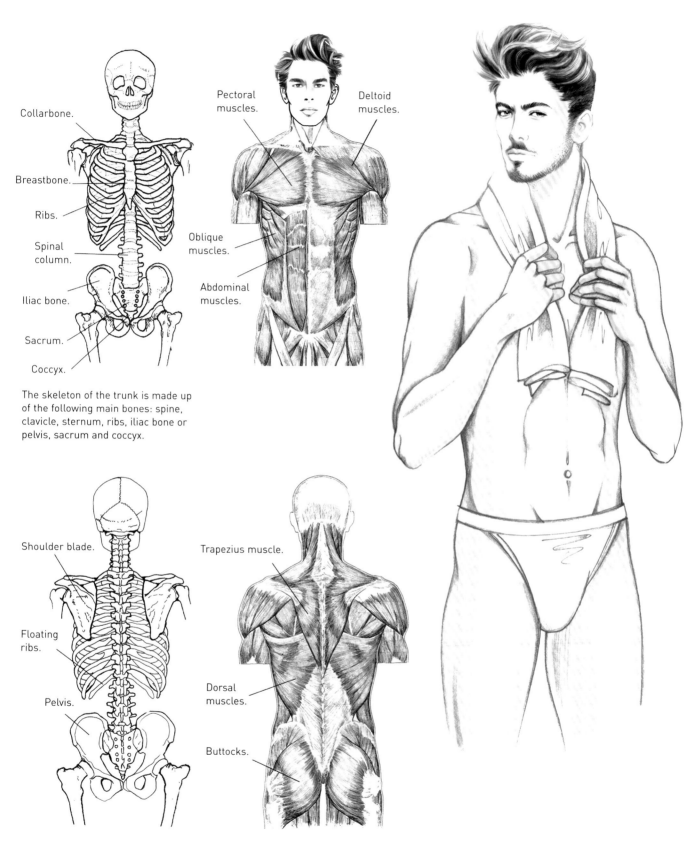

Collarbone.

Breastbone.

Ribs.

Spinal column.

Iliac bone.

Sacrum.

Coccyx.

Pectoral muscles.

Deltoid muscles.

Oblique muscles.

Abdominal muscles.

The skeleton of the trunk is made up of the following main bones: spine, clavicle, sternum, ribs, iliac bone or pelvis, sacrum and coccyx.

Shoulder blade.

Floating ribs.

Pelvis.

Trapezius muscle.

Dorsal muscles.

Buttocks.

The back features the shoulder blades, which follow the movement of the arms, the ribs, and the spine, which supports the torso and whose particular anatomical arrangement allows an infinite number of positions and movements. The muscular system is characterised by its powerful motile structure, which is subdivided into large, medium and small muscles, each of which has a precise contraction function that determines the movement of the parts to which it is attached. The respective diagrams show the major muscle masses of the torso and their names.

ANALOGIES

Exercise
1. Copy the drawings in this chapter.
2. Copy torsos from life and from fashion magazines.

UPPER LIMBS

THE ARM: ANALYSIS AND STRUCTURE

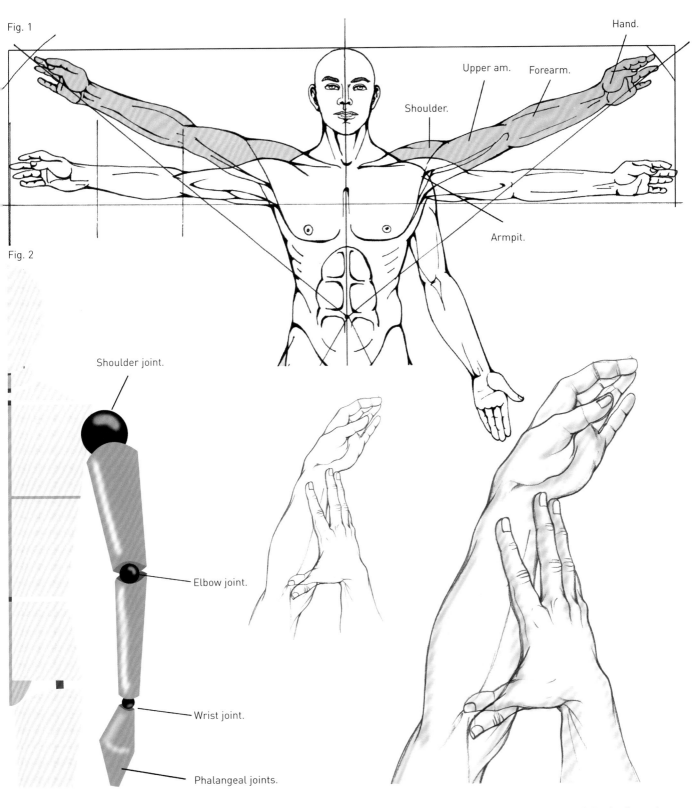

Fig. 1

Hand.

Upper am. Forearm.

Shoulder.

Armpit.

Fig. 2

Shoulder joint.

Elbow joint.

Wrist joint.

Phalangeal joints.

The arm is the upper limb of the body and is made up of four moving parts: shoulder, arm, forearm, and hand (Fig. 1). Each part has a corresponding joint, represented here by a small sphere, which allows extreme flexibility, mobility and rotation. The most schematic depiction of the arm can be made using two long, narrow cylinders, while the hand is represented by a rhomboid shape (fig. 2). The length of the arm extends from the shoulder to the waist; the forearm, from the waist to the groin; the hand reaches as far as the middle of the thigh. The shoulders are the widest part of the body and are drawn on the outside of the trunk. For a better understanding of the masses and joints, we always recommend that you use artist mannequins, draw from life, and use materials you have to hand, to study the body.

SKELETON AND DIAGRAMS

Fig. 1

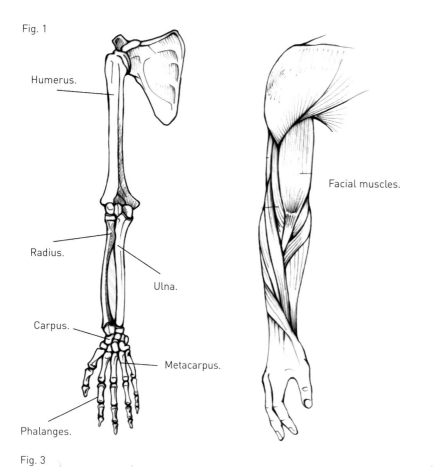

Humerus.

Radius.

Ulna.

Carpus.

Metacarpus.

Phalanges.

Facial muscles.

Fig. 2

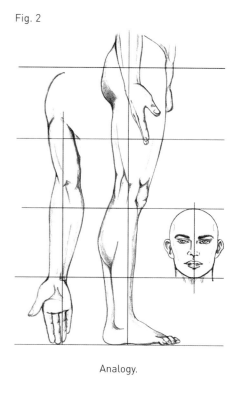

Analogy.

Fig. 3

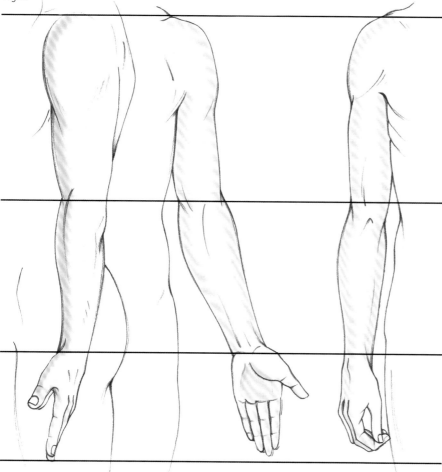

The arm seen from three angles.

The skeleton of the arm and hand is made up of the following main bones: humerus, radius, ulna, carpus, metacarpus, and phalanges. The body mass of the arm is made up of a robust, muscular framework (Fig. 1).

ANALOGIES

The total length of the upper and lower limbs is about four modules. The arms are as long as the legs (fig. 2).
The shoulder protrudes outside of the trunk. The elbow lines up with the waist, the wrist with the pubis and buttocks, the hand with the middle of the thigh (fig. 3).

THE HAND

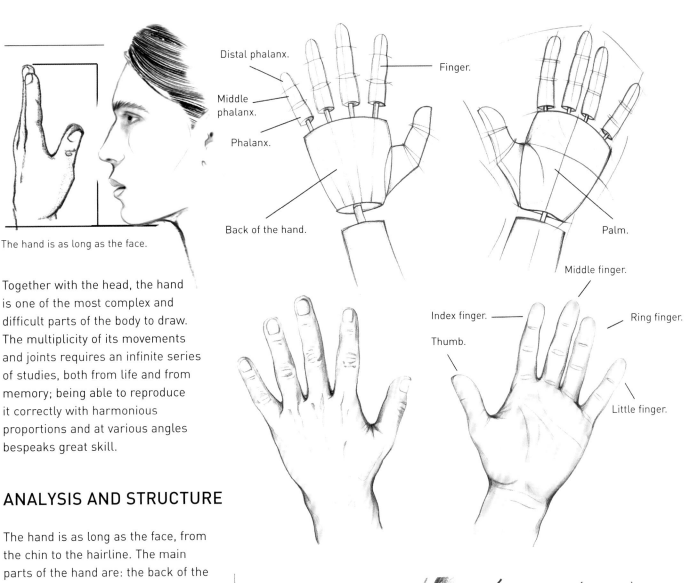

The hand is as long as the face.

Together with the head, the hand is one of the most complex and difficult parts of the body to draw. The multiplicity of its movements and joints requires an infinite series of studies, both from life and from memory; being able to reproduce it correctly with harmonious proportions and at various angles bespeaks great skill.

ANALYSIS AND STRUCTURE

The hand is as long as the face, from the chin to the hairline. The main parts of the hand are: the back of the hand, the palm and digits.
The digits are: the thumb, which is thicker and shorter than the others and formed of two phalanges; the index finger; the middle finger, which is the longest; the ring finger and the little finger, which is almost as short as the thumb.
The last four fingers are made up of three phalanges called: the proximal phalanx, which is nearest to the main part of the hand; the middle phalanx, in the middle of the finger, and the distal phalanx at the end of the finger, containing the nail.
Each finger has a different length. The many points of articulation and movement make the hand the body's grasping instrument; furthermore, their morphology and expressiveness often reveal the character and sensitivity of the person.

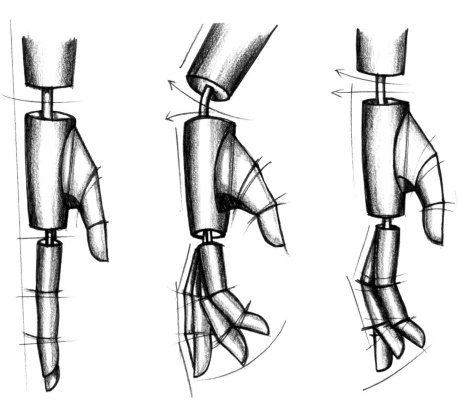

Movements of an articulated wooden hand.

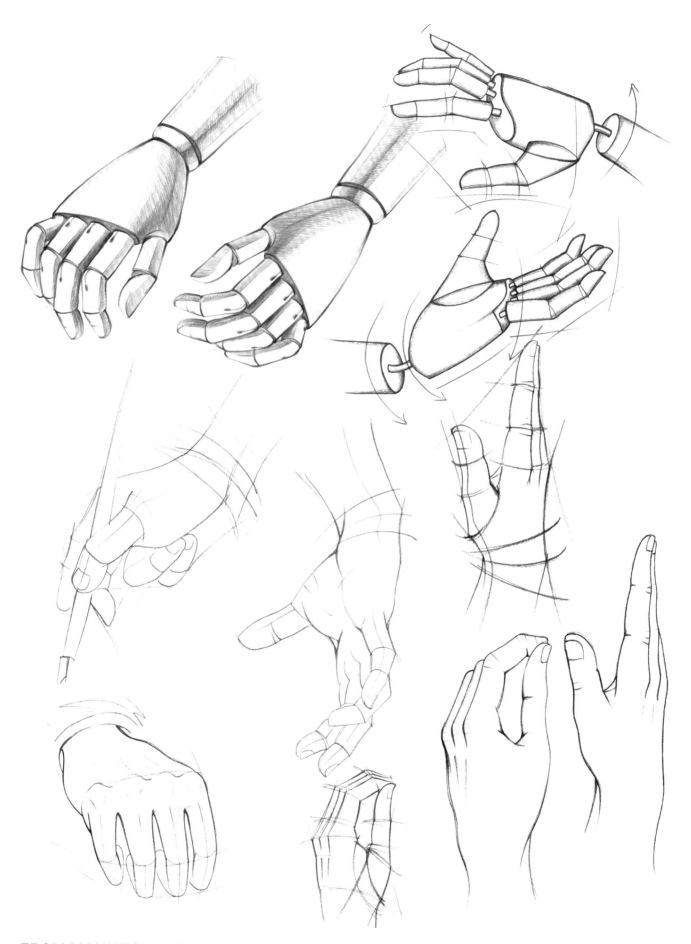

FROM MANNEQUIN TO REAL HAND

In order to study proportions correctly, it is best to first practice with an articulated wooden hand, which you can find in any fine arts store. These show the joints of the fingers and are useful aids to understanding the individual movements of the fingers and those of the whole hand. You can alternate between studying the mannequin and real hands.

Technique. Using mechanical pencils, these pictures were initially drawn with a HB, and then finished off with a 2B.

THE OUTSTRETCHED HAND, SEEN FROM DIFFERENT ANGLES

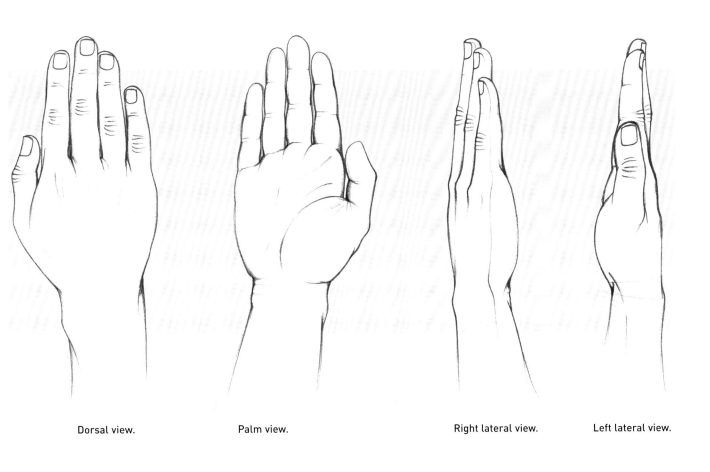

Dorsal view. Palm view. Right lateral view. Left lateral view.

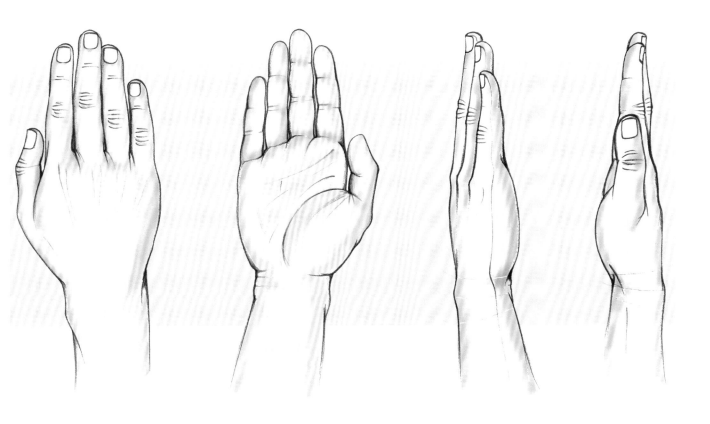

ARM AND HAND

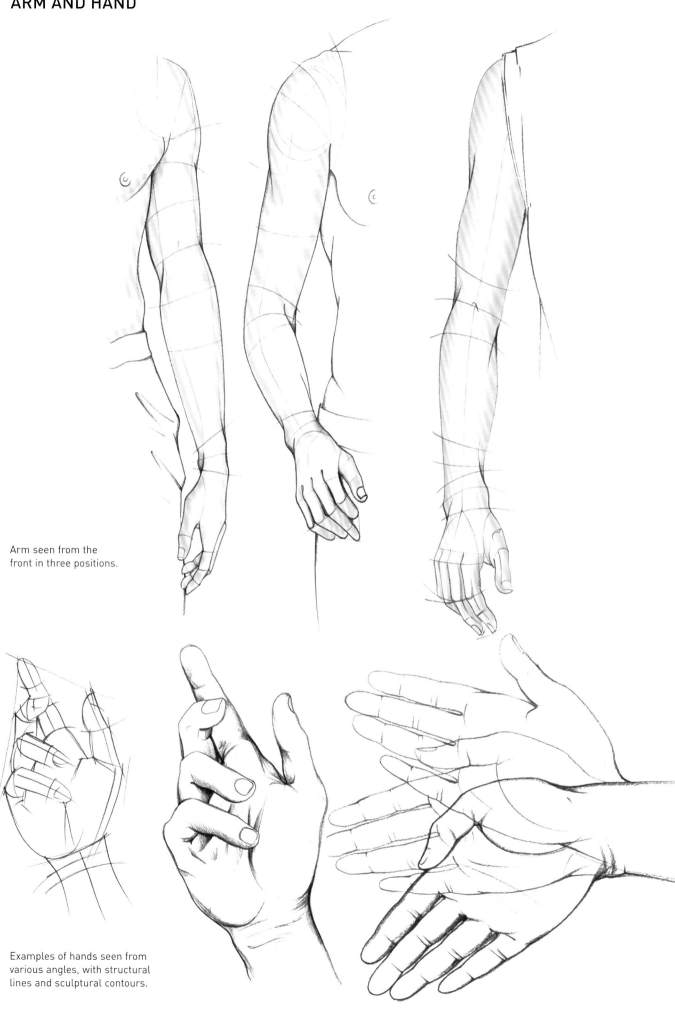

Arm seen from the
front in three positions.

Examples of hands seen from
various angles, with structural
lines and sculptural contours.

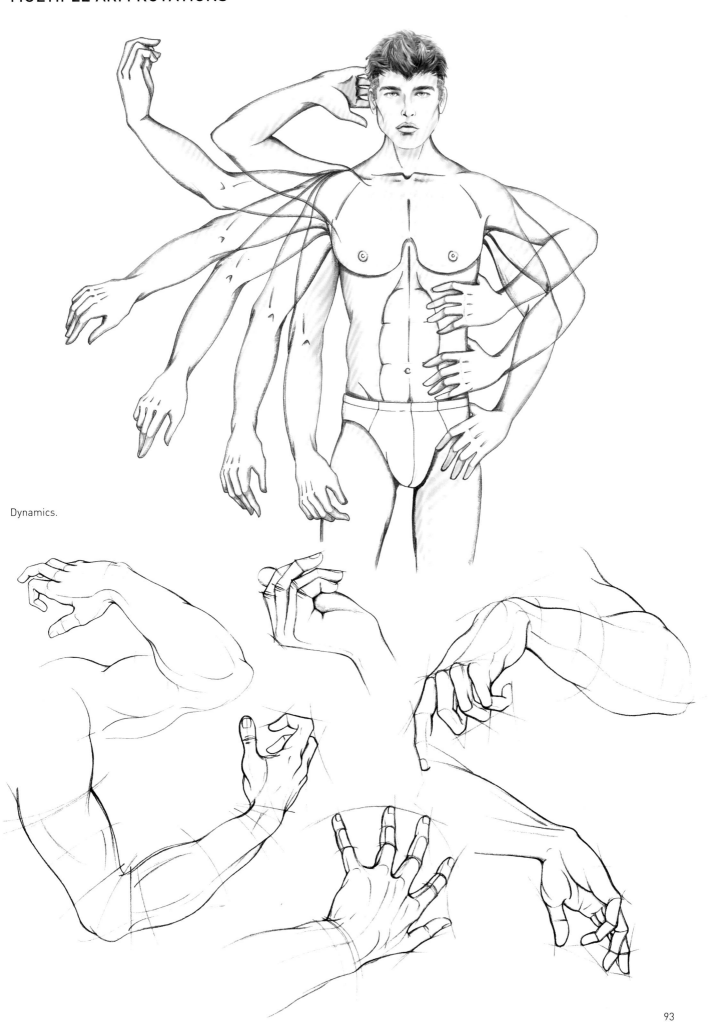

Dynamics.

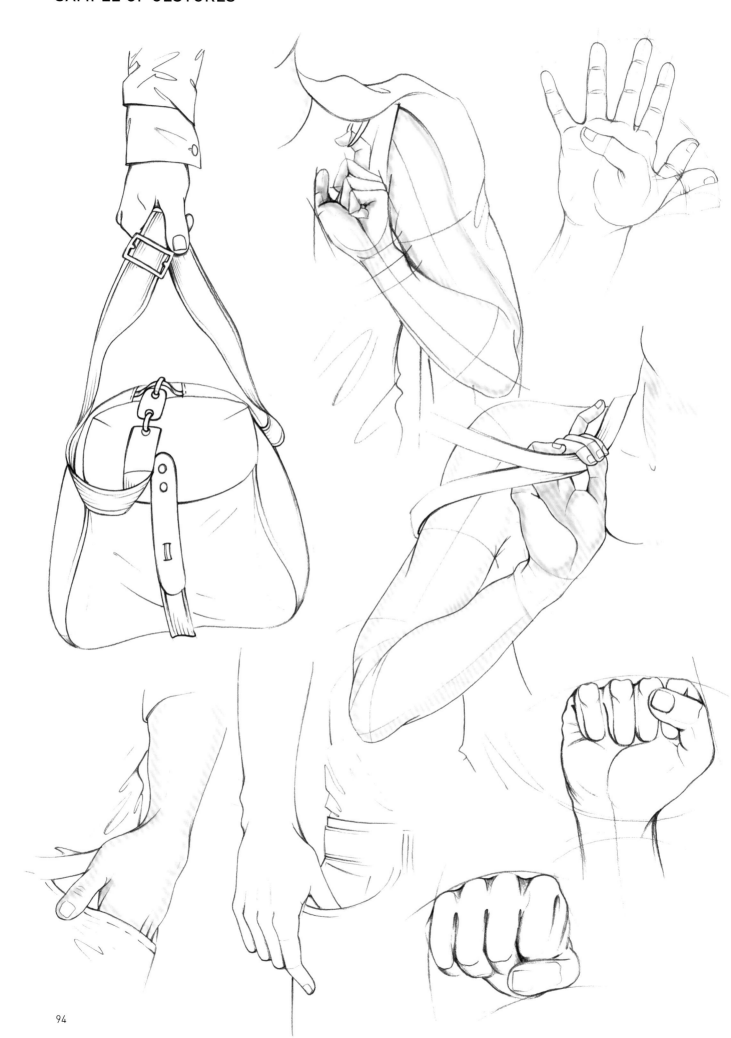

LOWER LIMBS

THE LEG: ANALYSIS AND STRUCTURE

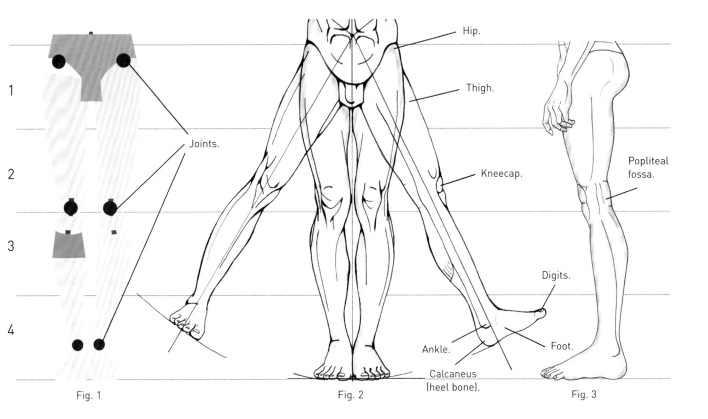

Joints.

Hip.

Thigh.

Kneecap.

Popliteal fossa.

Digits.

Ankle.

Foot.

Calcaneus (heel bone).

Fig. 1

Fig. 2

Fig. 3

The leg is the lower limb, the longest of the body. Including the foot, it takes up almost four of the Greek canon's modules. Structurally, the limb consists of three moving parts: the thigh, the leg and the foot, and is joined by the hip, knee and ankle joints (fig. 2). The leg in profile takes on a curvilinear appearance, due to the prominent thigh and the line of the leg from below the knee to the instep. The "pit" on the back of the leg is called the popliteal fossa and is slightly above the level of the kneecap (Fig. 3). The various anatomical parts flex and rotate through a motile and spherical bone structure that allows great mobility, similar to that seen in the arm. The diagram has been drawn using cylindrical and tapered shapes for the thigh and leg, spherical shapes for the joints, a truncated cone shape for each calf and a wedge for each foot. Three spheres of different sizes indicate the points where the limbs are attached to the body (Fig. 1).

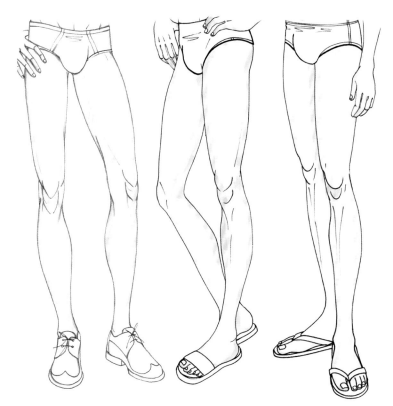

Legs with shoes, seen at various angles.

Positioned together, the leg muscles touch at the upper inner thighs, knees, calves and ankles; there are no points of contact on the inside of the thighs, between the knee and the calf, on the lower part of the legs, or between the ankles and the foot.

The lower limb is made up of the following main bones: femur, patella, tibia, fibula, and foot bones. The body mass of the leg is made up of a robust muscular framework.

ANALOGIES

Analogies are the equivalent measurements of various parts of the body.

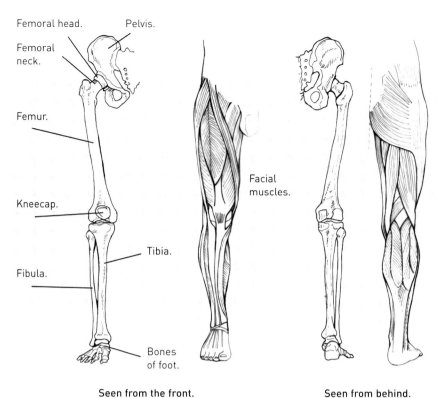

Femoral head. Pelvis.
Femoral neck.
Femur.
Facial muscles.
Kneecap.
Tibia.
Fibula.
Bones of foot.

Seen from the front.

Seen from behind.

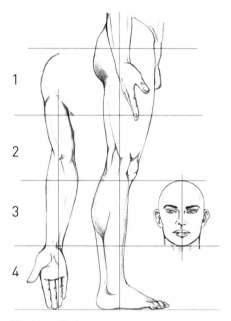

The lower limb measures about four modules.

The length of the thigh is equal to the width of both thighs at the thickest part.

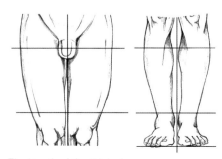

The length of the thighs is equal to that of the calves.

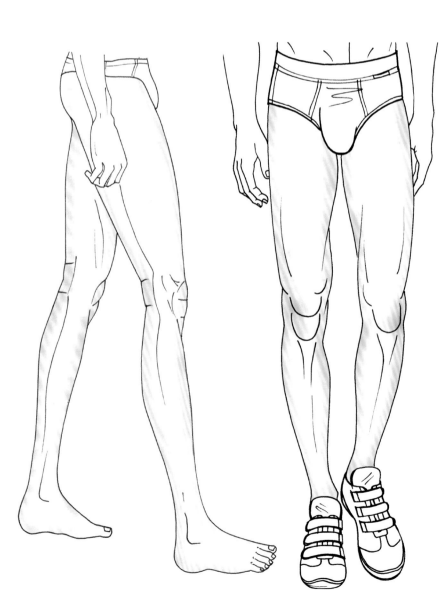

THE FOOT: ANALYSIS AND STRUCTURE

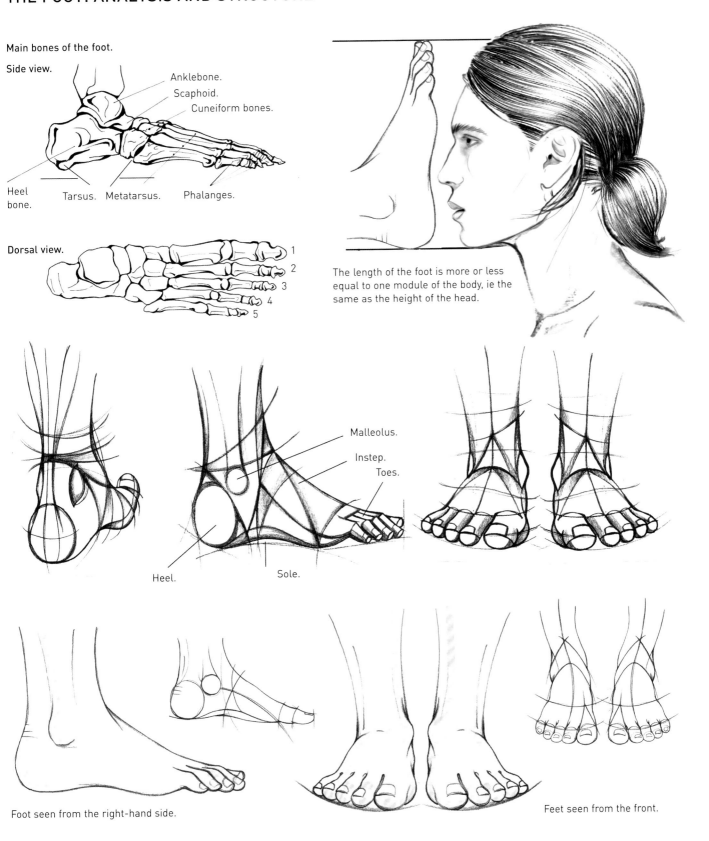

Main bones of the foot.

Side view.

Anklebone.
Scaphoid.
Cuneiform bones.

Heel bone.

Tarsus. Metatarsus.

Phalanges.

Dorsal view.

1
2
3
4
5

The length of the foot is more or less equal to one module of the body, ie the same as the height of the head.

Malleolus.

Instep.

Toes.

Heel.

Sole.

Foot seen from the right-hand side.

Feet seen from the front.

Compared to the hand, the foot has a more closed and compact mass. With its elongated wedge shape, it functions as a support for the body. Structurally, it is composed of five fundamental parts: the heel, on which we find the malleoli; the concave instep; the five toes and, finally, the sole, which supports the body. The big toe, or *hallux*, is the thickest one and points downward. The main bones of the foot are: the tarsus, made up of the heel, or calcaneus, and the cuneiform bones, metatarsal and phalanges.

The diagrams show the foot from various angles with construction segments.

FEET PERSPECTIVES, WITH DIAGRAMS AND THREE-DIMENSIONAL DRAWINGS

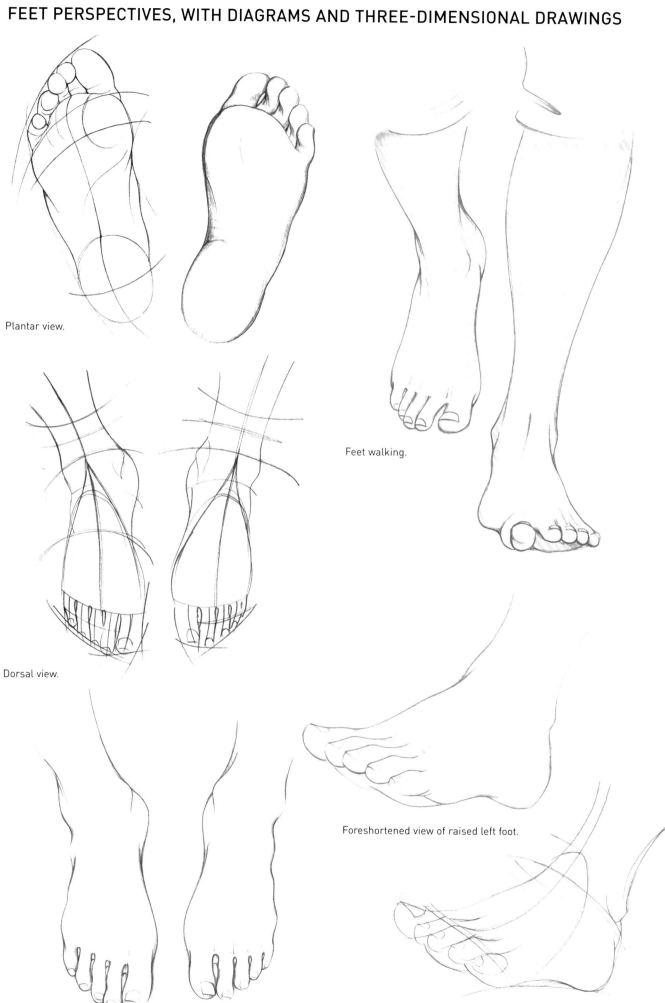

Plantar view.

Dorsal view.

Feet walking.

Foreshortened view of raised left foot.

RAISED HEELS

Left internal profile with slightly raised heel.

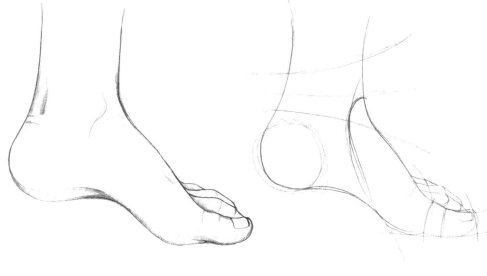

Right external profile with raised heel and toes touching the ground.

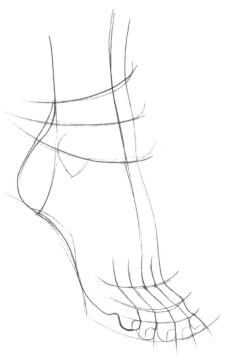
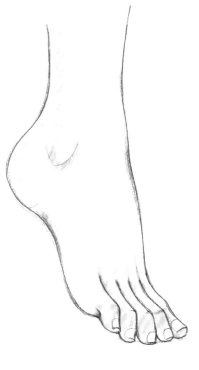

Right external profile with raised heel and toes supported by the ground.

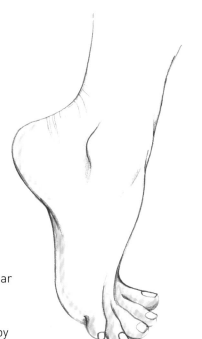
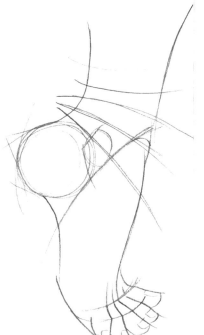

Exercise

1. Draw the legs and feet that appear on these pages several times, starting with the diagrams.
2. Practice drawing from memory by drawing feet in various positions.

FEET AND FOOTWEAR

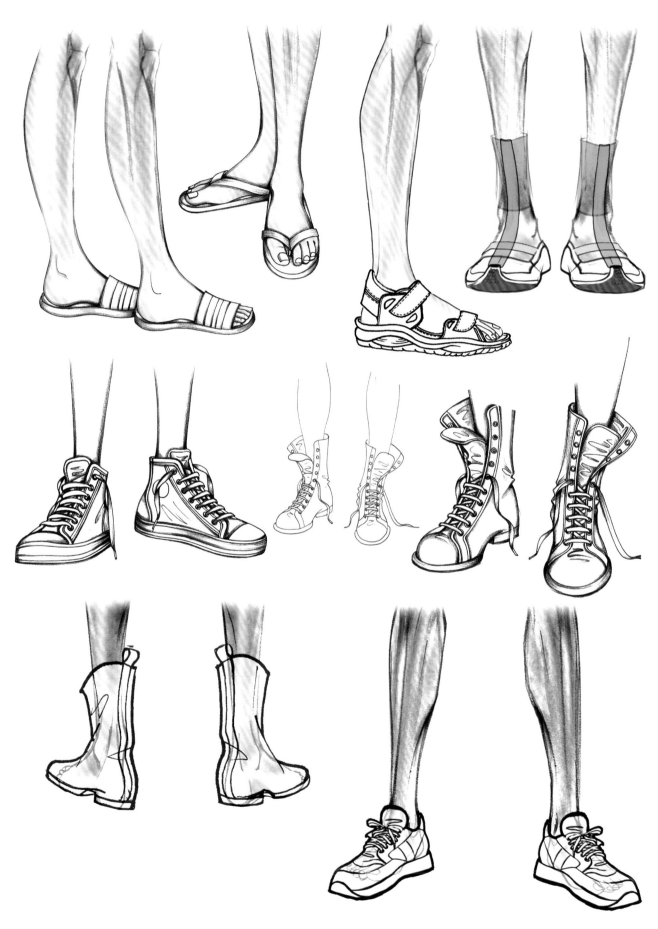

It is important to learn how to draw feet in different types of shoes and from various angles. This adds flair and the finishing touch to project ideas. Practice copying these pictures and perfect the footwear designs by copying from magazines and other fashion industry materials.

ARRANGEMENT OF FOLDS

FOLDS AND MOVEMENT

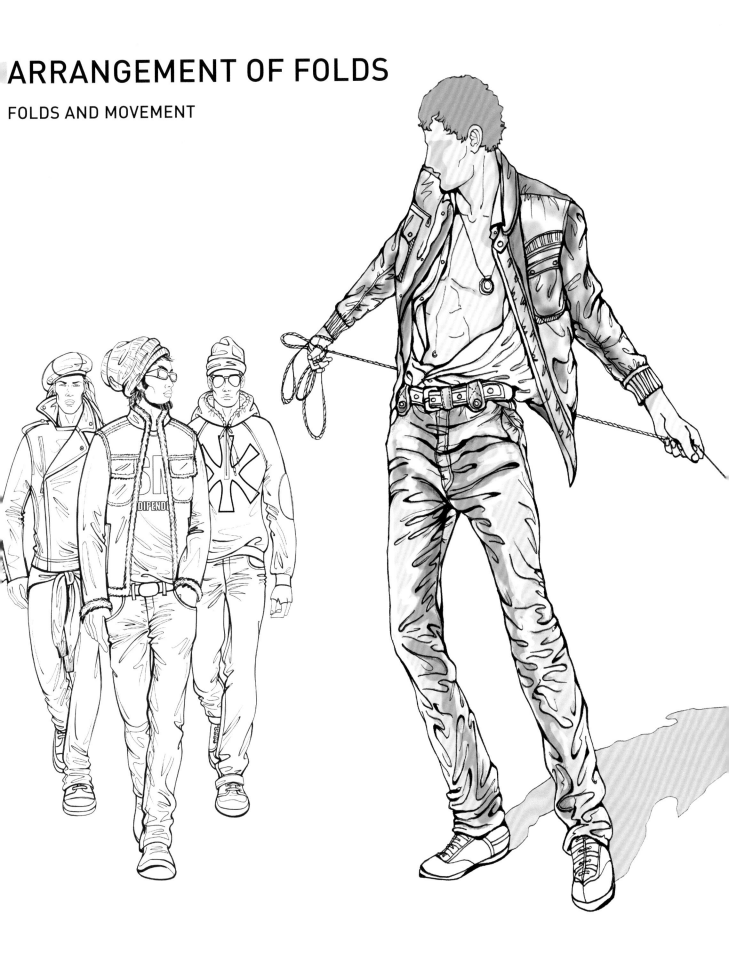

The way folds are arranged on fashion figurines shows the relationship between the fabric and the kinetic movement of the body wearing it. In this chapter, we will look at several types of complex fold arrangements, classified according to their characteristics. It is very important to know how to draw them and understand that folds, draped fabric and ruffles are not independent effects that are separate to the body, but rather that they interact with it. Depending on its structure and quality, fabric can wrap around the movement of the body like a second skin, creating soft plasticity or round geometry.

BODY ANCHOR POINTS

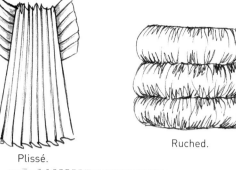

Complex pleats.

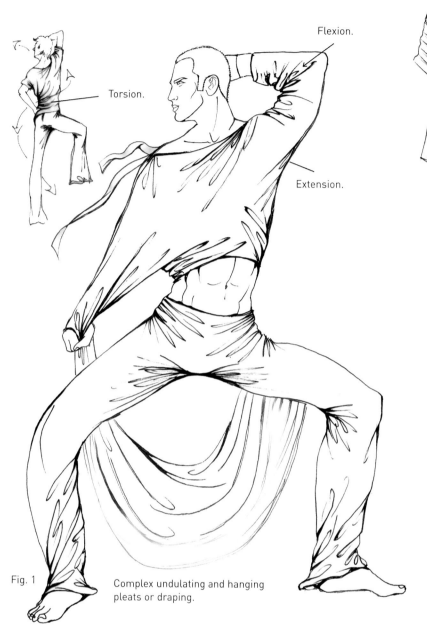

Torsion.

Flexion.

Extension.

Fig. 1

Complex undulating and hanging pleats or draping.

Plissé.

Ruched.

Draped.

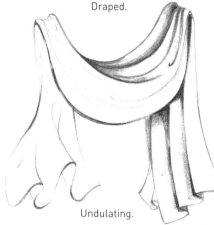

Undulating.

Twists and turns in spiral folds.

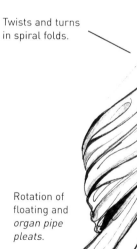

Rotation of floating and *organ pipe pleats*.

When we say *anchor points*, we mean the areas of the body where the garment has a tighter fit and clings to the skin, which can therefore create an infinite amount of folds, depending on the movement of the body and the character and width of the fabric. The main anchor points are: the neck, shoulders, armpits, elbows, waist, flanks, groin and knees, which generate four main actions: flexion, extension, torsion and rotation (Fig. 1).

Flexion occurs when a shape is closed. The fabric is compressed and wrinkled, creating small folds that are close together.

Extension is when the body, or part

of it, stretches in a straight line. The fabric extends in the direction of the tension exerted.

Torsion, or twisting, is manifested when the body performs opposite actions, for example, when the bust turns to the right and the hips to the left. The fabric moves in an "S" spiral.

Rotation occurs when the various parts of the body make circular movements. The fabric opens up as it moves through the air, creating fluctuating, organ-tube-shaped folds. Pleated, gathered, draped and undulating are among the more complex types of pleat. These folds are dense and of various thicknesses, so reproducing them graphically

means practicing how to depict three dimensions, darkening underneath the folds to give the fabric just the right volume.

FLOATING PLEATS, *ORGAN PIPE PLEATS*, BLOCK AND CLOSED PLEATS

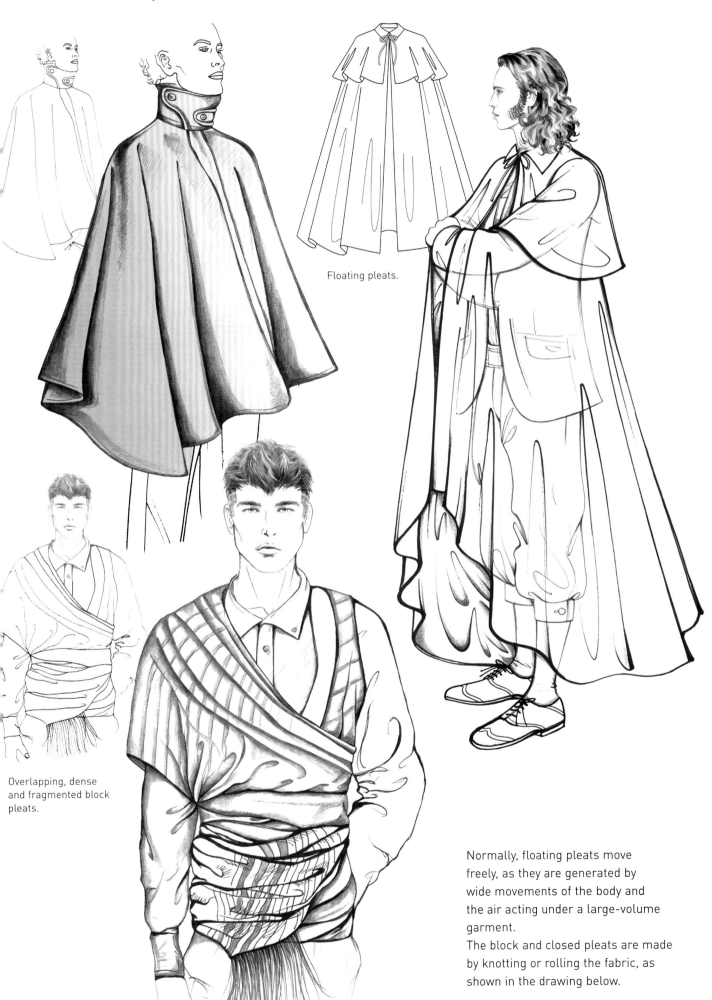

Floating pleats.

Overlapping, dense and fragmented block pleats.

Normally, floating pleats move freely, as they are generated by wide movements of the body and the air acting under a large-volume garment.
The block and closed pleats are made by knotting or rolling the fabric, as shown in the drawing below.

UNDULATING AND FLAT PLEATS USING THE CHIAROSCURO TECHNIQUE IN PENCIL

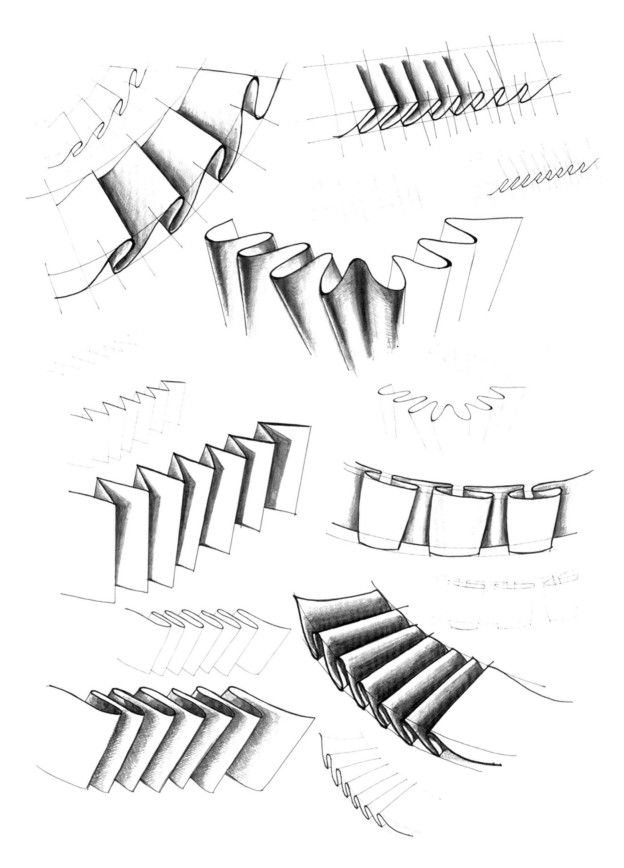

The pictures show the geometric construction that underlies the pleat pattern.

Each study is accompanied by a basic outline drawing and the corresponding three-dimensional version.

Technique Once the light source has been established, the whole area of the pleat gradually fades away, emphasising its internal support more clearly, as shown in the drawings. Where the pleat is on the surface, it is shaded lighter; the sections underneath are shaded darker to create a greater tonal contrast, that is, a more accentuated shadow. The area most exposed to the light is left white, without any shading.

UNDULATING PLEATS - RUCHED - RUFFLES

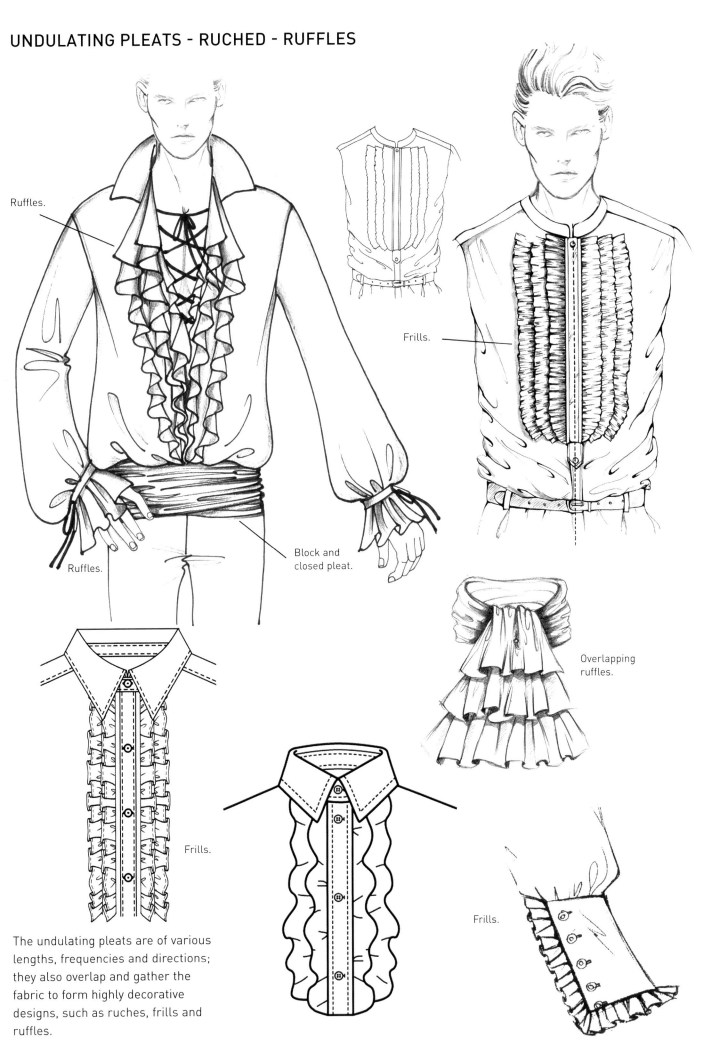

Ruffles.

Ruffles.

Block and closed pleat.

Frills.

Overlapping ruffles.

Frills.

Frills.

The undulating pleats are of various lengths, frequencies and directions; they also overlap and gather the fabric to form highly decorative designs, such as ruches, frills and ruffles.

SMALL, DENSE AND FRAGMENTED PLEATS

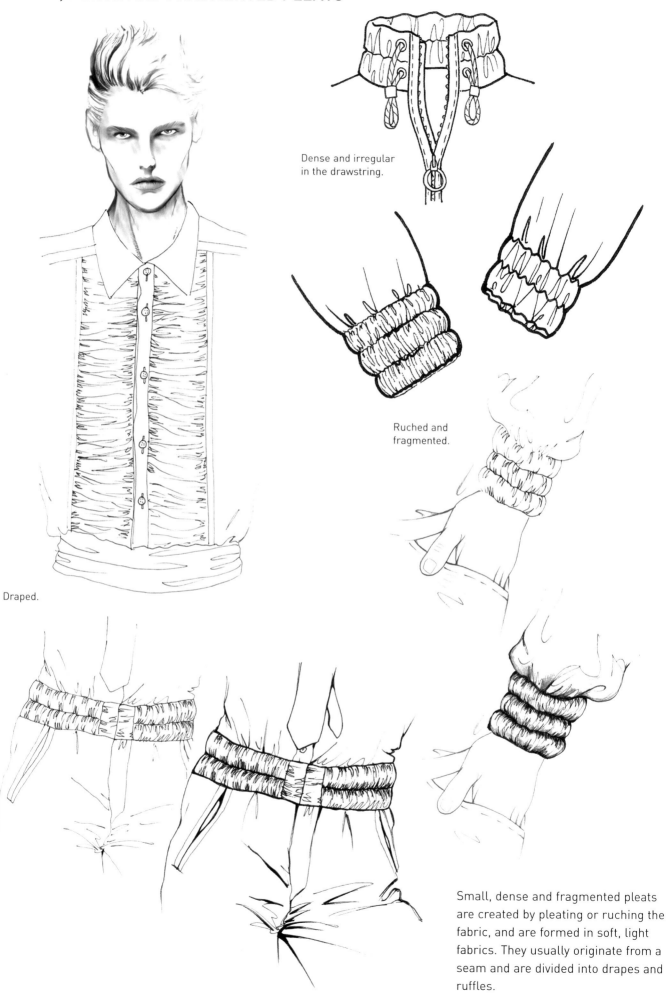

Dense and irregular in the drawstring.

Ruched and fragmented.

Draped.

Small, dense and fragmented pleats are created by pleating or ruching the fabric, and are formed in soft, light fabrics. They usually originate from a seam and are divided into drapes and ruffles.

TIGHT AND IRREGULAR PLEATS

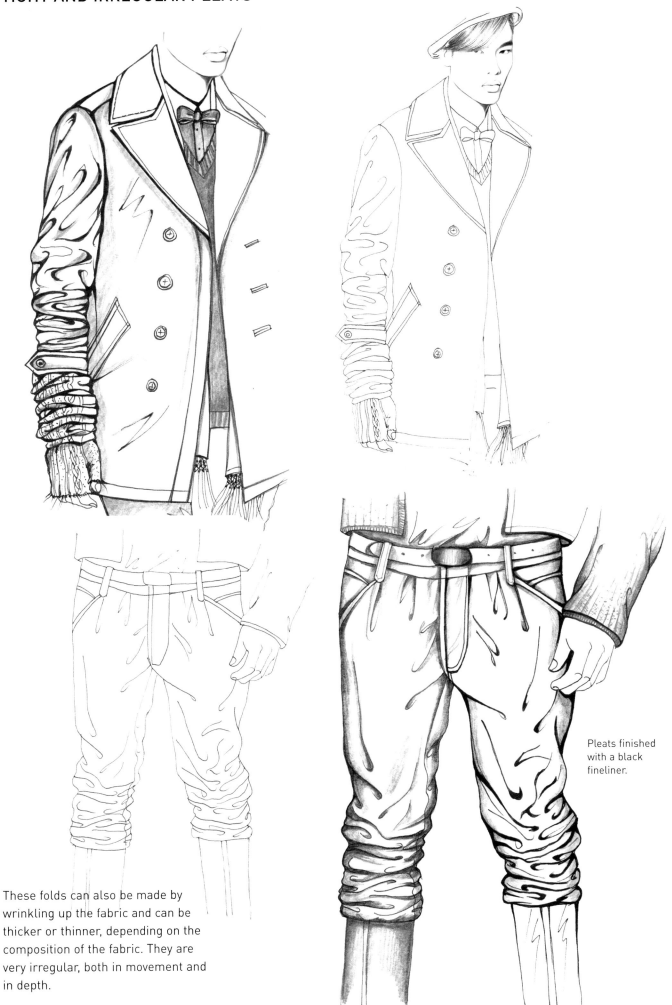

These folds can also be made by wrinkling up the fabric and can be thicker or thinner, depending on the composition of the fabric. They are very irregular, both in movement and in depth.

Pleats finished with a black fineliner.

BLOCK AND FRAGMENTED PLEATS

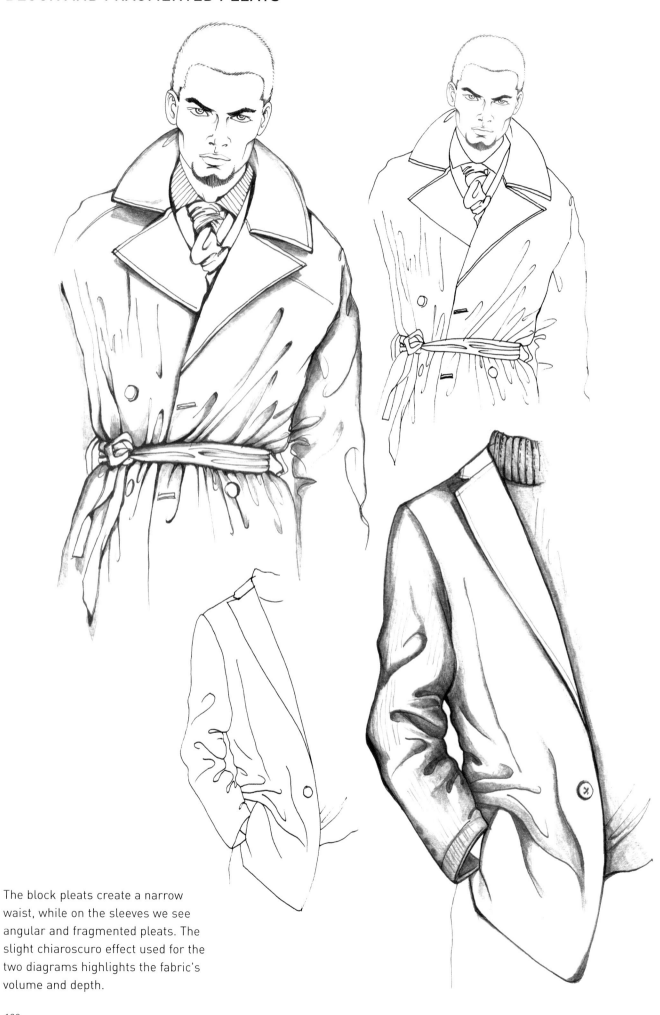

The block pleats create a narrow waist, while on the sleeves we see angular and fragmented pleats. The slight chiaroscuro effect used for the two diagrams highlights the fabric's volume and depth.

RADIAL PLEATS

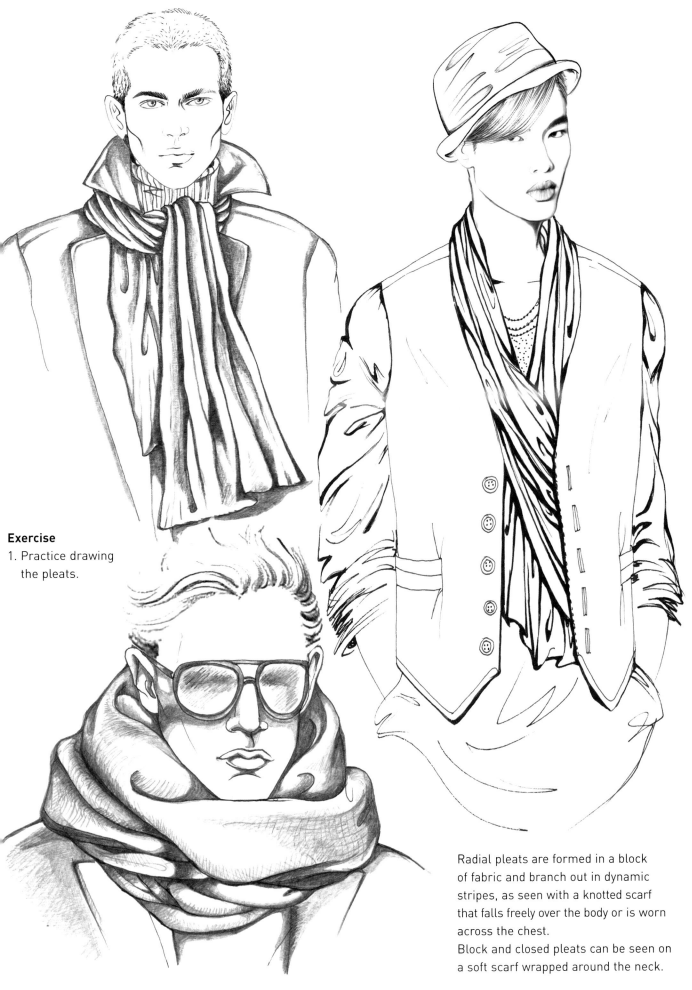

Exercise

1. Practice drawing the pleats.

Radial pleats are formed in a block of fabric and branch out in dynamic stripes, as seen with a knotted scarf that falls freely over the body or is worn across the chest.

Block and closed pleats can be seen on a soft scarf wrapped around the neck.

Third module
THE FASHION FIGURE AND *FASHION DESIGN*

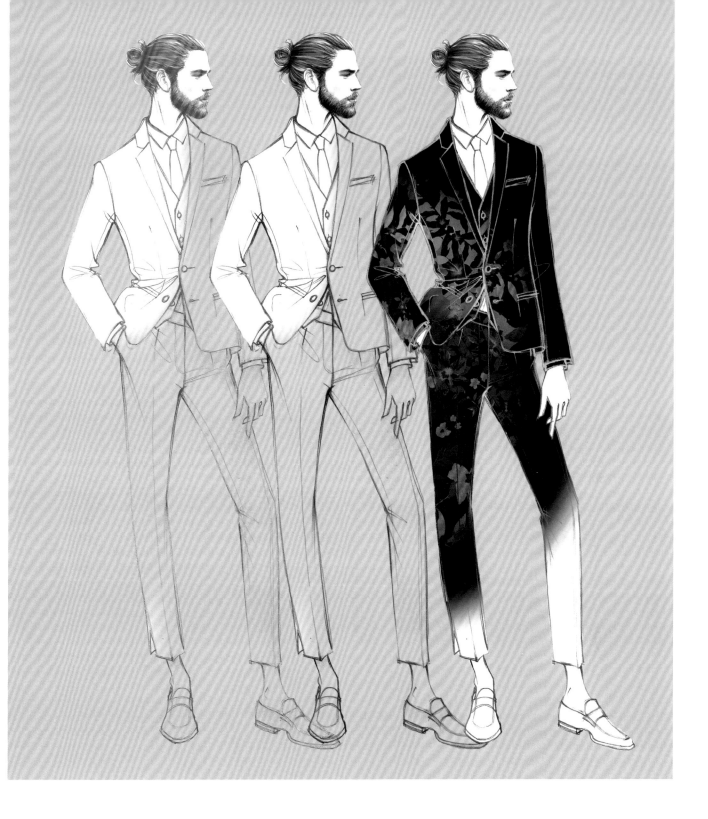

This chapter opens with pictures of fashion figurines that are undressed and standing in poses often adopted by models in photoshoots and at fashion shows. These stylised poses, elongated over the nine modules of the fashion canon, are suitable for any type of clothing as well as to be used for flat representation, since they are drawn from multiple perspectives that showcase the particular characteristics of each garment. The second part of the chapter deals with clothing and includes lots of examples about time-saving methods to make beautiful outfits of the most varied styles. All the included looks and the various capsules have been created for educational purposes only, with the intention of providing the best way to draw effective fashion figurines that perfectly interpret the stylistic proposals of contemporary brands. From the technical side of things, the figures were drawn using a 2B pencil and were partly coloured in by hand and finished off on the computer, using special programs.

However, very similar results can also be obtained with pantone or watercolour paints, or coloured crayons, etc., or a combination of these.

All of these pictures are excellent examples for studying proportions and fit, and they help to develop your capacity to reflect and reproduce the same. Students will quickly overcome their dependence on copying and will start to reach a free and creative dimension, from which their stylistic language will naturally emerge.

THE FASHION FIGURINE

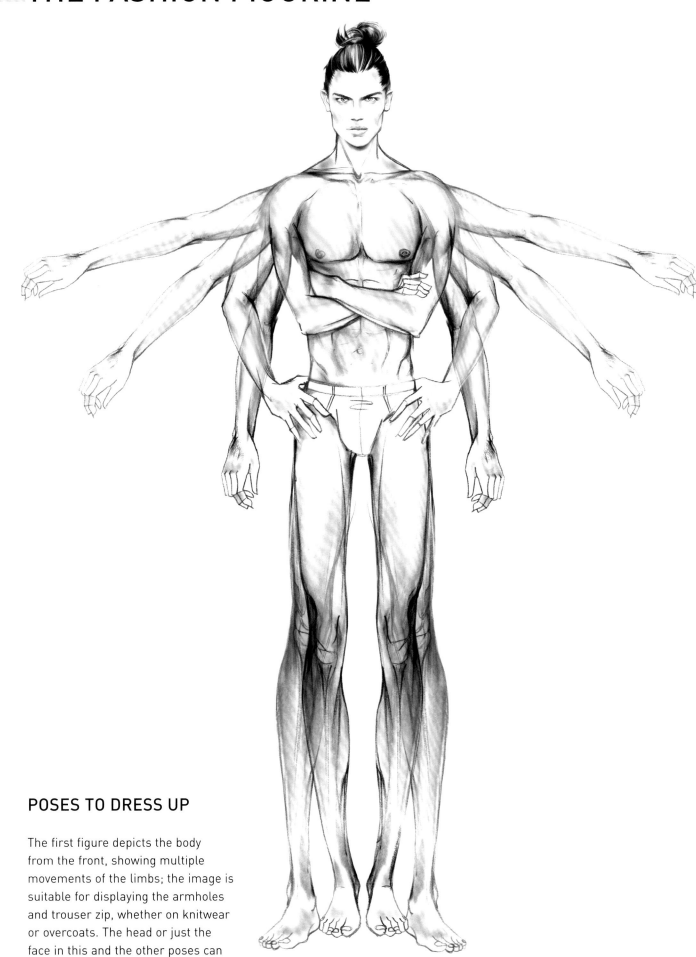

POSES TO DRESS UP

The first figure depicts the body from the front, showing multiple movements of the limbs; the image is suitable for displaying the armholes and trouser zip, whether on knitwear or overcoats. The head or just the face in this and the other poses can be replaced by any of the close-ups in the chapter dedicated to heads.

Multiple frontal pose with fixed torso.

FASHION POSE, FRONT

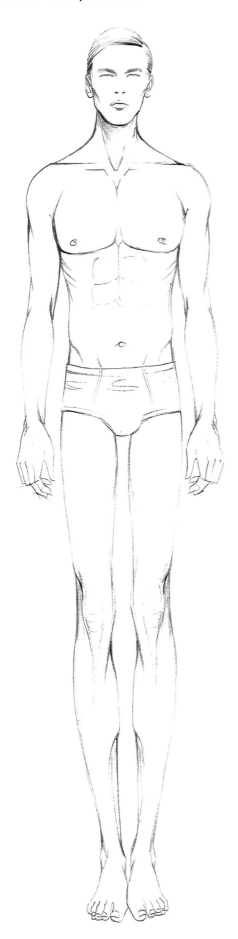

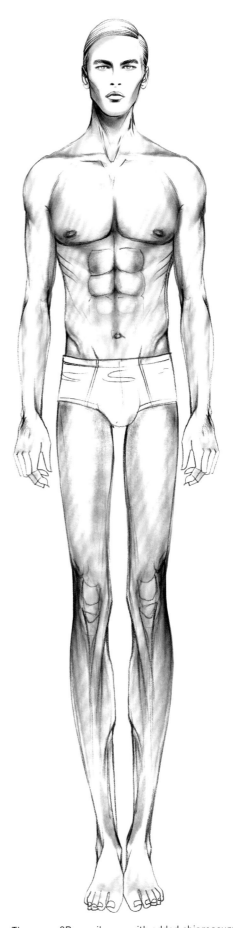

Basic frontal pose drawn in 2B pencil.

The same 2B pencil pose with added chiaroscuro, coloured in by crayon and retouched on the computer to increase the contrast of lighter areas and the shading effect.

CUSTOMISING THE POSES

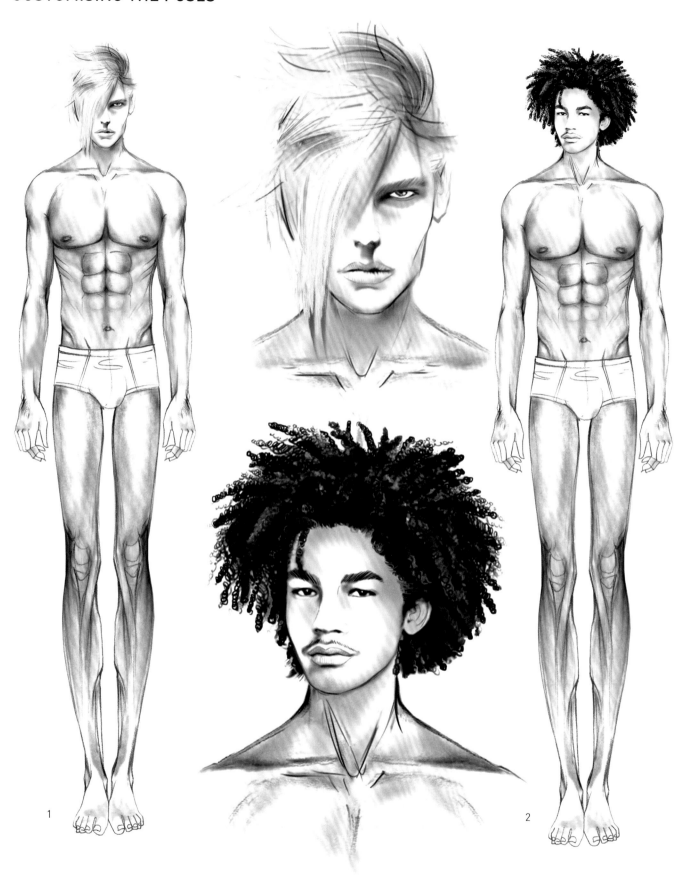

1

2

To give the figurine a character that reflects your personality and style, it is important to choose the right face, as this is an even more effective way to interpret and characterise the outfit. As we can see in images 1 and 2, the figurine's look and identity can be altered dramatically, simply by changing the face and hairstyle.

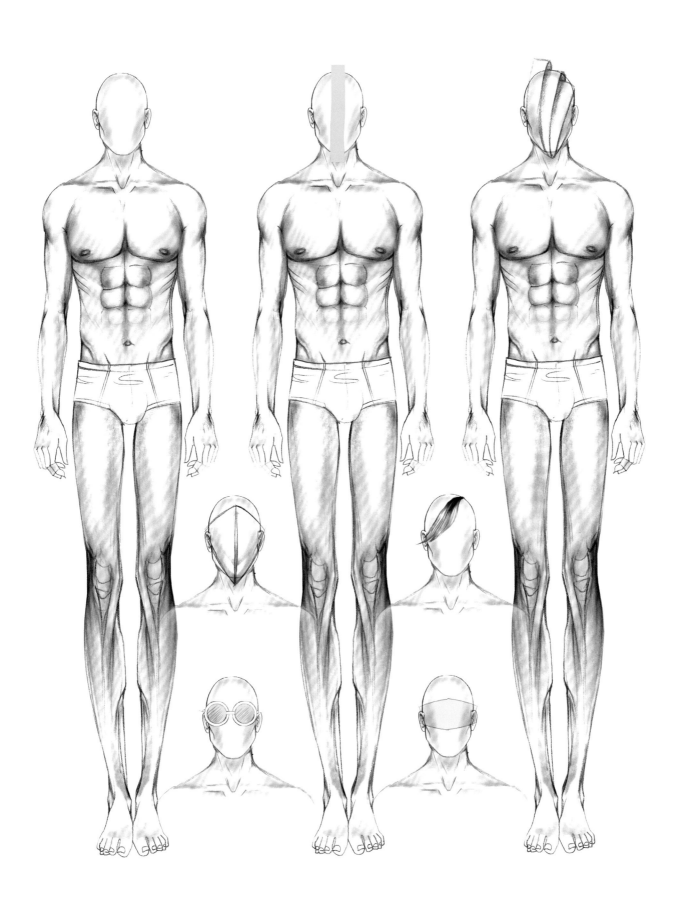

Sometimes it is better to make the figurine less prominent, so that the clothes stand out more, but still give it a personalised touch; for example, you can opt for an empty face or a face with artificial features, such as details related to the theme of the collection. The aesthetic flavour given to the final images is the sole responsibility of their creator, but this should be chosen carefully, based on the stylistic message that you want to convey.

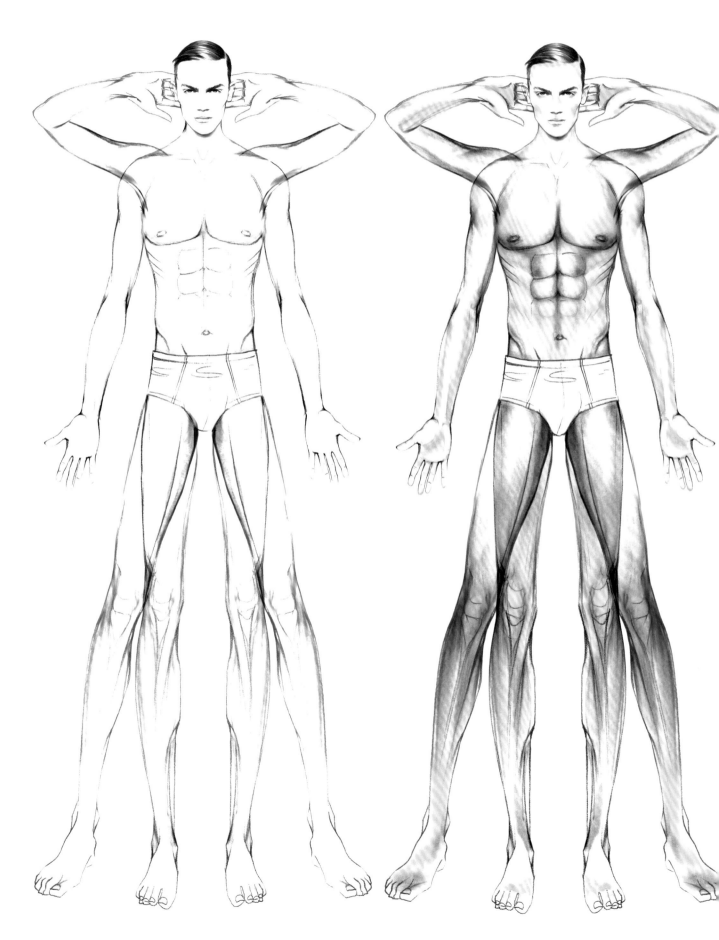

Multiple pose with fixed torso, in pencil and colour.

SINGLE POSE 1

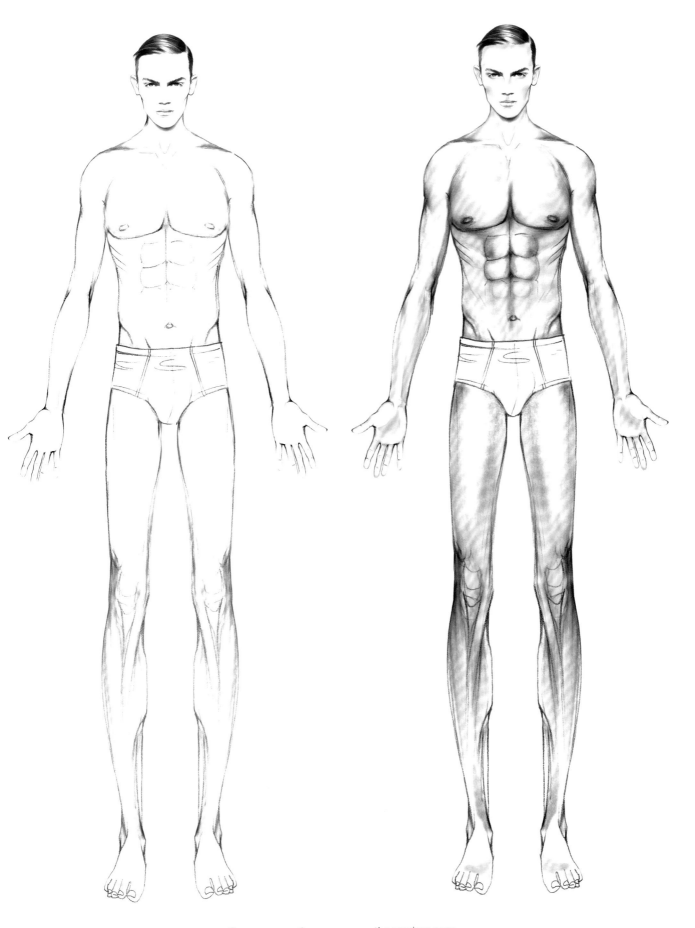

Same pose as the one seen on the previous page.

SINGLE POSE 2

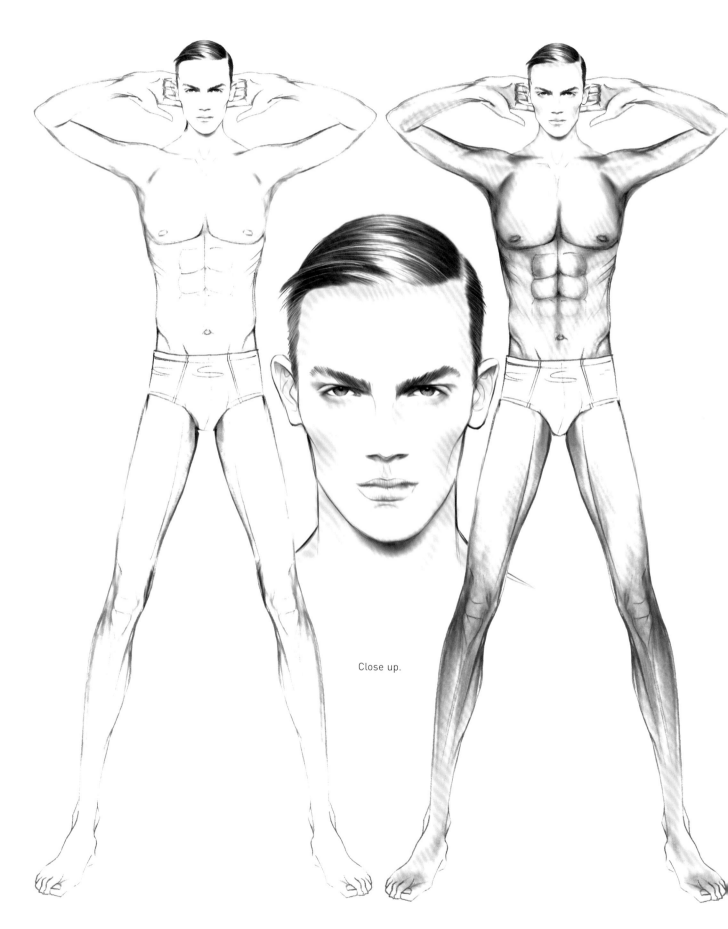

Close up.

Pose extrapolated from the multiple pose and close-up face.

FRONT POSE WITH HANDS ON HIPS

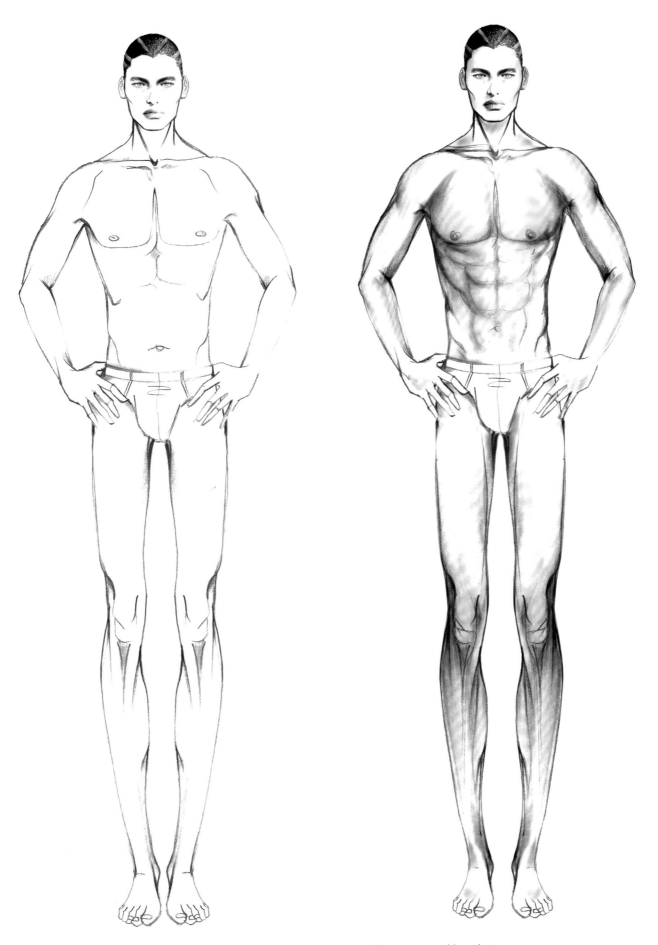

Pose with hands on hips, suitable for presenting garments with pockets.

POSE WITH ARMS FOLDED

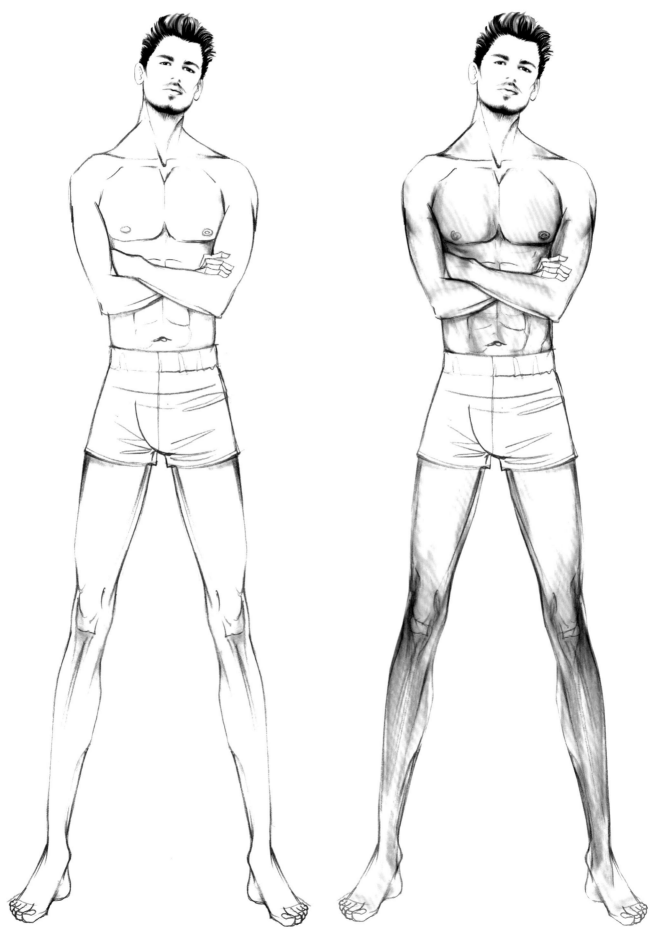

Frontal pose with arms folded and legs apart.

POSE WITH TORSO LEANING FORWARD

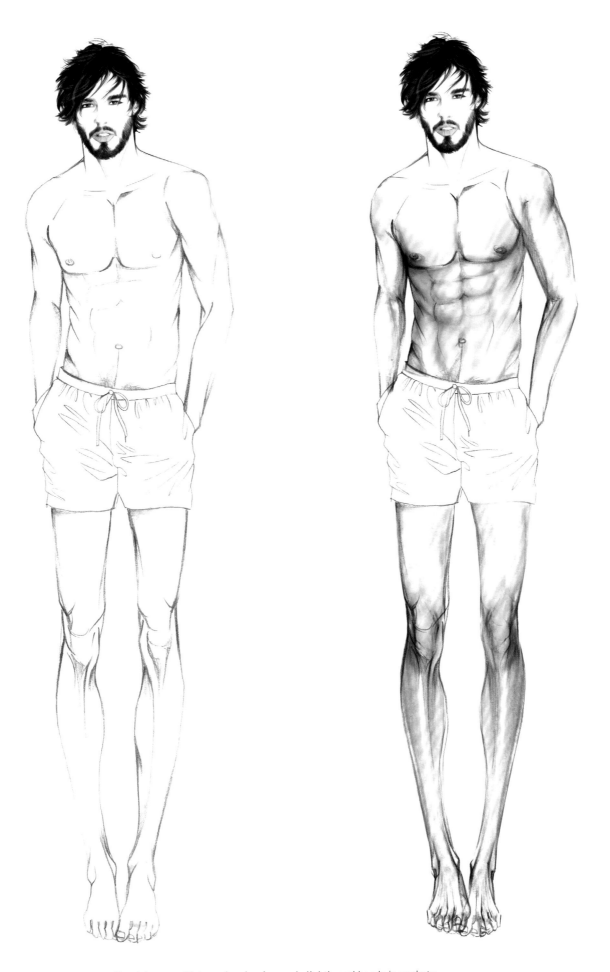

Frontal pose with torso leaning forward slightly and hands in pockets.

SLIGHT 3/4 POSE

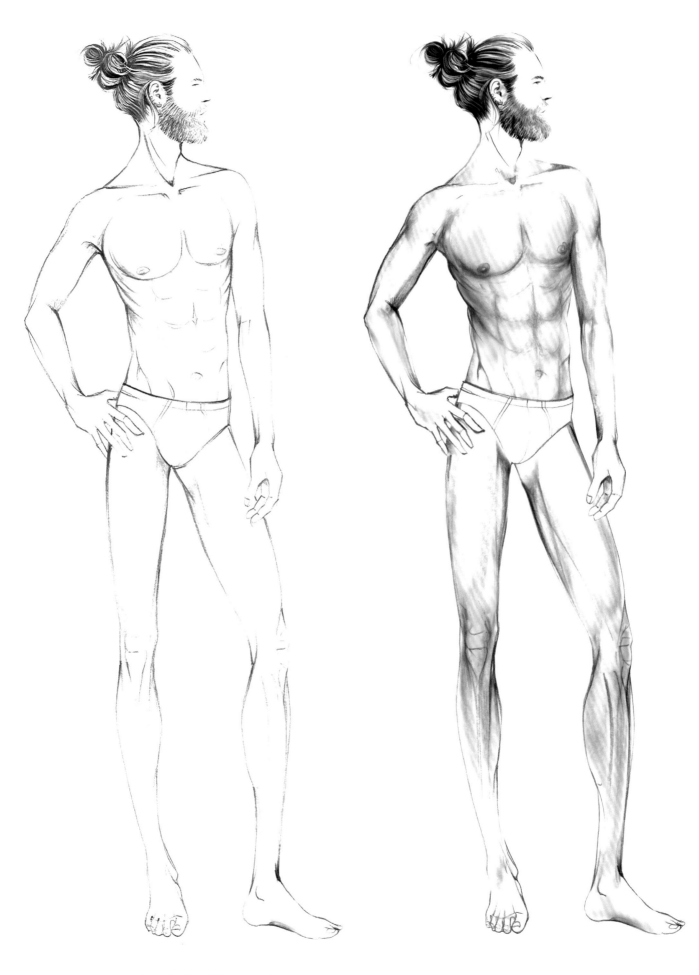

Pose in slight 3/4 position, face in profile with bent arm, suitable for garments with pockets.

MULTIPLE POSE

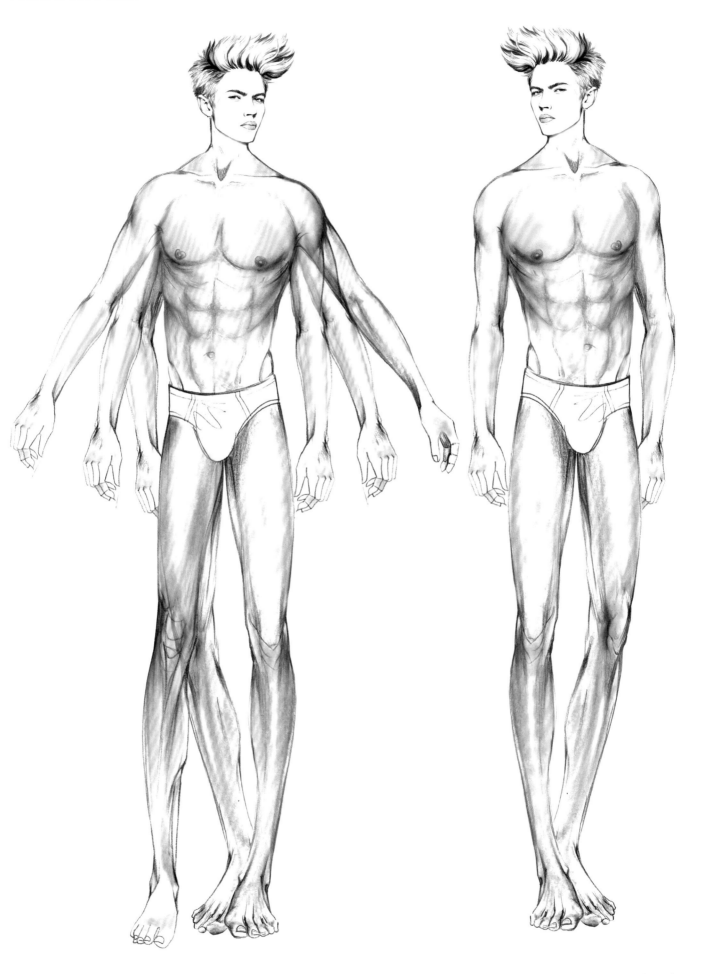

Multiple pose with fixed torso.

Pose taken from the multiple pose and reflected.

3/4 POSE

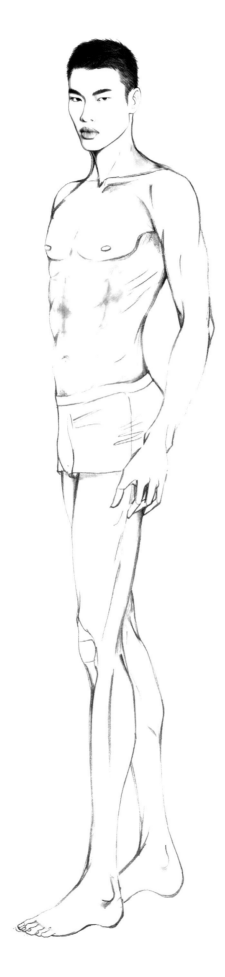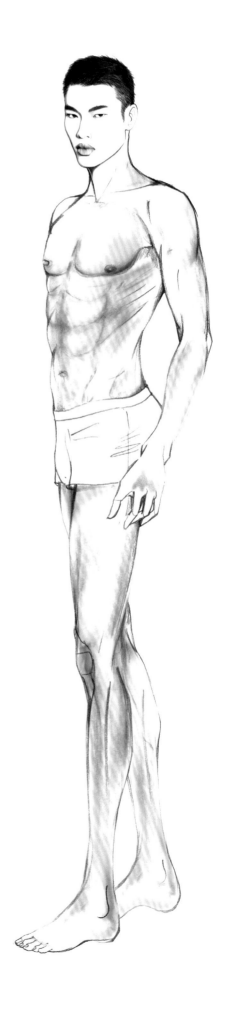

3/4 left side pose.

REAR POSE

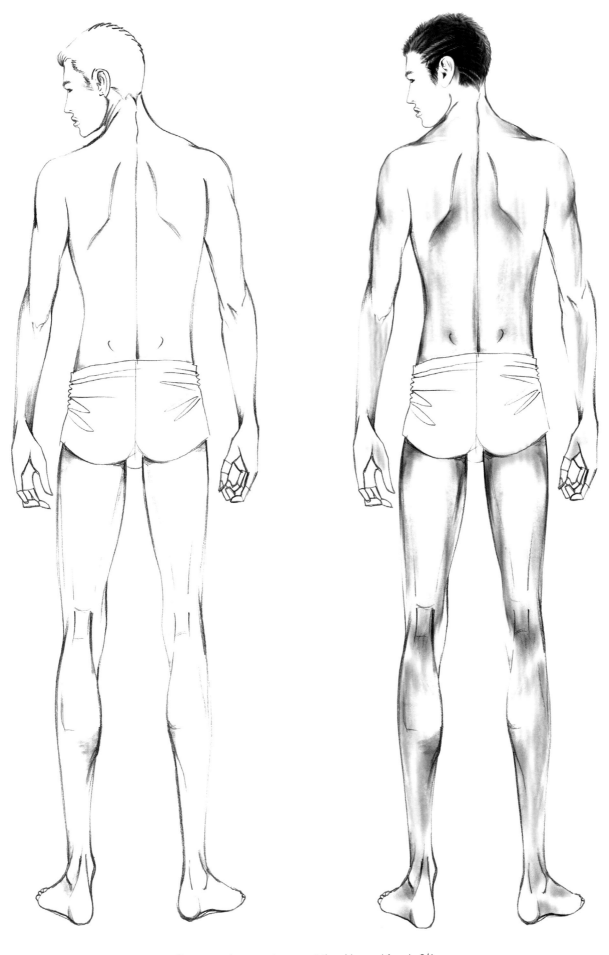

Rear pose, legs apart, arms at the sides and face in 3/4.

STATIC POSE IN PROFILE

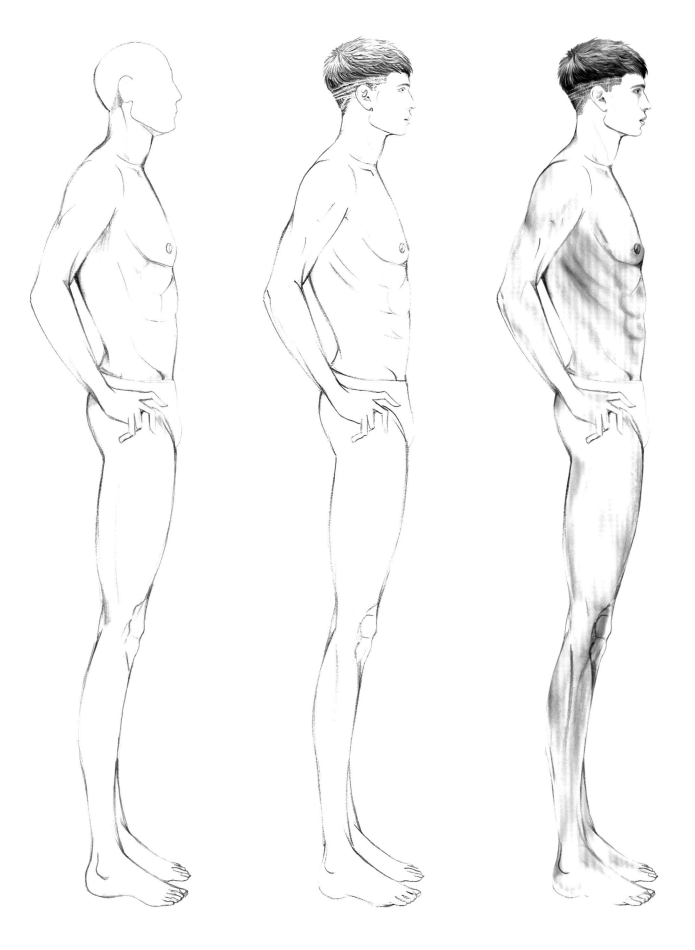

Static right profile pose with hands at the sides.

MULTIPLE PROFILE POSE

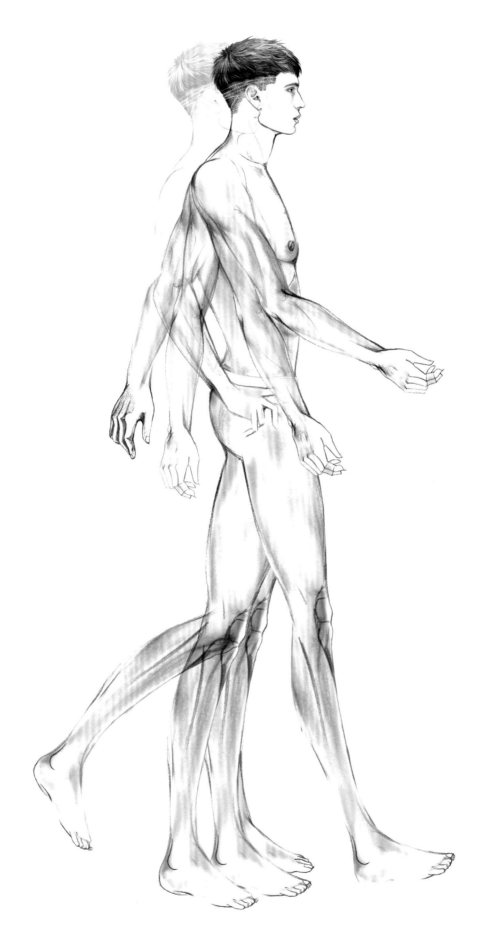

Multiple profile pose, walking.

BASIC REAR POSE

Basic rear pose, arms at the sides and legs together.

BASIC REAR POSE 2

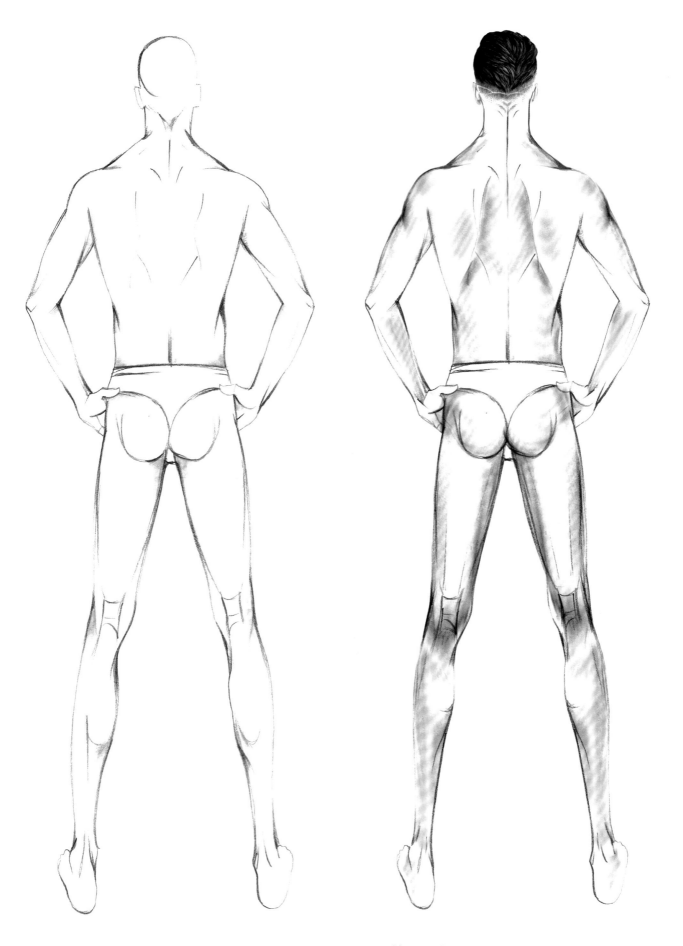

Rear pose, hands at the sides and legs apart.

DRESSED POSES

OUTFIT 1

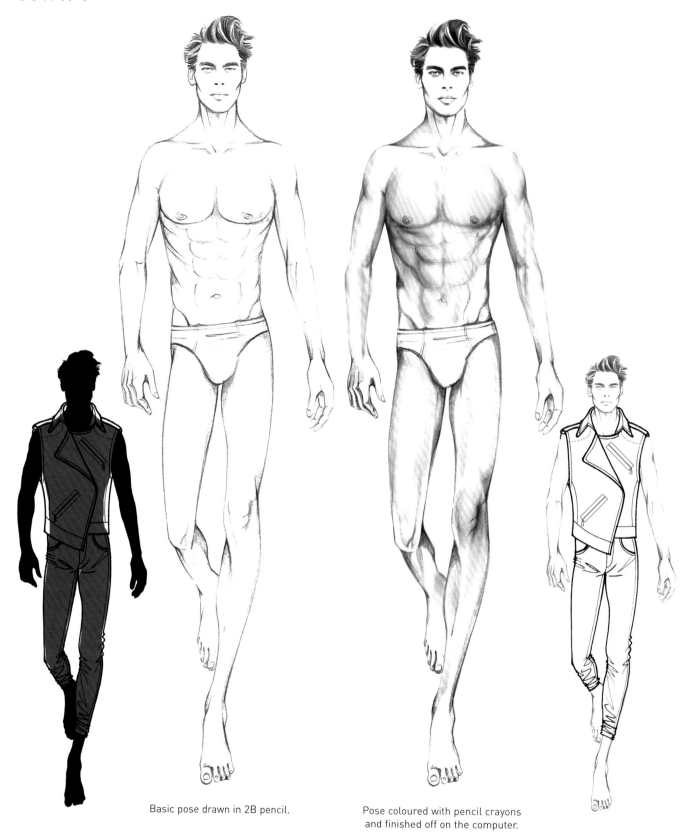

Basic pose drawn in 2B pencil.

Pose coloured with pencil crayons and finished off on the computer.

Many methods can be used to add clothing to a pose. The method you choose depends on several factors, includitng the need to speed up work done in schools, fashion design studios and companies, which often use these methods to duplicate the same style for all the figurines in the same collection. In the didactic sense, the multiple outfits presented here also offer an opportunity to observe the various fits of an item of clothing, since these are left transparent on the bodies and are then translated into fashion figurines that can be copied and coloured according to current trends.

HOW TO DRESS THE FIGURINE

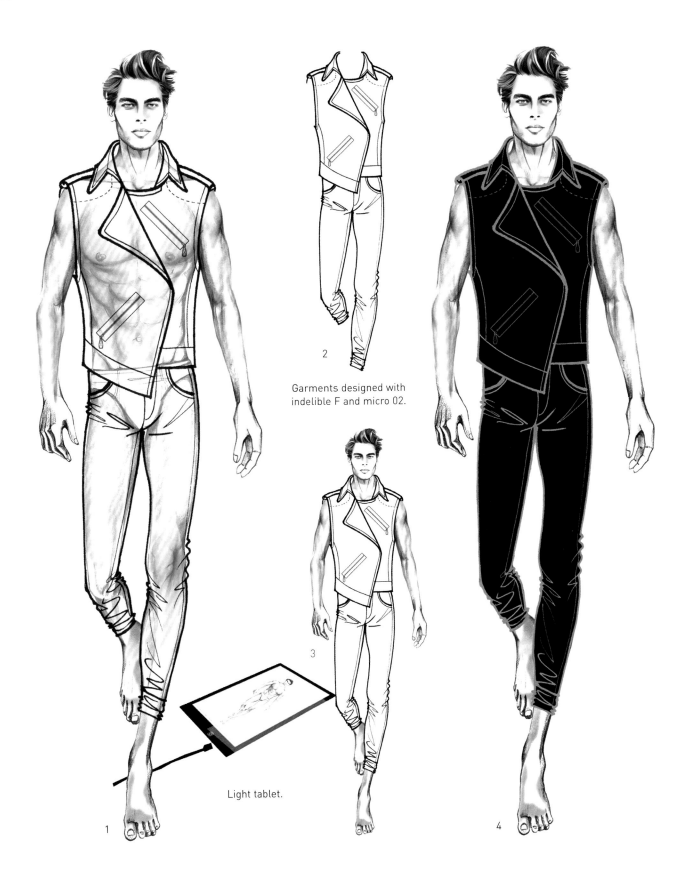

2

Garments designed with indelible F and micro 02.

3

Light tablet.

1

4

1. Print the most suitable pose to showcase your outfit, put it on the luminous tablet and place a sheet of tracing paper on top. Then use a 2B pencil to draw the various garments on the paper.

2. Neaten the outlines of the garments with an indelible marker, as shown in figure 2.

3. Scan the garments and outline the images on the computer, then place each garment of the outfit directly over the pose.

4. Colour in all the elements. This procedure can also be carried out entirely by hand.

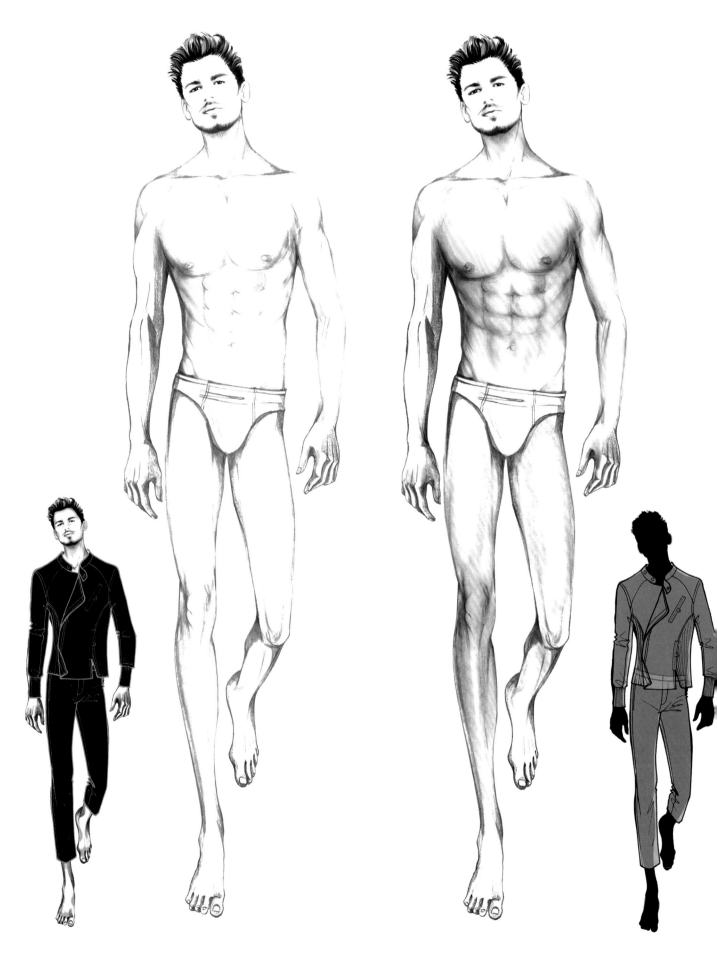

Basic pose drawn in 2B pencil.

Coloured pose.

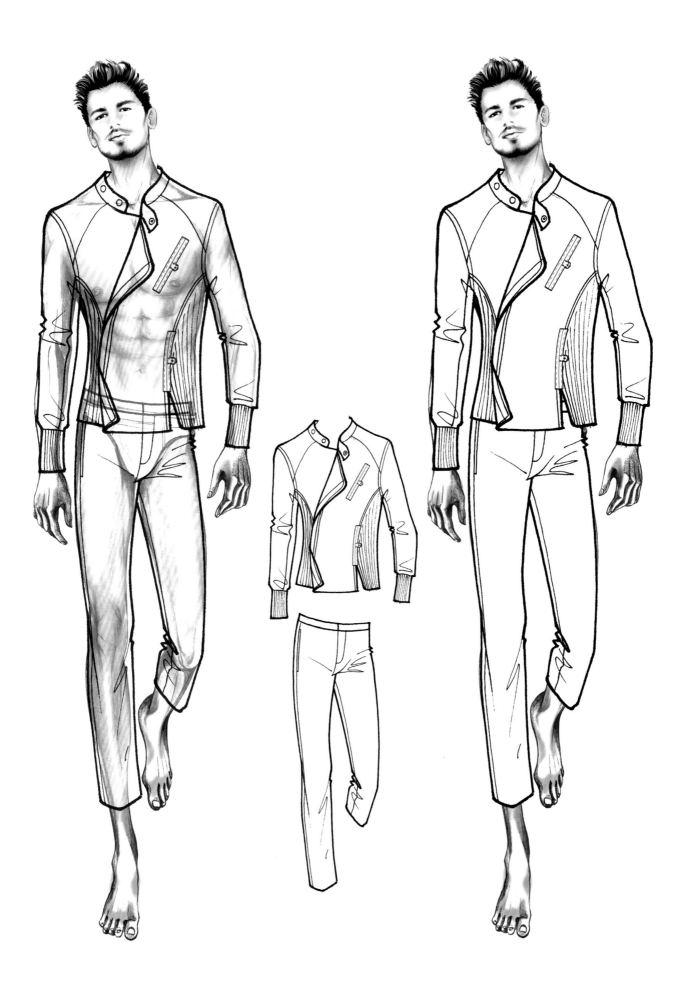

Garments drawn with indelible Stabilo F and micro 02.

OUTFIT 3

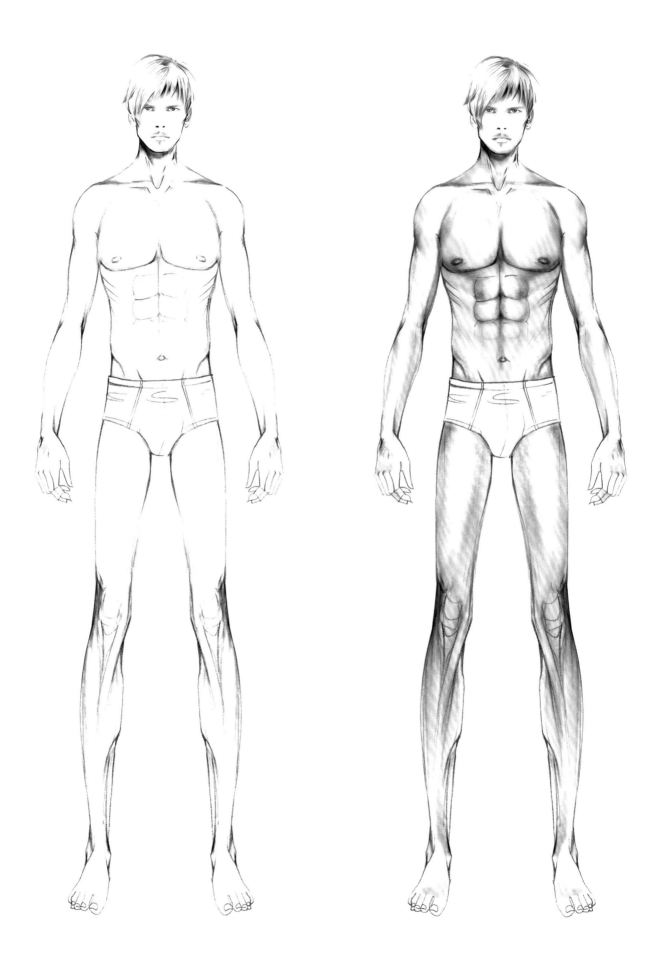

Basic pose drawn in 2B pencil.

Coloured pose.

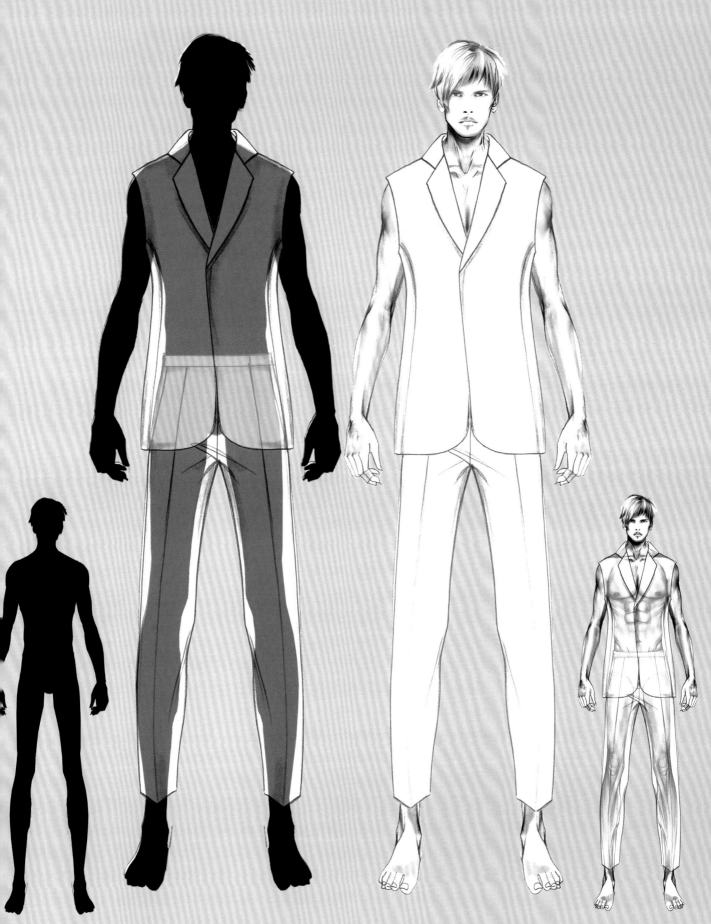

Outfit drawn in semi-transparency over a black figure, in order to better visualise its size.

Final outfit.

OUTFIT 4

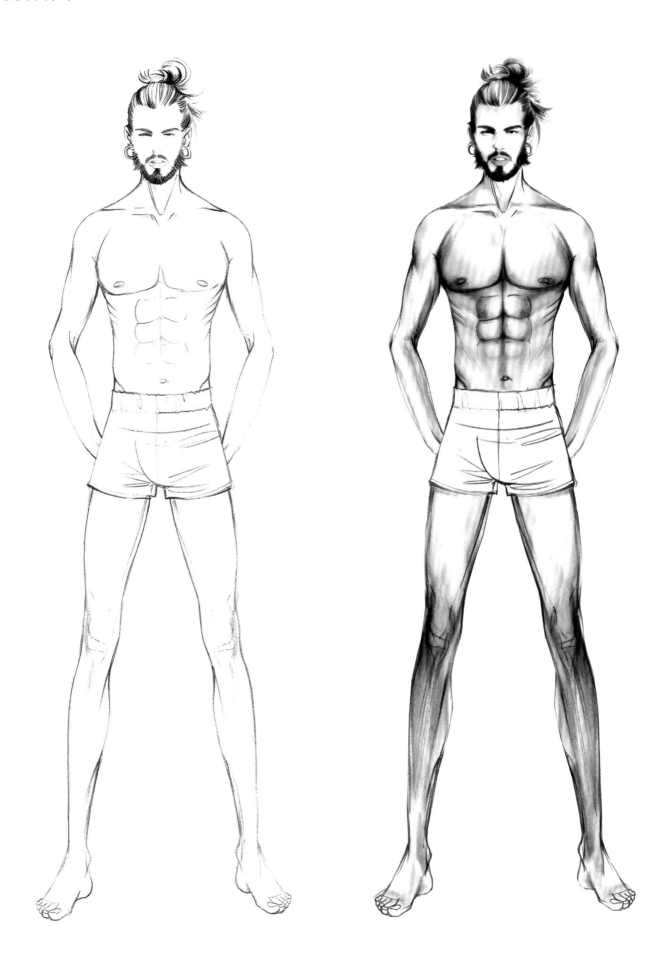

Basic pose drawn in 2B pencil.

Coloured pose.

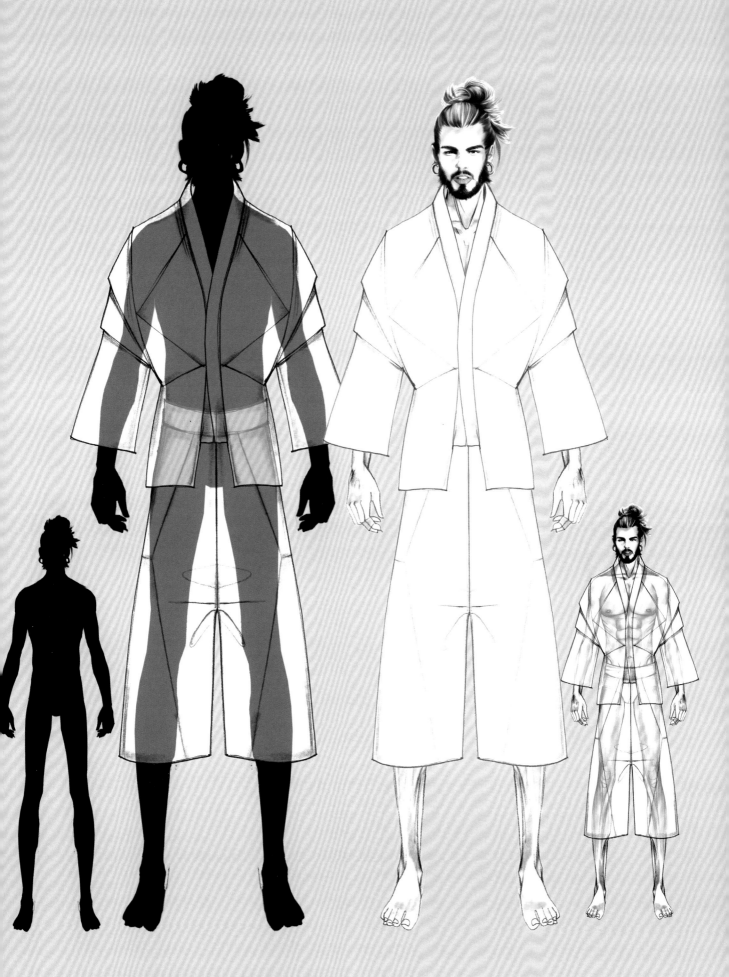

Outfit drawn in semi-transparency over a black
figure, in order to better visualise its size.

Final outfit.

OUTFIT 5

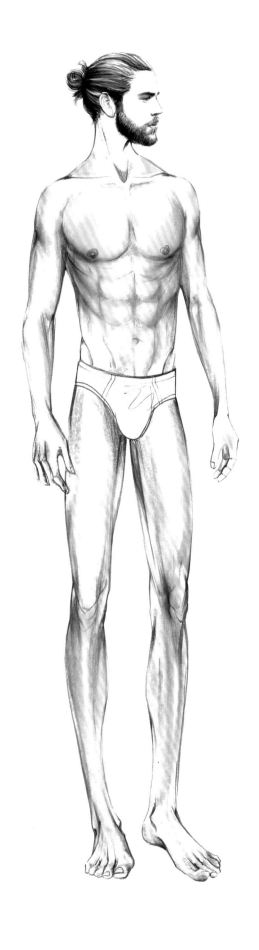

Basic pose drawn in 2B pencil.

Coloured pose.

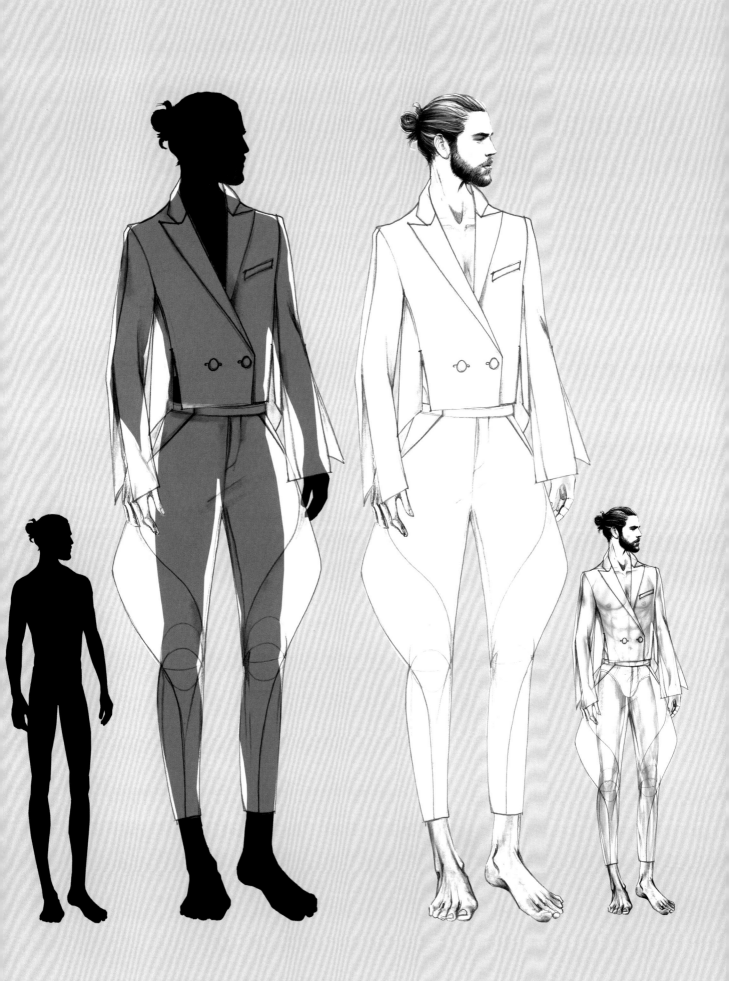

Outfit drawn in semi-transparency over a black
figure, in order to better visualise its size.

Final outfit.

OUTFIT 6

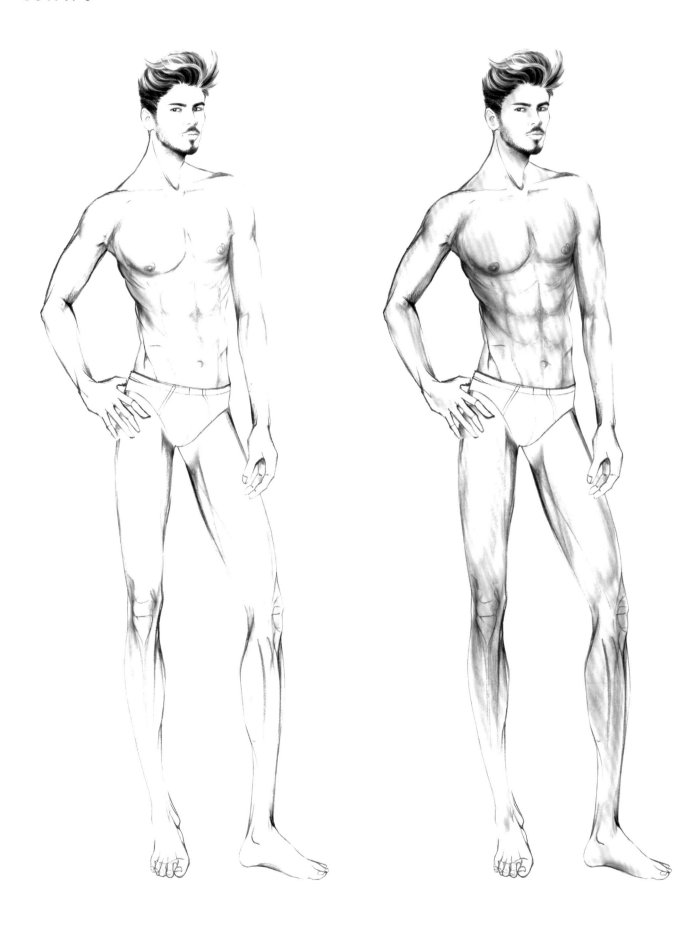

Basic pose drawn in 2B pencil.

Coloured pose.

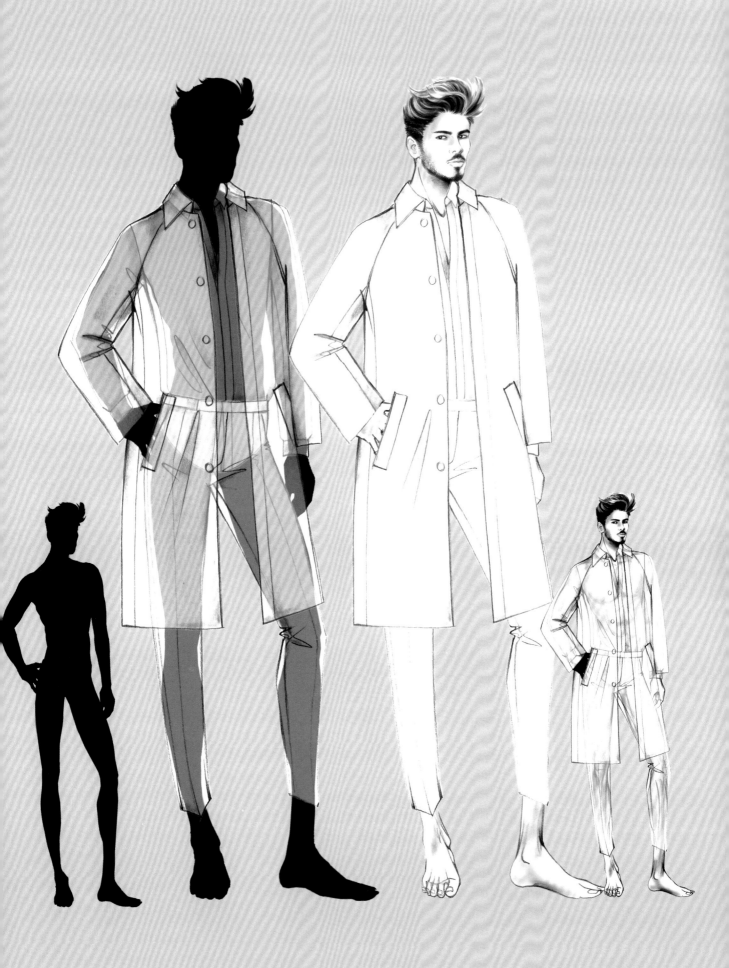

Outfit drawn in semi-transparency over a black figure, in order to better visualise its size.

Final outfit.

141

OUTFIT 7

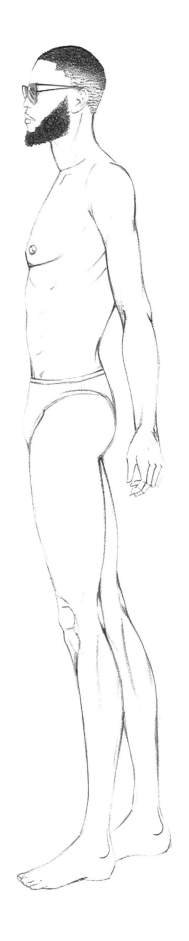

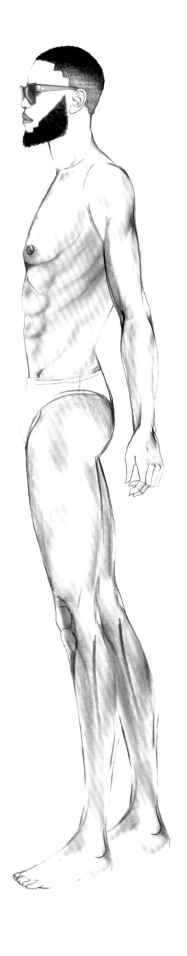

Basic pose drawn in 2B pencil.

Coloured pose.

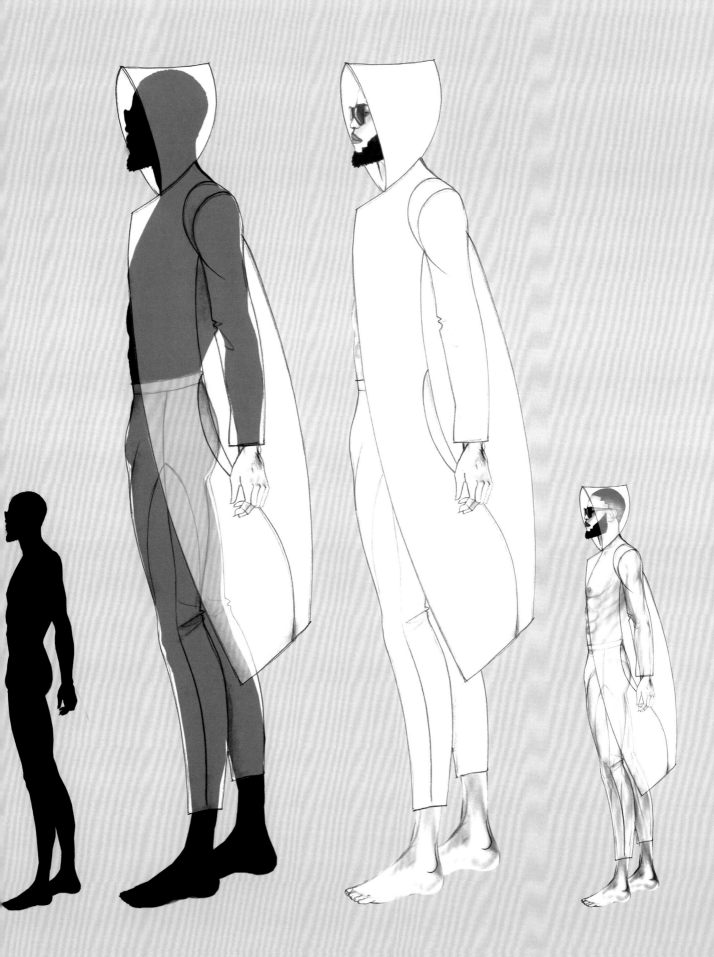

Outfit drawn in semi-transparency over a black figure, in order to better visualise its size.

Final outfit.

OUTFIT 8

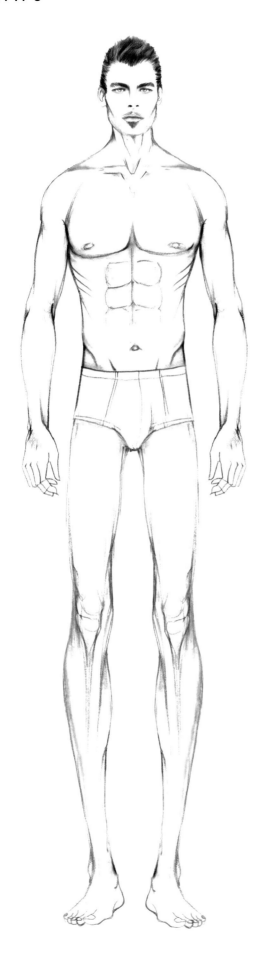 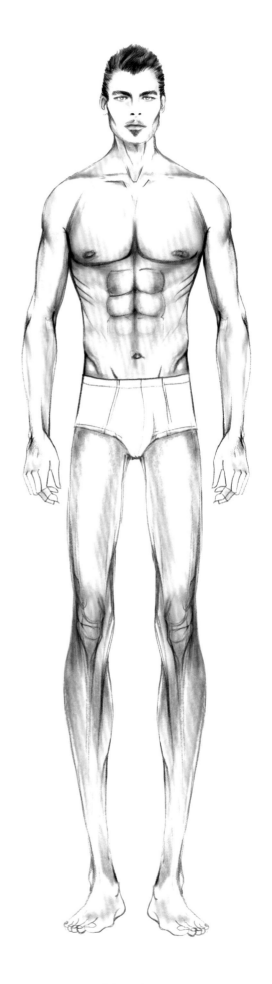

Basic pose drawn in 2B pencil.

Coloured pose.

144

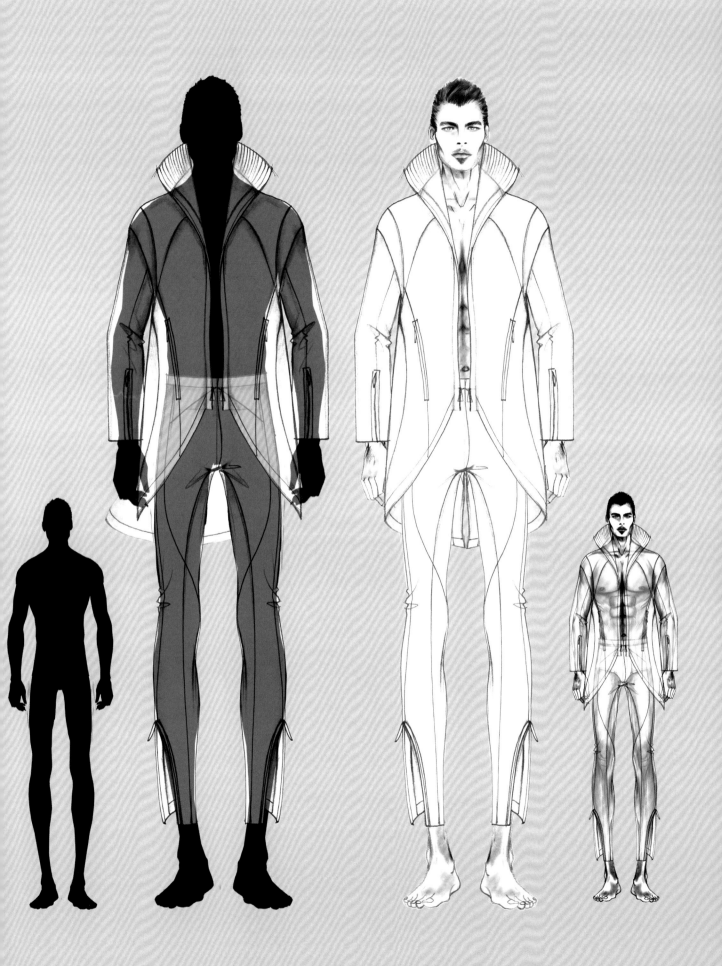

Outfit drawn in semi-transparency over a black
figure, in order to better visualise its size.

Final outfit.

OUTFIT 9

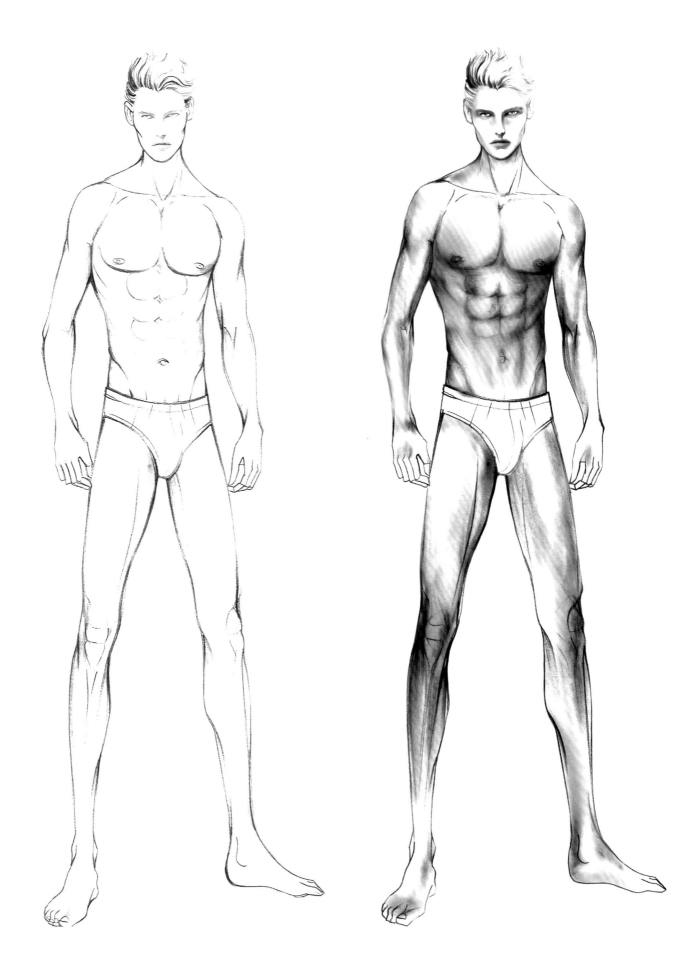

Basic pose drawn in 2B pencil.

Coloured pose.

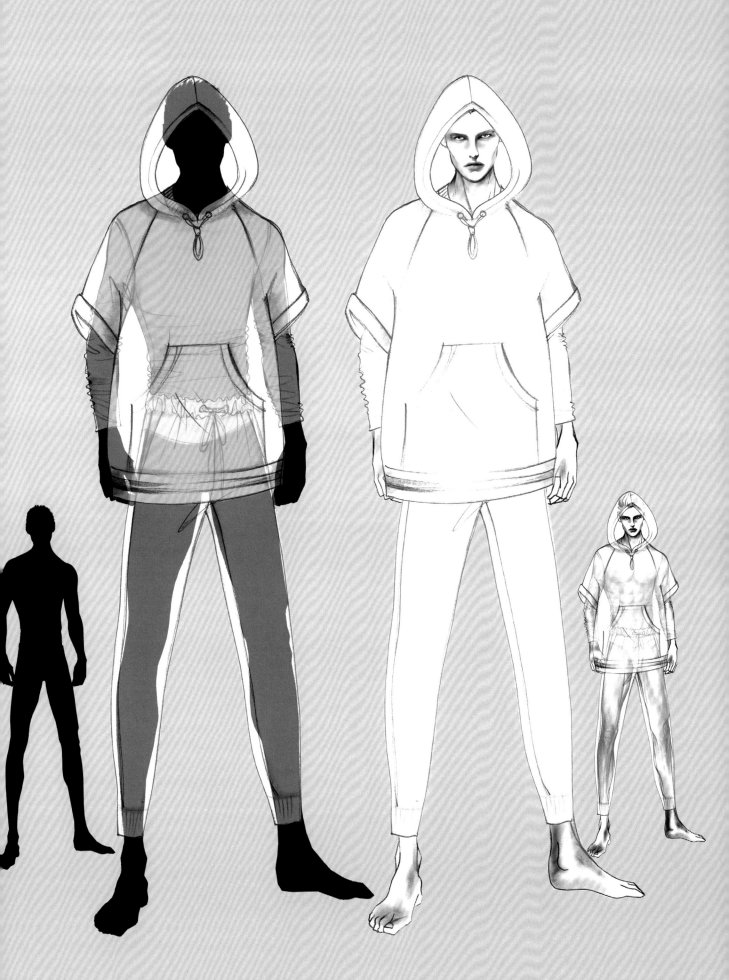

Outfit drawn in semi-transparency over a black figure, in order to better visualise its size.

Final outfit.

OUTFIT 10

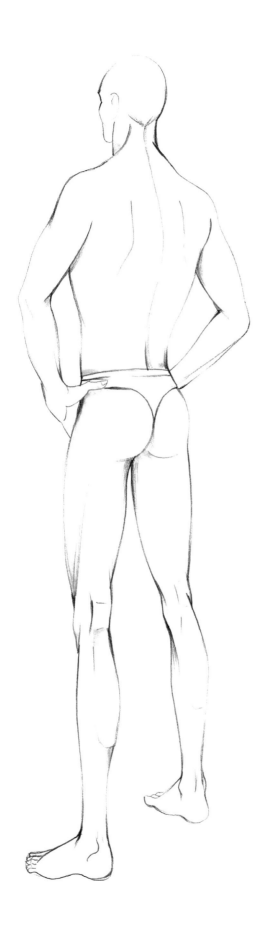

Basic pose drawn in 2B pencil.

Coloured pose.

Outfit drawn in semi-transparency over a black figure, in order to better visualise its size.

Final outfit.

OUTFITS 11A - 11B - 11C

11A

11B

11C

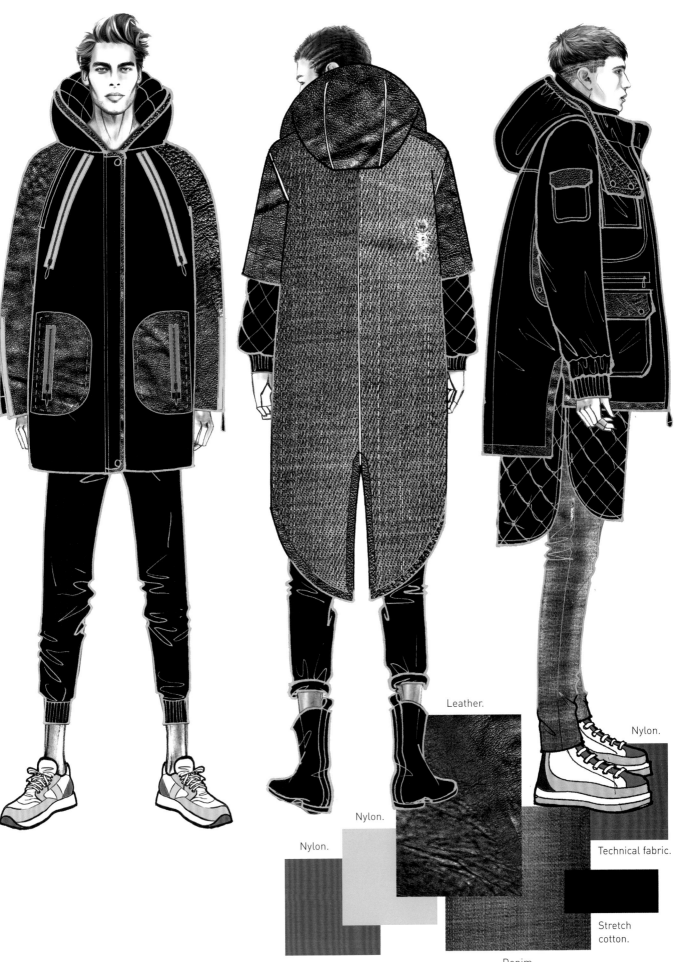

Leather.

Nylon.

Nylon.

Nylon.

Technical fabric.

Stretch cotton.

Denim.

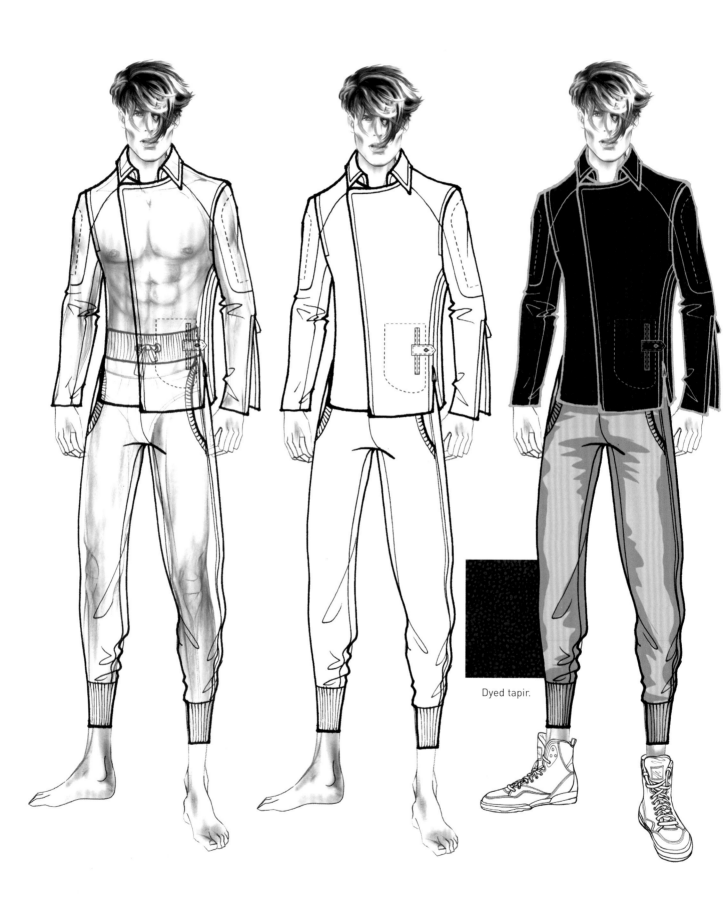

Dyed tapir.

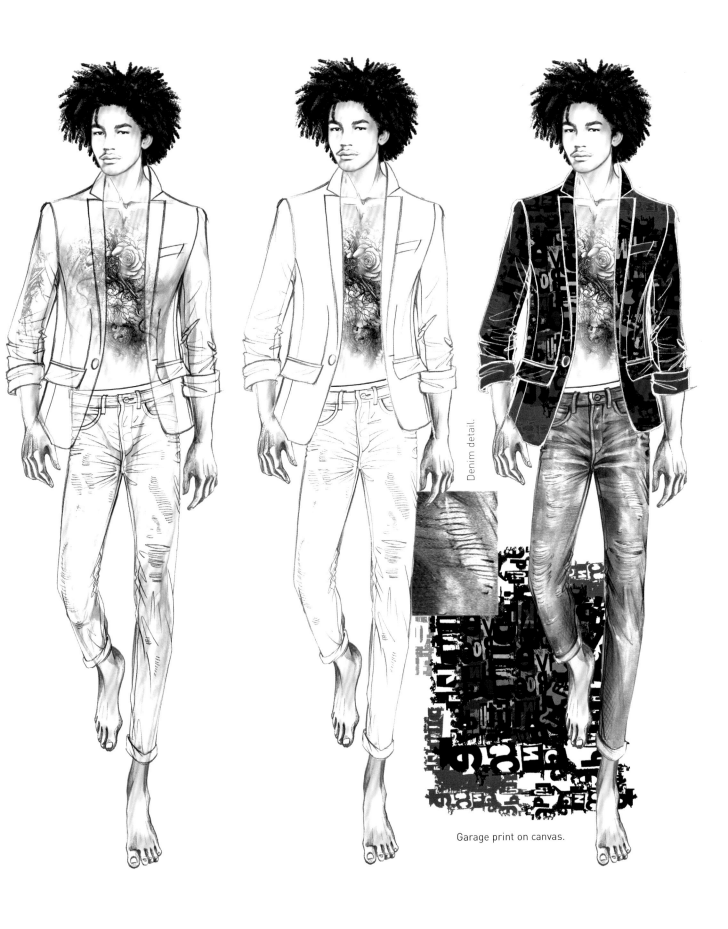

Denim detail.

Garage print on canvas.

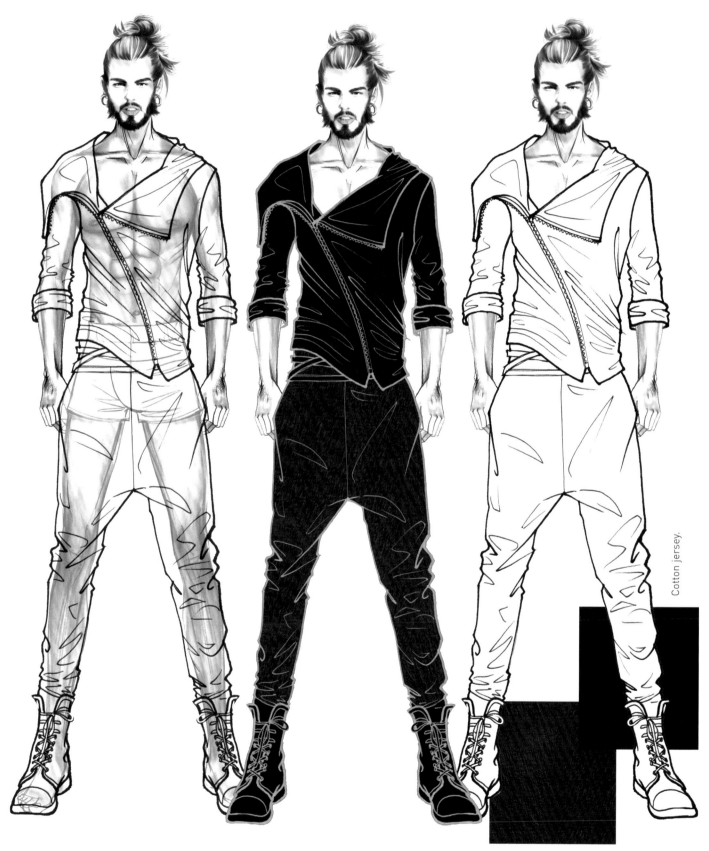

Cotton jersey.

Linen and bamboo.

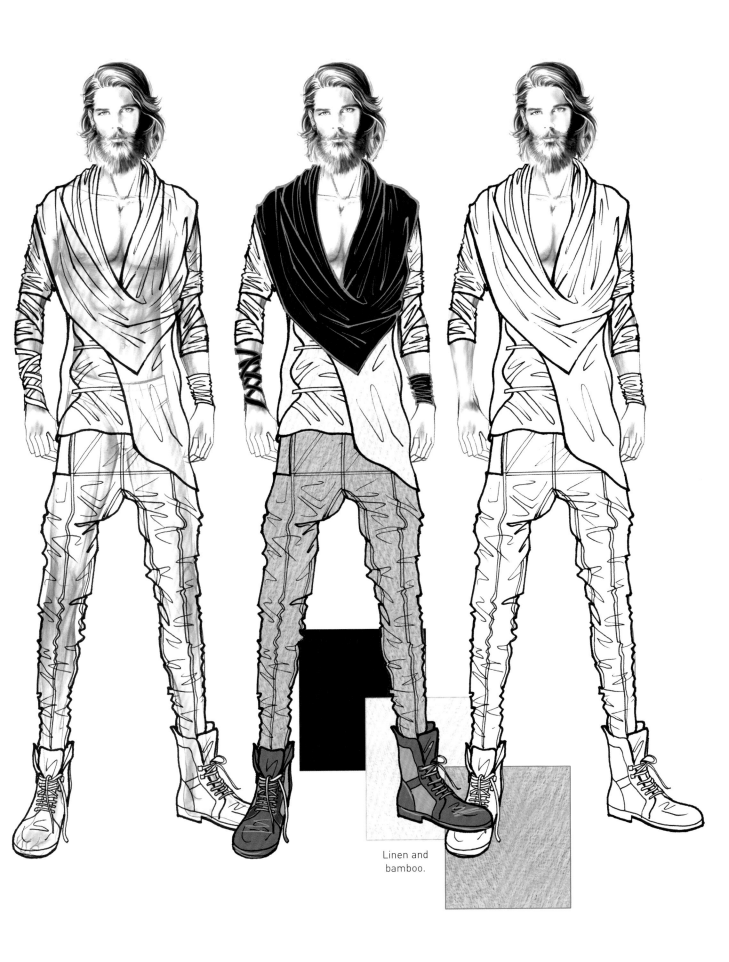

Linen and bamboo.

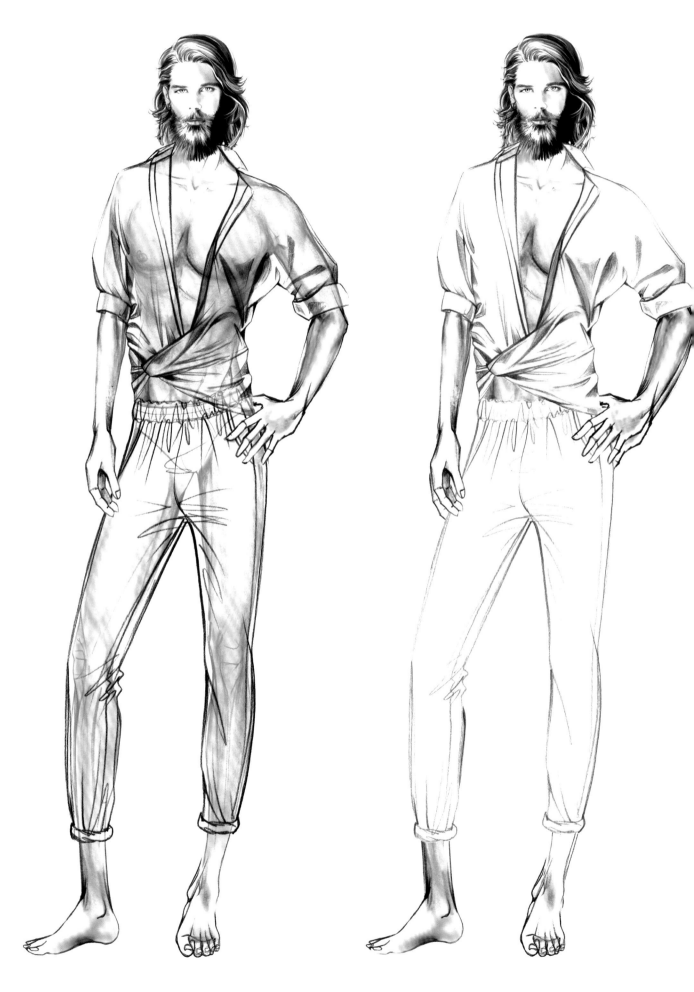

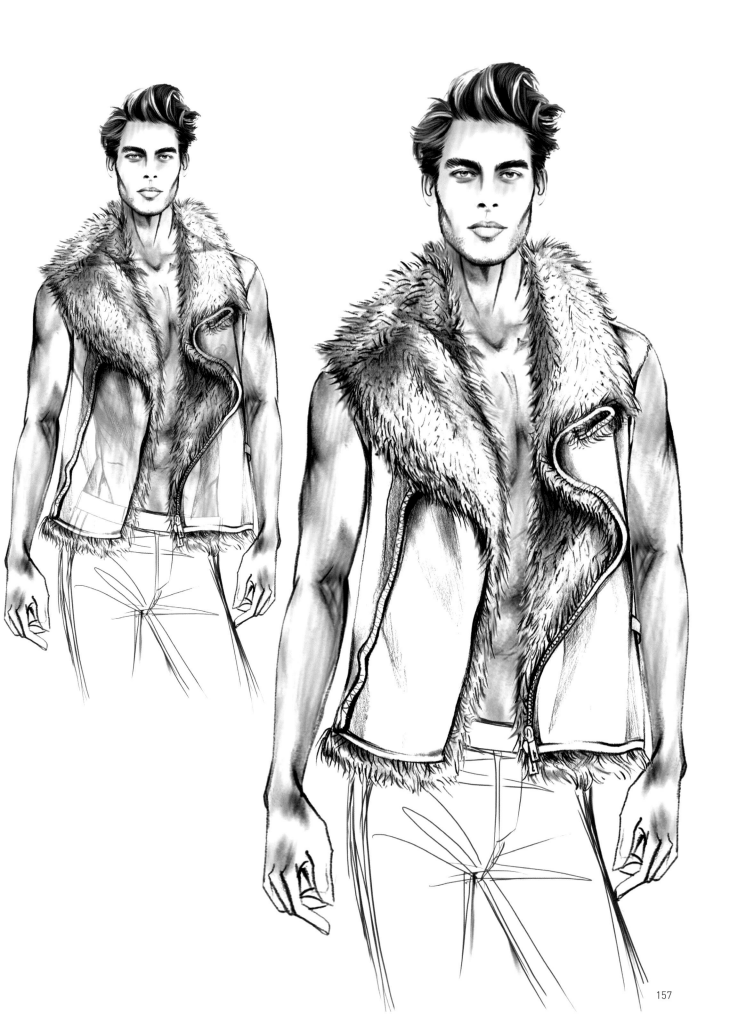

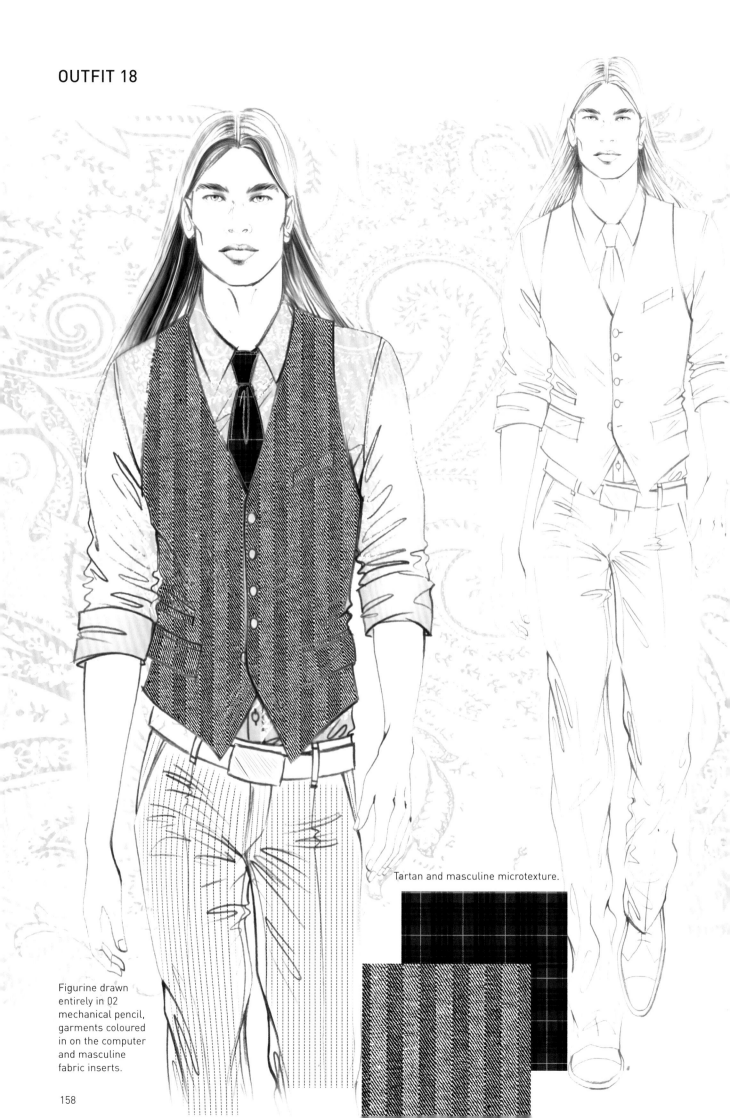

OUTFIT 18

Tartan and masculine microtexture.

Figurine drawn entirely in 02 mechanical pencil, garments coloured in on the computer and masculine fabric inserts.

OUTFIT 19

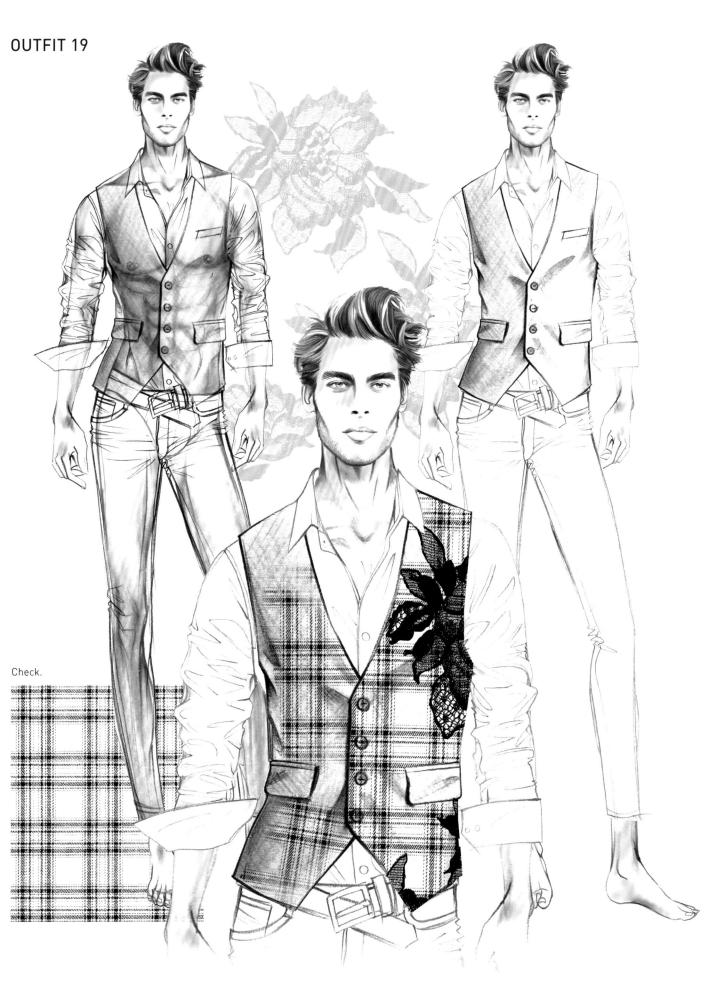

Check.

Basic pose drawn by hand, printed and used as a basis for drawing the garments. Garments drawn separately with a 02 mechanical pencil and coloured crayons, then scanned and placed onto the pose by computer. Garments coloured in on the computer, with masculine fabric inserts and lace applications.

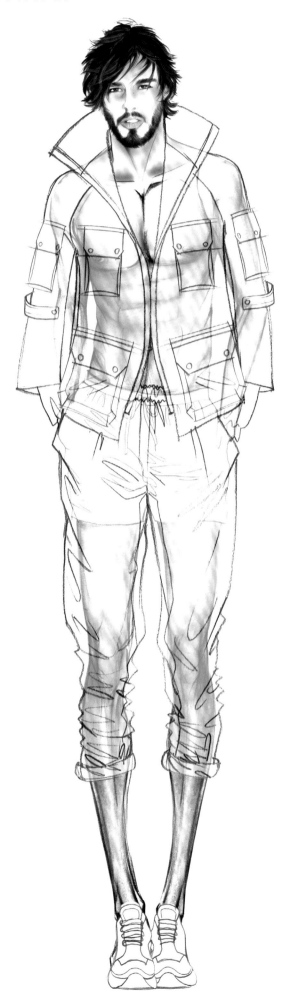
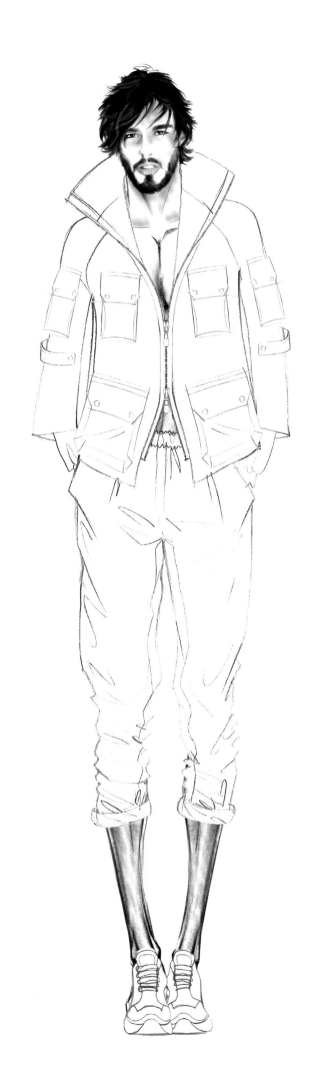

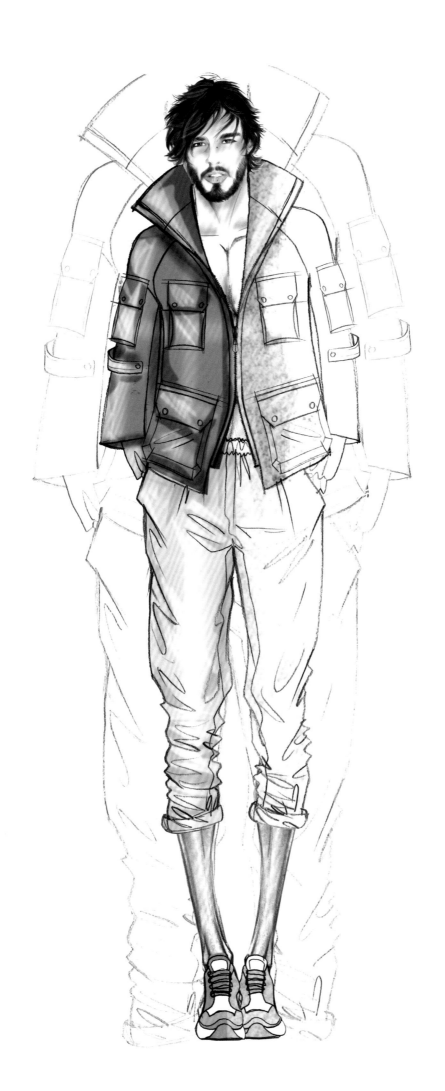

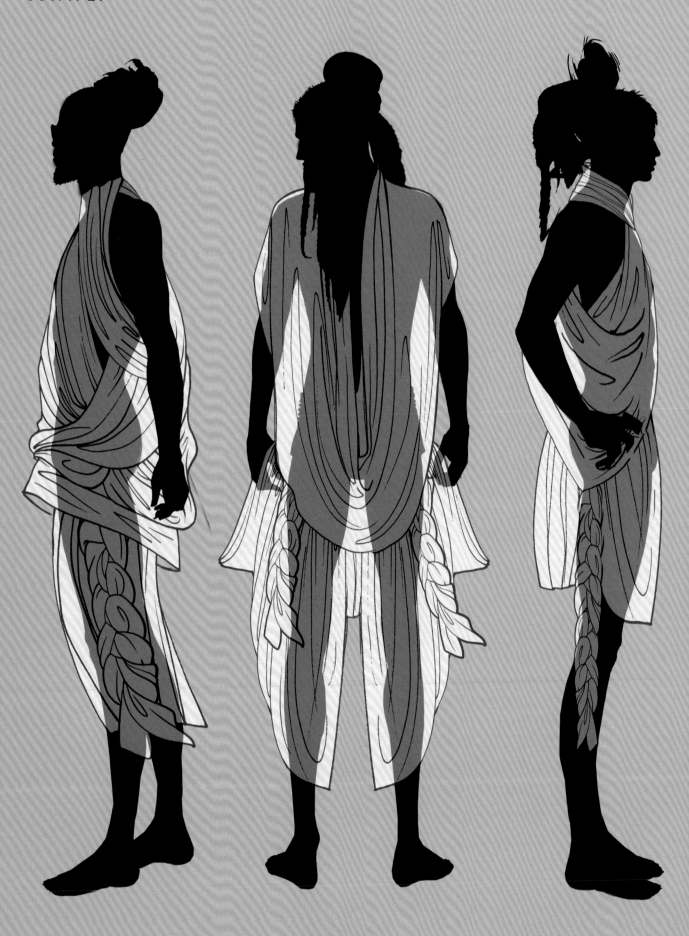

Black outlines and transparent garments.

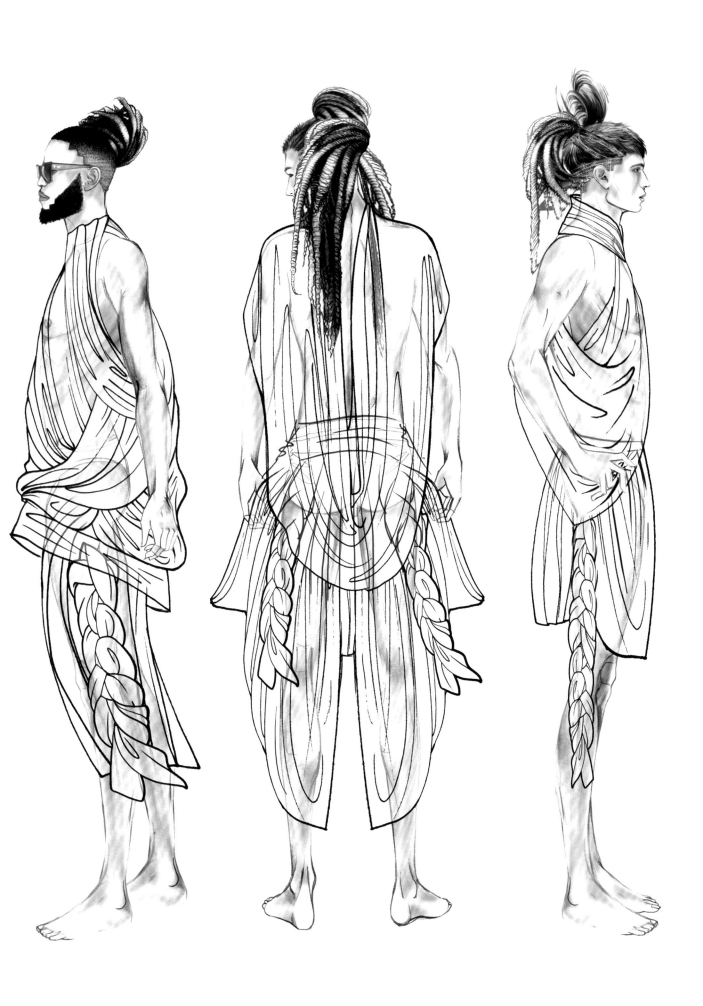

Poses shown in colour and garments shown in transparency.

HAIRSTYLE DETAILS

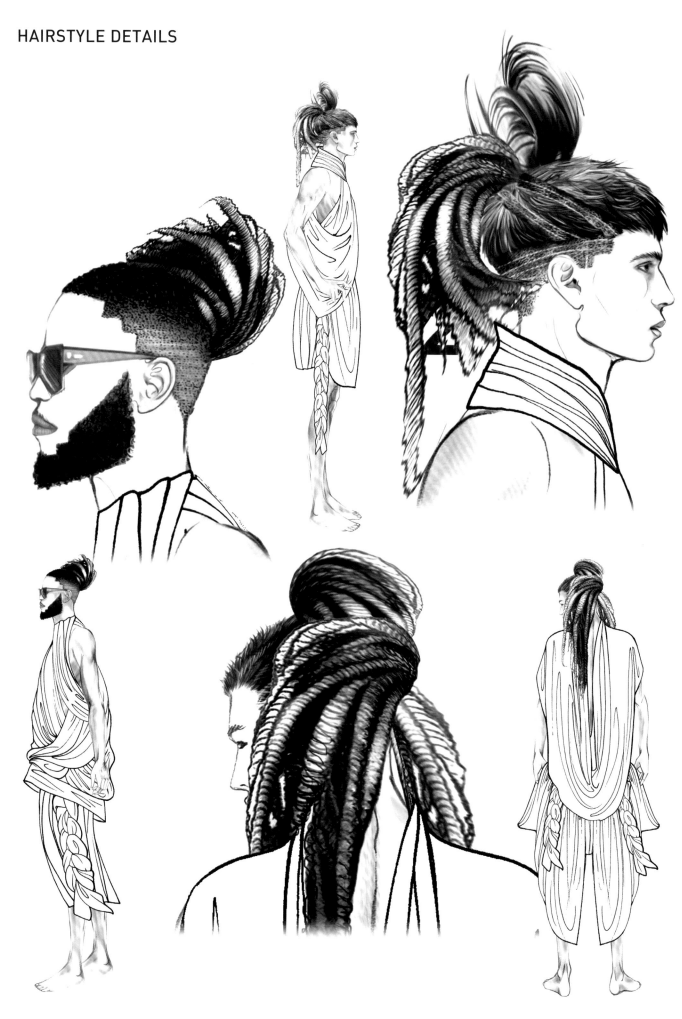

Hair drawn by hand and coloured in on the computer.

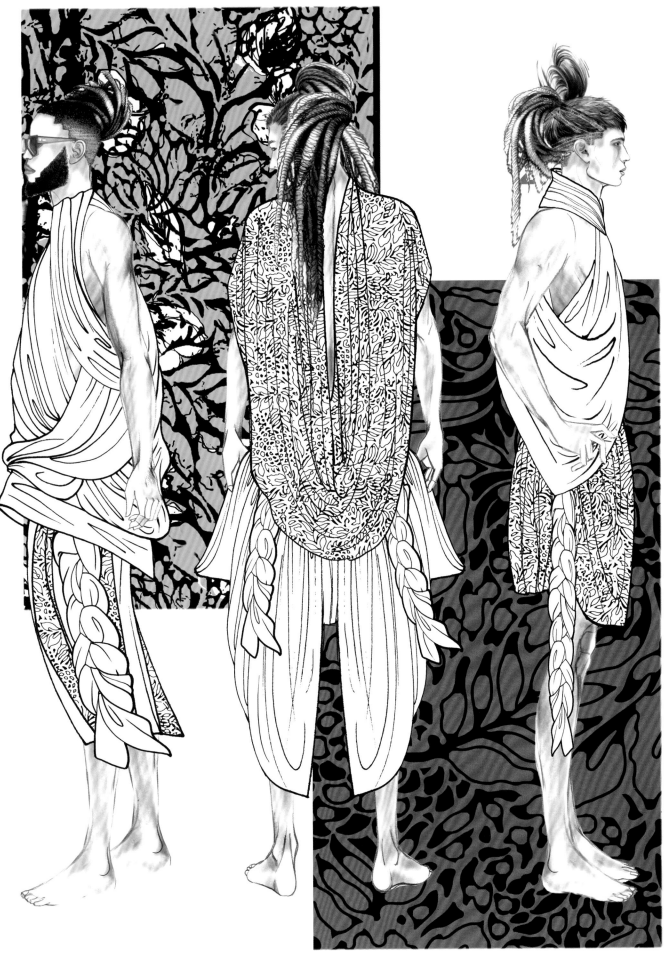

Batik floral print.

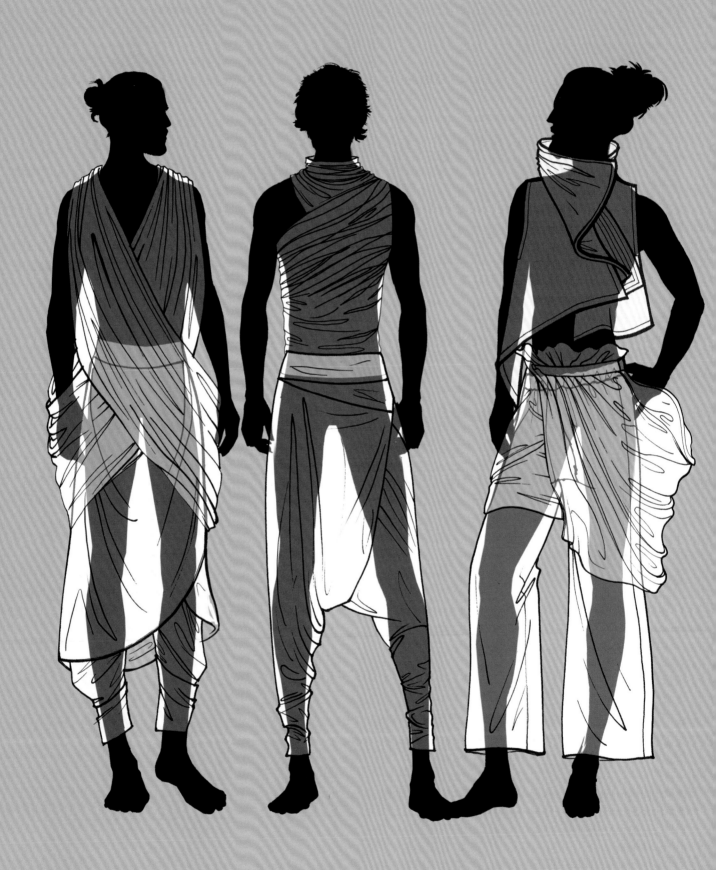

Black outlines and transparent garments.

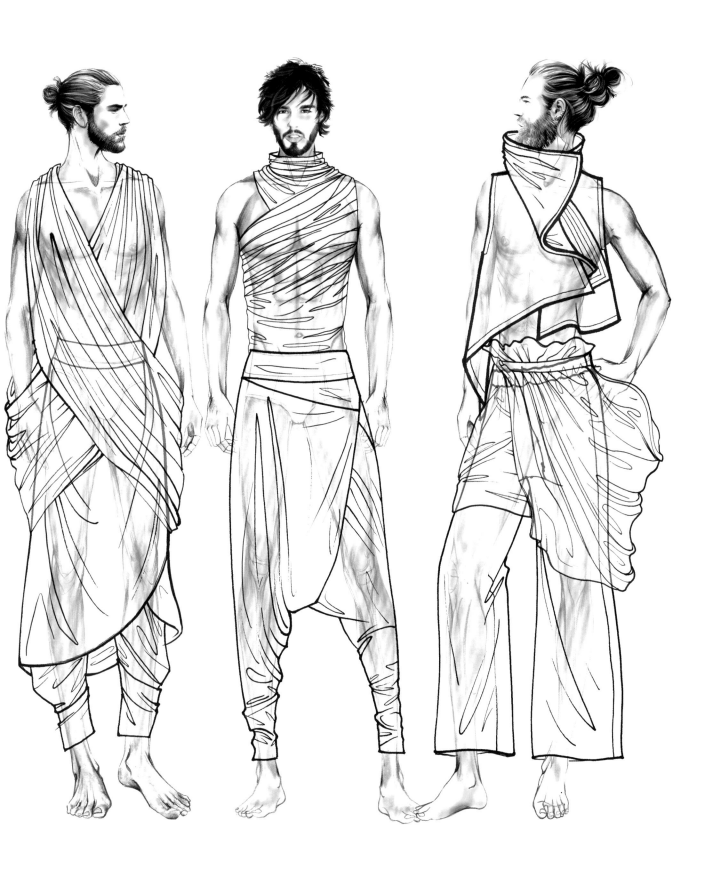

Poses shown in colour and garments shown in transparency.

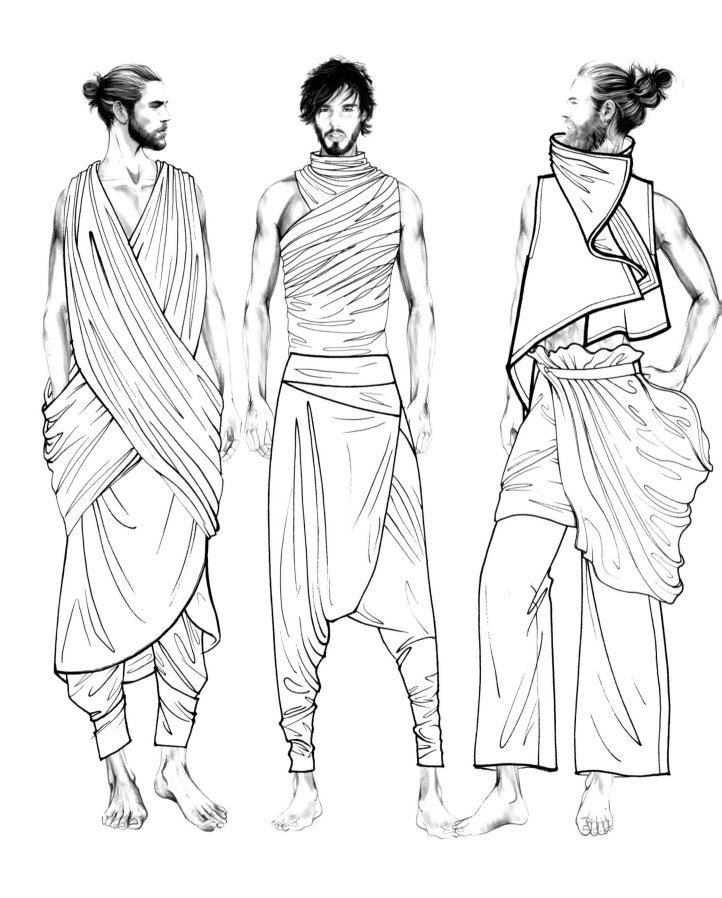

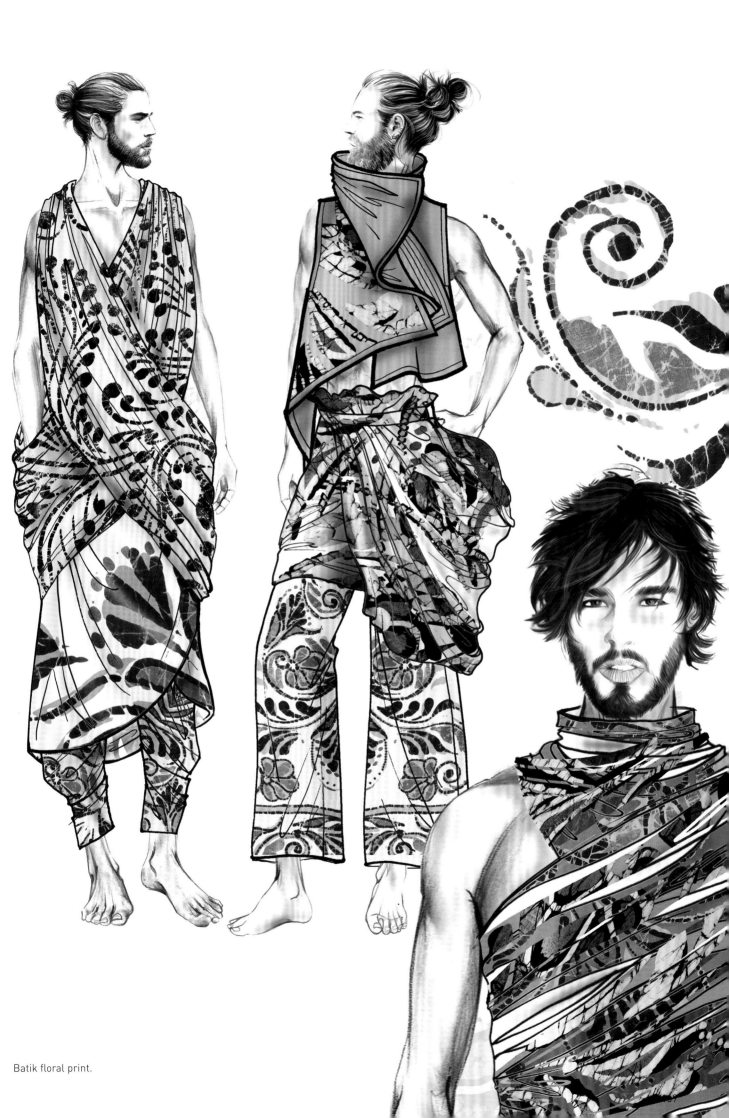

Batik floral print.

CUSTOMISING AN OUTFIT

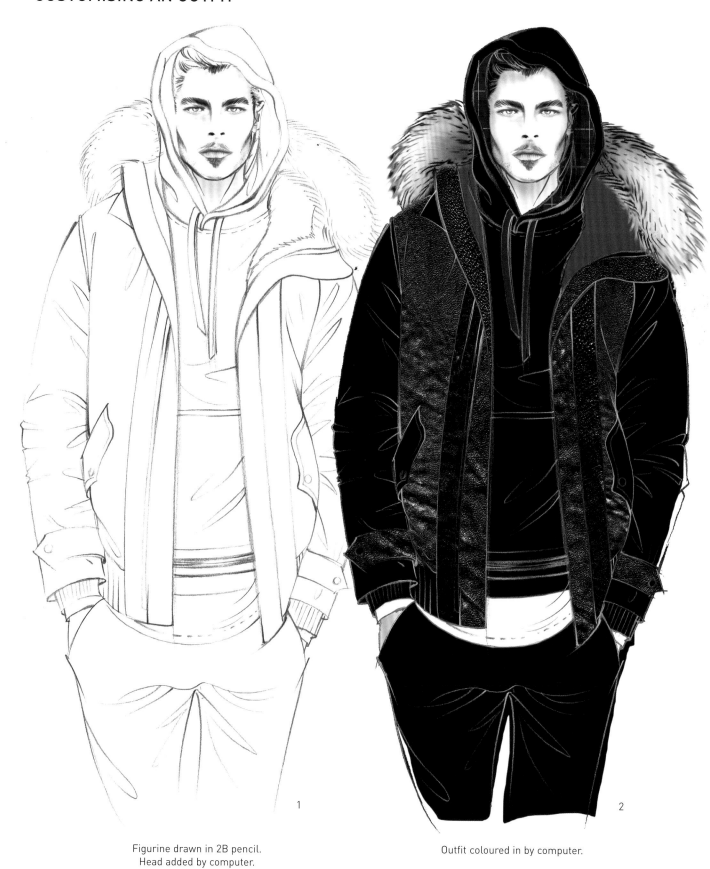

Figurine drawn in 2B pencil.
Head added by computer.

Outfit coloured in by computer.

As we said at the beginning of this chapter, it is possible to personalise a figure so it has its own identity and style, by adding a different face and hairstyle to the same outfit. If you compare the figures on the preceding pages that are wearing the same garments, you will immediately notice how this trick greatly influences the style and communication of the same piece of clothing. As an exercise, you can try to make similar changes using the faces drawn in the heads chapter and come up with other ones according to current trends.

SAME OUTFIT WITH DIFFERENT HEADS

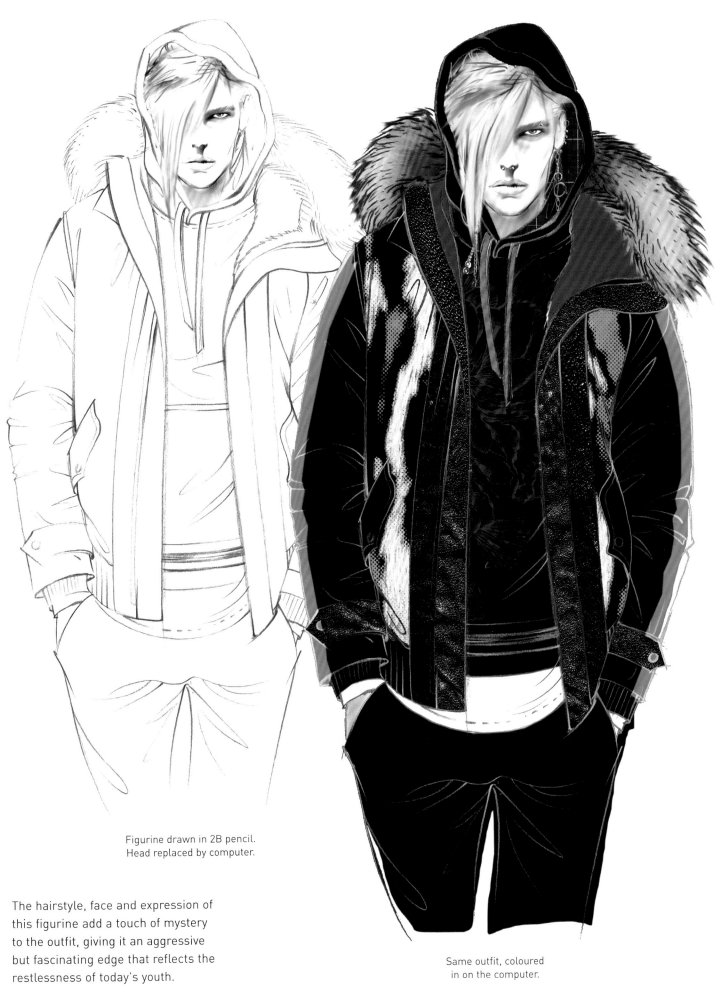

Figurine drawn in 2B pencil.
Head replaced by computer.

The hairstyle, face and expression of
this figurine add a touch of mystery
to the outfit, giving it an aggressive
but fascinating edge that reflects the
restlessness of today's youth.

Same outfit, coloured
in on the computer.

OUTFIT 25

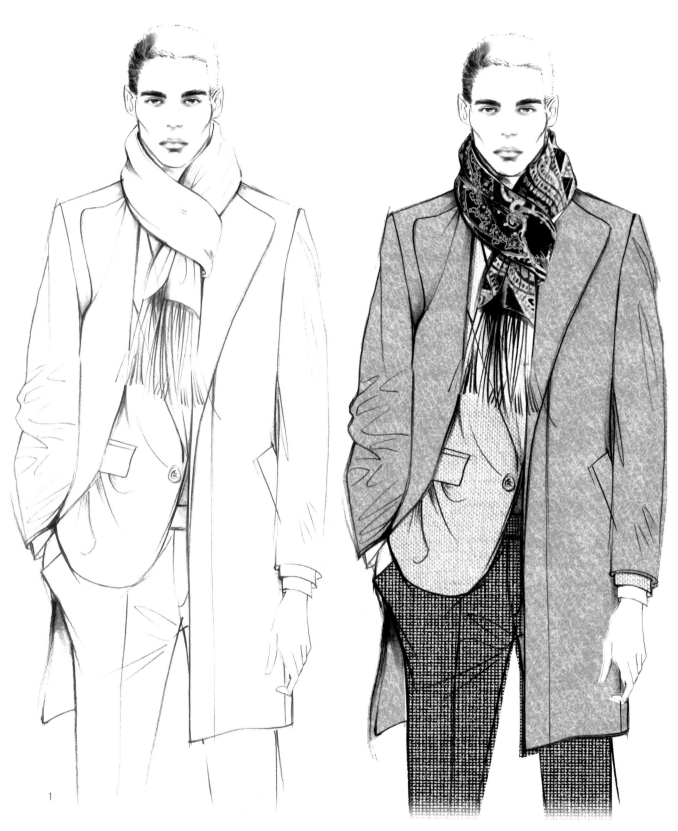

Figurine with classic face in black
and white, drawn in pencil.

Figurine with classic colours and
fabrics added by computer.

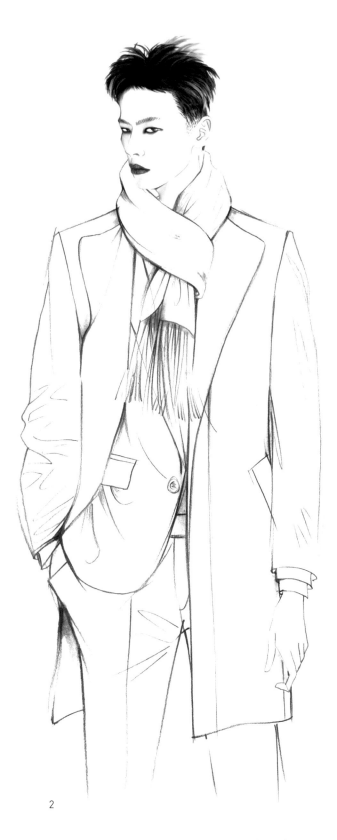

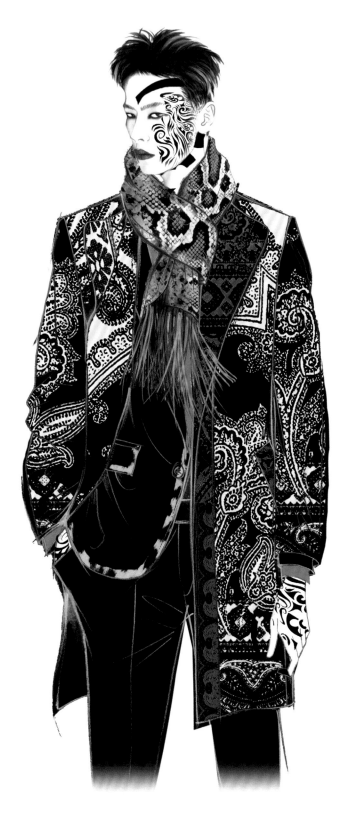

2

Asian figurine, with face shown from a ¾ angle,
using the computer to switch the previous attire.

Figurine with colours and pattern
added by computer.

In this case, the head of figurine 1, seen from the front, the classic pose and the neutral expression have been replaced in fig. 2. by another head taken from a ¾ angle that has a serious facial expression, Asian features, tribal tattoos and an elegant hairstyle. Both this new face and the Asian print give the outfit a new look, making it very exclusive and trendy.

CUSTOMISING AN OUTFIT

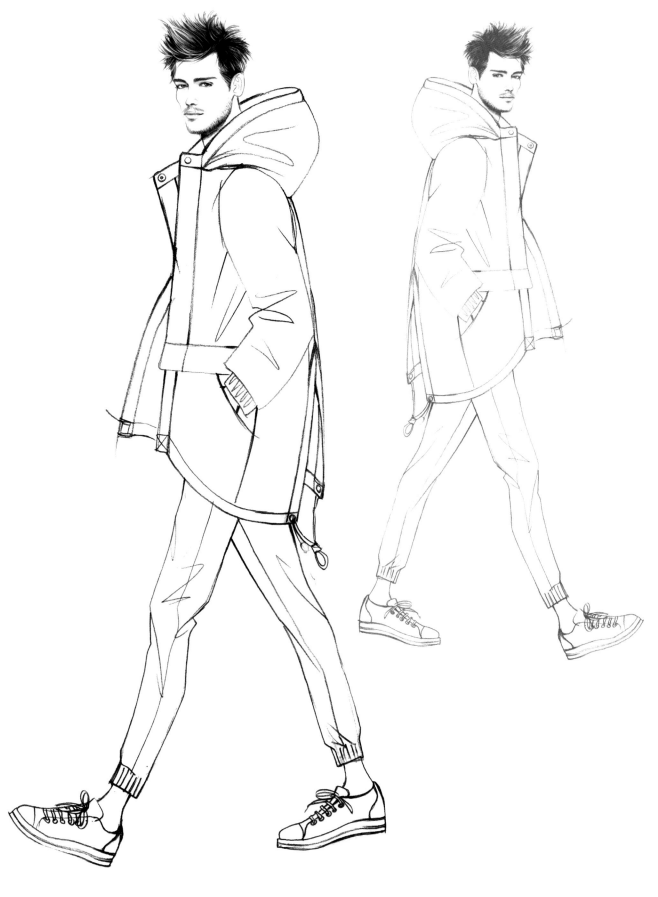

As we have seen in the previous pages, just changing the face and the fabrics can change the style of a piece of clothing. On this theme, we now suggest some excellent exercises that will activate your imagination even more, using the figurines on the following pages to experiment with details, accessories and fabrics to make different versions of each one in order to compare them as two proposals and see if this has added identity and personality to what you have created on the computer or by hand.

TWO PROPOSALS

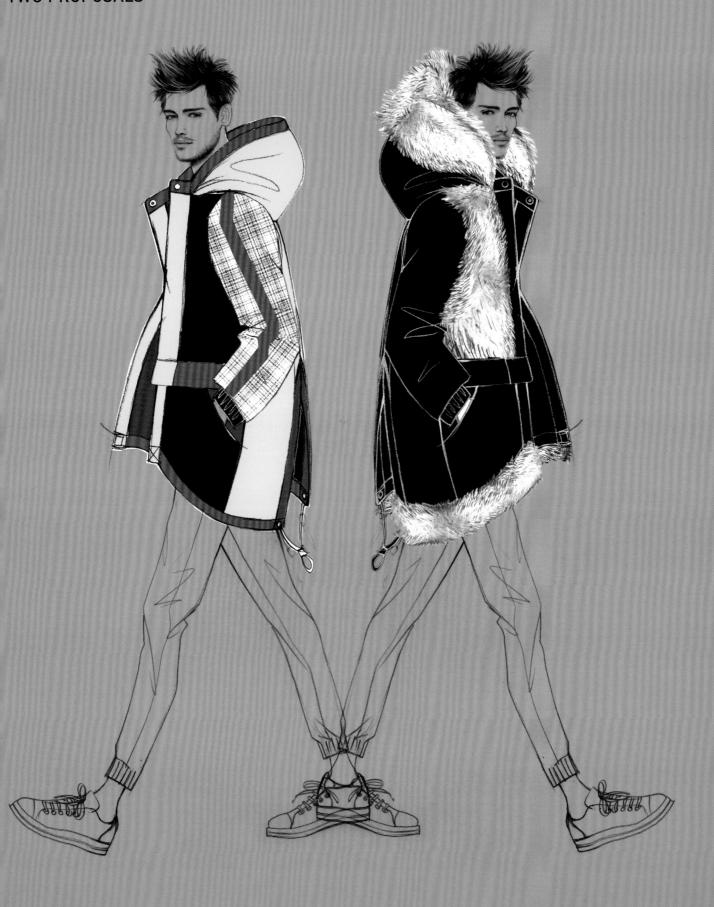

Example of the same pea coat design
developed into two different styles.
You can continue to further modify
the trousers and shoes.

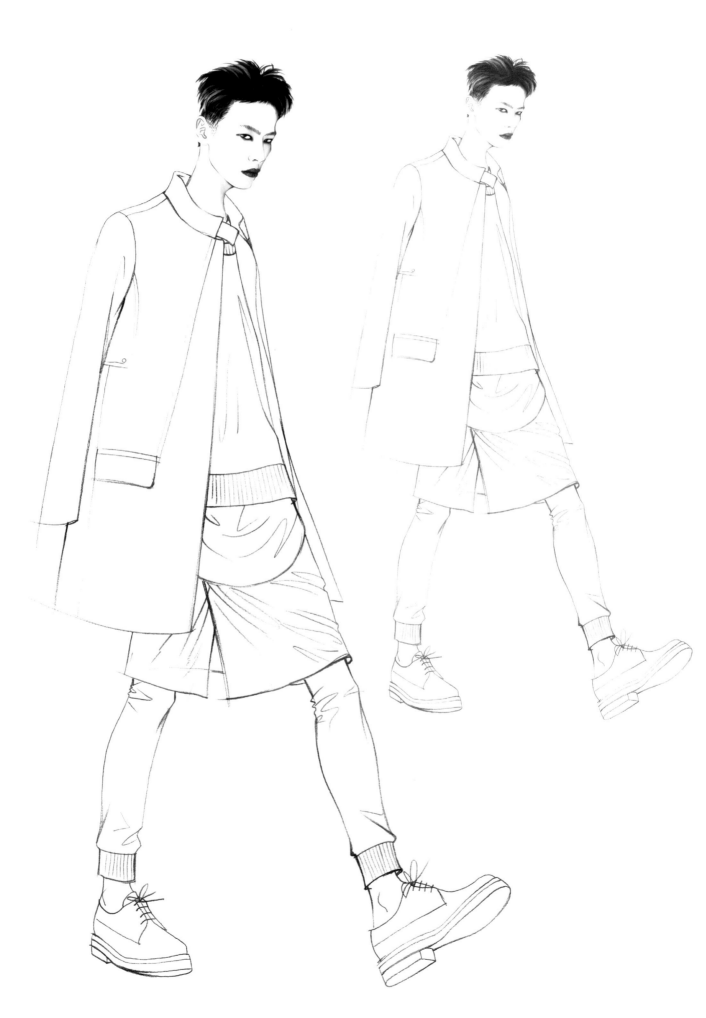

THREE PROPOSALS

Example of the same coat design developed in three different directions by changing the fabrics and details, but keeping the same style.

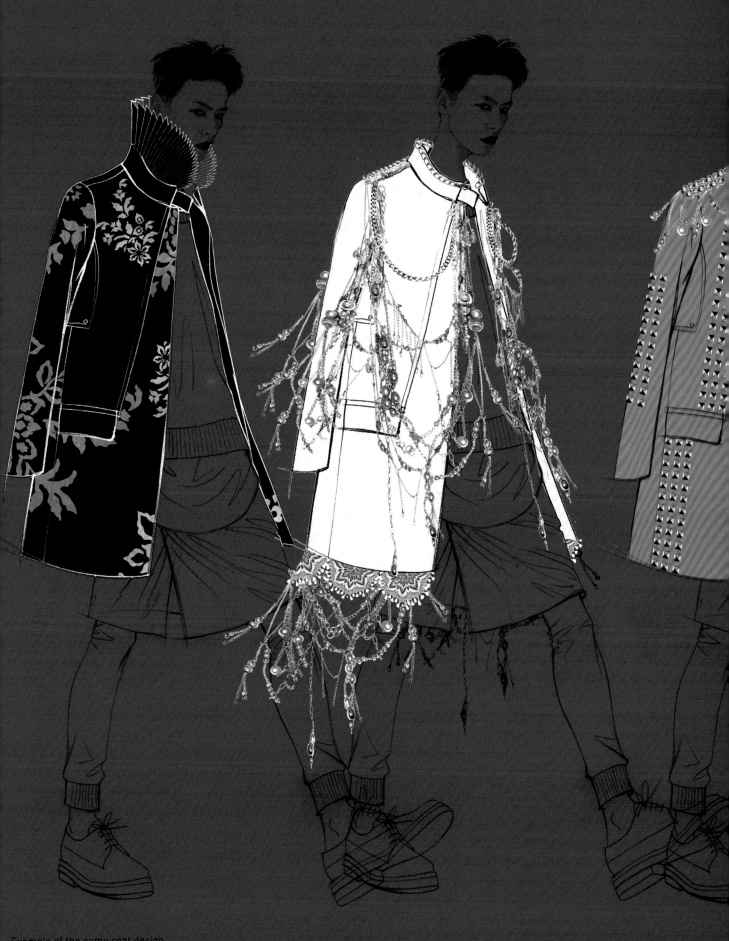

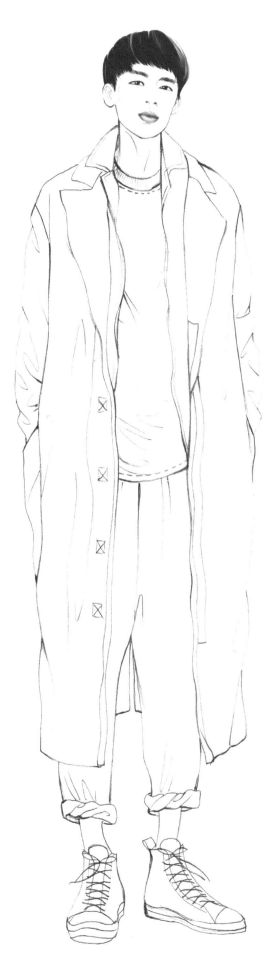
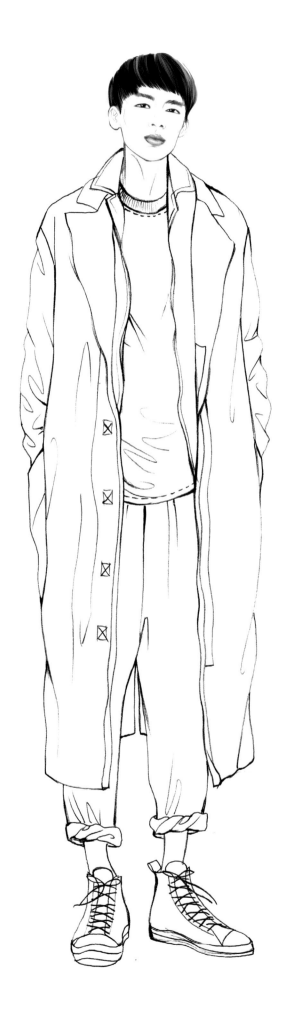

On this and the following pages, you will find some drawn figurines that you can use to create and develop your *fashion* ideas and stylistic variants, by hand or on the computer.

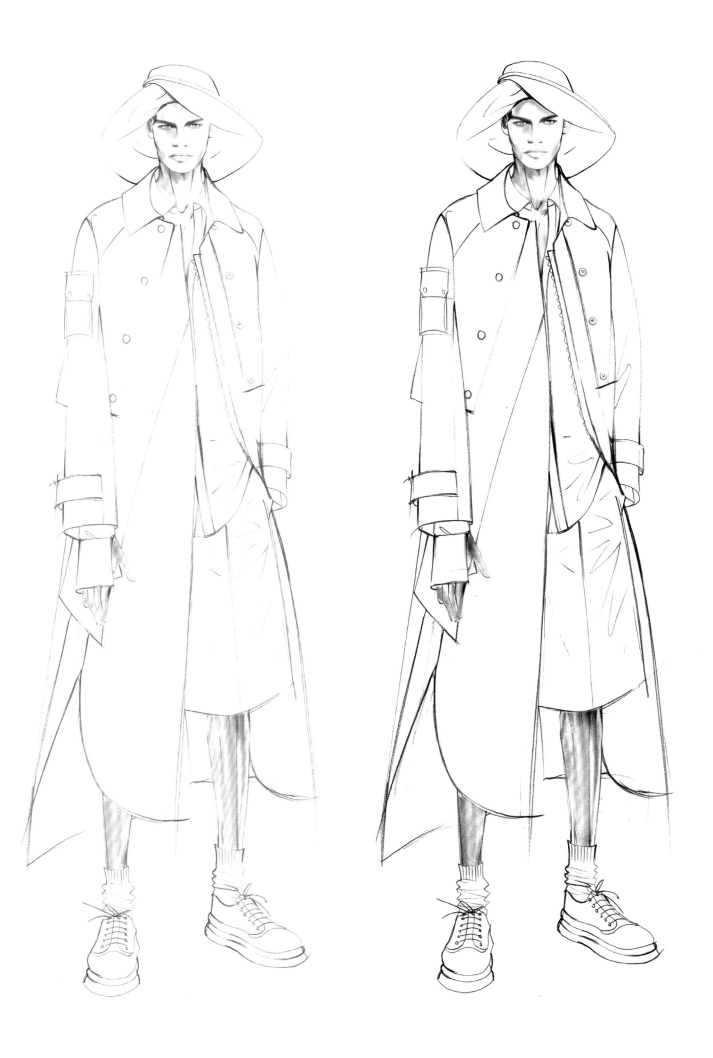

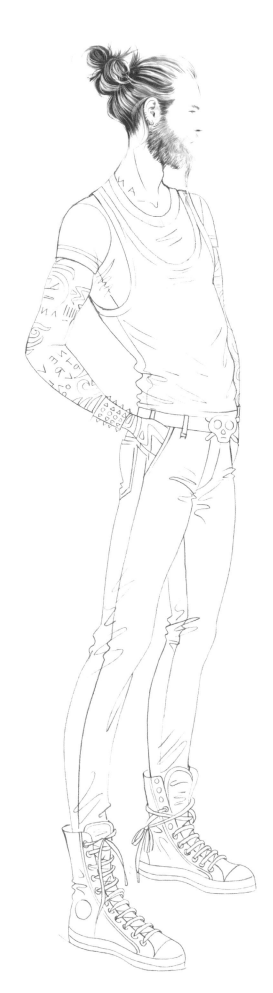
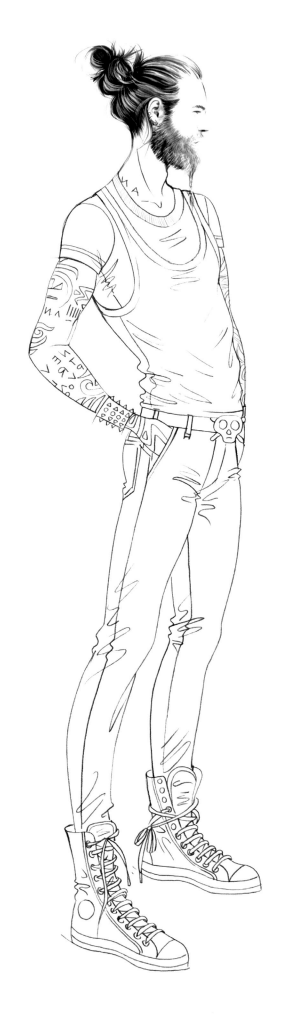

ONE OUTFIT FOR TWO FACES

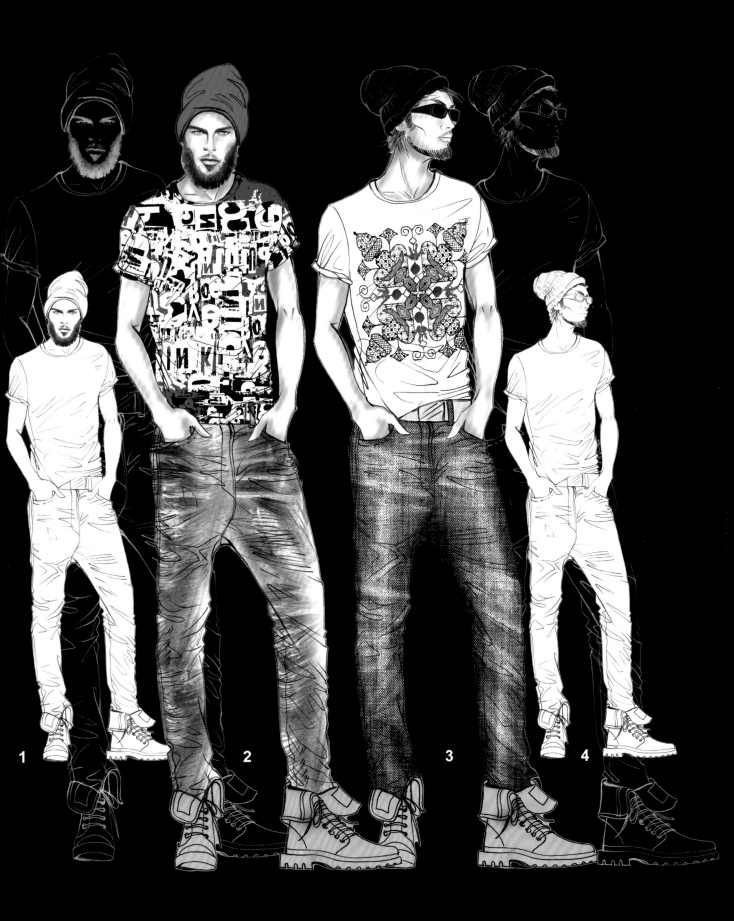

1

2

3

4

We continue with the examples, showing
how to diversify the same pose with
different faces, increasing the variation
by adding different fabrics and patterns.

DESIGNING ON THE COMPUTER

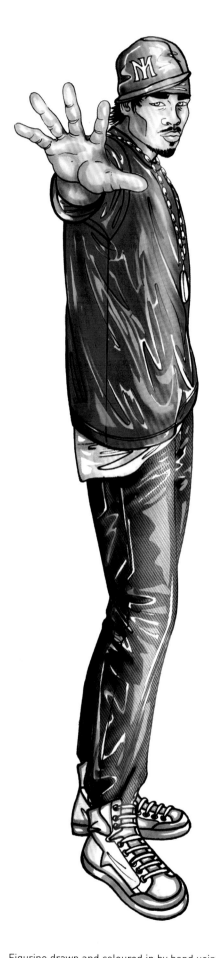

Figurines drawn by hand in 2B pencil and neatened with indelible felt-tip marker and 02 mechanical pencil.

Figurine drawn and coloured in by hand using a Promarker, then retouched on the computer to insert semi-transparent textures on the trousers and create points that catch the light.

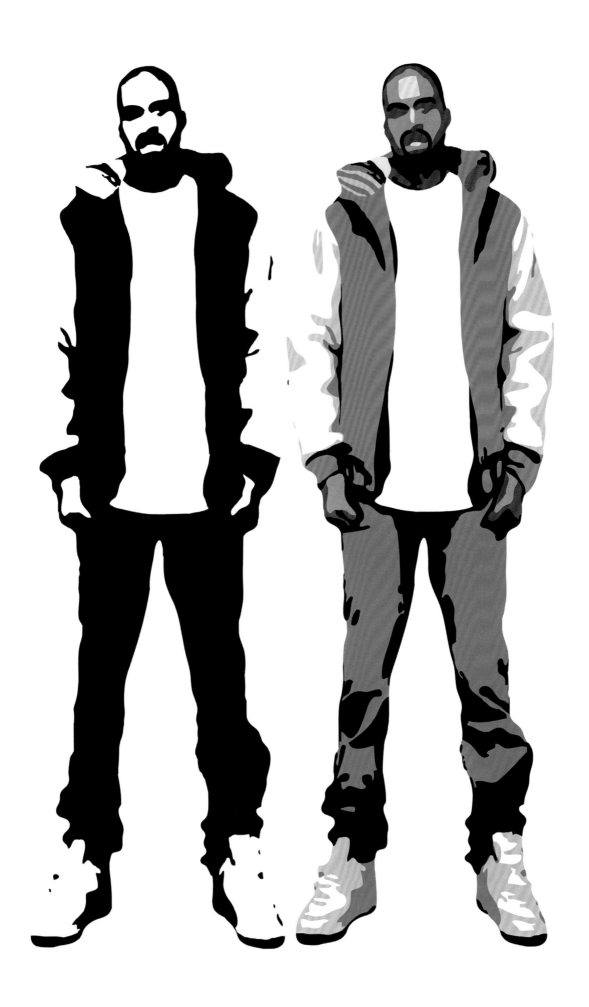

Figurines drawn by hand and recreated in vector with Illustrator.

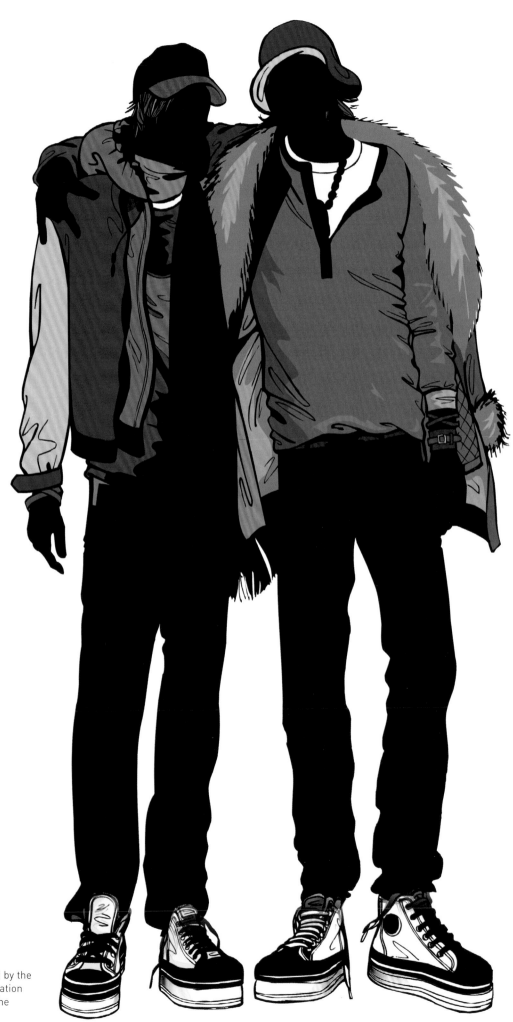

Figurines obtained by the automatic vectorisation of the images on the following page.

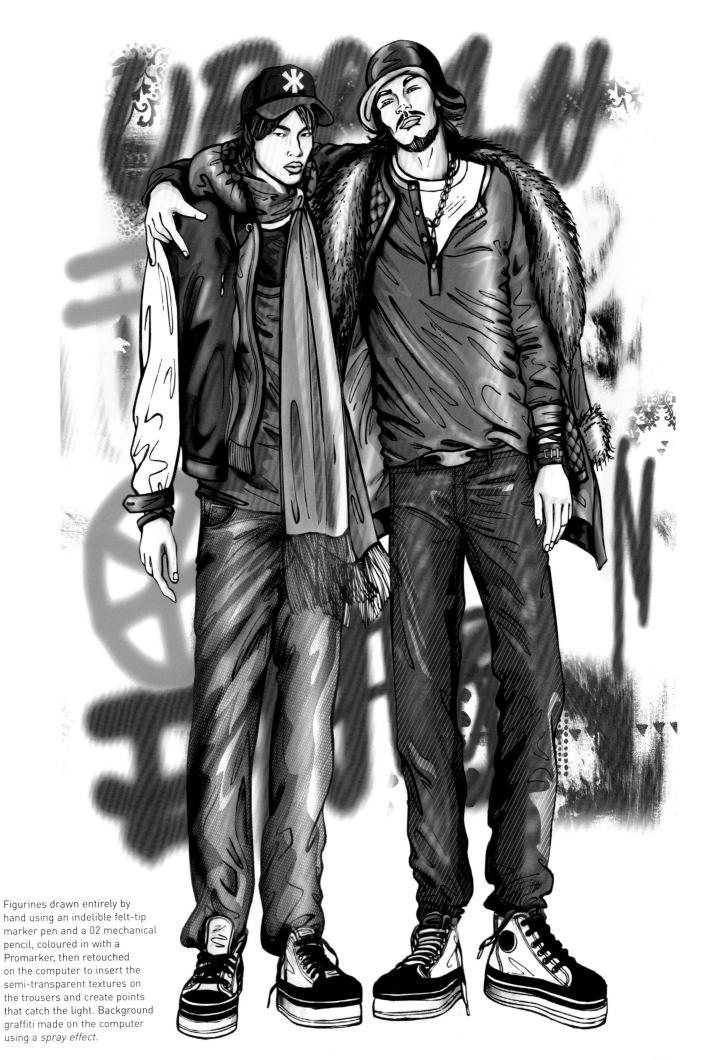

Figurines drawn entirely by hand using an indelible felt-tip marker pen and a 02 mechanical pencil, coloured in with a Promarker, then retouched on the computer to insert the semi-transparent textures on the trousers and create points that catch the light. Background graffiti made on the computer using a *spray effect*.

KNITWEAR

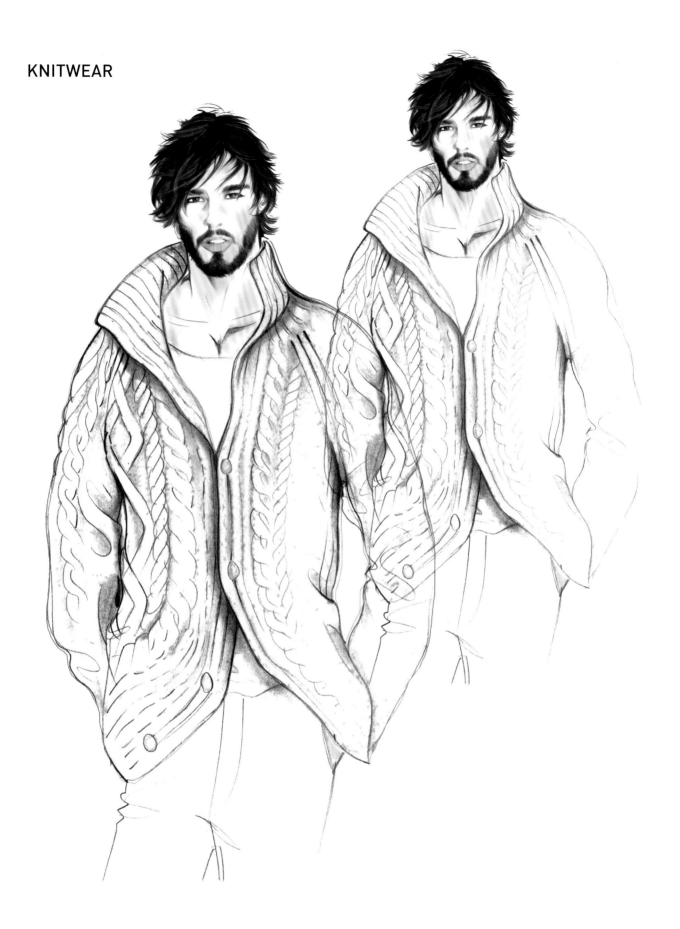

The classic way to design knitwear is to draw it by hand using a pencil and a little shading. This method leaves all the poetry and softness of the stitches intact, for the reader to enjoy. The only drawback for professional design studios, is time. In a fashion design studio, drawing like this is a luxury that is only permitted when it comes to illustrations for magazines and portfolios, as time is very limited in the frenzy between collections. However, it is an absolutely essential way for students to improve their various graphic and chromatic techniques.

The above outfit was drawn by hand using a 02 mechanical pencil. The Aran cardigan was coloured in on the computer using a flat colour base, with the other colours on top obtained by changing the pencil colour to yellow.

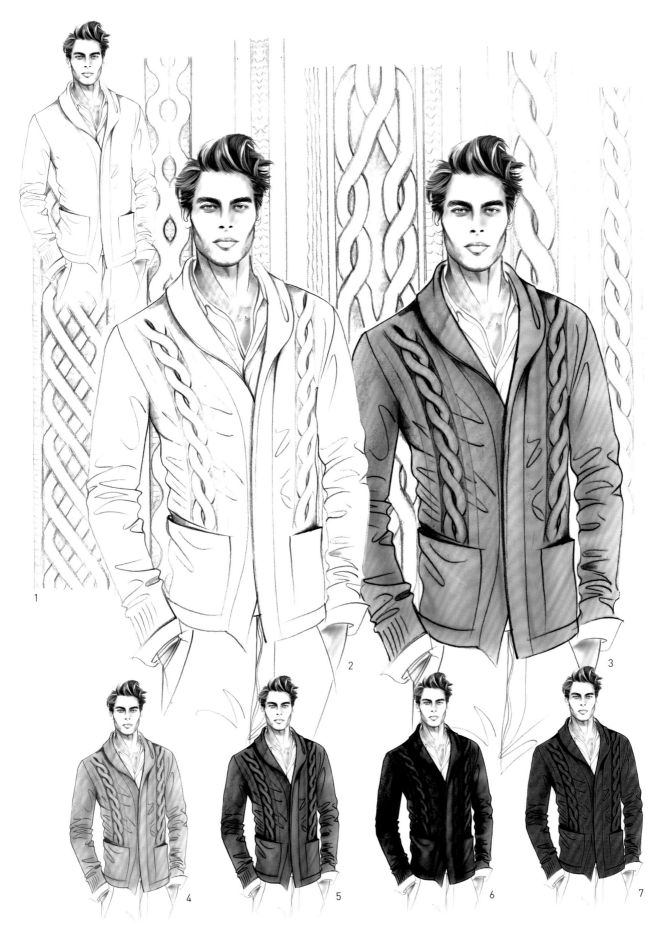

HOW TO OPTIMISE THE TIME REQUIRED TO DRAW BY HAND

To optimise the time required for a classic pencil drawing, organise a file of knitwear samples (background images) that can be used on a clean base (1) by simply cutting and pasting them on the computer (2). To add colour to the figurine, we recommend using the computer (3), but the classic method of colouring in with a Pantone or other favorite felt-tip pen is just as valid and effective.

We recommend using a computer because it allows you to easily rework the colour (4-5-6-7).

PLAYING WITH THE KNITWEAR FILE

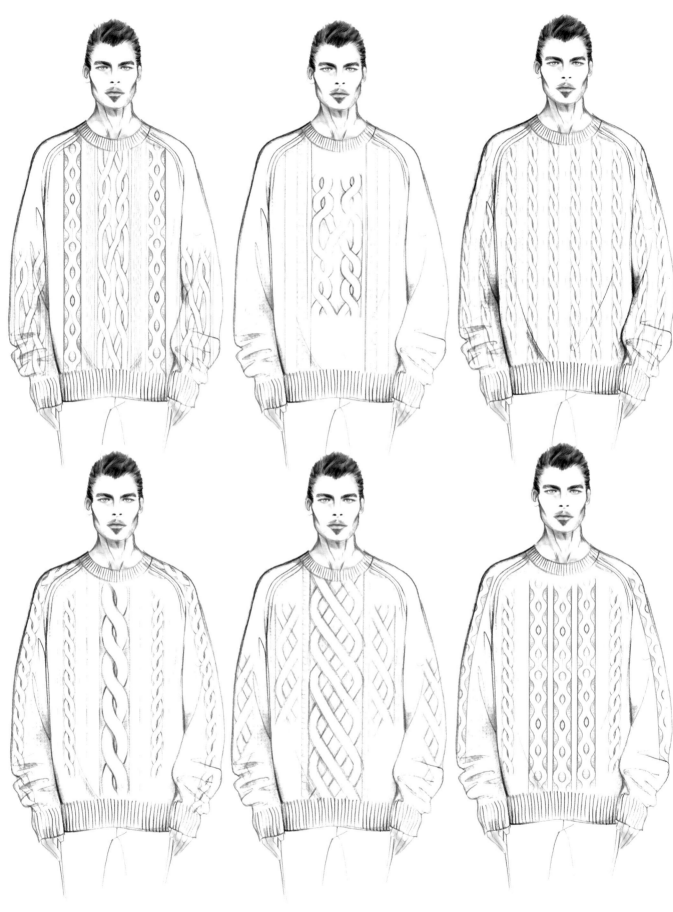

Once the knitwear drawings file is created, you can have fun inventing different types of garments in a short amount of time.

Here, we have created some examples of classic knitwear using the same basic collar.
Remember that the "knitwear file - copy and paste" method can be applied to any type of garment, structure or ensemble.

KNITTED MAXI CARDIGAN, DRAWN BY HAND AND COLOURED IN ON THE COMPUTER

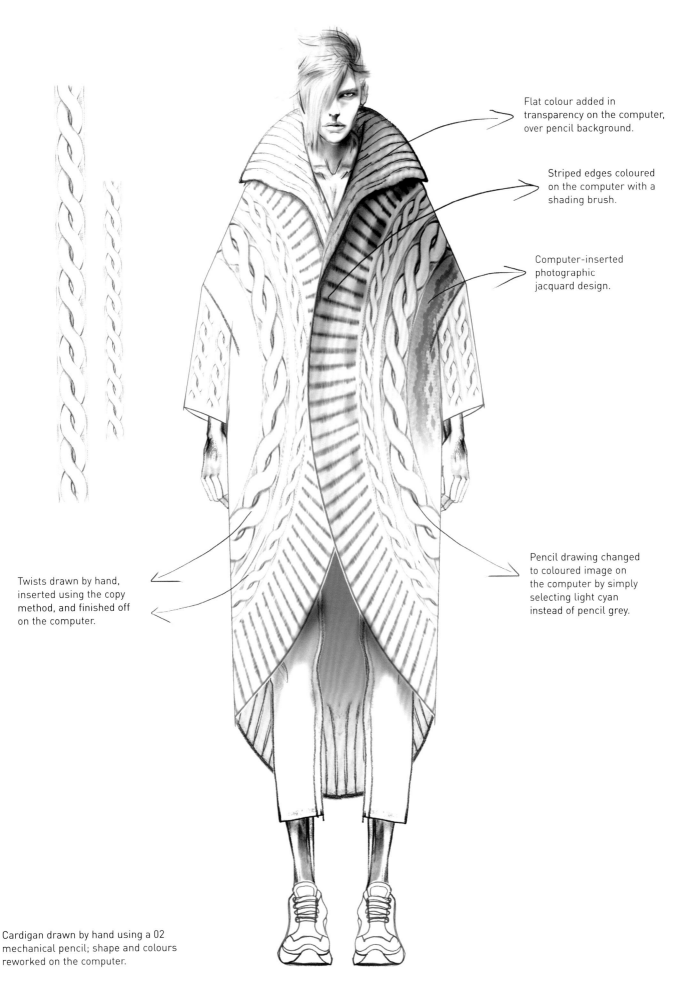

Flat colour added in transparency on the computer, over pencil background.

Striped edges coloured on the computer with a shading brush.

Computer-inserted photographic jacquard design.

Pencil drawing changed to coloured image on the computer by simply selecting light cyan instead of pencil grey.

Twists drawn by hand, inserted using the copy method, and finished off on the computer.

Cardigan drawn by hand using a 02 mechanical pencil; shape and colours reworked on the computer.

KNITWEAR CREATED ON THE COMPUTER
USING PATTERNS AND PHOTOGRAPHIC IMAGES

1

2

3-4

1. Collect basic knit textures starting from the simplest patterns, such as stocking stitch.
2. Choose a basic figure, preferably a simple frontal pose, so that you can work quickly and get results that are easy to understand.
3. Place the texture over the chosen figurine.
4. Cut out a sample of the texture to get a basic piece to work on, adding different types of collars, details and other workmanship.
5. Basic jumper.

The method used below serves to better develop new knitwear proposals in the best possible way, optimising design timescales. Before proceeding to knit new items of clothing, it is important that you learn about the basic characteristics of knitting, in order to be able to distinguish between hand-knitted and crocheted techniques, and knitting using industrial processes.
Read up on the ABC's of knitting techniques, the characteristics and thicknesses of yarn, the various types of classic finishes, overcasting, lacework and anything else that can help you to create your collector's item in a realistic and professional way.
To learn more about this topic, we recommend that you consult books and tutorials, analyse with your own eyes and touch real knitwear with your hands. Only after detailed initial research will you be in a position to make your ideas a reality.

5

PHOTO ARCHIVE OF KNITTED ELEMENTS

When creating an archive of useful items, from which you can make new knitwear proposals, just have fun looking for interesting garments online or in fashion magazines, or photograph and scan any of your own knitwear and collect details and features that may be useful to complete your project.

Afterwards, you can copy and paste the parts you have chosen and proceed to cut out the images so that you have material that is ready to be assembled and worked on.

On this page are some examples of photographic materials that have been collected for subsequent assembly and reworking, in order to create the knitwear that is seen on the following pages.

KNITTED CREATIONS MADE USING PHOTOGRAPHIC ELEMENTS

Computer-generated images of a cardigan, made by assembling the elements seen next to the figurine.

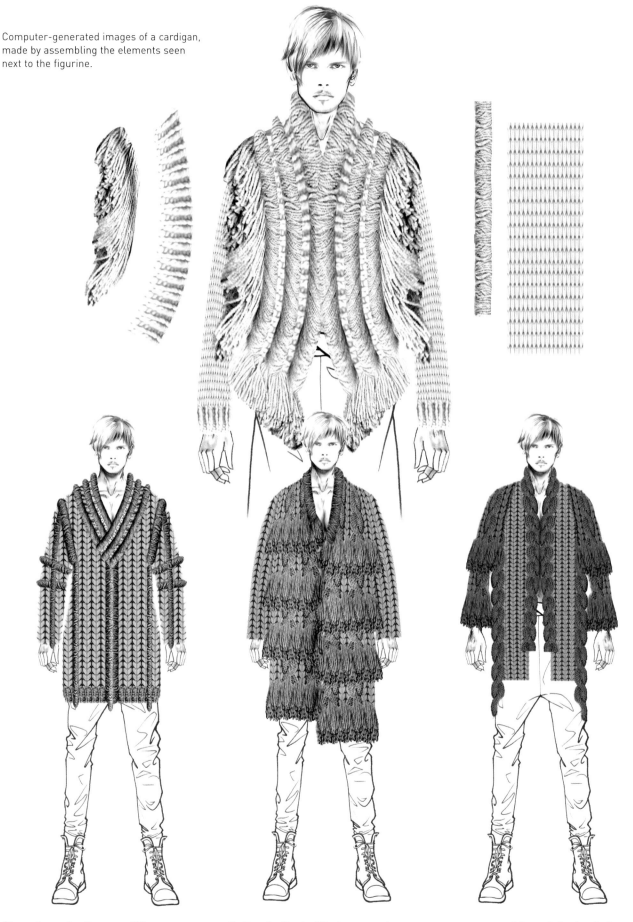

Steps to make these outfits:

1. Draw a complete figurine with trousers and shoes in the style of the outfit you want to make.

2. Create the knitted garment on the computer, mounting the photographic elements directly on the chosen pose, starting from the composition of the basic bust and the sleeves.

3. Next, add the details and the various finishes.

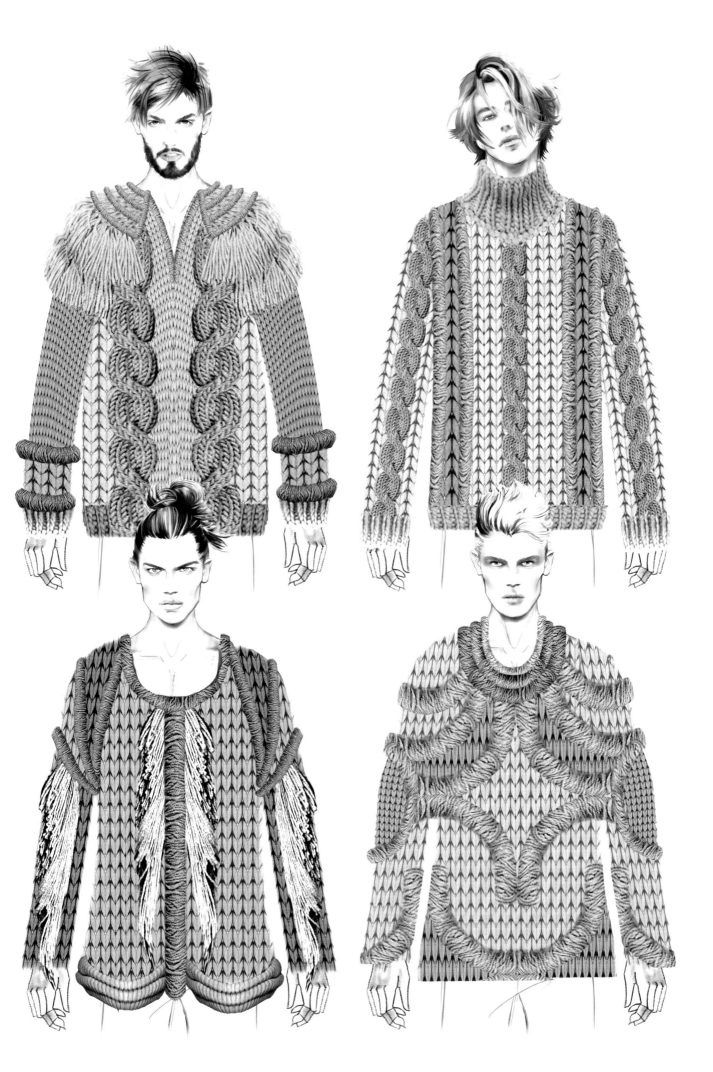

JACQUARD

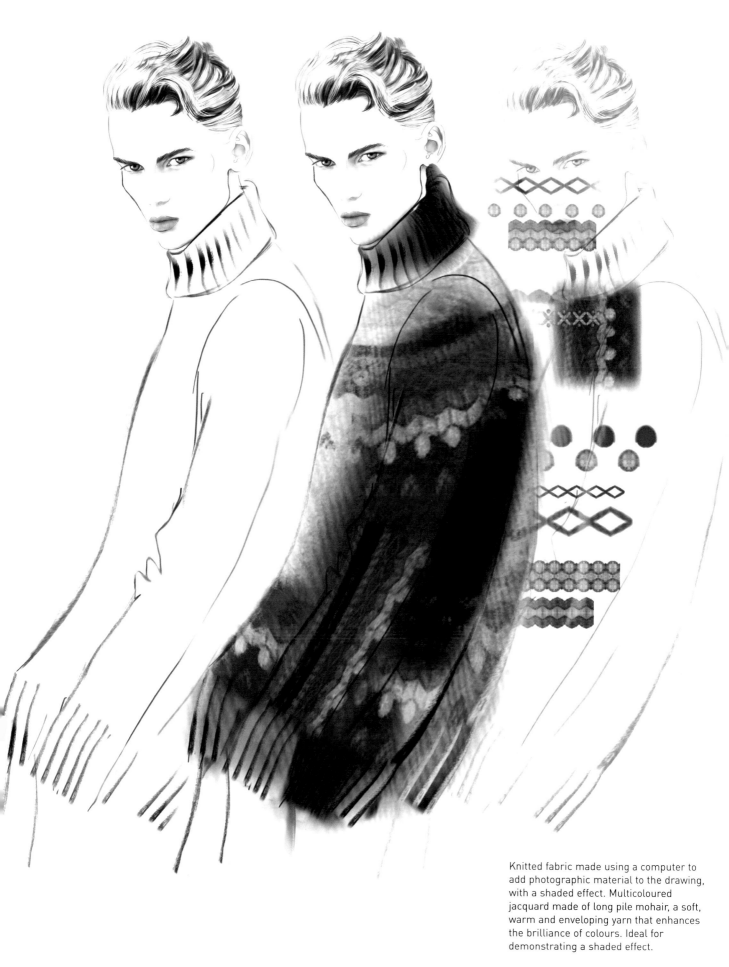

Knitted fabric made using a computer to add photographic material to the drawing, with a shaded effect. Multicoloured jacquard made of long pile mohair, a soft, warm and enveloping yarn that enhances the brilliance of colours. Ideal for demonstrating a shaded effect.

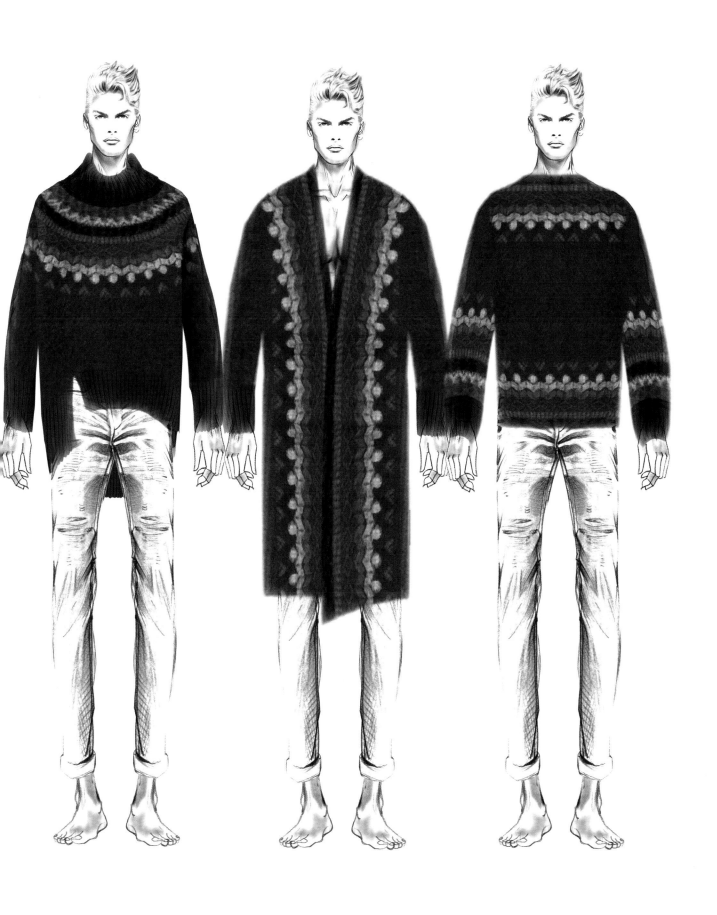

Jacquard knitwear made on the computer,
using photographic material.

CASHMERE NIGHT FEVER

Figurines drawn with a 02 mechanical pencil. Garments featuring fabric inserts and cashmere-themed prints, coloured in on the computer.

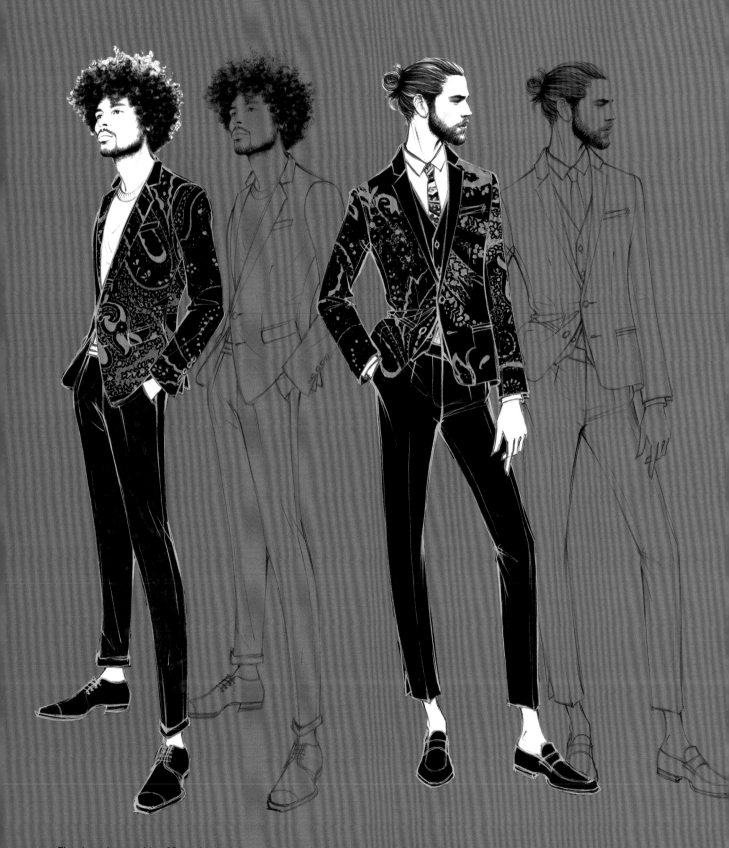

FLORAL STREET FEELING

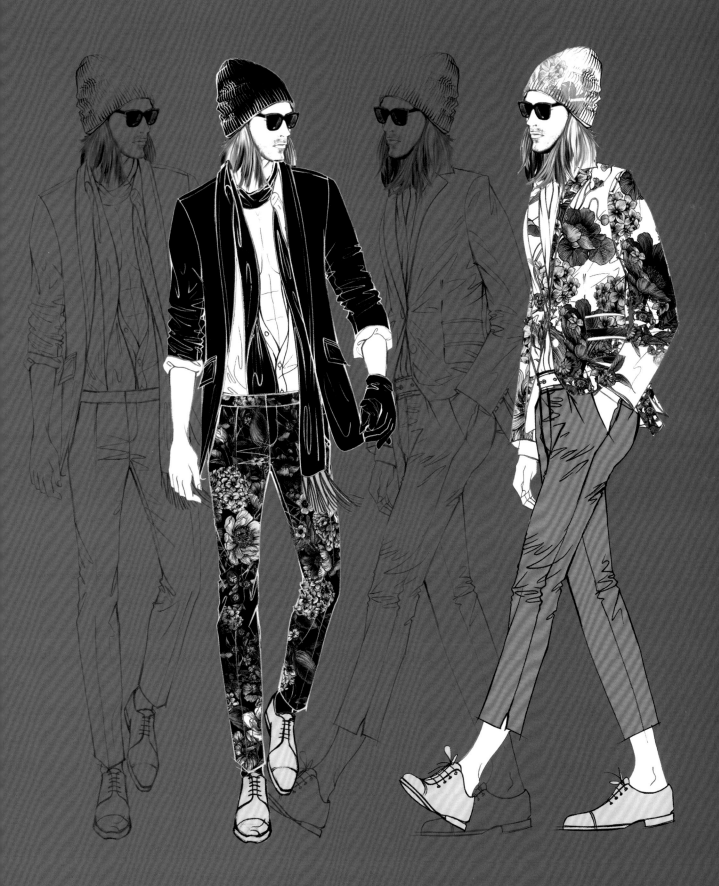

Figurines drawn with a 02 mechanical
pencil. Garments featuring fabric
inserts and floral prints, coloured in
on the computer.

TAILORED ETHNIC PATCHWORK

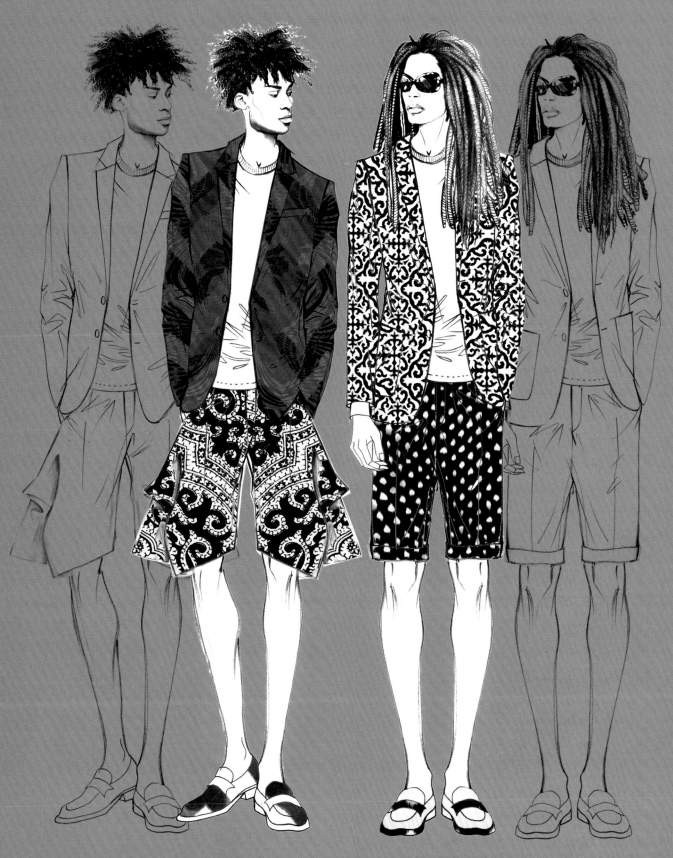

Figurines drawn with a 02 mechanical
pencil. Garments featuring fabric
inserts and ethnic prints, coloured in
on the computer.

MAGNIFIED FLOWERS PRINT

Figurines drawn with a 02 mechanical
pencil. Garments featuring fabric inserts
and floral prints, drawn with a 02 fineliner
and coloured in on the computer.

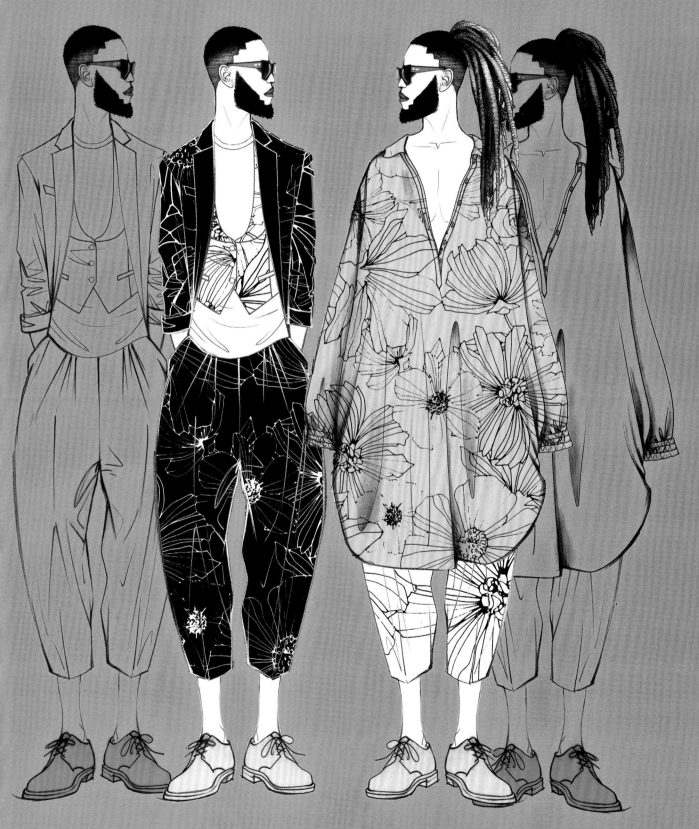

CLASSIC TAILORED MENSWEAR

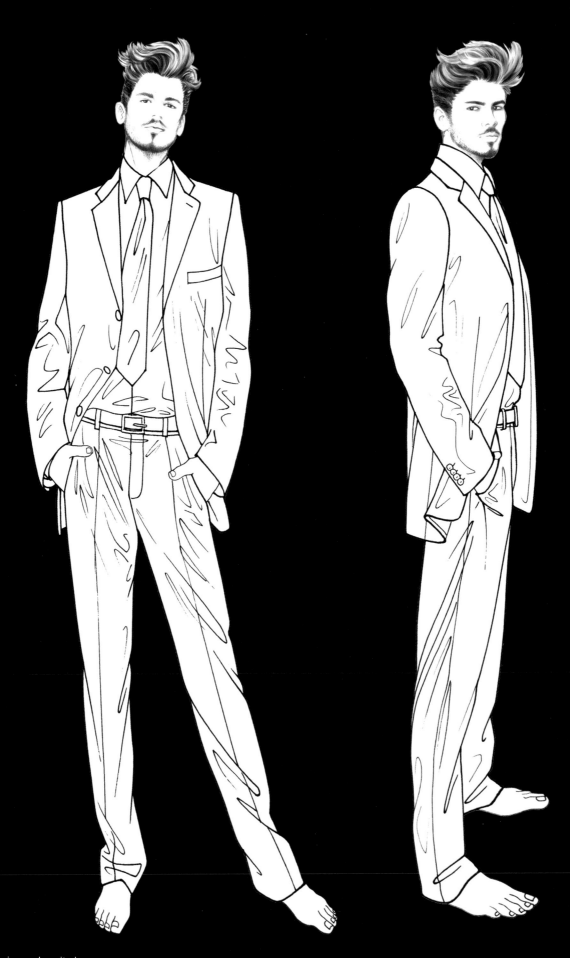

Classic men's suit shown
in four positions.

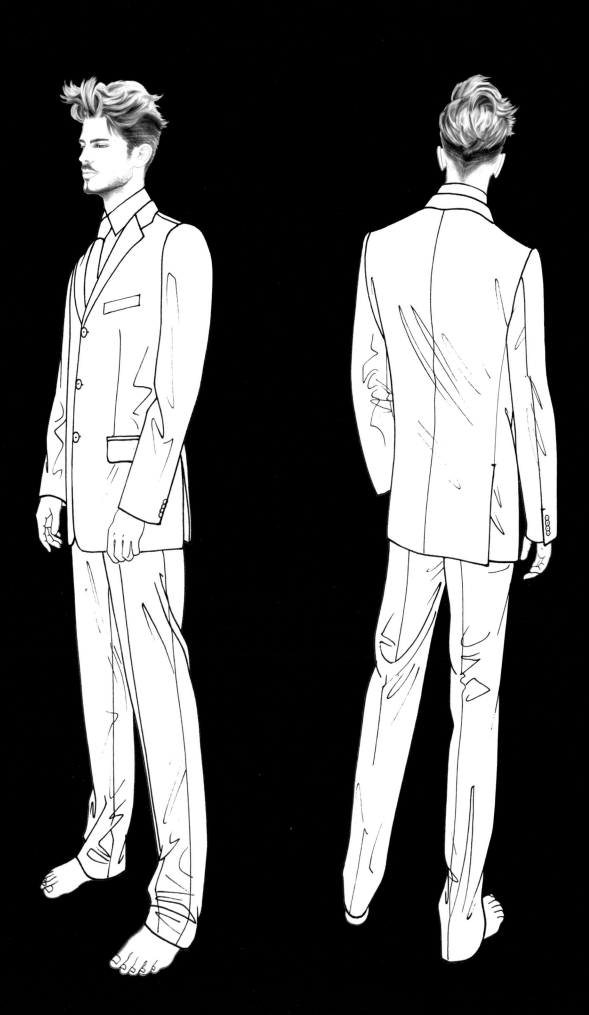

CLASSIC MENSWEAR FABRICS

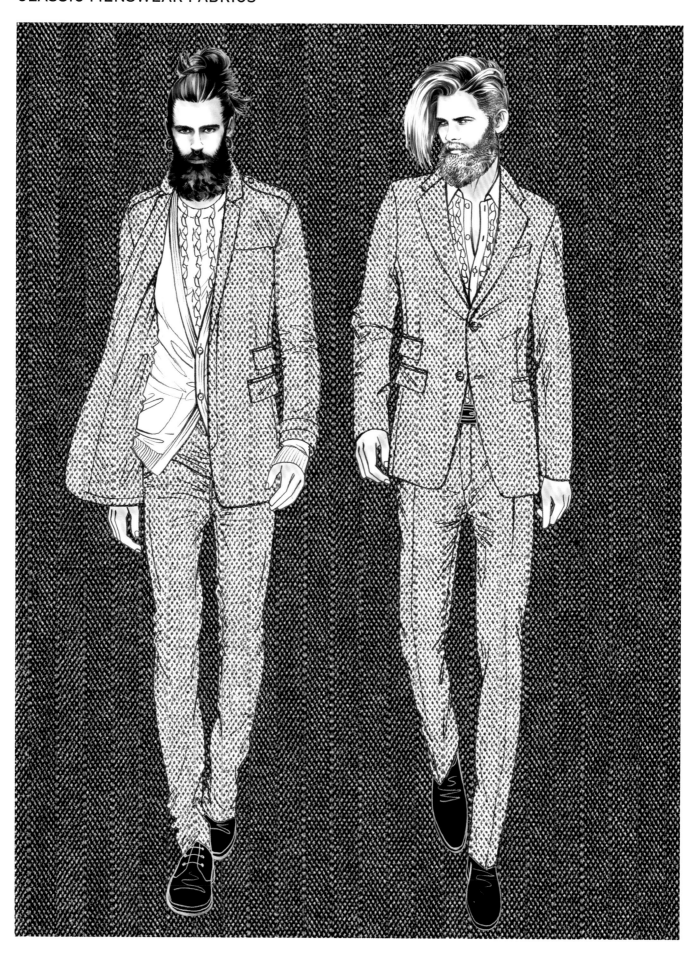

Figurines drawn with a 02 mechanical pencil.
Garments created using a computer to
overlay menswear fabric.

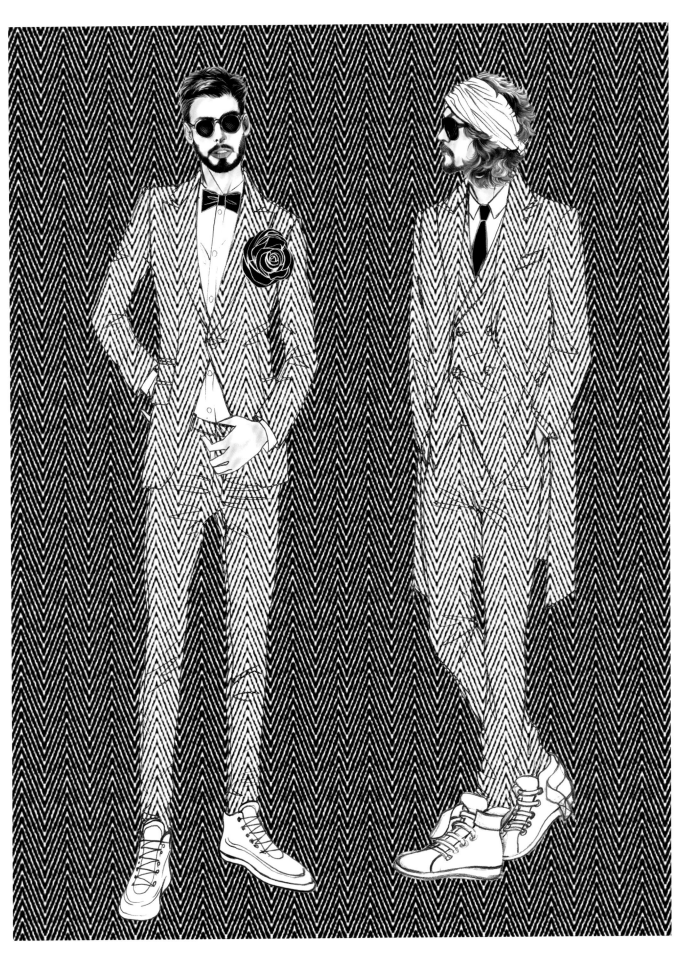

Figurines drawn with a 02 mechanical pencil.
Garments created using a computer to
overlay menswear fabrics.

RELAXED TIGHT FIT
FIGURINE REWORKED WITH COMPUTER EFFECTS

Posterised.

Ragged edges.

Photocopy.

Charcoal.

Light charcoal.

Pen.

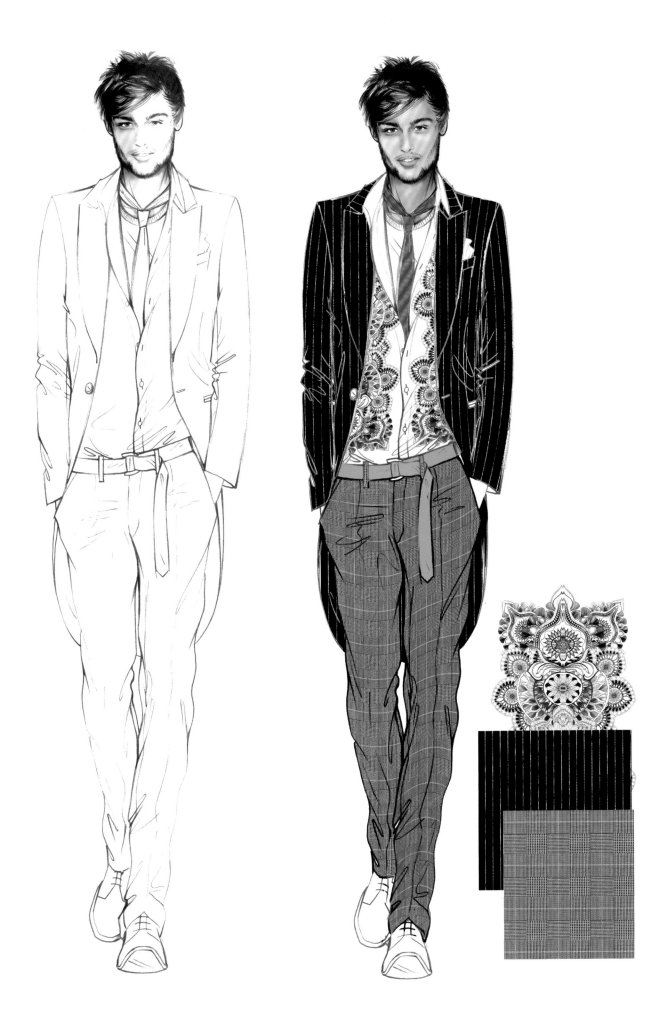

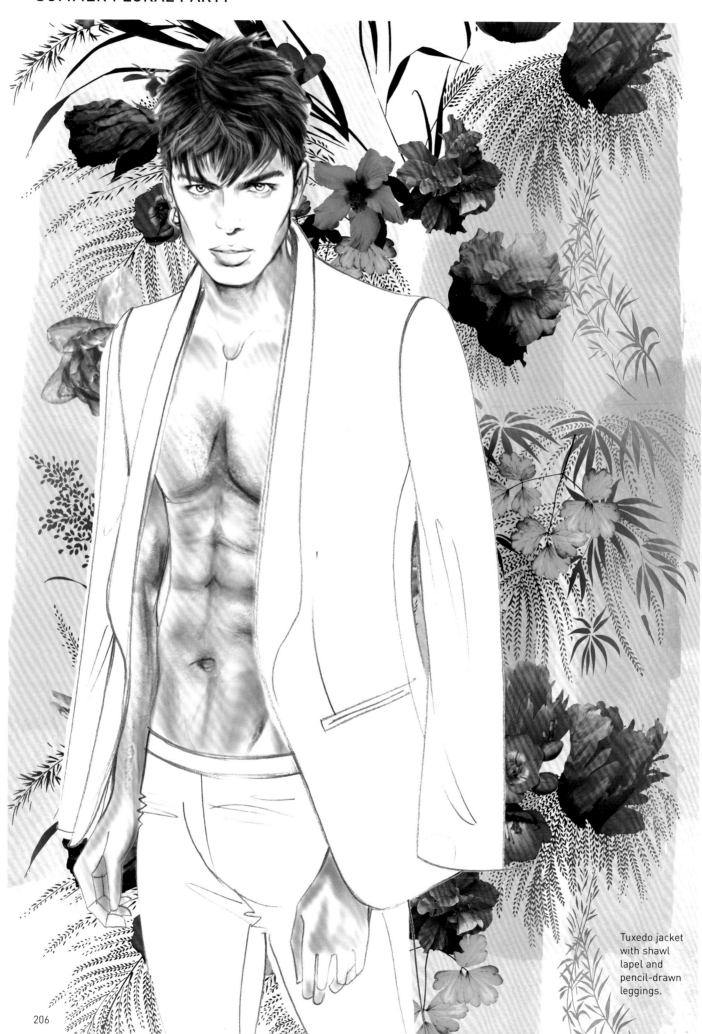

Tuxedo jacket with shawl lapel and pencil-drawn leggings.

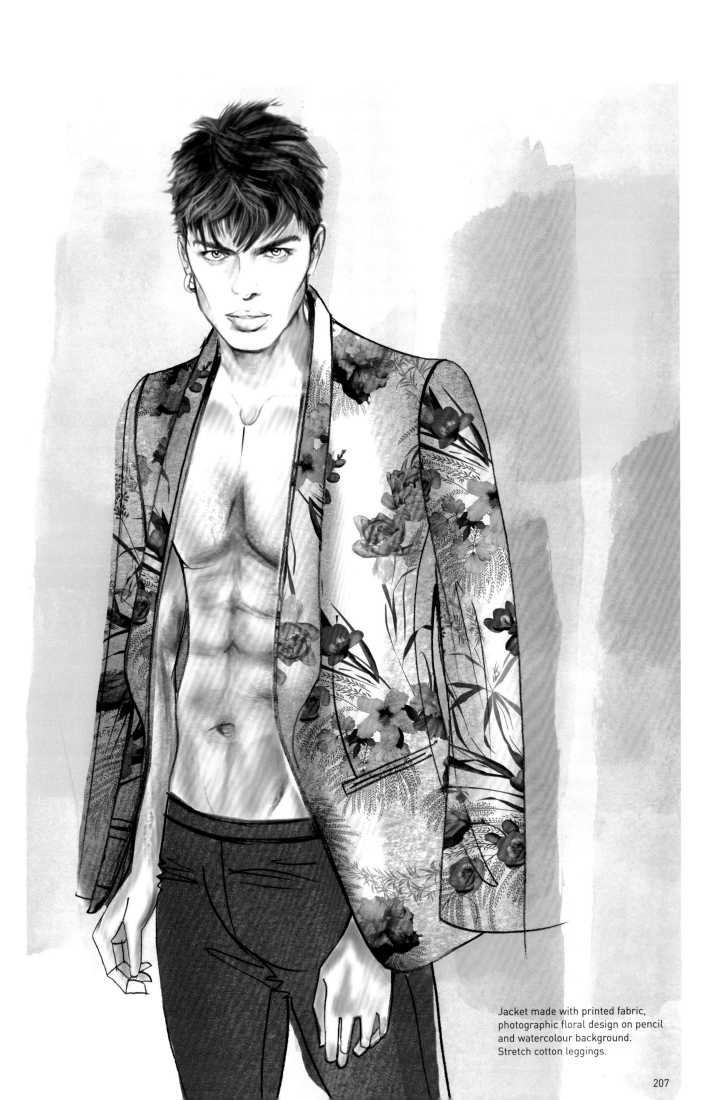

Jacket made with printed fabric,
photographic floral design on pencil
and watercolour background.
Stretch cotton leggings.

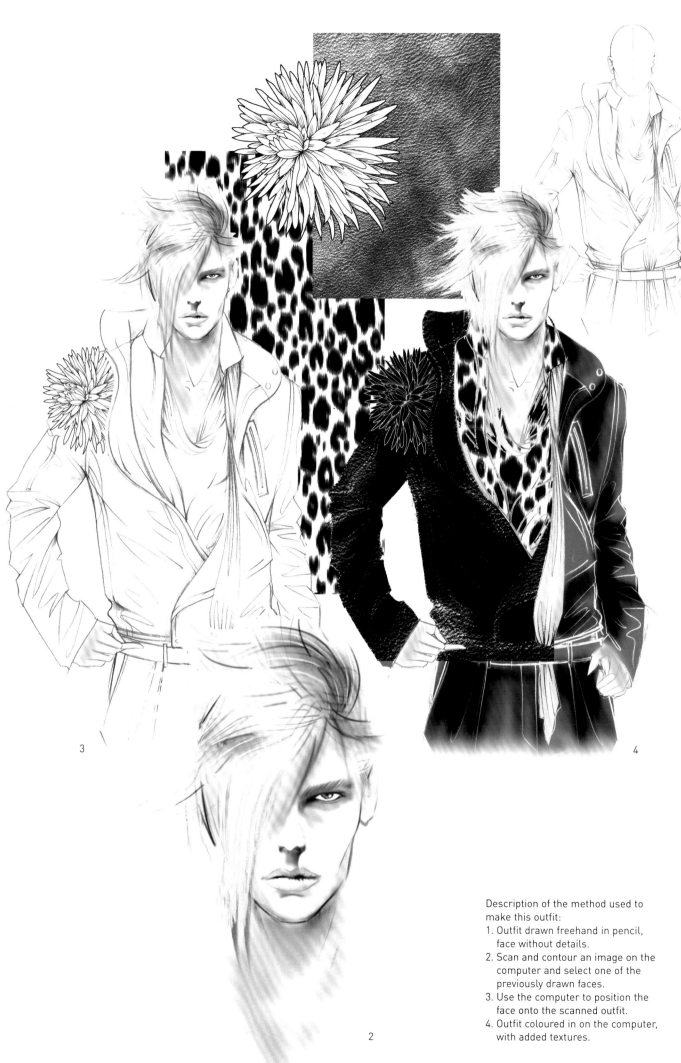

Description of the method used to make this outfit:

1. Outfit drawn freehand in pencil, face without details.
2. Scan and contour an image on the computer and select one of the previously drawn faces.
3. Use the computer to position the face onto the scanned outfit.
4. Outfit coloured in on the computer, with added textures.

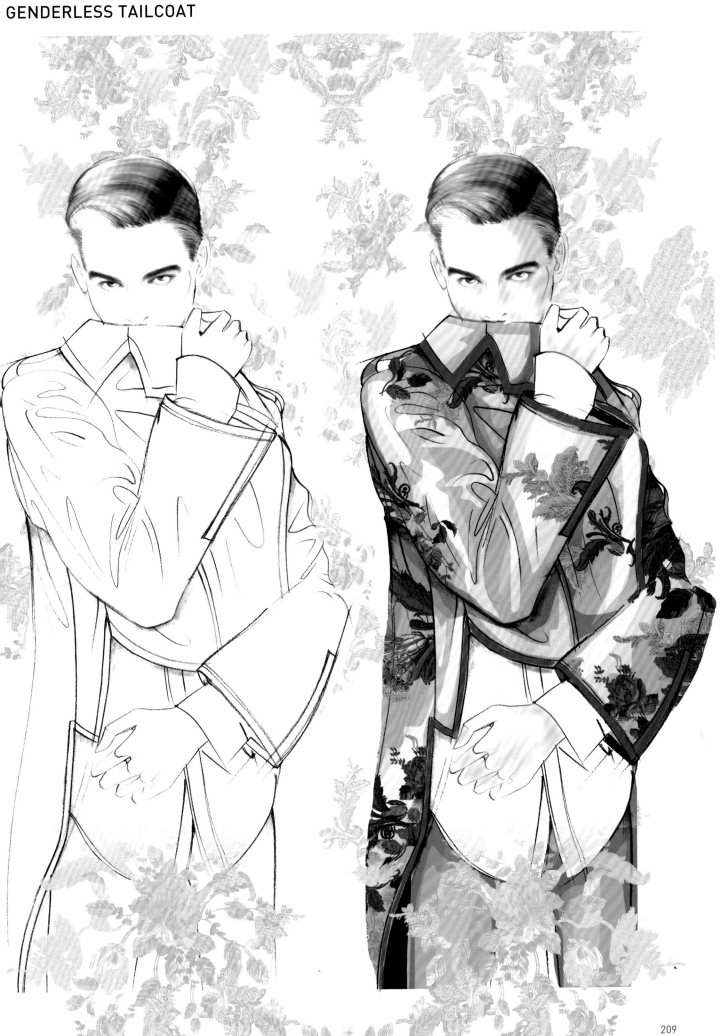

JACKETS AND COATS
3 DIFFERENT JACKETS OVER THE SAME BASIC OUTFIT

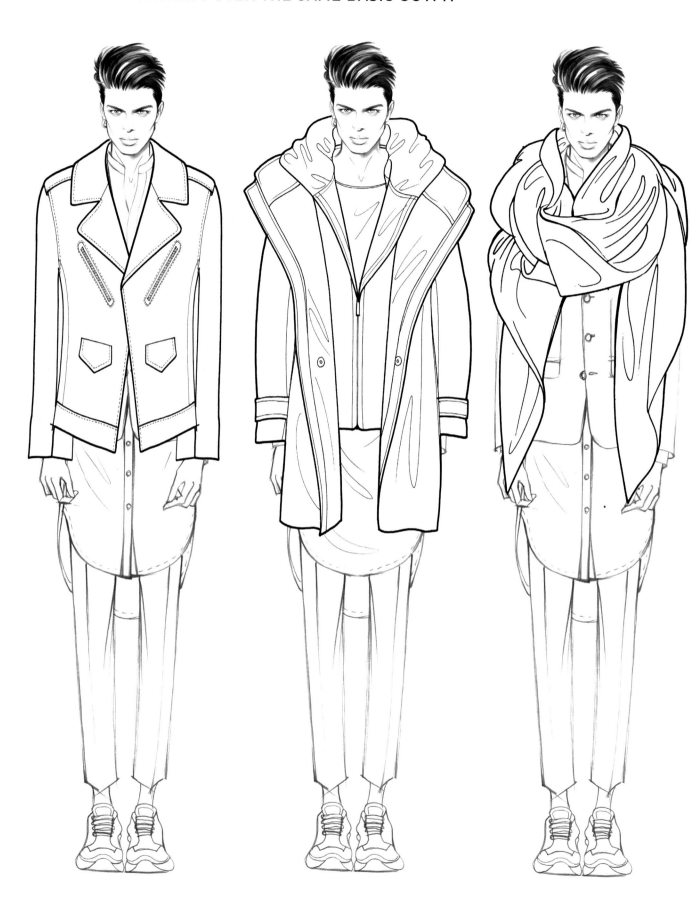

Jackets drawn with an indelible felt-tip
marker pen and 02 mechanical pencil,
placed over outfits drawn using a 02
mechanical pencil.

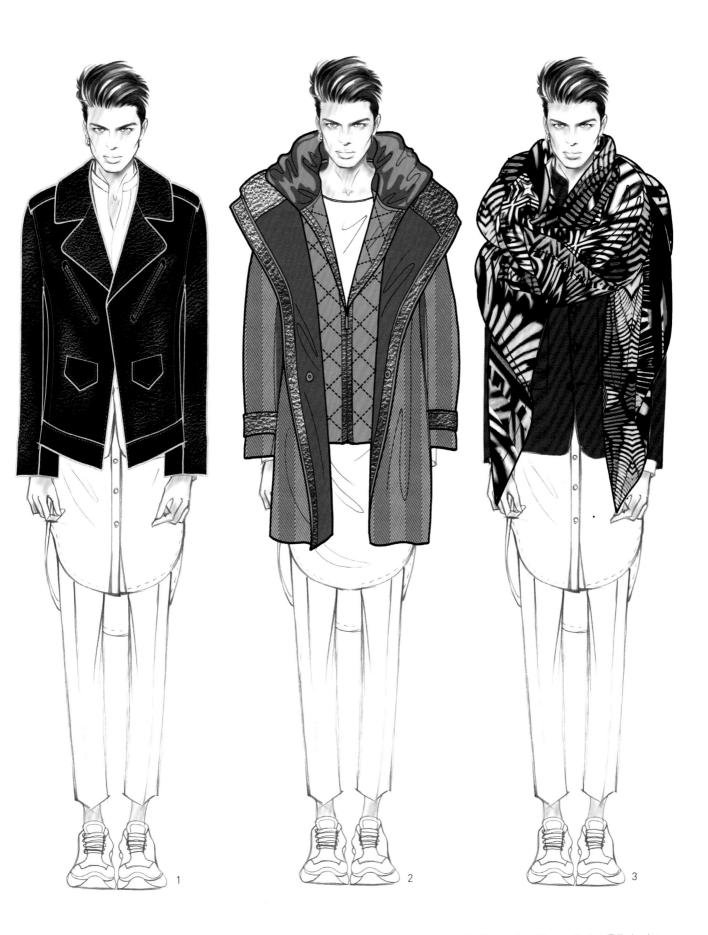

Coloured in on the computer, with patterns added afterwards.

1. Unstructured jacket, with leather effect pattern.

2. Sports coat in a patterned micro-textured technical fabric, featuring leather trim and removable padded down lining.

3. Block colour Korean jacket. Tribal print pashmina.

MINIMAL COATS

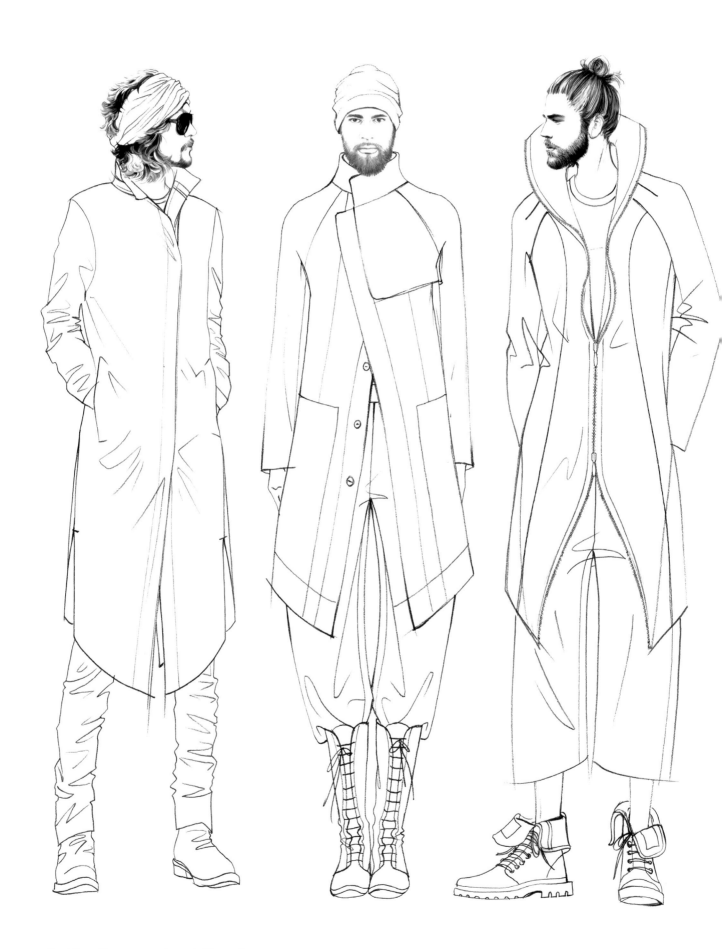

3 outfits, with overcoats drawn in 02 pencil.

MENSWEAR FABRIC PATCHWORK

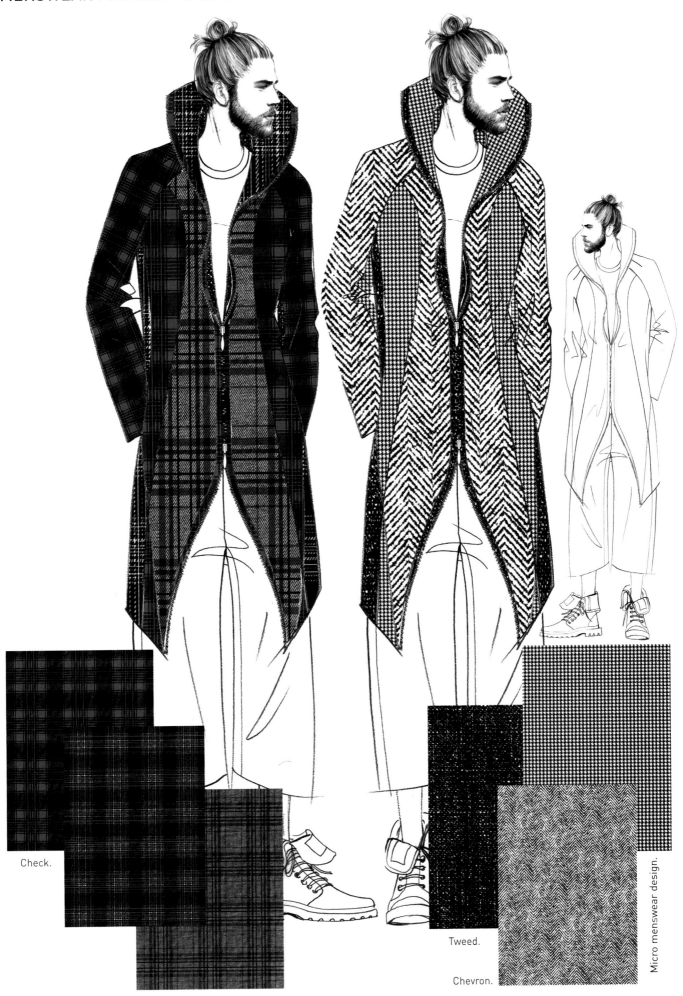

Check.

Tweed.

Chevron.

Micro menswear design.

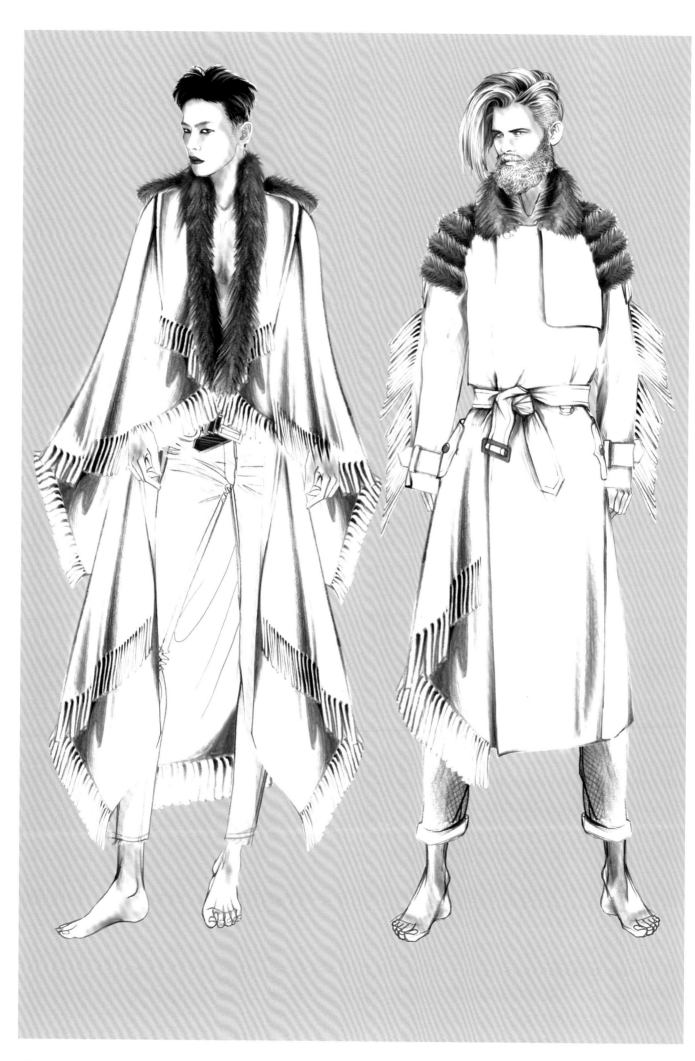

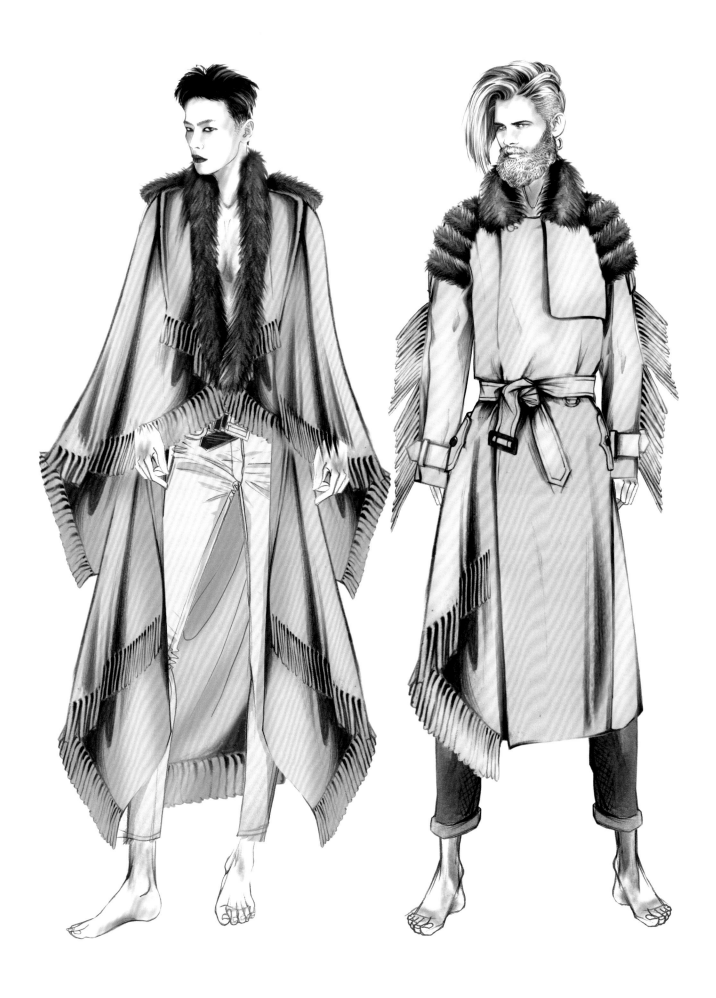

Cashmere overcoat with fringe and mink-effect faux fur details, drawn using an 02 mechanical pencil.

Fur coat shaded by hand using pencil and crayons. Fabric coloured in on the computer.

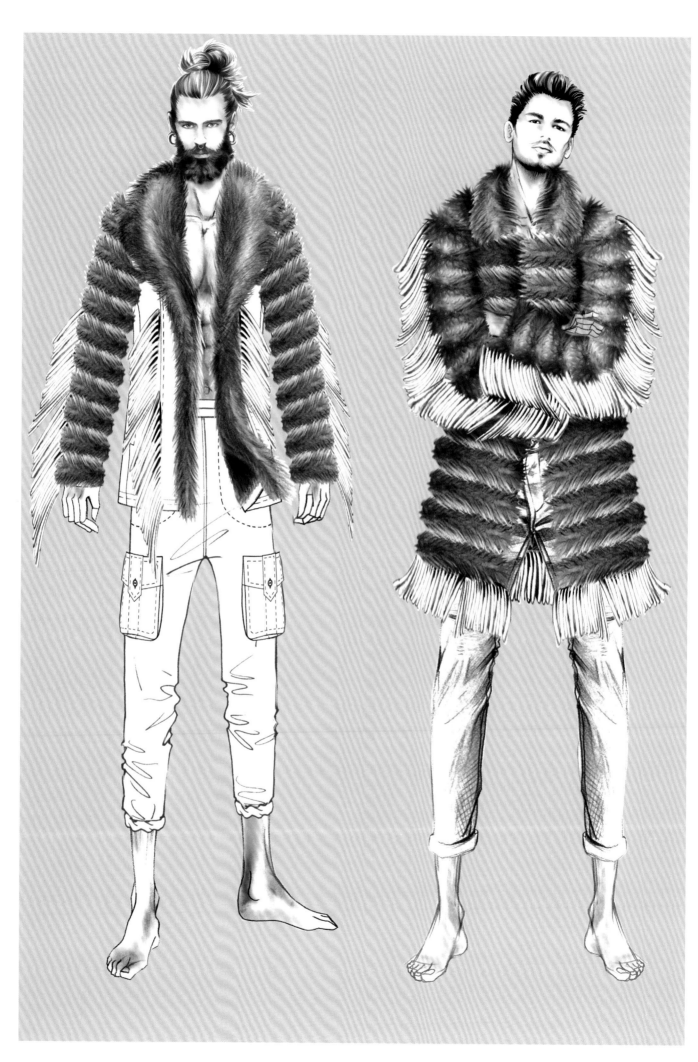

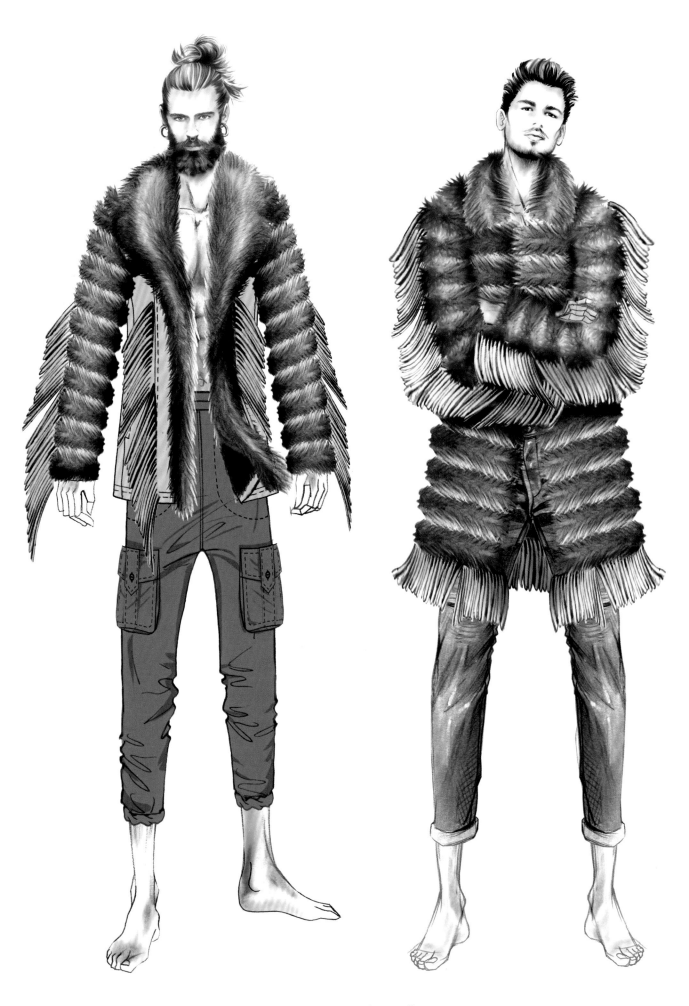

Cashmere jacket with fringe and mink-effect faux fur details, drawn using an 02 mechanical pencil.

Fur coat shaded by hand using pencil and crayons. Fabric coloured in on the computer.

BUTTERFLY CAPE

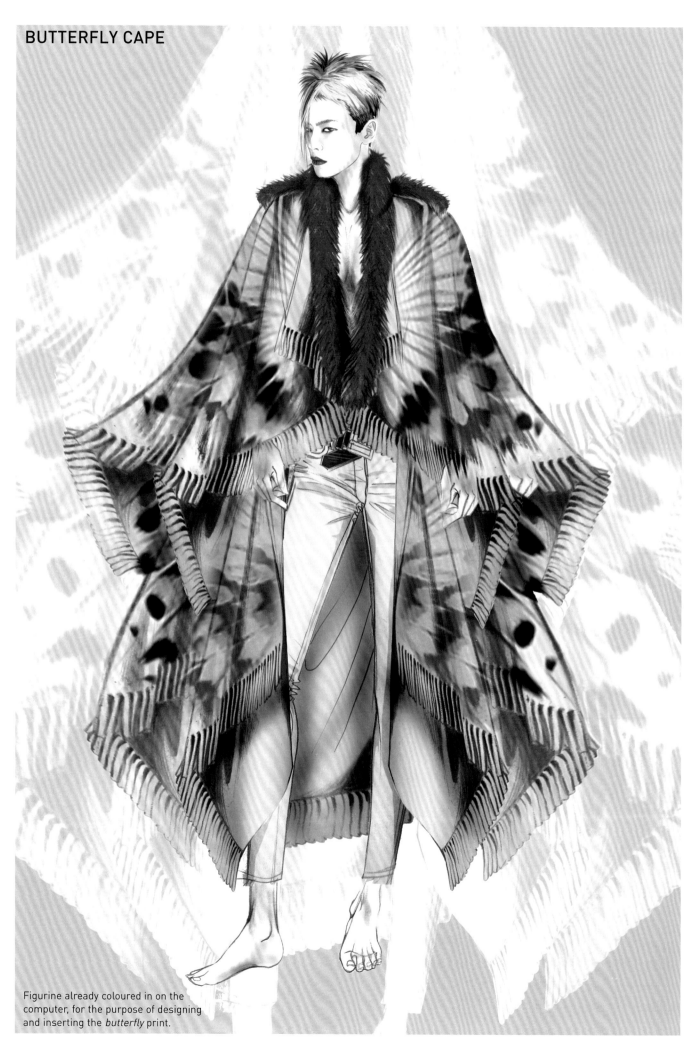

Figurine already coloured in on the computer, for the purpose of designing and inserting the *butterfly* print.

OVERSIZED MULTICOLOUR FUR COAT

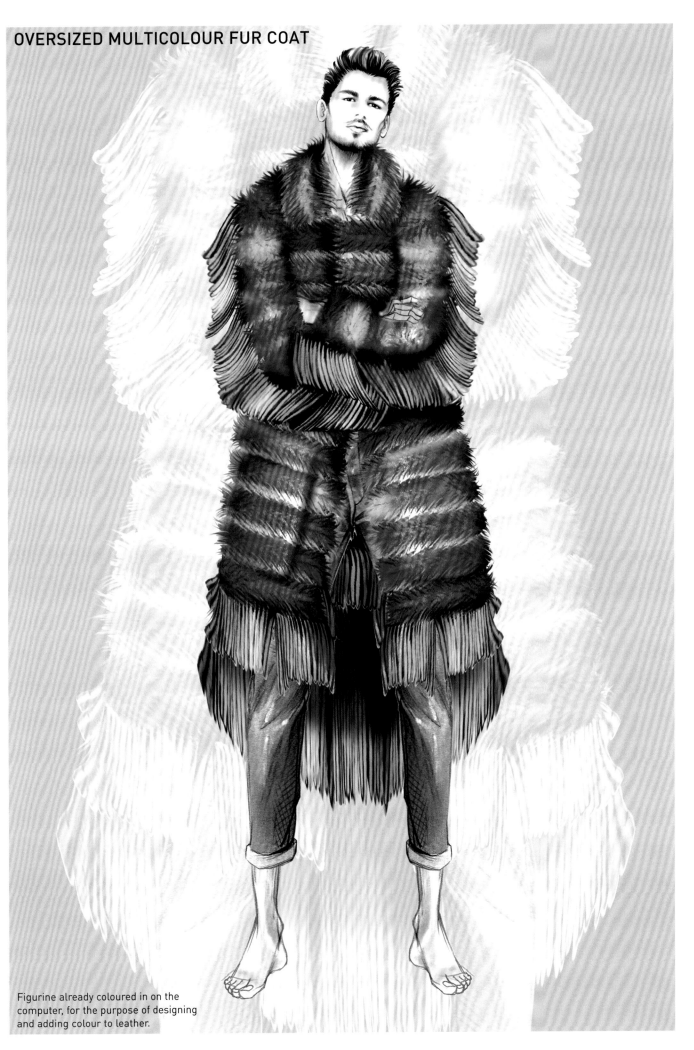

Figurine already coloured in on the computer, for the purpose of designing and adding colour to leather.

HYPER BRIGHTS GENDERLESS - DECONSTRUCTED ARCHITECTURE

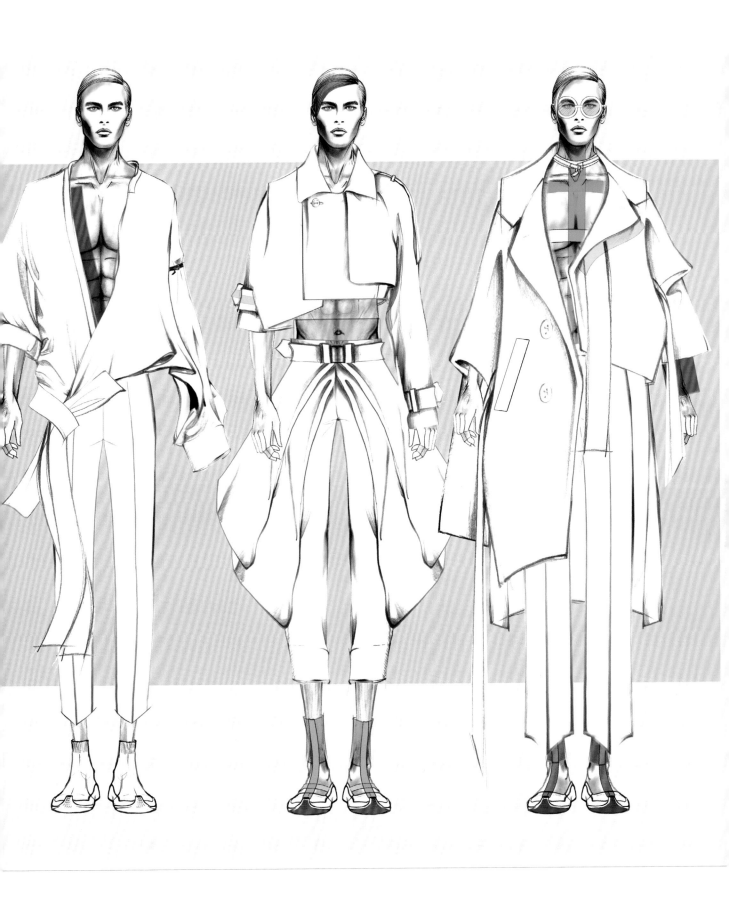

Outfit drawn using 02 mechanical pencil,
with touches of fluorescent colours and
transparencies added on the computer.

Layers of the outfit shown in
transparency on a contrasting
background.

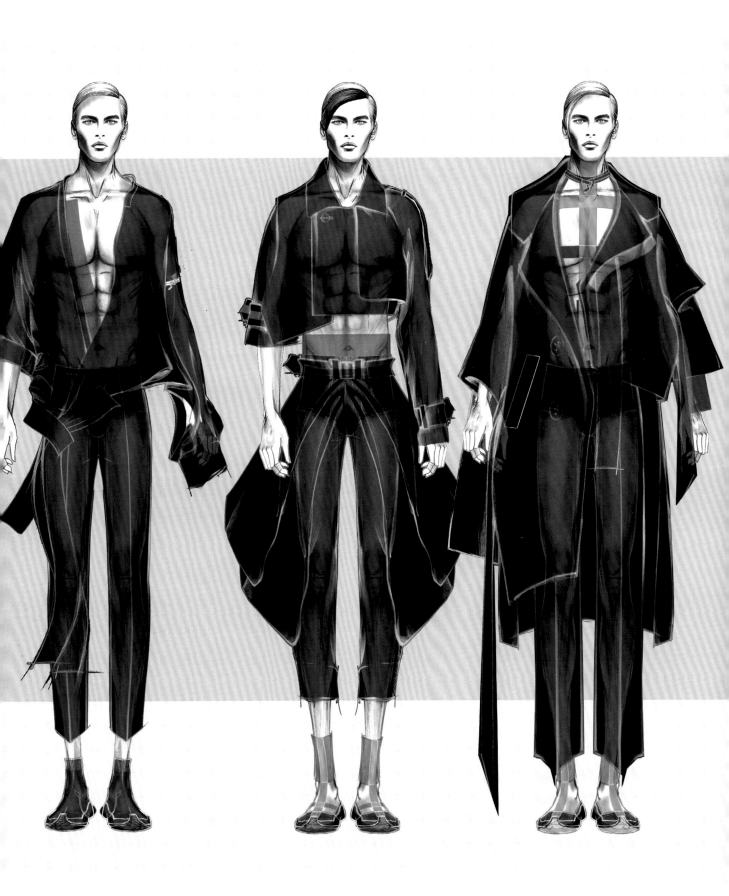

Outfit drawn using 02 mechanical pencil,
with touches of fluorescent colours and
transparencies added on the computer.

WATERCOLOUR ON NEW SHAPES
ARCHITECTURAL ORIENTAL SHAPE

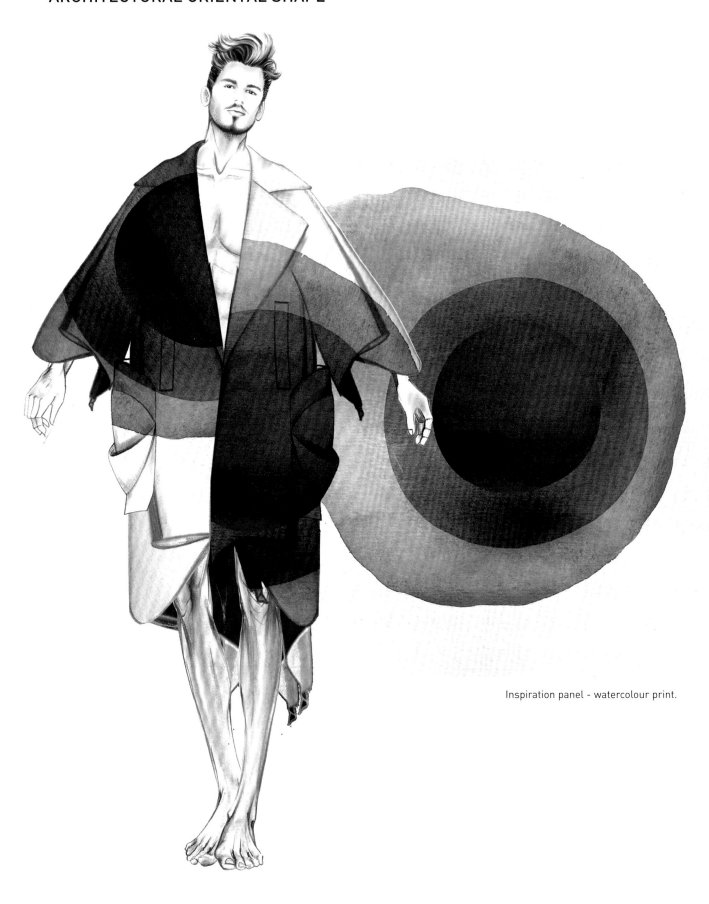

Inspiration panel - watercolour print.

Design printed by hand onto the finished, voluminous kimono-style garment with architectural tailoring and details, raw cut. Drawn and shaded by hand using a 02 mechanical pencil, then watercolour design added on the computer.

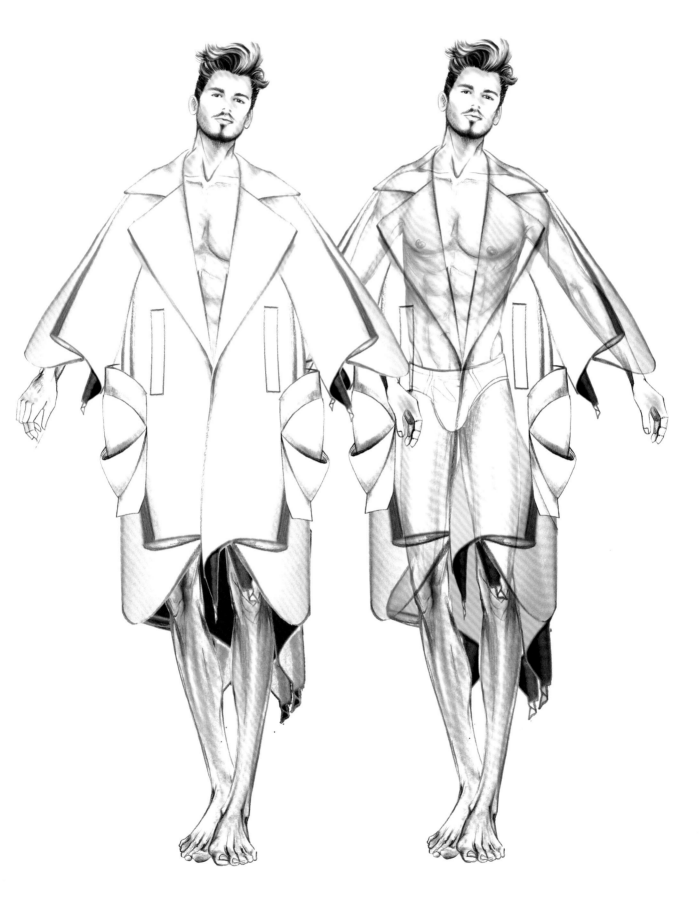

Blanket fabric coat, raw cut.
Drawn and shaded by hand using a 02 mechanical pencil.

Example of a coat shown in transparency
to better visualise its size on the body.

ARCHITECTURAL POCKETS

Coat drawn and shaded by hand using
a 02 micro-lead mechanical pencil,
watercolour design added on the
computer afterwards.

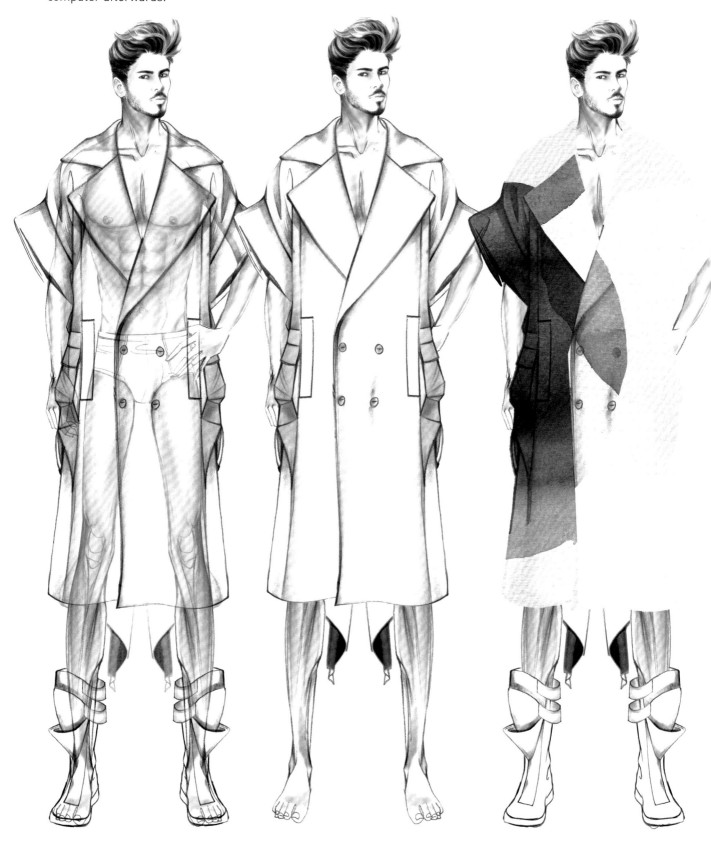

Example of a coat shown in transparency
to better visualise its size on the body.

Overcoat in raw cut fabric.

Overcoat in pictorial sequence.

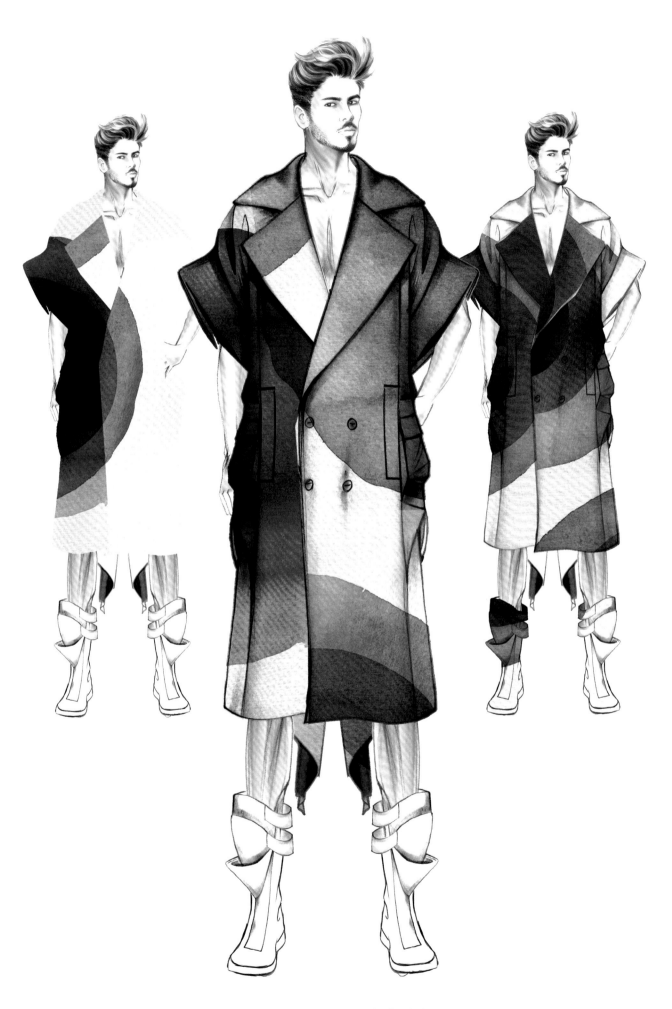

3 proposals for hand-printed design on the finished garment.

ASYMMETRICAL ARCHITECTURE T-SHIRT

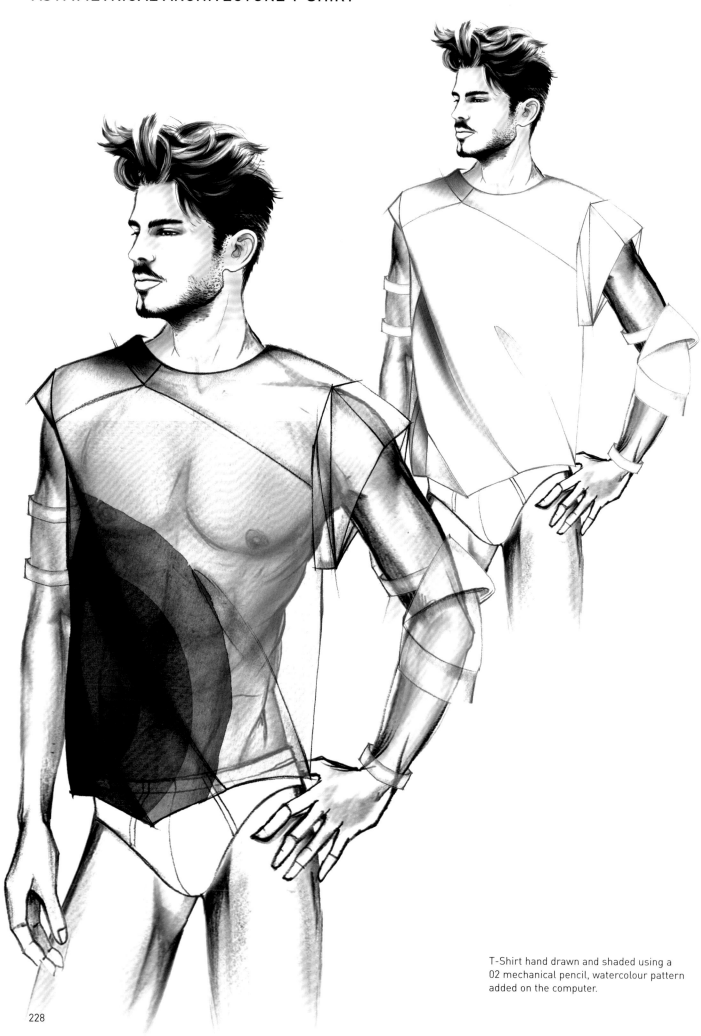

T-Shirt hand drawn and shaded using a 02 mechanical pencil, watercolour pattern added on the computer.

DECONSTRUCTED ORIGAMI

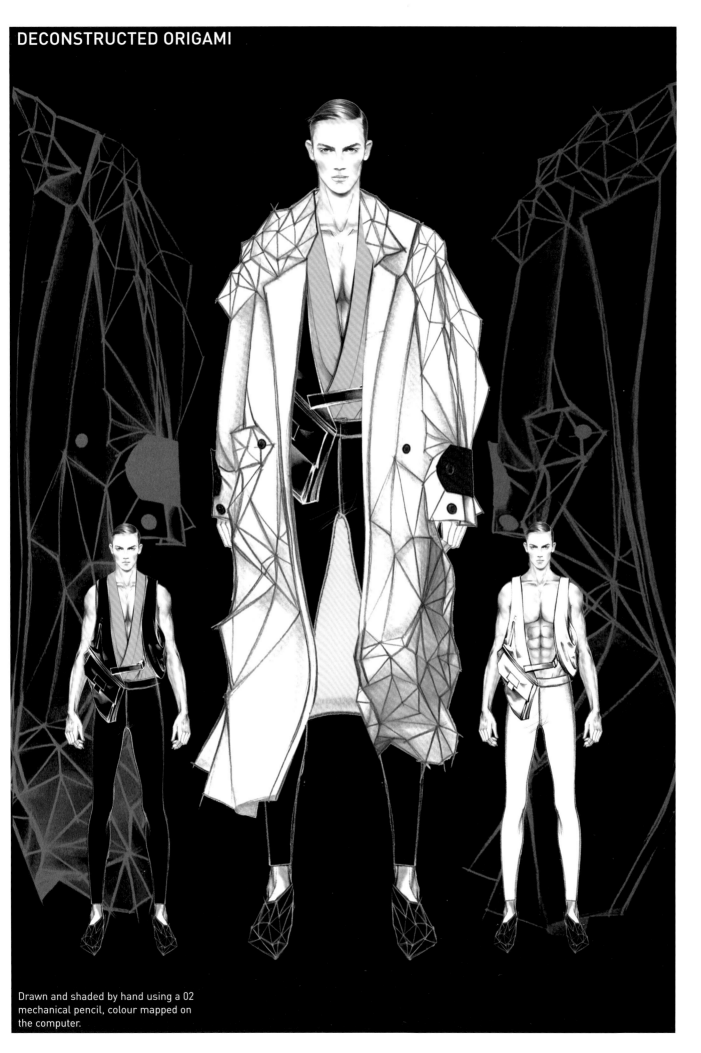

Drawn and shaded by hand using a 02
mechanical pencil, colour mapped on
the computer.

SHARP DIMENSIONS - CYBER WARRIOR

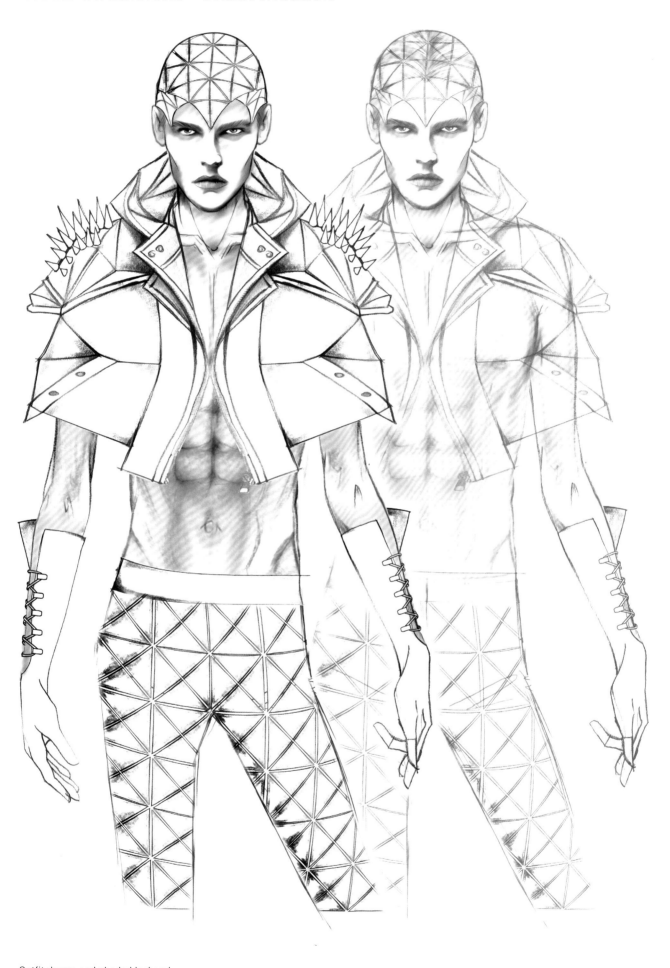

Outfit drawn and shaded by hand
using a 02 mechanical pencil.

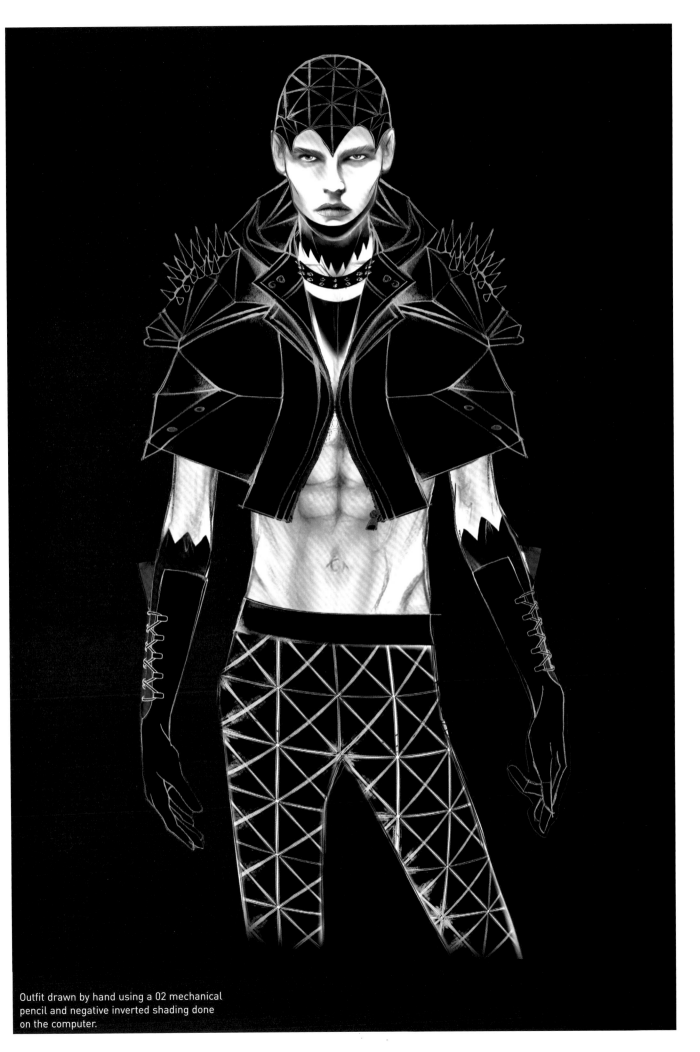

Outfit drawn by hand using a 02 mechanical
pencil and negative inverted shading done
on the computer.

CYBER AVIATOR

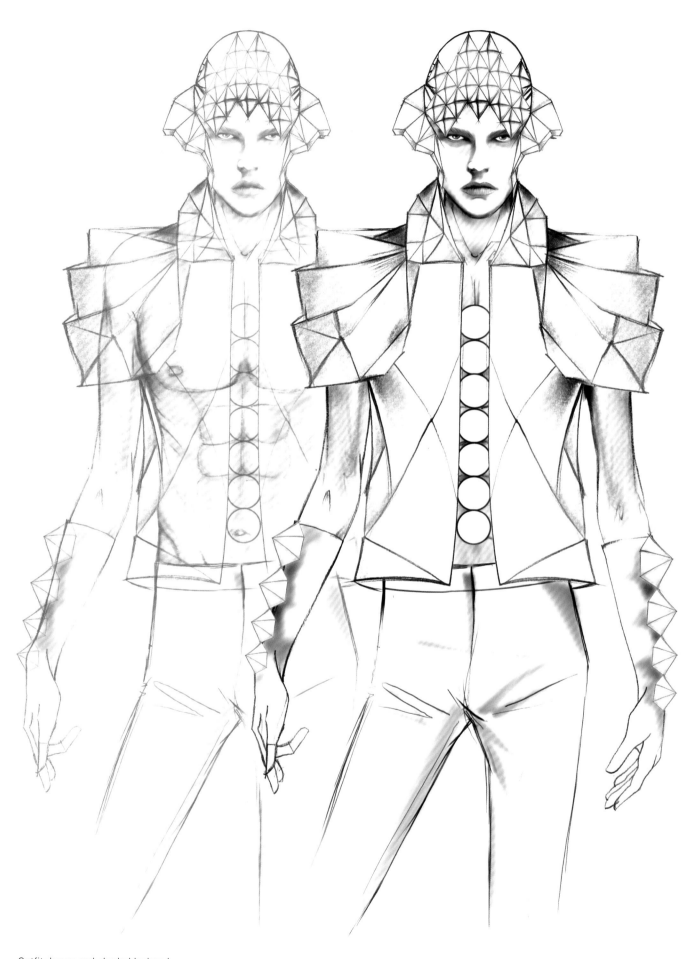

Outfit drawn and shaded by hand
using a 02 mechanical pencil.

DELUXE CYBER AVIATOR

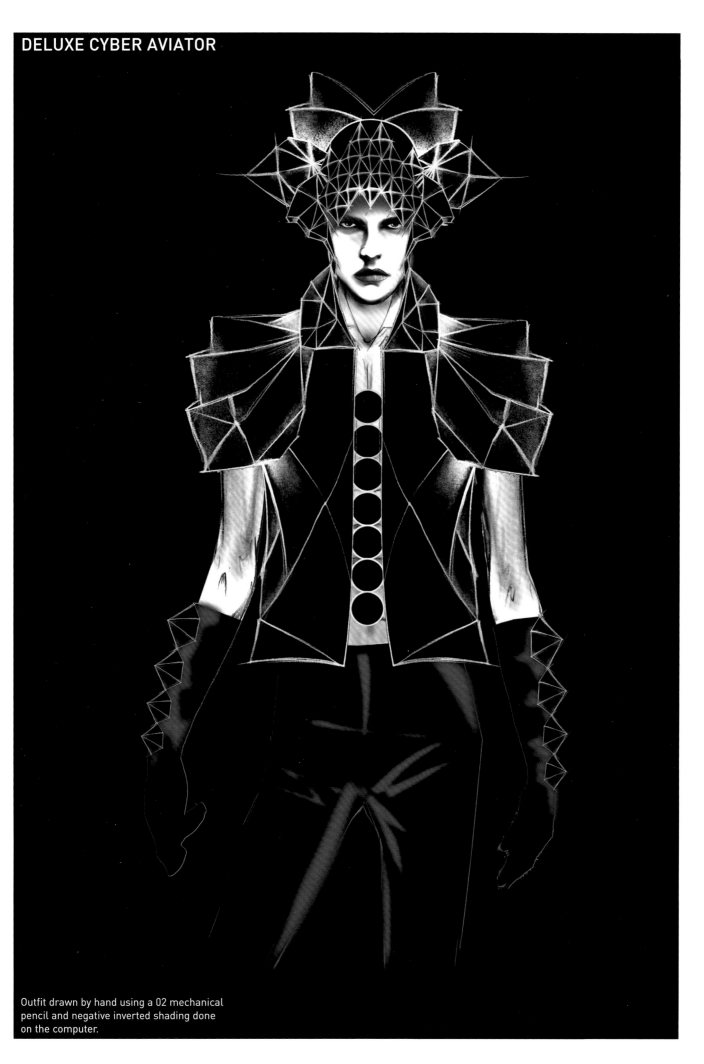

Outfit drawn by hand using a 02 mechanical
pencil and negative inverted shading done
on the computer.

CYBER MILITARY OFFICER

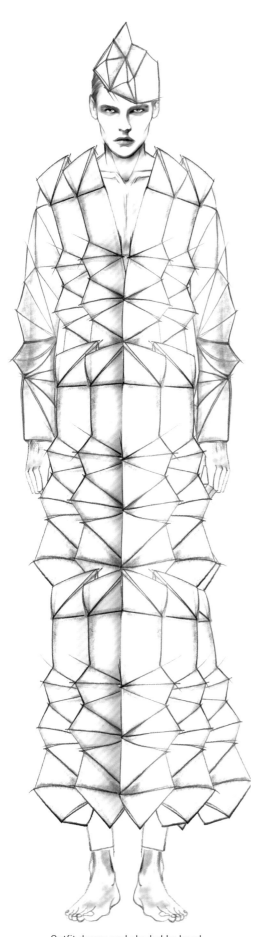

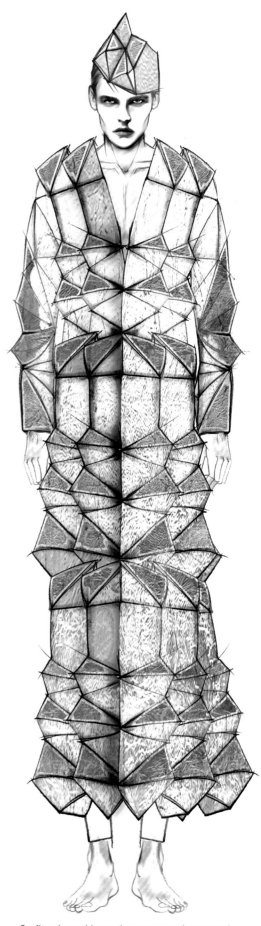

Outfit drawn and shaded by hand using a 02 mechanical pencil.

Outfit coloured in on the computer in an aged gold effect, deconstructed and retouched in flat colours with shaded contours.

CYBER PERSIAN

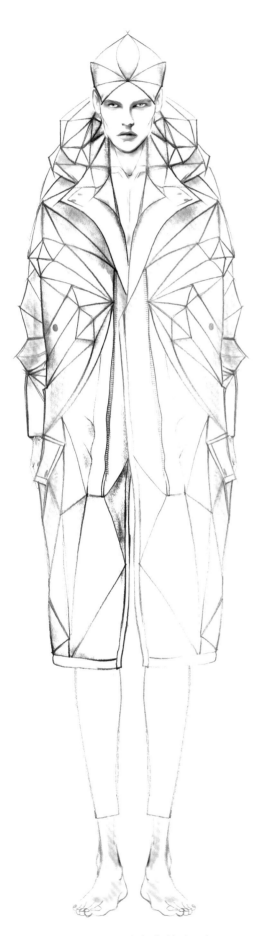

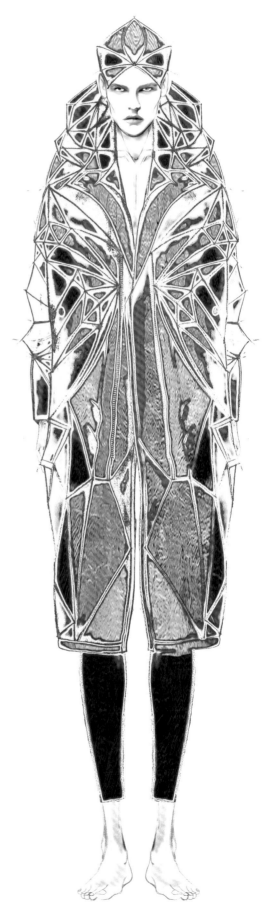

Outfit drawn and shaded by hand
using a 02 mechanical pencil.

Outfit coloured in on the computer in an aged
gold effect, deconstructed and retouched in
flat colours with shaded contours.

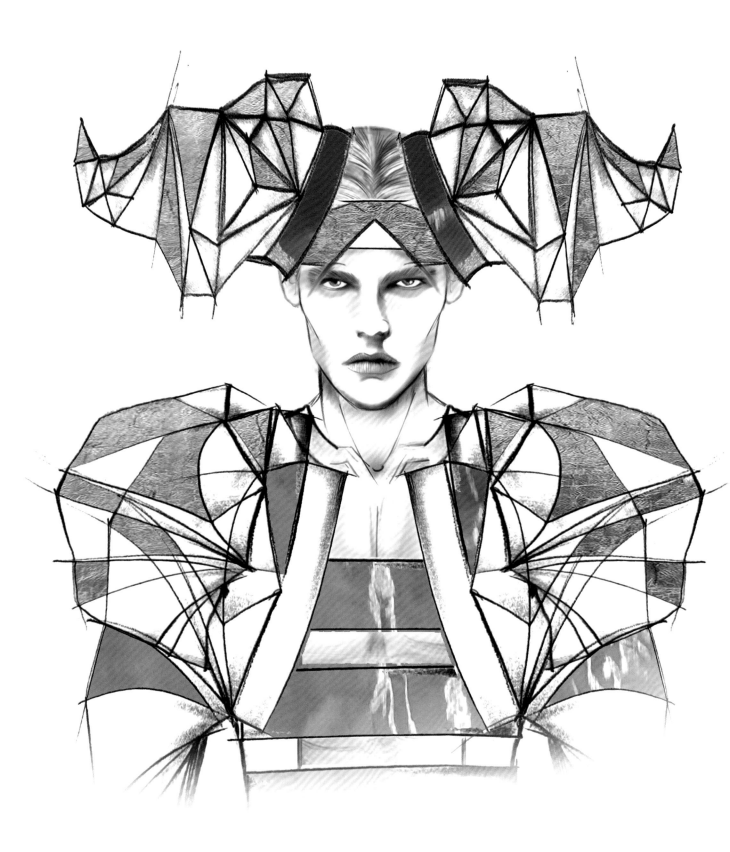

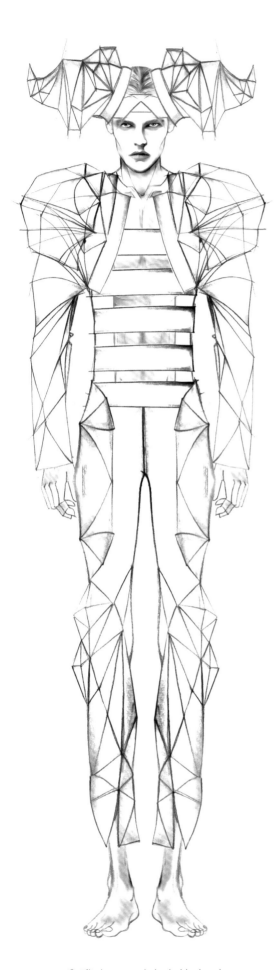

Outfit drawn and shaded by hand
using a 02 mechanical pencil.

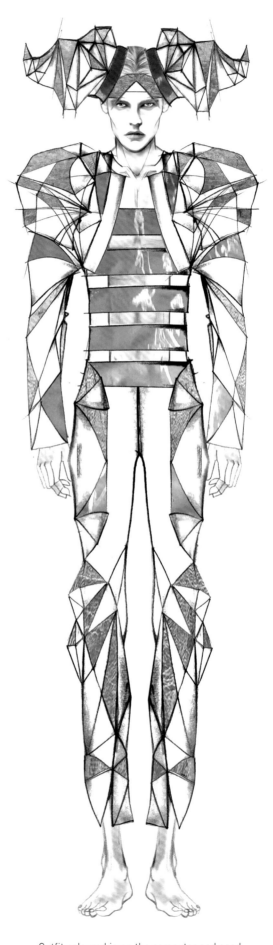

Outfit coloured in on the computer and aged
gold and copper plating effects added.

CYBER EGYPTIAN

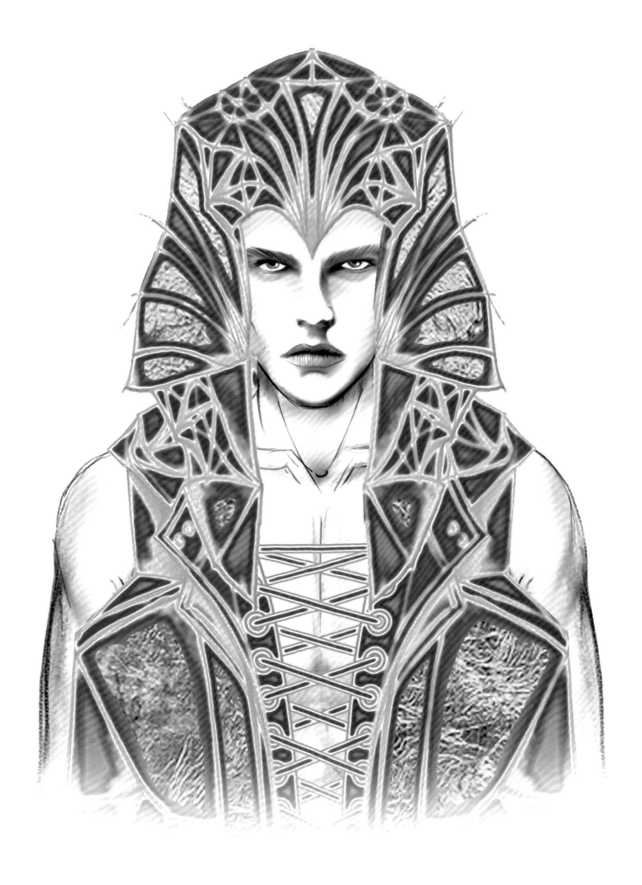

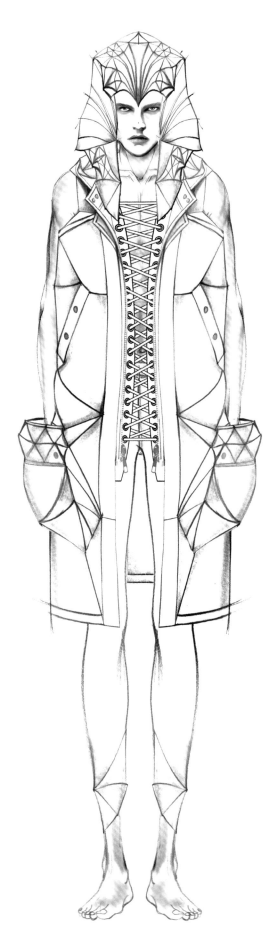

Outfit drawn and shaded by hand
using a 02 mechanical pencil.

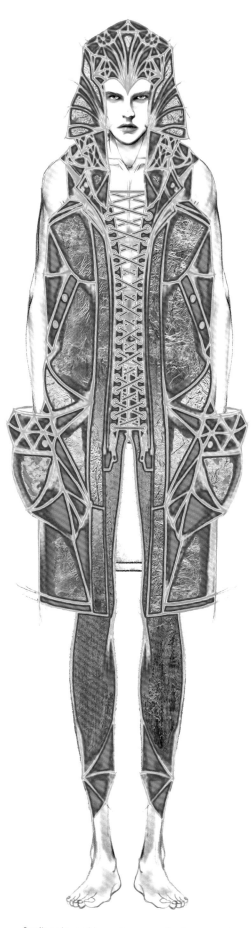

Outfit coloured in on the computer in an aged
gold effect, deconstructed and retouched in
flat colours with shaded contours.

Fourth module
TECHNICAL DATA SHEETS

FLAT DRAWING

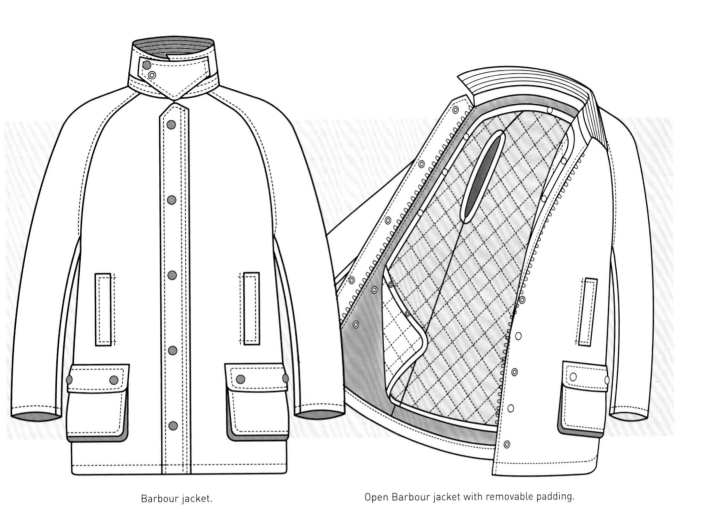

Barbour jacket.

Open Barbour jacket with removable padding.

Flat drawings, or flat line drawings, are highly technical, geometric illustrations that depict the garment as though it were on a flat surface or hanging from a hanger. These pictures are an integral part of design language and are useful to fashion and prototype designers because they allow the model to be interpreted from all aspects and perspectives. Flat drawings are the link between the sketch and the finished garment, and many designers prefer it to drawing on the figure, for its immediacy. Provided with descriptive notes, it presents a detailed depiction of the garment seen from the front, the back and sometimes also in profile, showing the seams, stitches, zips, hems and all the essential specifications. The flat drawing is provided along with the figurine, and accompanies the technical data and production sheets throughout the manufacturing process. Mastering this descriptive technique perfectly requires precision, neatness, time and patience, which is why many students are reluctant to use it at first, although they soon become accomplished practitioners. The flat drawings that we exhibit in this module refer to the basic garments of men's clothing. The chosen sample, without being exhaustive, presents the main clothing items in all types of outfit.
The technical tables, made with scientific criteria, are an altogether indispensable work tool.

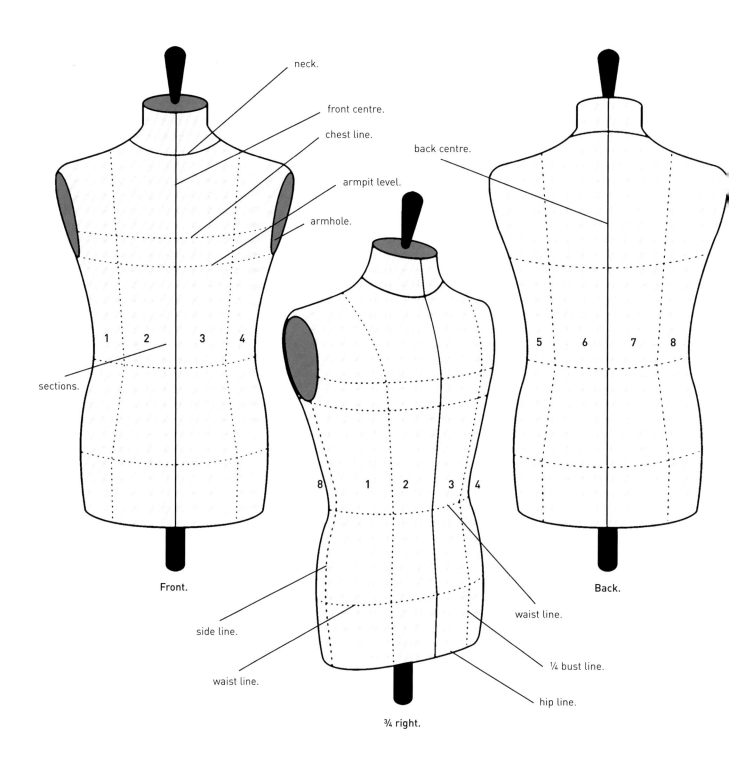

neck.

front centre.

chest line.

armpit level.

armhole.

back centre.

sections.

1 2 3 4

5 6 7 8

Front.

8 1 2 3 4

Back.

side line.

waist line.

waist line.

¼ bust line.

hip line.

¾ right.

THE TAILOR'S DUMMY

The tailor's dummy consists of a full-size bust, which is padded and mounted on a chrome-plated pole. Used in tailoring and fashion design workshops, it is an indispensable tool for building and correcting designs. Textile companies display them aesthetically to present the new collection of the season. Mannequins for men, women and children are available in all main sizes, and size-adjustable shaped mannequins are also available commercially. The bust allows us to see how items look together so we can create spontaneously, applying skillful movements to the fabric: everything that our imagination can come up with. The three diagrams demonstrate this through the main perspectives, including specific sections and measurement levels.

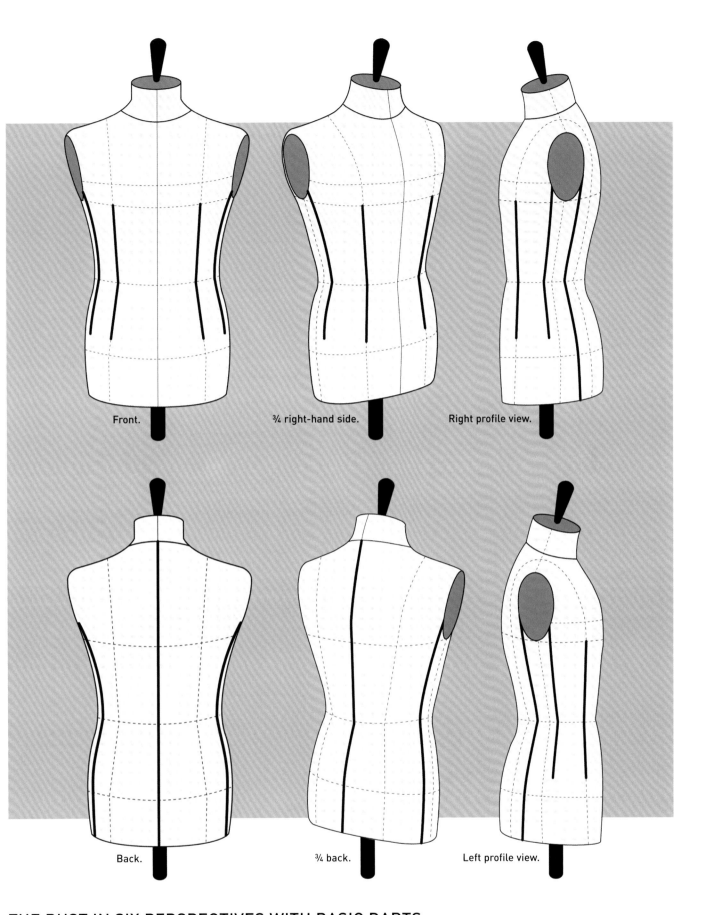

Front.

¾ right-hand side.

Right profile view.

Back.

¾ back.

Left profile view.

THE BUST IN SIX PERSPECTIVES WITH BASIC DARTS

The dart is a triangular fold of stitched fabric that gives shape to an item of clothing; it gathers the fabric around the curves of the body, highlighting its anatomical shape. The position, direction, and placement of the darts vary according to the model and they are usually vertical. The darts can be visible, as seen here, inserted into the tailoring, or absorbed by the width of the model. Unlike specially-tailored women's jackets, the main darts on men's jackets are reduced to the bare essentials and cut vertically across the bust in the area from below the chest and below the armpit to the hip. The side seam is moved to the back, where the vertical tailoring is always in the middle.

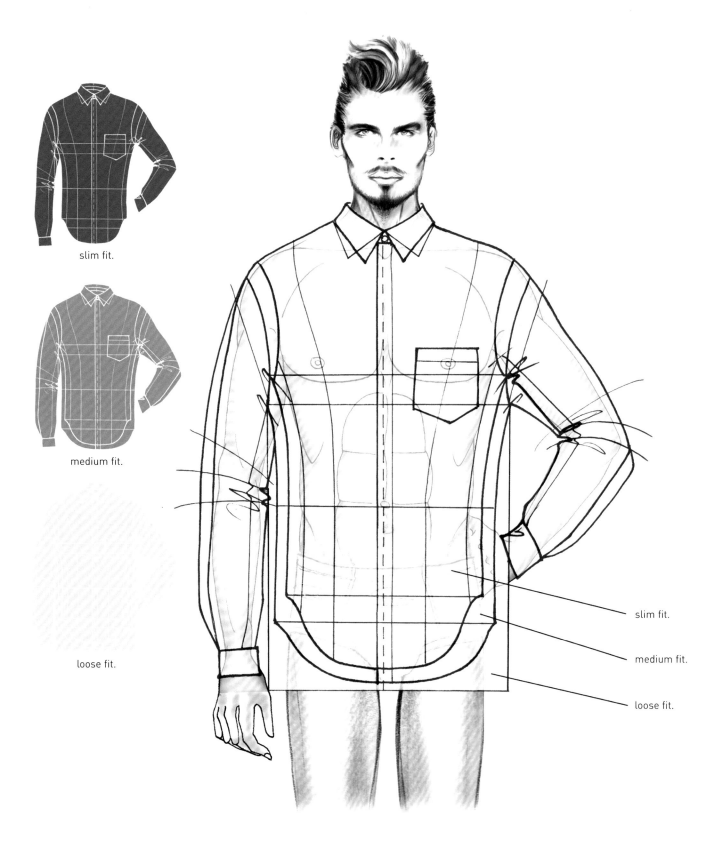

slim fit.

medium fit.

loose fit.

slim fit.

medium fit.

loose fit.

FIT

The fit is the ratio of the length to the width of the garment and results in how much movement space there is between the fabric and the wearer's body. Technically, it is expressed in the centimetres that are added to the areas where the garment sits nearer or further away from the body. The range of sizes is given in a table

which, depending on the style and type of fabric, delineates how loose or close-fitting the garment being made needs to be. The more elasticated a fabric is, the less it needs to be loose-fitting and, conversely, non-elastic fabrics need to allow more room for manoeuvre.

In the diagram, for example, we

see three generic shirt sizes: slim fit, medium fit and loose fit. As the design widens in accordance with the size, the armhole gradually moves away from the body, falling at the shoulder and armpit. The length of the sleeves, along with the width of the bust and collar, can be modified and adapted on any garment.

ARTICLE	SEASON	LINE	DESCRIP. MATERIAL	MODEL DESCRIPTION	DATE:
1124			poplin	SHIRT	

#									
1	CHEST	37	38	39	40	41	42	43	
2	1/2 BOTTOM	48	50	52	54	56	58	60	
3	SHOULDER	47.5	49.5	51.5	53.5	55.5	57.5	59.5	
4	WIDTH COLLAR	37	38	39	40	41	42	43	
5	WIDTH CUFF	22.8	23.4	24	24.6	25.2	25.8	26.4	
6	1/2 BICEPS	19	19.5	20	20.5	21	21.5	22	
7	CENTRE BACK LENGTH	75	76.5	78	79.5	81	82.5	84	
8	SLEEVE LENGTH INC. CUFF	64.1	65.3	66.5	67.7	68.9	70.1	71.3	
9	LENGTH REAR DART	34	34	34	34	34	34	34	
10	TOTAL DEPTH REAR DART	2.5	2.5	2.5	2.5	2.5	2.5	2.5	
11	PLACKET	3	3	3	3	3	3	3	
12	EMBROIDERED BRAND LOGO	32.3	32.9	33.5	34.1	34.7	35.3	35.9	
13	CUFF PLACKET LENGTH	14.5	14.5	15	15	15.5	15.5	16	
14	CUFF HEIGHT	6.5	6.5	6.5	6.5	6.5	6.5	6.5	
15	COLLAR POINT	6.5	6.5	6.5	6.5	6.5	6.5	6.5	
16	BACK OF COLLAR	4.2	4.2	4.2	4.2	4.2	4.2	4.2	

LIST OF MATERIALS

code	material	garment	quantity		position	SEAMS	DESCRIPTION
						0.6 CM	REAR SIDE
5039	ADHESIVE 32115/3	garment	MT		NECKLINE + CUFFS + DETACHABLE COLLAR.	1.2 CM	FRONT SIDE
	LIN BUTTONS 18	garment	NR	10+1	FRONT + DETACHABLE COLLAR + CUFFS		
	LIN BUTTONS 16	garment	NR	2+1	SLEEVE OPENING	1 CM	FOR ARMHOLE AND 2 CM FOR SLEEVE CUP
							CLEARLY VISIBLE SEAM 1 CM
	EMBROIDERED LOGO	garment	NR	1	FRONT RIGHT		BOTH WITH FREE ARM MACHINE
	ROD	garment		2.00	COLLAR	1.5 CM	FOR CUFF CLOSURE
							FOR CUFF AND WRISTBAND
	THREAD No. 20					0.5 CM	LOW-CUT VISIBLE HEM
						0.7 CM	COLLAR, DETACHABLE COLLAR AND CUFF PERIMETER
	COMPOSITION LABEL		1		LEFT SIDE 10 CM UNDERNEATH		FOR WRIST
	BRAND LABEL		1		RIGHT YOKE 3.7 CM FROM THE SEAM	BACKSTITCH	POSITIONS
	TG NUMBER LABEL		1		UNDER LABEL C/TD YOKE	0.5 CM	PERIMETER, COLLAR AND CUFFS
						ALONG THE EDGE	SHOULDERS, YOKE, SLEEVE OPENINGS AND CUFF CLOSURE
	BACKSTITCH POINTS 6 PER CM					1 CM	ARMHOLE
						0.5 CM	HEM
						1 CM	DOUBLE BACKSTITCH CUFF CLOSURE
	KEEP TO THE STITCH TYPE ADVISED ON THE SHEET						

NOTES

ATTENTION: FOR THE REAR DARTS, SEW 1.5 CM LONGER, SINCE THE HOLE IS IN THE MIDDLE AND THE DART IS 2.5 CM IN TOTAL. FOR THE WIDTH, BE SURE TO KEEP THE DART THE SAME SIZE AS STIPULATED AND UNPICK AS INDICATED WITH THE GREATEST PRECISION
- ATTENTION: BE SURE TO OVERLAP THE FRONT PLACKET AND THE COLLAR CORRECTLY -
ATTENTION: THE BUTTONHOLE SHOULD BE AT AN ANGLE, SEE TEMPLATE - PAY ATTENTION TO THE IRONING INSTRUCTIONS ON THE FRONT PLACKET - SEE PATTERN FOR CUFF HEIGHT

EMBROIDERER

TEMPLATES
COLLAR, CUFF, DETACHABLE COLLAR, FRONT BUTTONHOLES AND DETACHABLE COLLAR NET
FRONT RIGHT LOGO WITH STITCHING
UNDER-COLLAR STRIP
TEMPLATE FOR PLEATS

TECHNICAL DATA SHEET FOR A SHIRT

The technical data sheet or production sheet is something that is used in the industry to specify all the technical aspects of a design being put into production. The one we see here is a professional document, in which a single garment is depicted flat, seen from the front and back, and includes the specifications of essential features. The file accompanies the design throughout the production cycle until its completion.

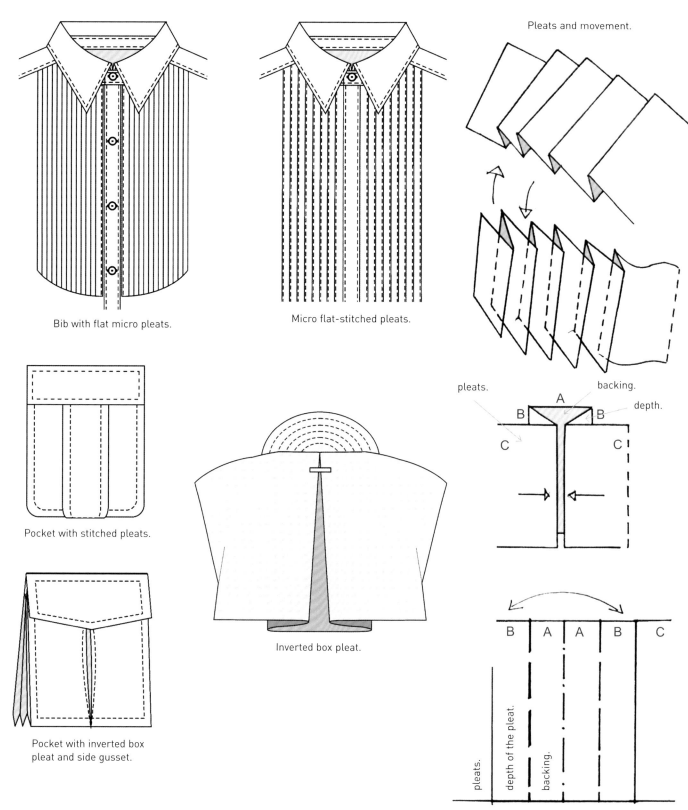

Bib with flat micro pleats.

Micro flat-stitched pleats.

Pleats and movement.

Pocket with stitched pleats.

Pocket with inverted box
pleat and side gusset.

Inverted box pleat.

pleats.

backing.

depth.

A

B B

C C

B A A B C

pleats.

depth of the pleat.

backing.

PLEATS AND PATTERNS

Pleats gather fabric around the body, or a specific part of the garment, and feature modular geometric designs; they can also be applied to the garment as a finishing touch. They consist of a fold line, a depth line and a backing line (A-B-C-D).

Applying pleats can create pleasant and surprising effects. There are many types of pleats and each type has multiple versions. Pleats can be spaced widely apart, in panels, ribbed, ironed or left soft, sewn or inside another piece of fabric; they

can also be arranged diagonally or horizontally with side seams. In all cases, the best effect is obtained with the pleats made on the straight grain, following the cadence of the fabric.

RUFFLES - FRILLS - PATTERNS

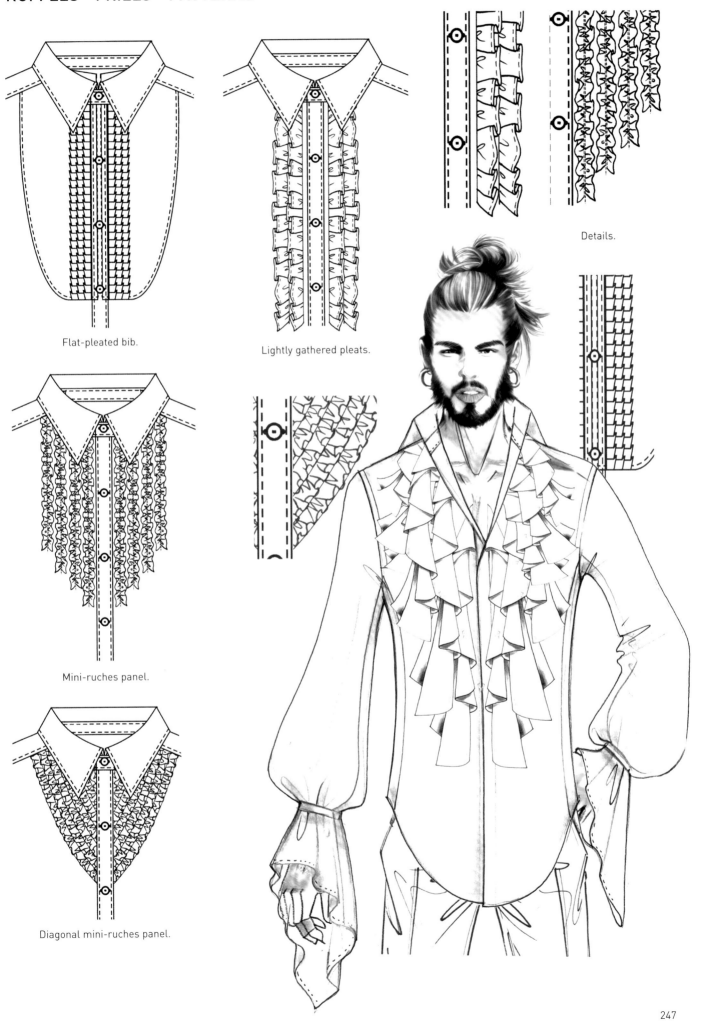

Flat-pleated bib.

Lightly gathered pleats.

Details.

Mini-ruches panel.

Diagonal mini-ruches panel.

POCKETS TYPES

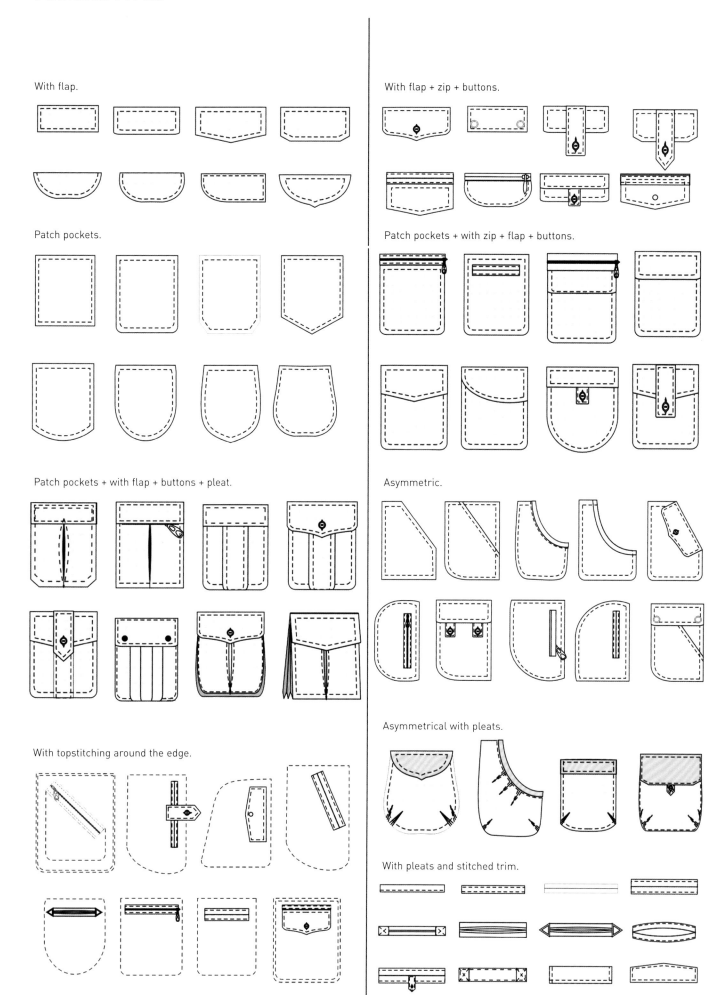

With flap.

Patch pockets.

Patch pockets + with flap + buttons + pleat.

With topstitching around the edge.

With flap + zip + buttons.

Patch pockets + with zip + flap + buttons.

Asymmetric.

Asymmetrical with pleats.

With pleats and stitched trim.

MILITARY STYLE TRENCH COAT WITH FLAP PATCH POCKETS

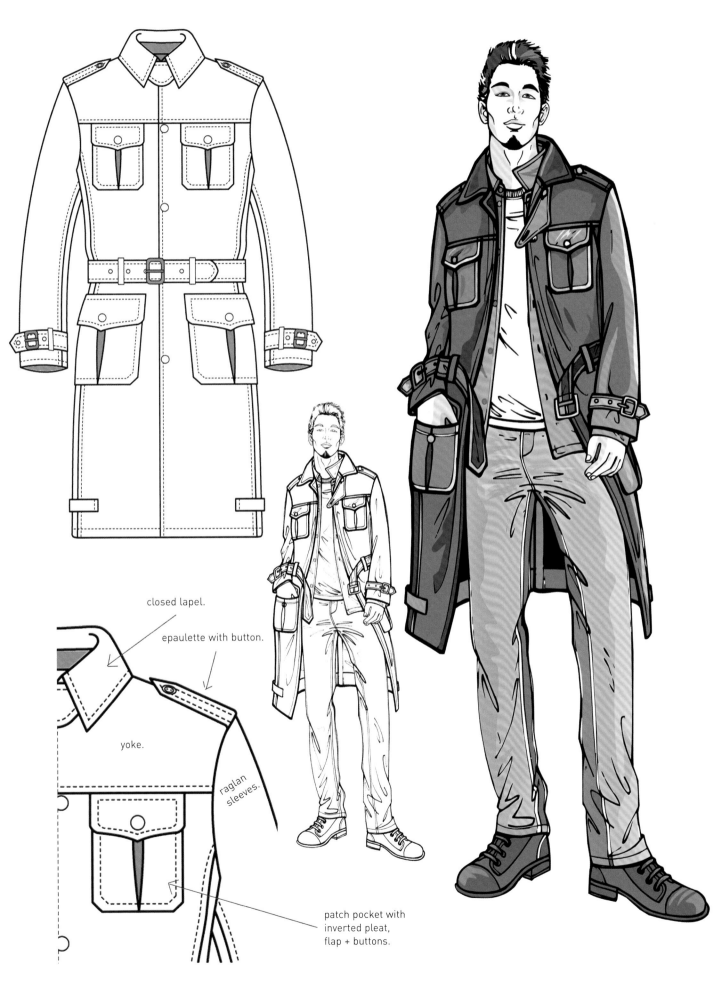

closed lapel.

epaulette with button.

yoke.

raglan sleeves.

patch pocket with inverted pleat, flap + buttons.

TYPES OF FASTENERS

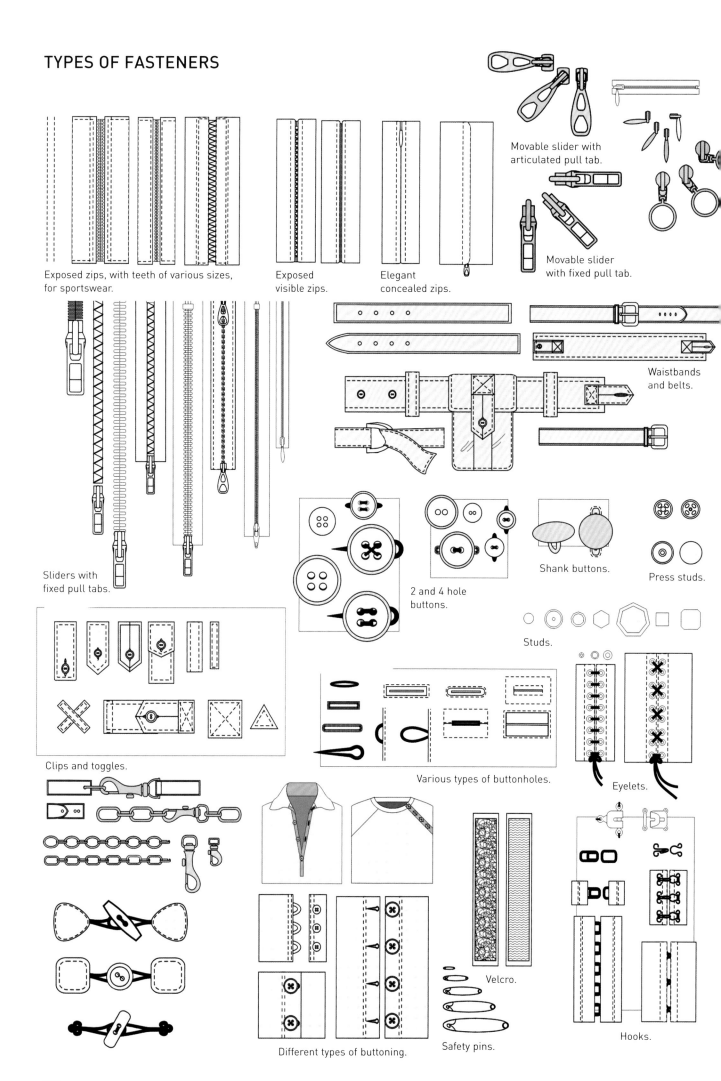

Exposed zips, with teeth of various sizes, for sportswear.

Exposed visible zips.

Elegant concealed zips.

Movable slider with articulated pull tab.

Movable slider with fixed pull tab.

Sliders with fixed pull tabs.

Waistbands and belts.

2 and 4 hole buttons.

Shank buttons.

Press studs.

Studs.

Clips and toggles.

Various types of buttonholes.

Eyelets.

Different types of buttoning.

Safety pins.

Velcro.

Hooks.

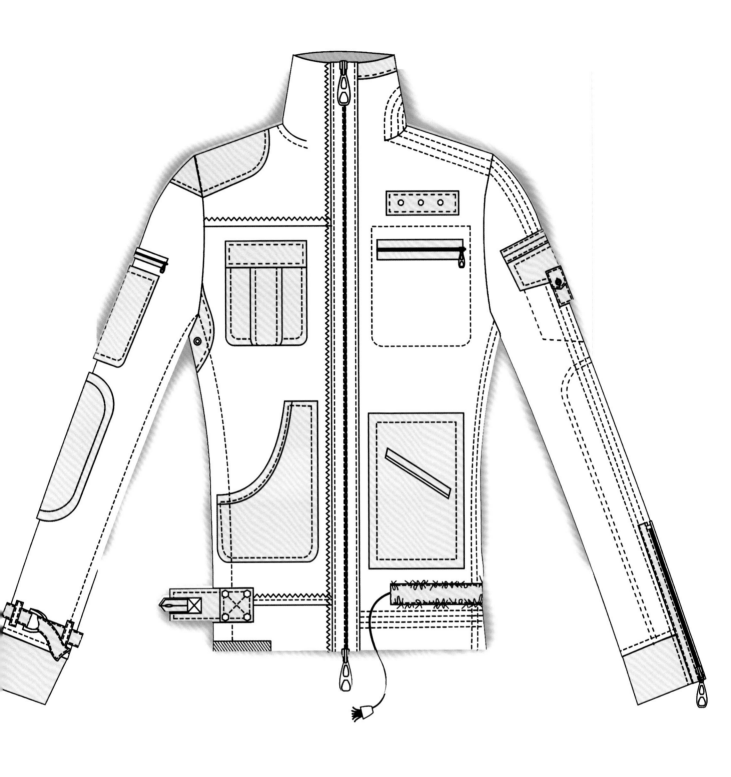

FINISHING TOUCHES TO A JACKET WITH VARIOUS ACCESSORIES

Technically, the *finishing touches* are all the elements that characterise the design, such as collars, cuffs, pockets, closures, lining, seams, buttons, applications, embroidery, pleats, etc.
We have devoted many pages to these details and, to put them into context, we have combined them with various types of clothing. The drawings, on the other hand, depict finishing touches that can be used on their own or modified as required, as long as they retain clarity and neatness. The various elements added to the multi-accessorised jacket are examples of the technical options that can change a garment's aesthetic.

Exercise
1. Keeping the same basic leather sports jacket, use different accessories to create five different designs.
2. Complete each version by designing the back and adding corresponding technical notes.

TYPES OF BASIC STITCHES - TRIMS - DRAWSTRINGS

■ = stitches photographed from real samples. □ = drawn stitches.

straight single stitch.

narrow twin needle stitch with overlock.

narrow twin needle stitch.

wide twin needle stitch with overlock.

wide twin needle stitch.

short zigzag stitch.

three needle stitch.

large, wide zigzag stitch.

three needle stitch with overlock.

long, tight zigzag stitch.

1
2
3
4
5
6
7

drawstring.

Ribbons and decorative trimming

1. Mouse tail.
2. Lanyard.
3. Ribbon.
4. Bias tape.
5. Bias for hems.
6. Herringbone.
7. Grosgrain.

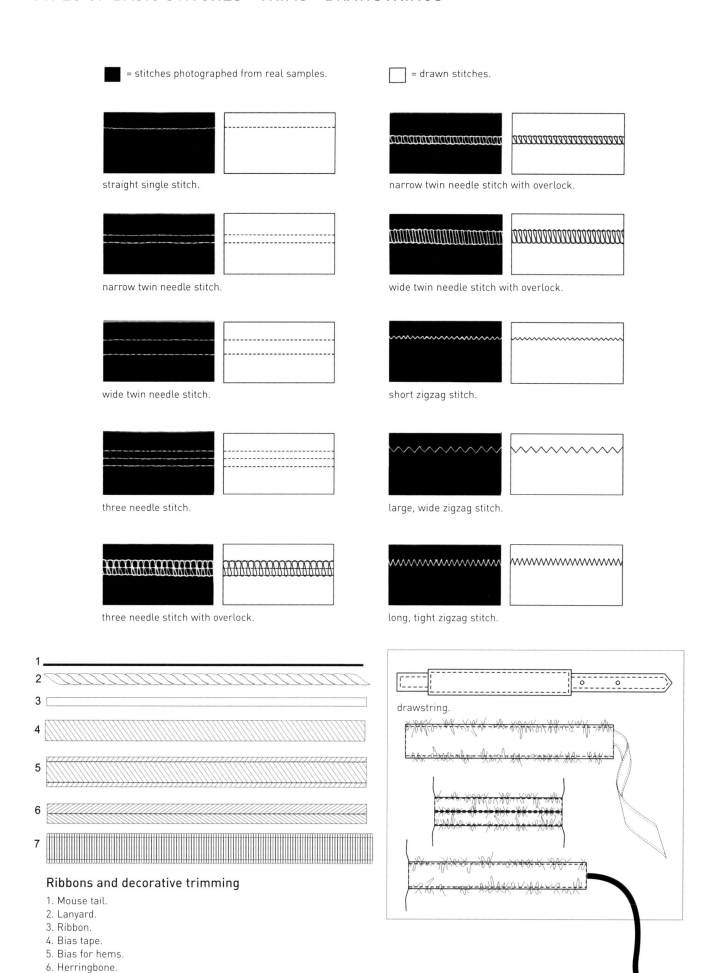

OVERCOAT

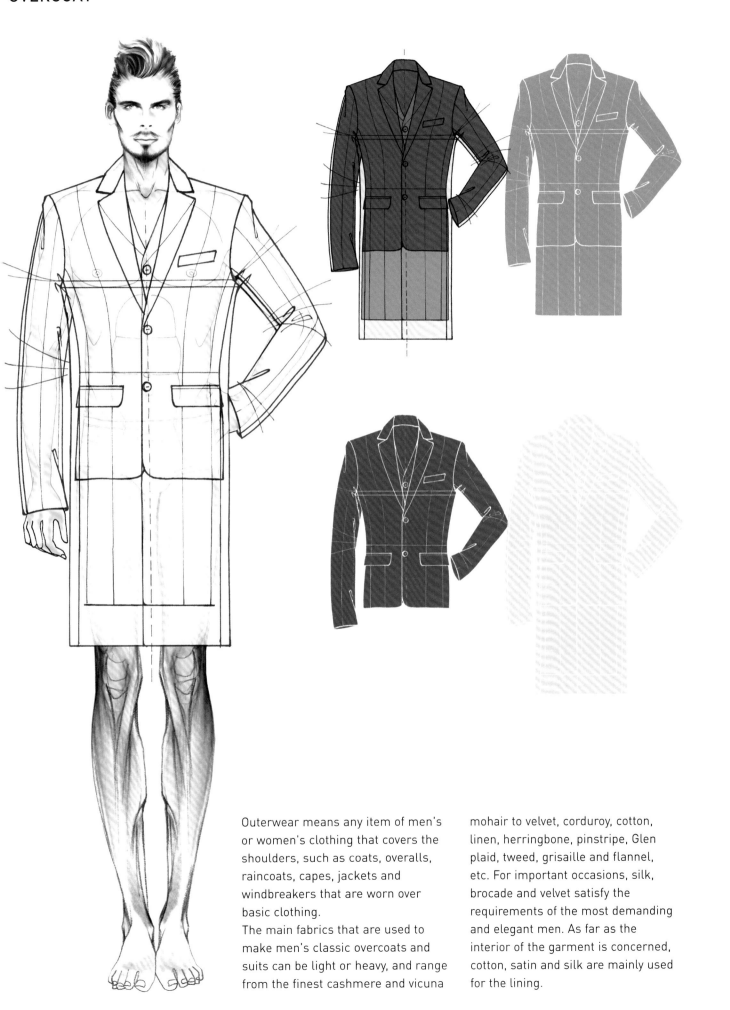

Outerwear means any item of men's or women's clothing that covers the shoulders, such as coats, overalls, raincoats, capes, jackets and windbreakers that are worn over basic clothing.

The main fabrics that are used to make men's classic overcoats and suits can be light or heavy, and range from the finest cashmere and vicuna mohair to velvet, corduroy, cotton, linen, herringbone, pinstripe, Glen plaid, tweed, grisaille and flannel, etc. For important occasions, silk, brocade and velvet satisfy the requirements of the most demanding and elegant men. As far as the interior of the garment is concerned, cotton, satin and silk are mainly used for the lining.

TYPES OF OVERCOAT

The two diagrams show how overcoats are classified, as a style guide to identify different types that can in turn be subdivided into further designs that can be made with various fabrics.

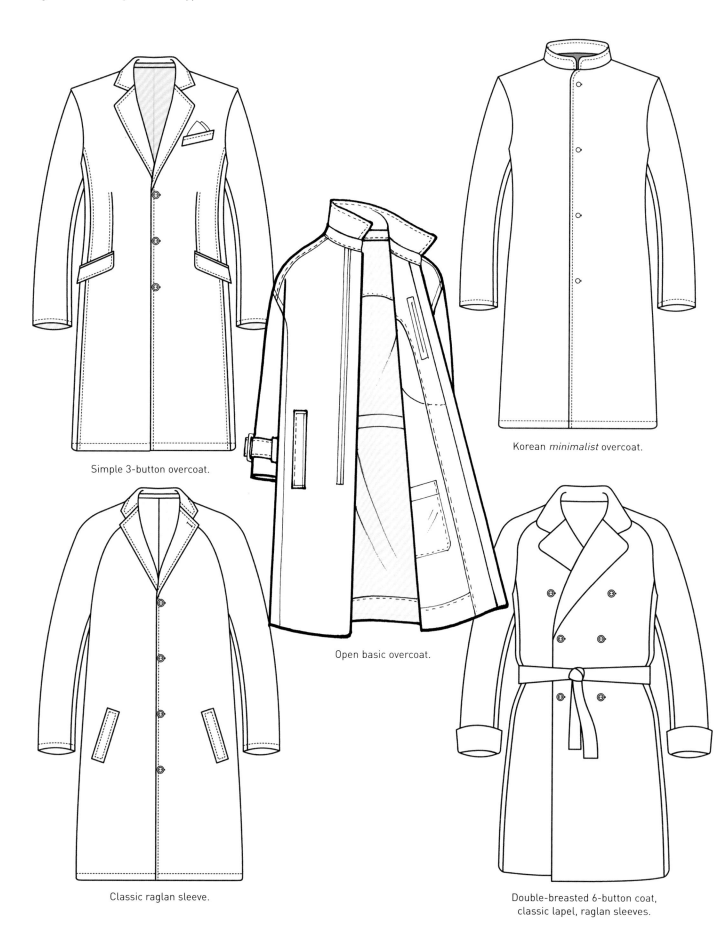

Simple 3-button overcoat.

Korean *minimalist* overcoat.

Open basic overcoat.

Classic raglan sleeve.

Double-breasted 6-button coat, classic lapel, raglan sleeves.

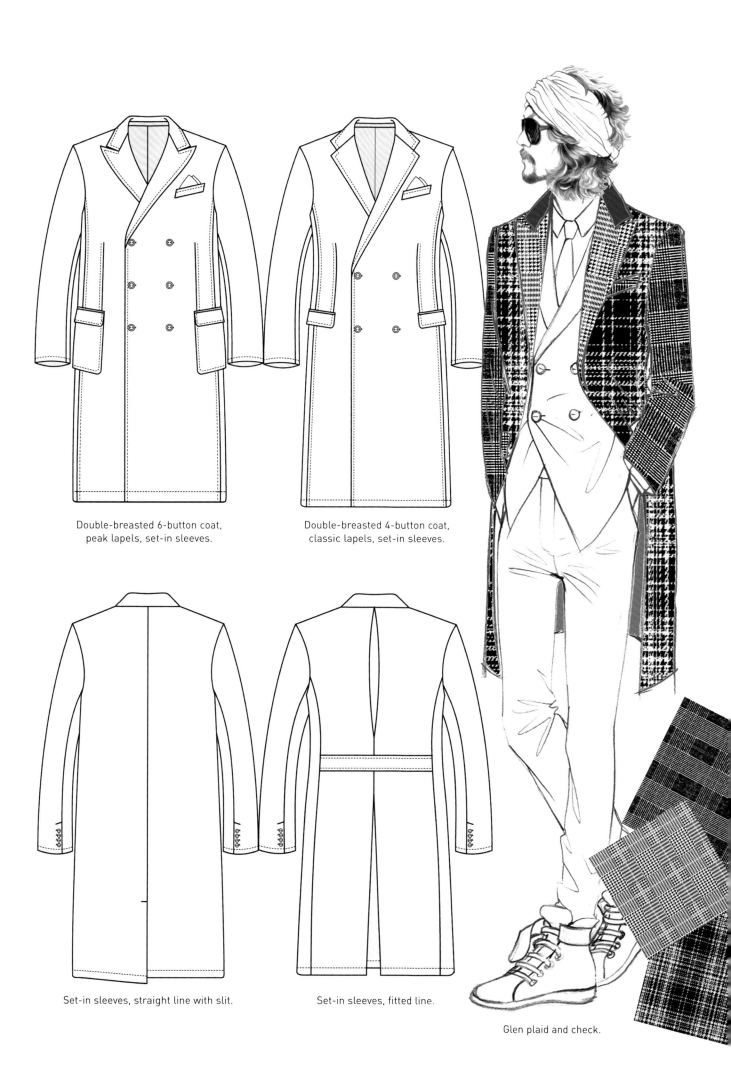

Double-breasted 6-button coat,
peak lapels, set-in sleeves.

Double-breasted 4-button coat,
classic lapels, set-in sleeves.

Set-in sleeves, straight line with slit.

Set-in sleeves, fitted line.

Glen plaid and check.

CLASSIC OVERCOAT DESIGNS

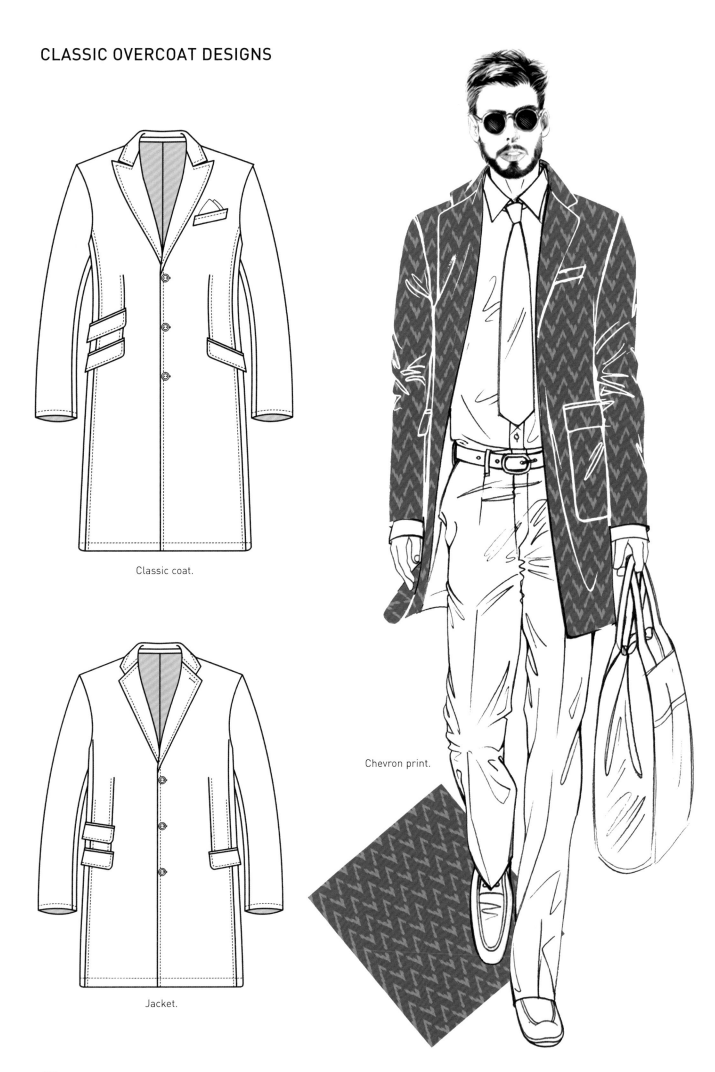

Classic coat.

Jacket.

Chevron print.

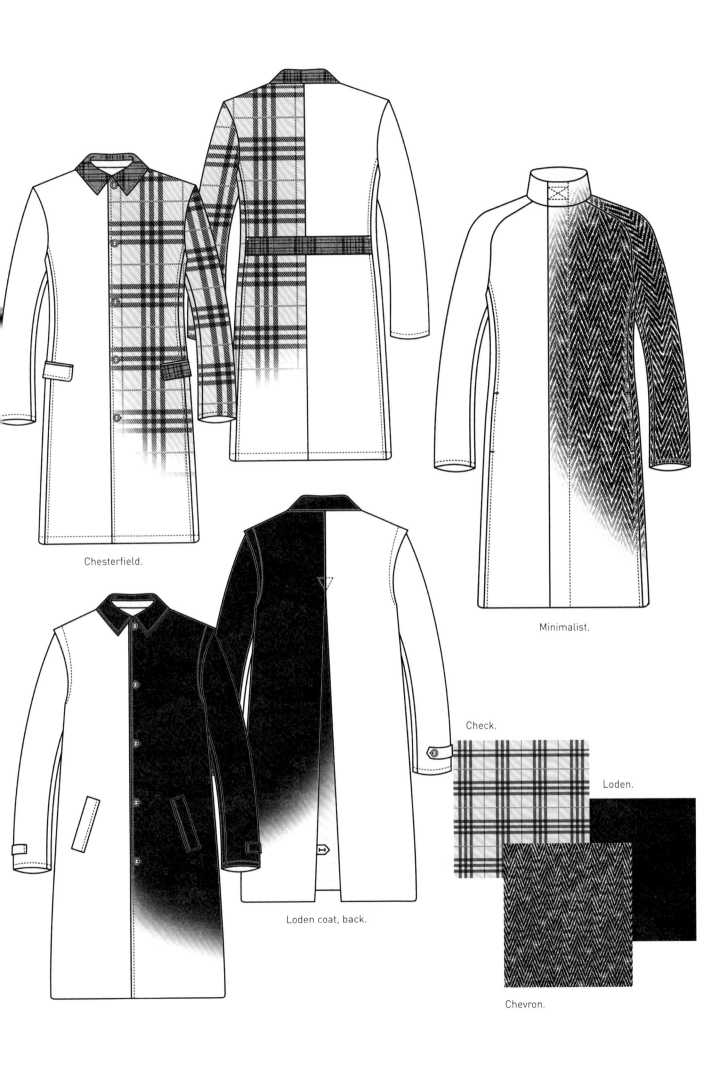

Chesterfield.

Minimalist.

Loden coat, back.

Check.

Loden.

Chevron.

DUFFLE COAT (MONTGOMERY)

The duffle coat is a classic, medium-length coat made of heavyweight khaki wool and featuring a hood and toggles, which was first conceived and worn by the English General B. Montgomery. It is a winter garment that became famous for its practical qualities after the Second World War, especially in the 1960s, when it became a symbol of youth protest due to its non-conformist style. Over time, it has become a versatile garment that is worn in winter over casual or informal outfits and comes back into fashion every year in a variety of colours and designs.

TRENCHCOATS AND RAINCOATS

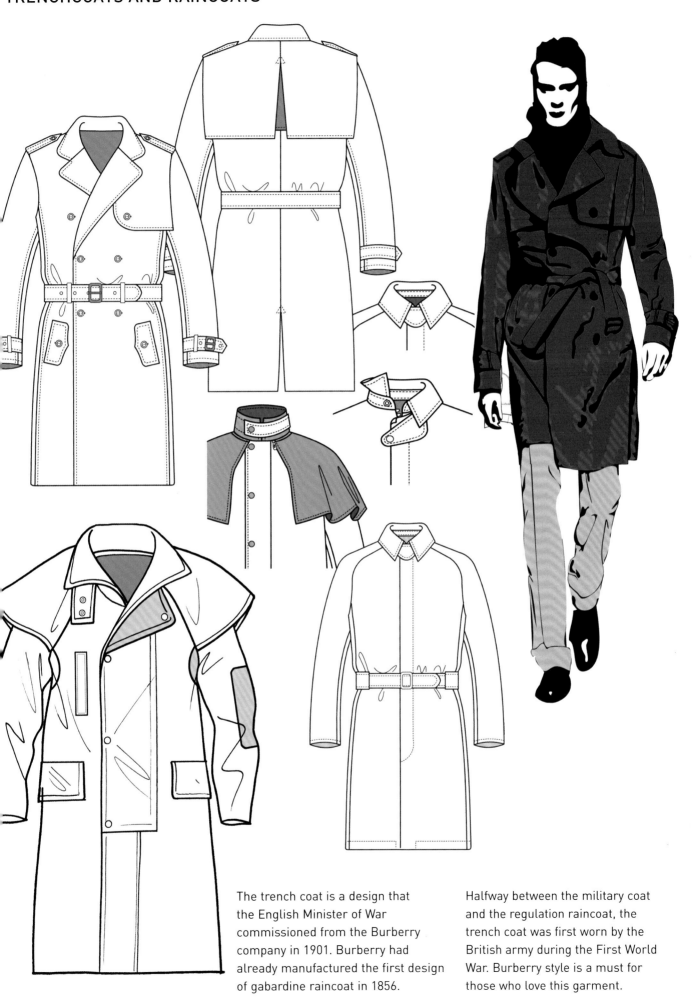

The trench coat is a design that the English Minister of War commissioned from the Burberry company in 1901. Burberry had already manufactured the first design of gabardine raincoat in 1856.

Halfway between the military coat and the regulation raincoat, the trench coat was first worn by the British army during the First World War. Burberry style is a must for those who love this garment.

MILITARY STYLE COAT

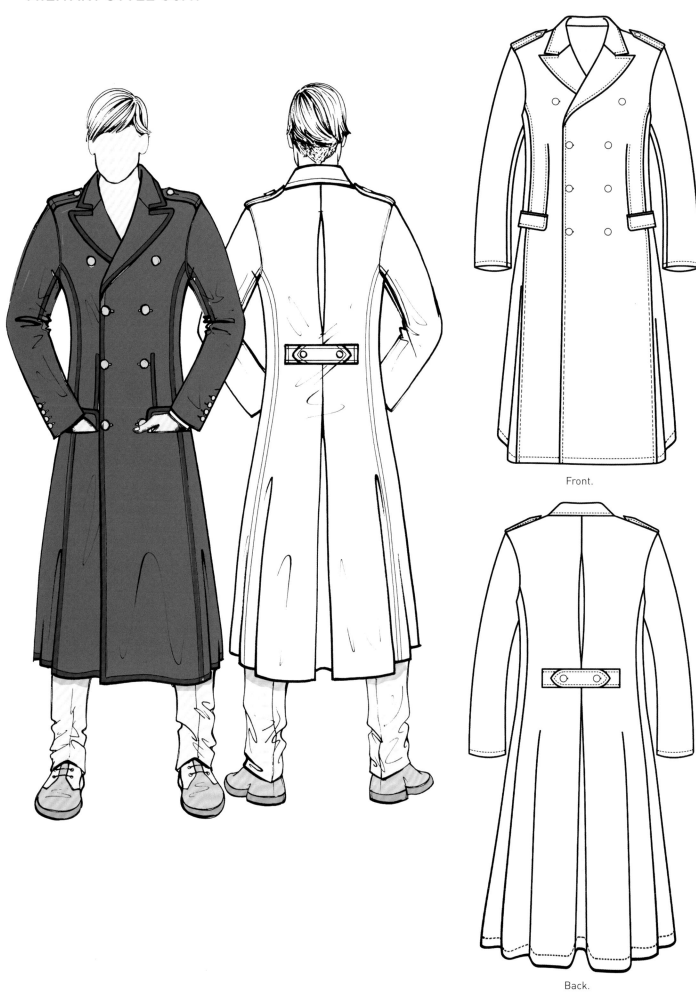

Front.

Back.

CONTEMPORARY OVERCOAT DESIGNS

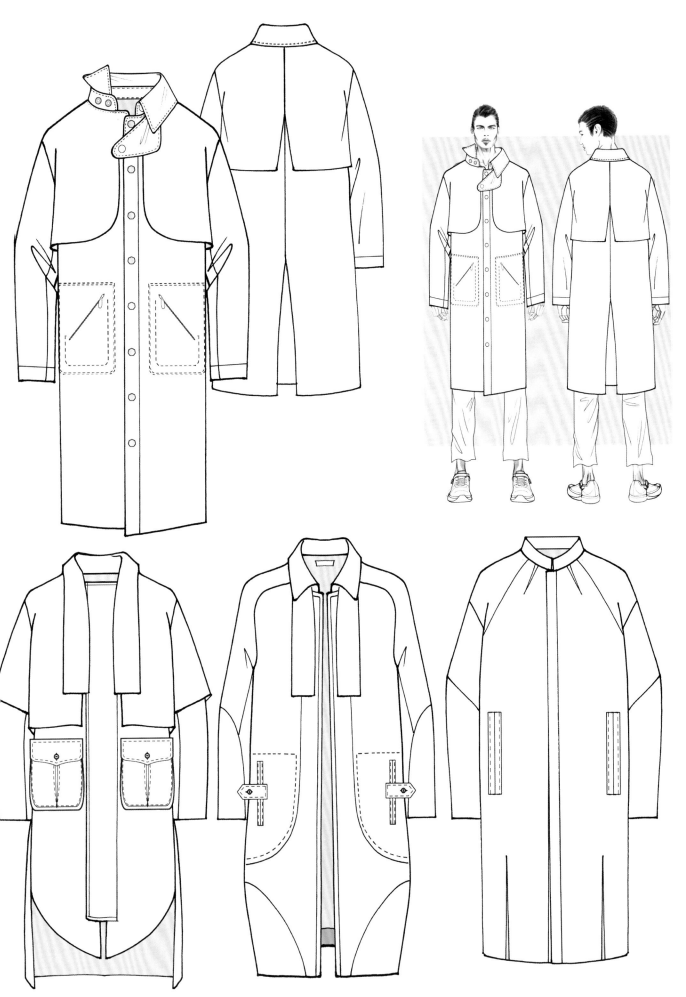

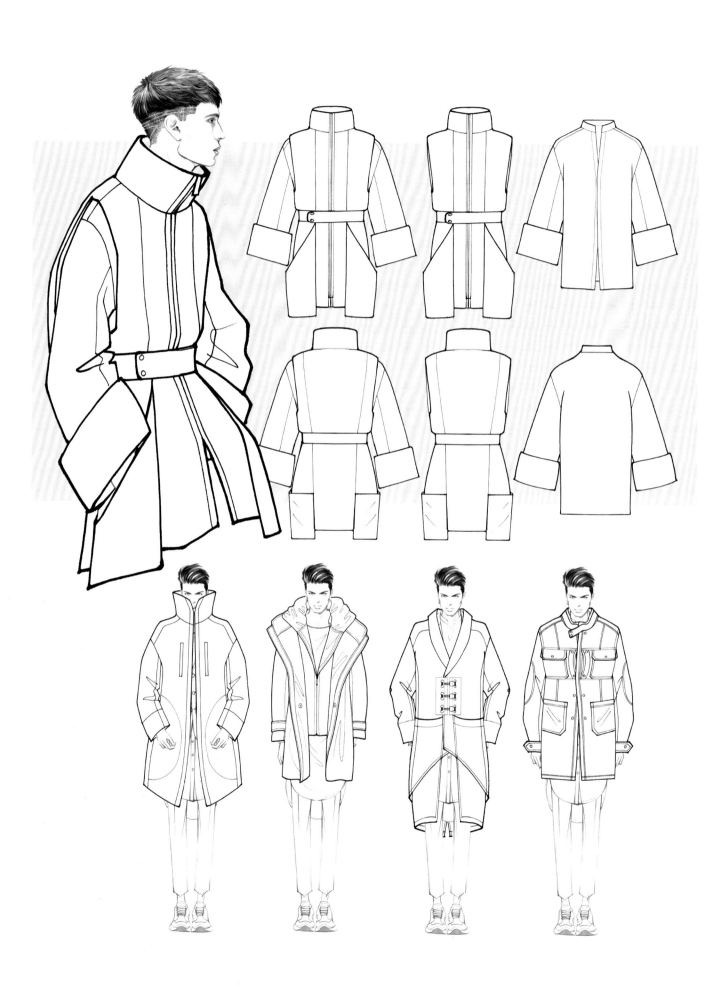

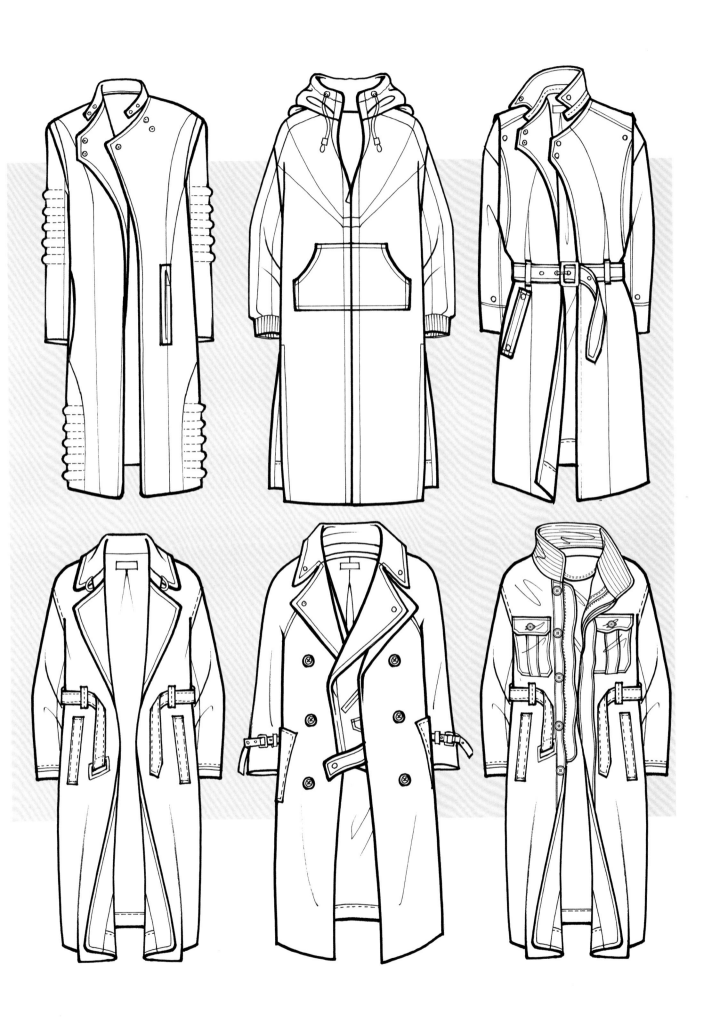

PATCHWORK COAT

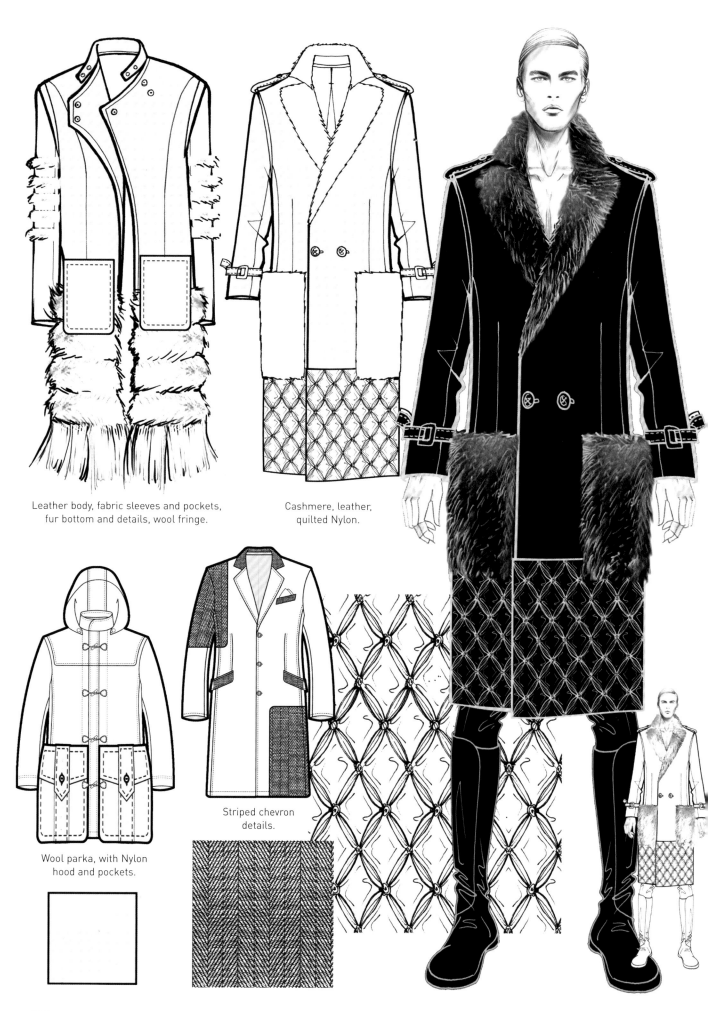

Leather body, fabric sleeves and pockets, fur bottom and details, wool fringe.

Cashmere, leather, quilted Nylon.

Wool parka, with Nylon hood and pockets.

Striped chevron details.

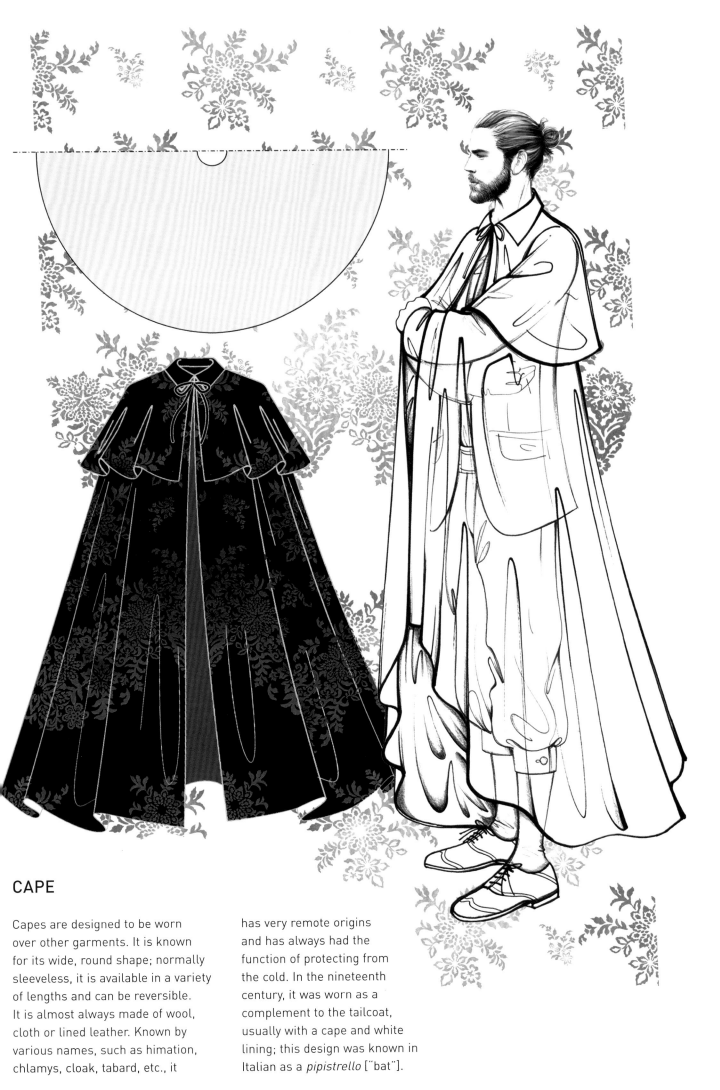

CAPE

Capes are designed to be worn over other garments. It is known for its wide, round shape; normally sleeveless, it is available in a variety of lengths and can be reversible. It is almost always made of wool, cloth or lined leather. Known by various names, such as himation, chlamys, cloak, tabard, etc., it has very remote origins and has always had the function of protecting from the cold. In the nineteenth century, it was worn as a complement to the tailcoat, usually with a cape and white lining; this design was known in Italian as a *pipistrello* [˝bat˝].

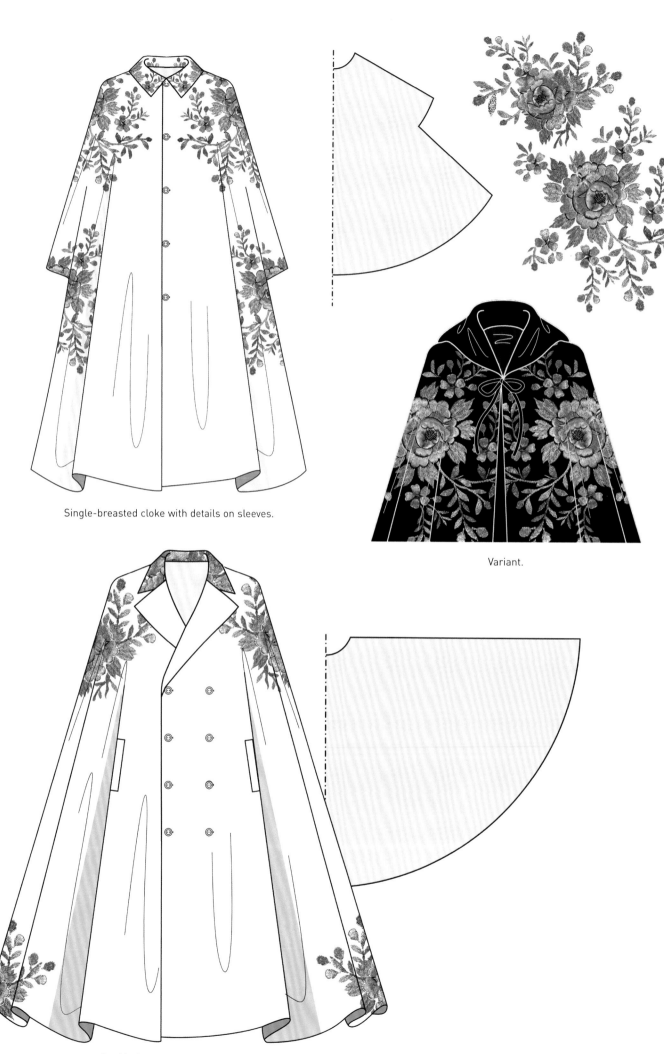

Single-breasted cloke with details on sleeves.

Variant.

Double-breasted cloak with reverse.

PONCHO

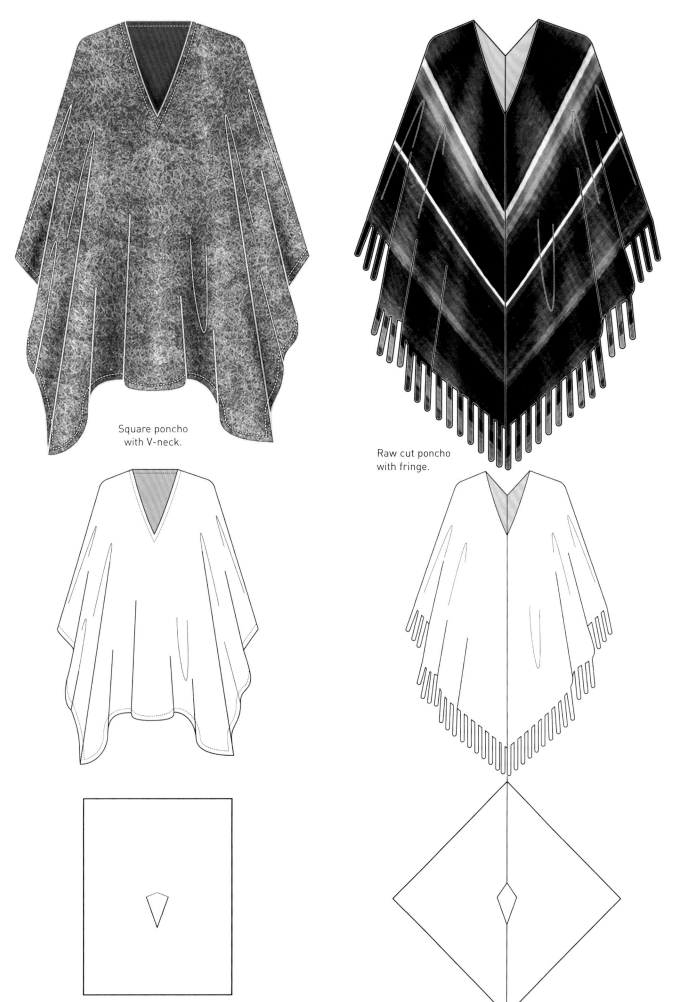

Square poncho
with V-neck.

Raw cut poncho
with fringe.

FAUX SHEARLING - MAXI GILET

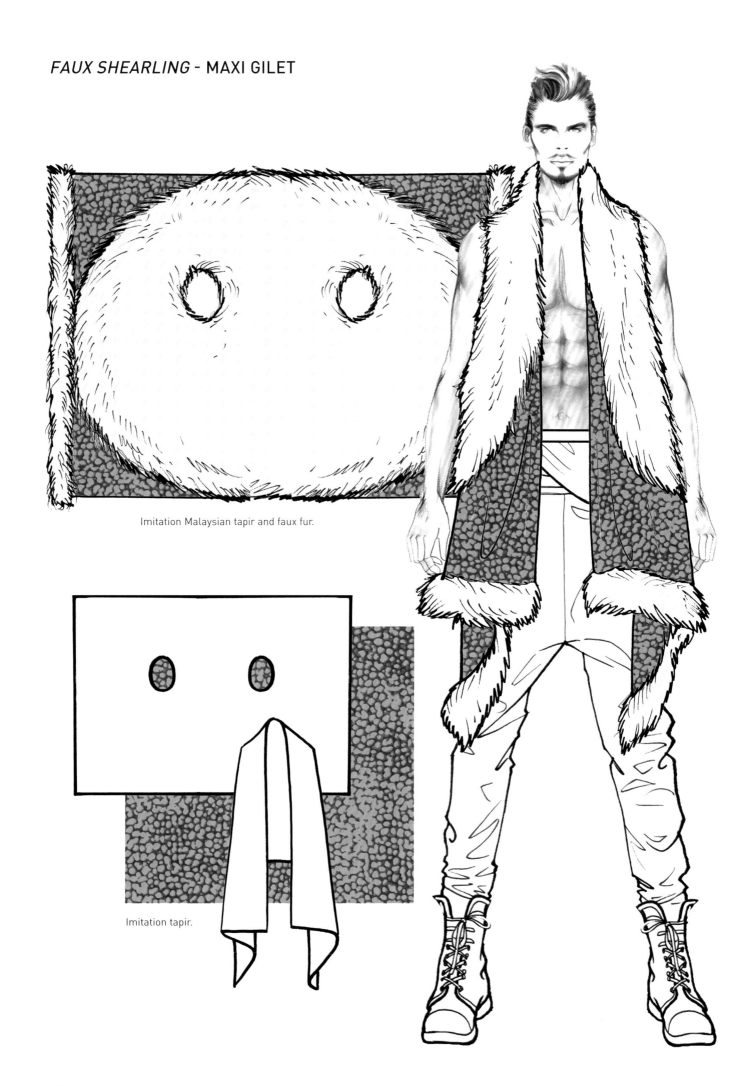

Imitation Malaysian tapir and faux fur.

Imitation tapir.

CASUAL JACKETS

Jackets and windbreakers are staples of men's wardrobes and can even replace an overcoat.
Long or short, padded or lined, light or heavy, but always made with soft and warm fabrics, they are worn with classic trousers or jogging bottoms. Every year, fashion interprets it in very different ways, depending on what is in vogue.

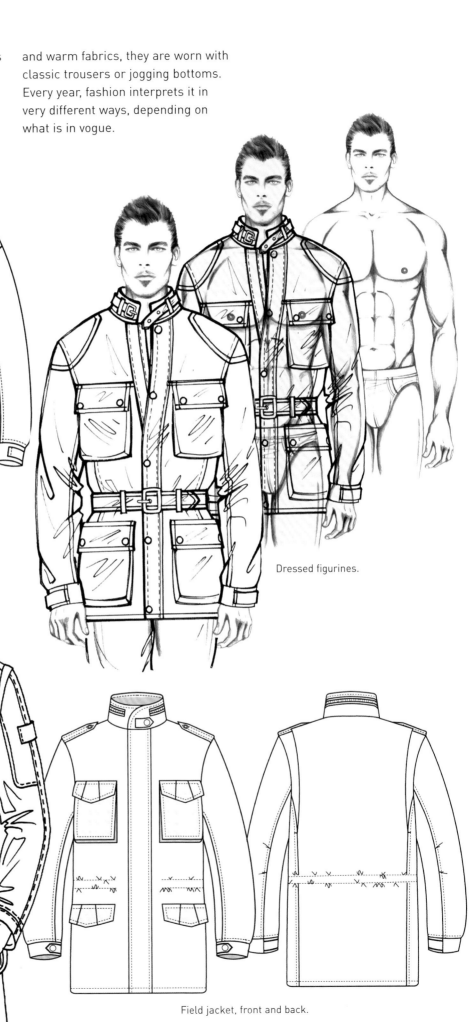

Belstaff style.

Dressed figurines.

Field jacket, front and back.

PADDED JACKETS

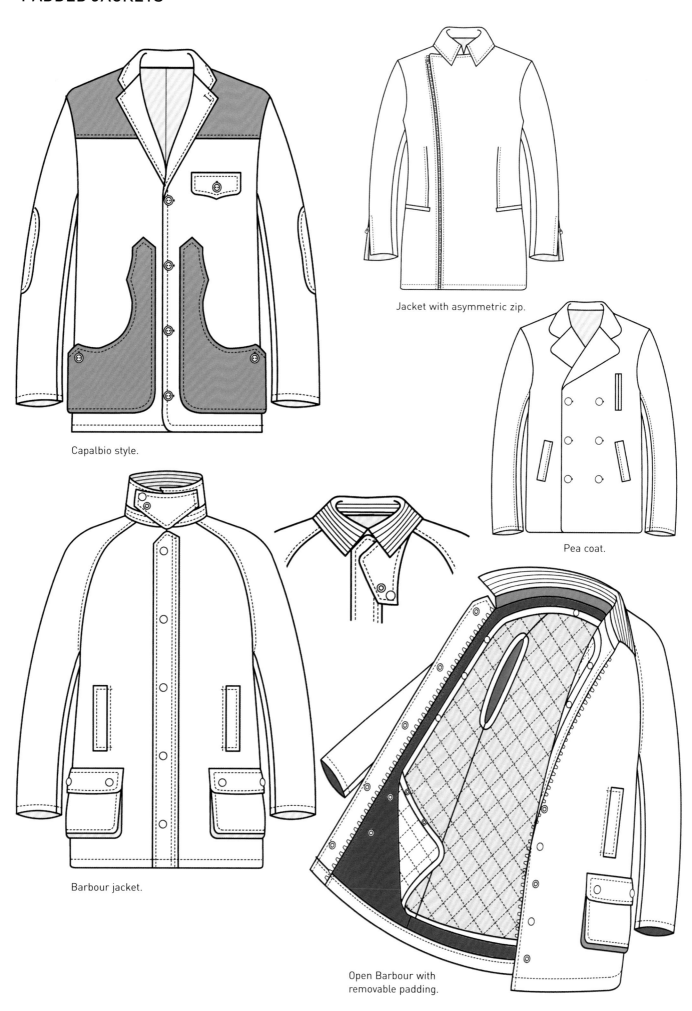

Capalbio style.

Jacket with asymmetric zip.

Pea coat.

Barbour jacket.

Open Barbour with removable padding.

JACKETS WITH FUR DETAILS

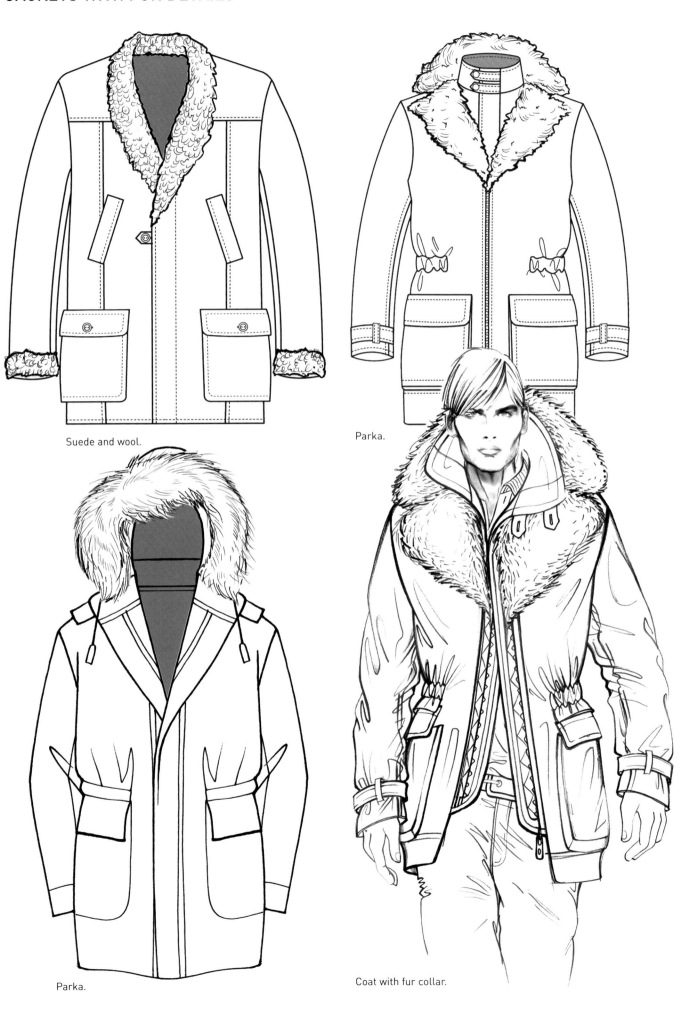

Suede and wool.

Parka.

Parka.

Coat with fur collar.

HUNTING WAISTCOAT

Hunting jackets are waist-length outer garments that feature a button or zip closure; like other jackets, they can be made in a variety of weights, styles and materials.

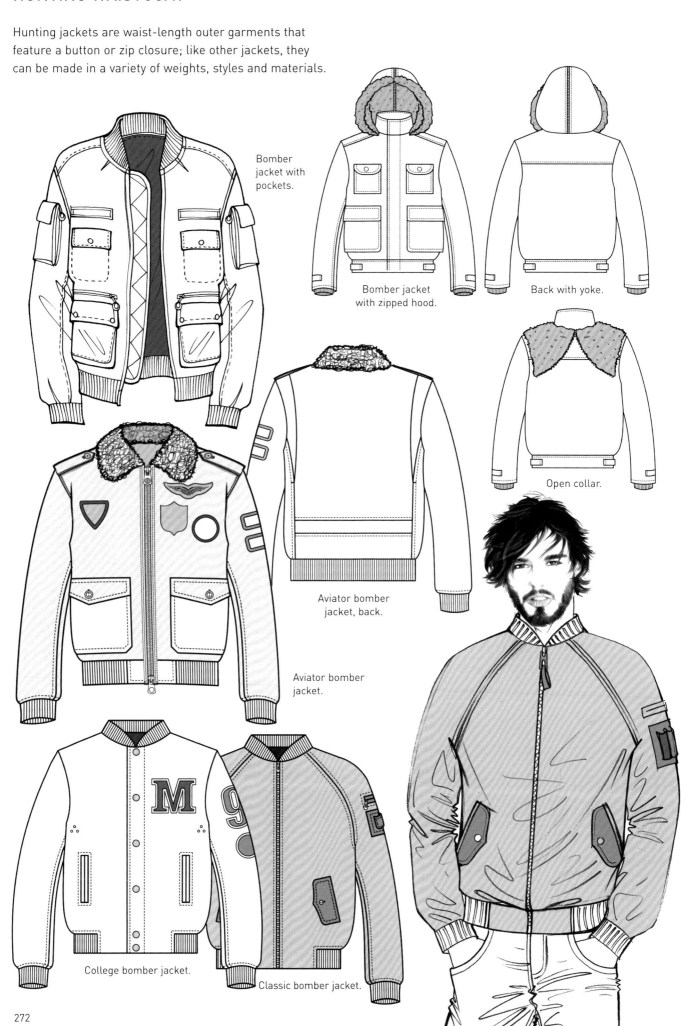

Bomber jacket with pockets.

Bomber jacket with zipped hood.

Back with yoke.

Open collar.

Aviator bomber jacket, back.

Aviator bomber jacket.

College bomber jacket.

Classic bomber jacket.

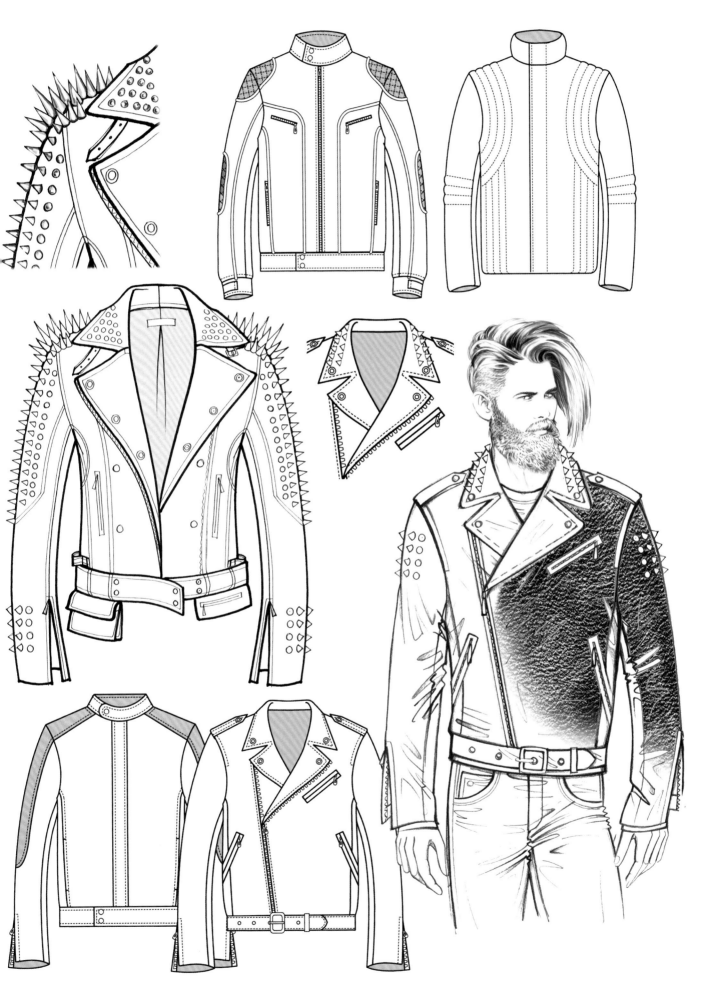

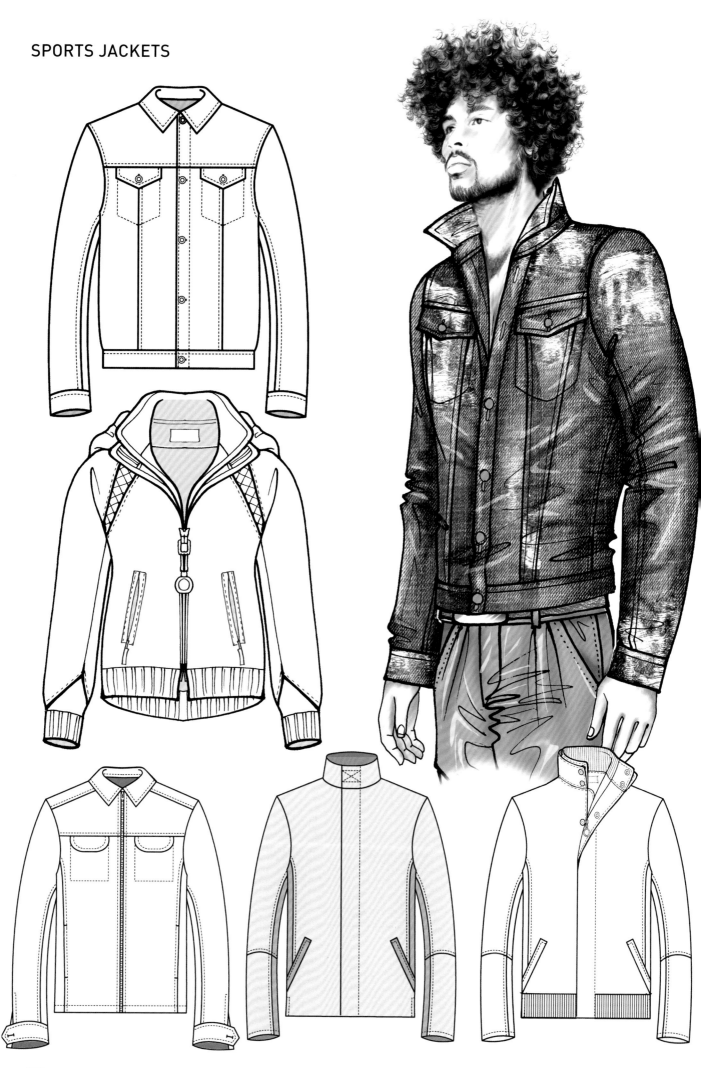

VARIOUS TYPES OF JACKET COLLAR

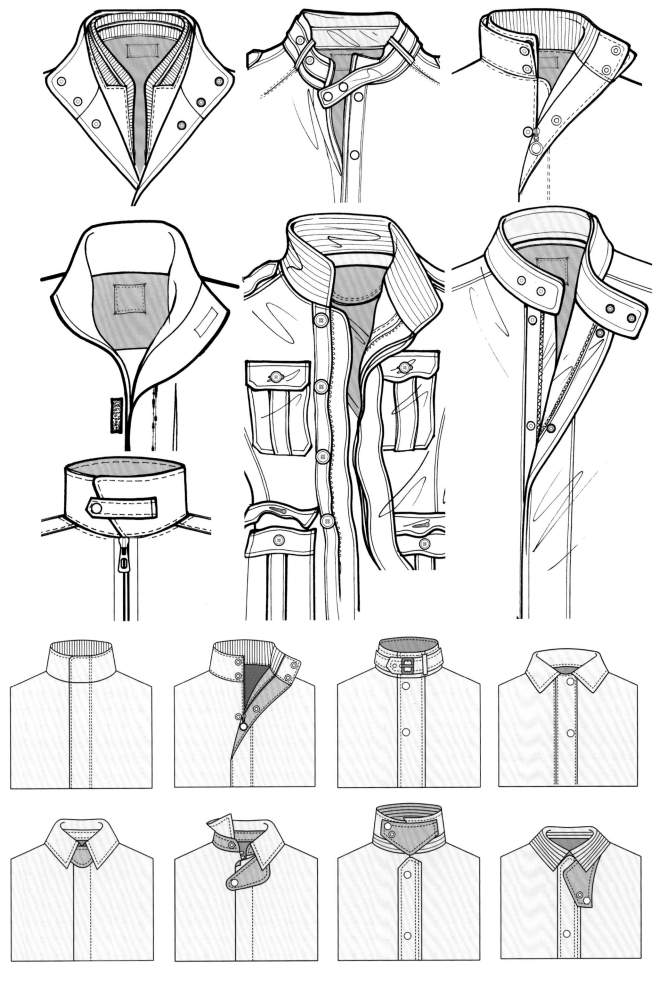

PUFFER JACKETS

Puffer jackets are winter garments
that are filled with goose feathers or
synthetic materials.

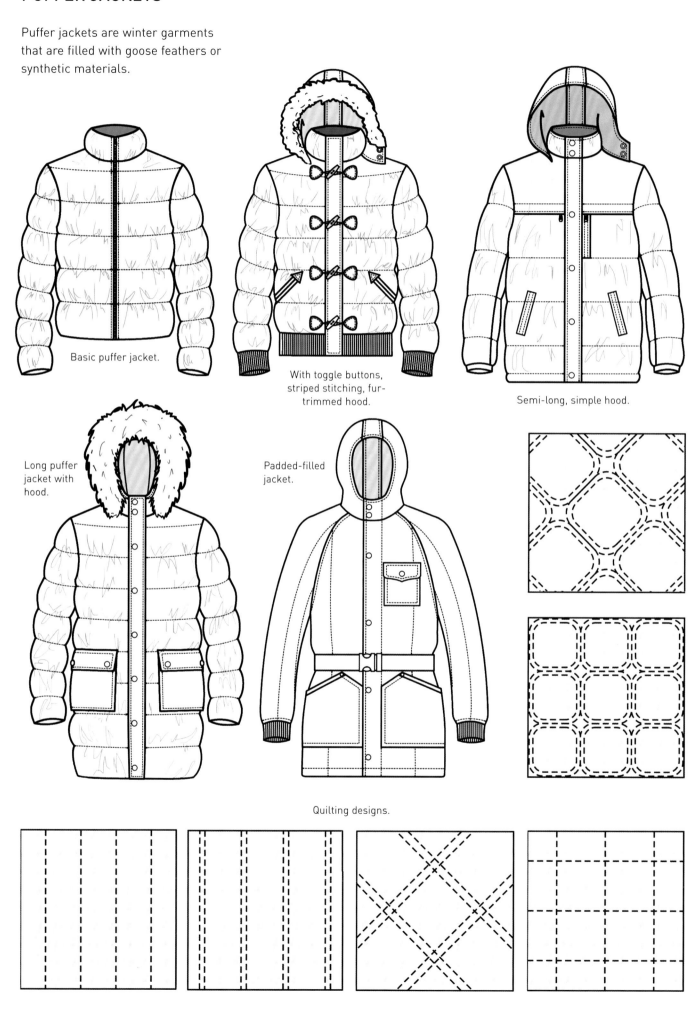

Basic puffer jacket.

With toggle buttons,
striped stitching, fur-
trimmed hood.

Semi-long, simple hood.

Long puffer
jacket with
hood.

Padded-filled
jacket.

Quilting designs.

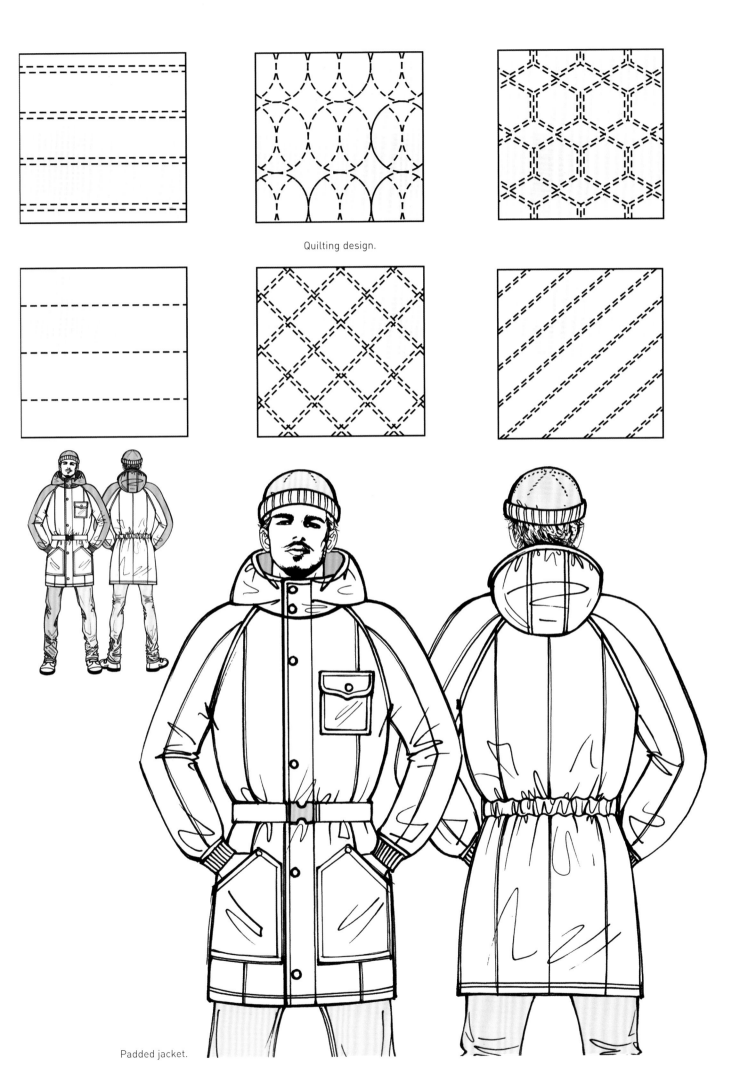

Quilting design.

Padded jacket.

LINED ANORAK

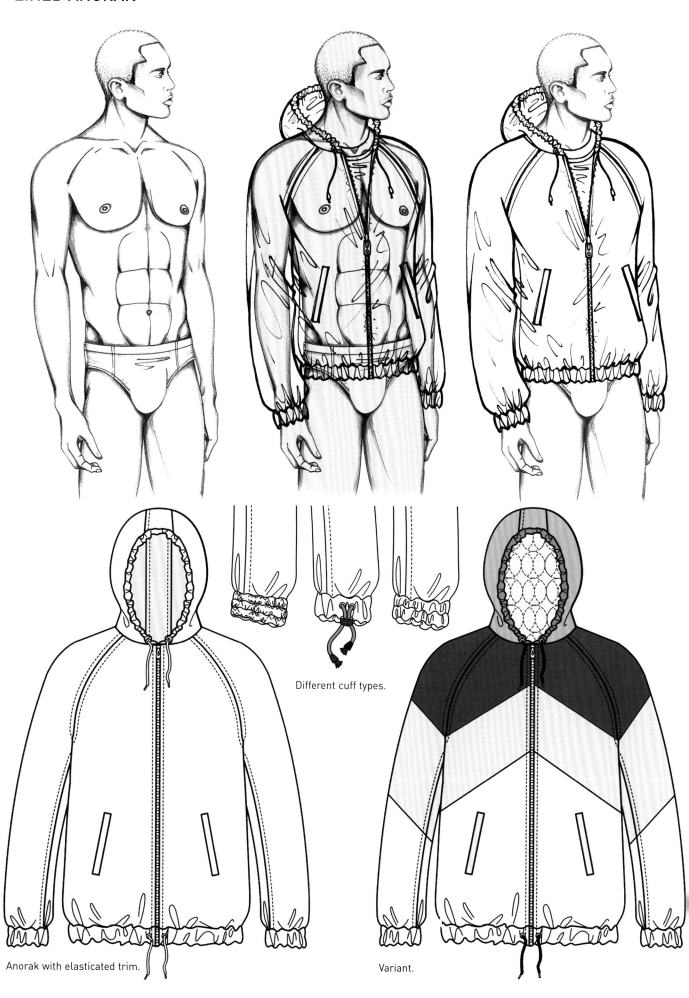

Different cuff types.

Anorak with elasticated trim.

Variant.

RAINCOATS

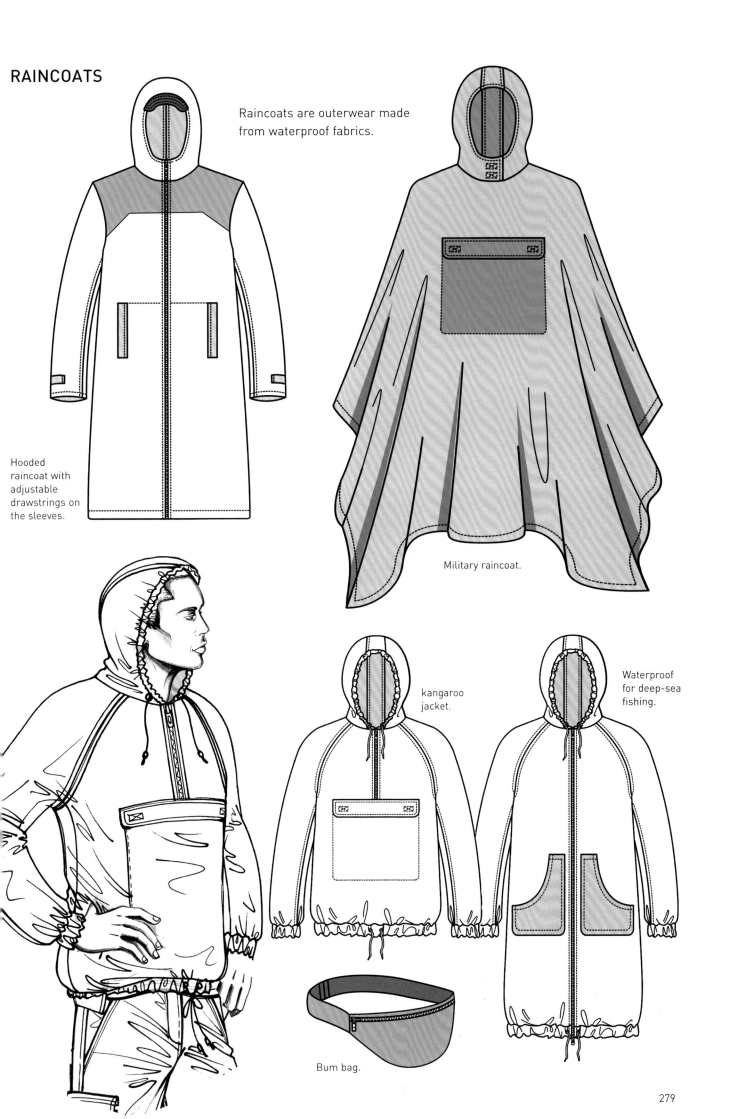

Raincoats are outerwear made from waterproof fabrics.

Hooded raincoat with adjustable drawstrings on the sleeves.

Military raincoat.

kangaroo jacket.

Waterproof for deep-sea fishing.

Bum bag.

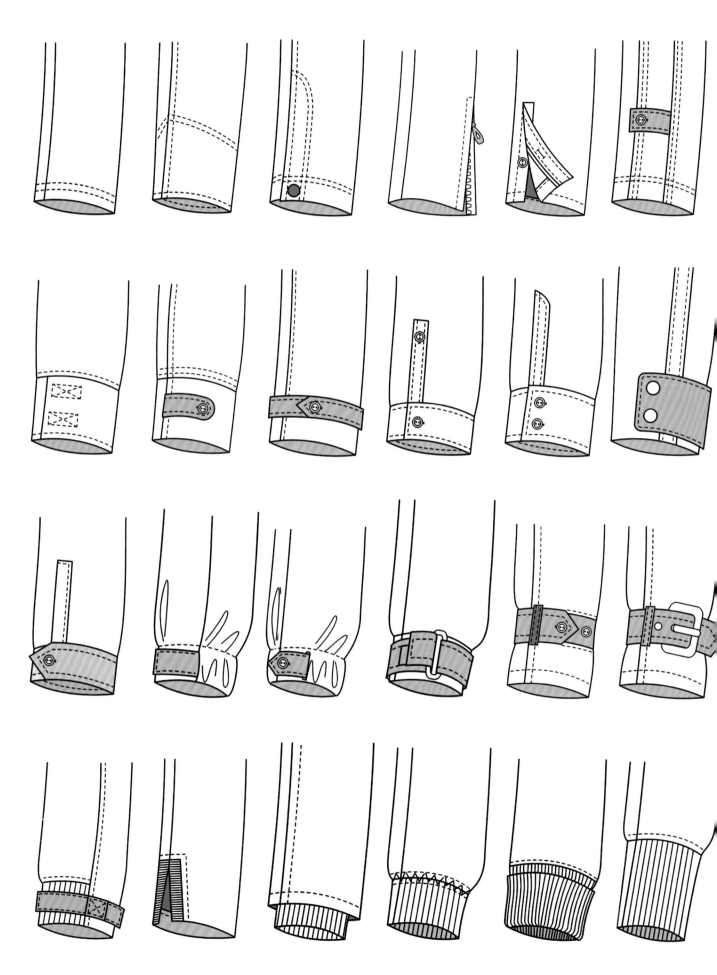

JACKET

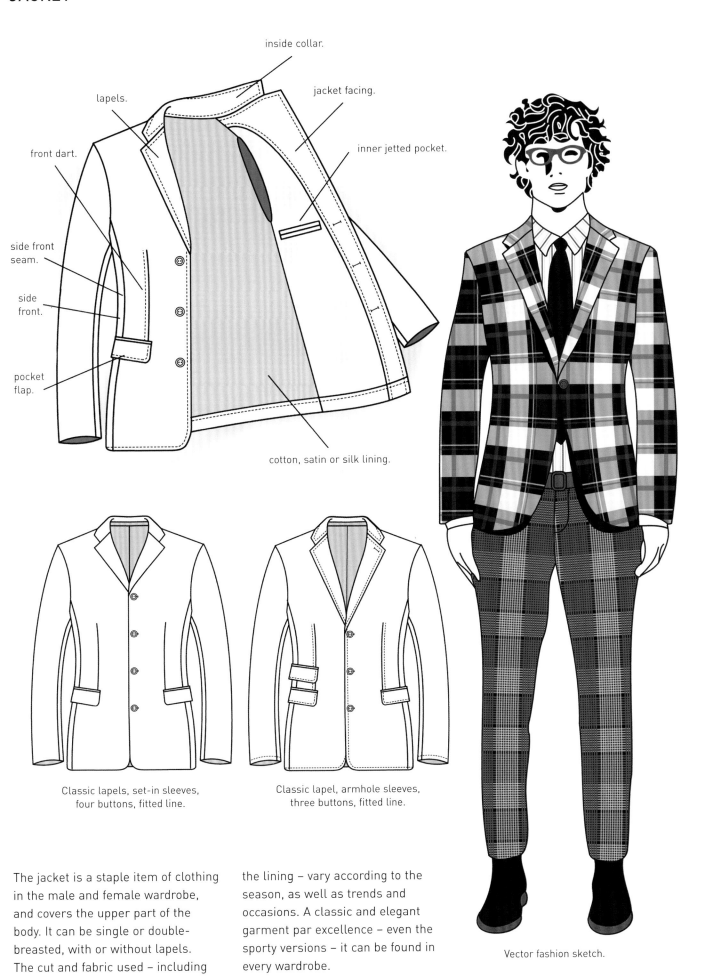

inside collar.

jacket facing.

lapels.

inner jetted pocket.

front dart.

side front seam.

side front.

pocket flap.

cotton, satin or silk lining.

Classic lapels, set-in sleeves, four buttons, fitted line.

Classic lapel, armhole sleeves, three buttons, fitted line.

The jacket is a staple item of clothing in the male and female wardrobe, and covers the upper part of the body. It can be single or double-breasted, with or without lapels. The cut and fabric used – including the lining – vary according to the season, as well as trends and occasions. A classic and elegant garment par excellence – even the sporty versions – it can be found in every wardrobe.

Vector fashion sketch.

BACKS OF JACKETS

The jacket slit came about for reasons of comfort and to facilitate the action of sitting.

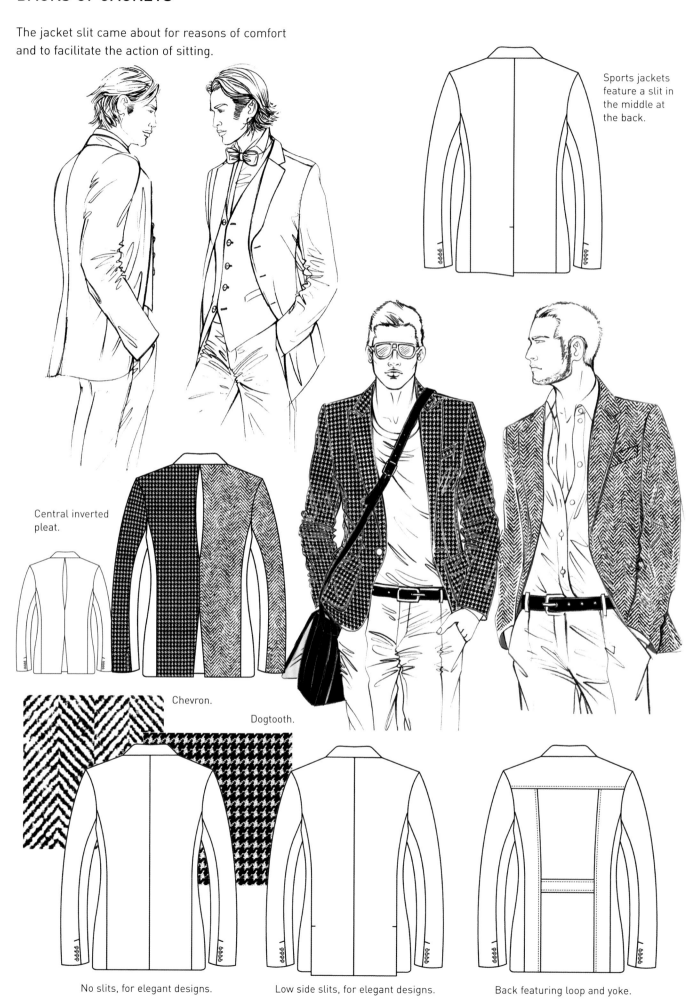

Sports jackets feature a slit in the middle at the back.

Central inverted pleat.

Chevron.

Dogtooth.

No slits, for elegant designs.

Low side slits, for elegant designs.

Back featuring loop and yoke.

ELEGANT JACKETS

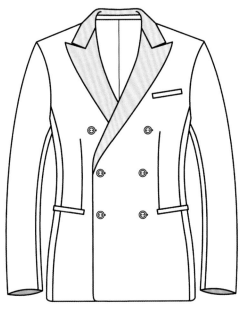

Peak lapels,
set-in sleeves,
six buttons.

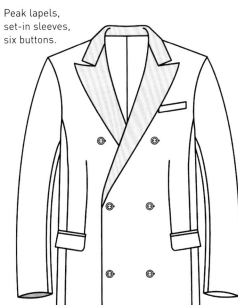

Navy blazer.

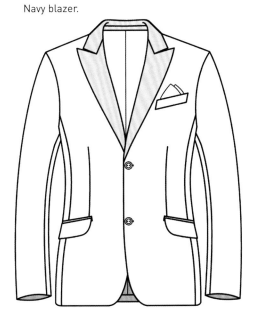

Peak lapels, set-in sleeves,
two buttons, fitted line.

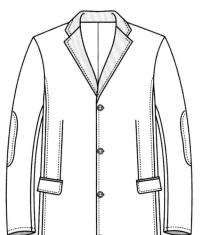

Small lapels, set-in sleeves,
four buttons, straight line.

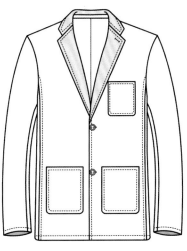

Classic lapels, set-in sleeves, two
buttons, casual patch pockets.

VARIOUS TYPES OF JACKETS

Colonial Saharan.

Norfolk.

Unstructured.

19th century military style, straight line.

19th century military style, slim fit.

Figurine coloured in with Photoshop.

Korean.

FORMAL SUITS

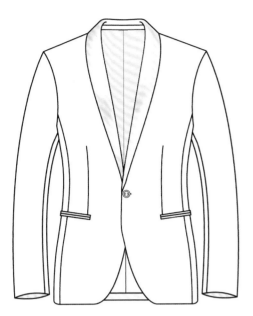

Shawl collar, rounded sleeves,
one button, slim fit.

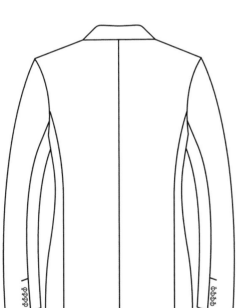

No slit.

Elegant waistcoats.

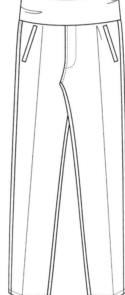

Tuxedo trousers.

Vector fashion sketch.

The tuxedo, also called the *dinner jacket* in the UK and a *smoking* in mainland Europe, constitutes, together with the tailcoat and the jacket, the quintessential elegant suit of a true *gentleman*. The tuxedo debuted in 1896, when Griswold Lorillard wore it for the first time at a dance that went down in history. Since then, this elegant jacket has flawlessly replaced the tailcoat. The black or white versions of the classic design can be single or double-breasted, with shawl or peak lapels. Occasions when this sumptuous garment can be worn are currently limited to ceremonies, concerts, large social evenings and gala dinners where a *white tie*, tailcoat or *black tie* and dinner jacket is expressly requested. No other style is more seductive or gives its wearer more distinction. Immovable to change, this centuries-old symbol of high social status, due to its impeccable and inimitable lines, has always been the formal garment par excellence. As an alternative to these formal garments, a dark suit can be worn: blue, black or ash grey.

GALA EVENING

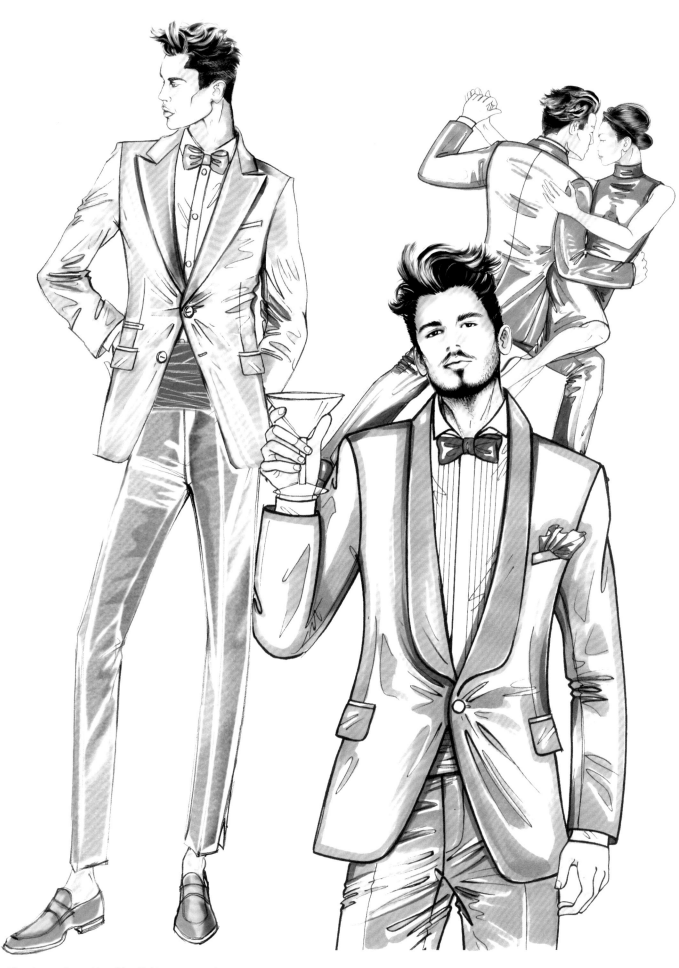

Figurines coloured in with a light mauve marker.

TUXEDO

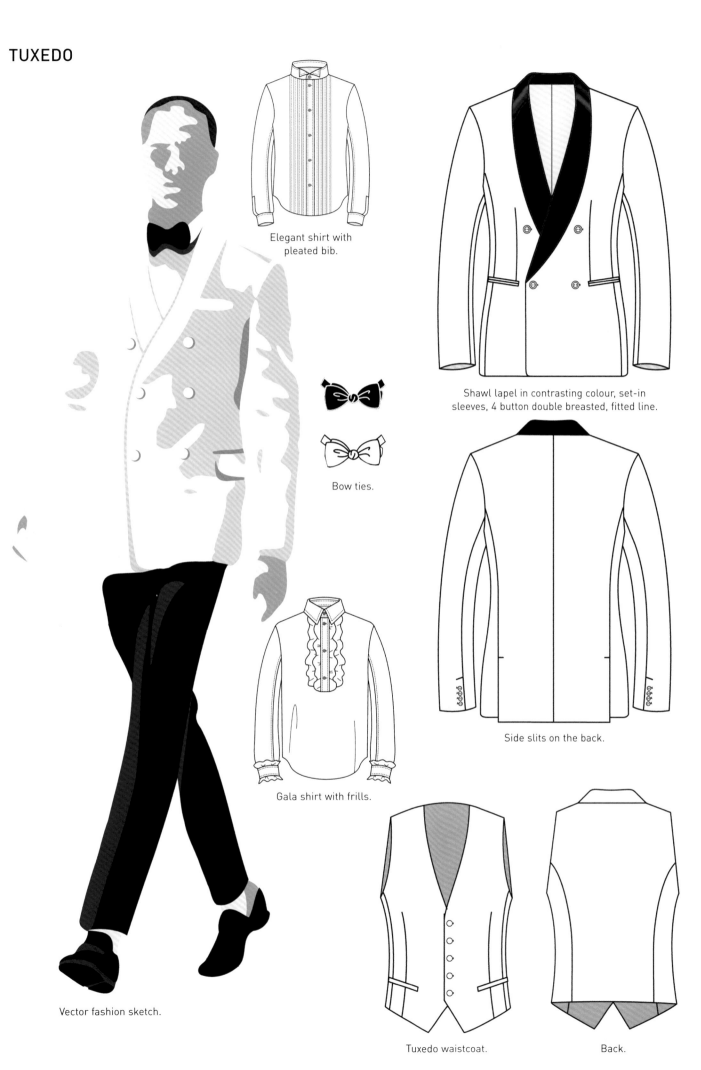

Elegant shirt with pleated bib.

Shawl lapel in contrasting colour, set-in sleeves, 4 button double breasted, fitted line.

Bow ties.

Side slits on the back.

Gala shirt with frills.

Vector fashion sketch.

Tuxedo waistcoat.

Back.

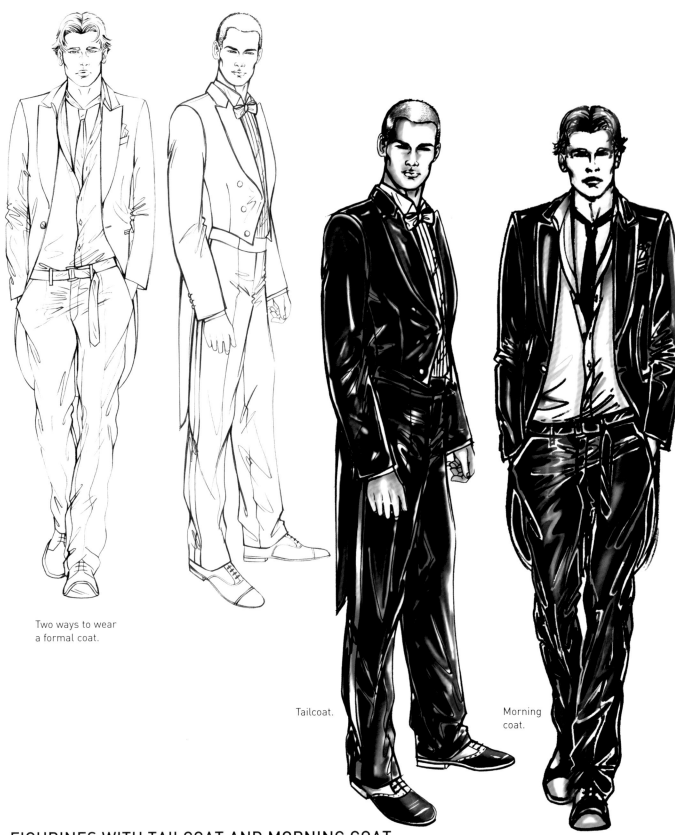

Two ways to wear
a formal coat.

Tailcoat.

Morning
coat.

FIGURINES WITH TAILCOAT AND MORNING COAT

The morning coat is a formal daytime garment that comprises a fitted black jacket (or frock coat) that features long, narrow tails, and black or grey vertically-striped trousers, a grey waistcoat and bow tie. The frock coat is a narrow jacket and tails; this black evening attire is not to be worn buttoned up. It is worn with a batiste shirt, white waistcoat, piqué bow tie, scarf, gloves, socks, silk top hat, and black patent leather shoes. Interestingly, some irreverent terms that are used to allude to the hat: "high hat", "silk hat", "stove pipe hat" and "topper", also defined as a gossip designed to scare people away. The gibus, or clack, is a cylinder that flattens and disappears, and opens again with a tap. The spencer or mess jacket is worn by officers for formal dinners. It is similar to a tailcoat, but has no tails. These days, on special occasions in the summertime, young people substitute these garments for the white tuxedo, which is worn with the buttons undone.

MORNING COAT - TAILCOAT - SPENCER

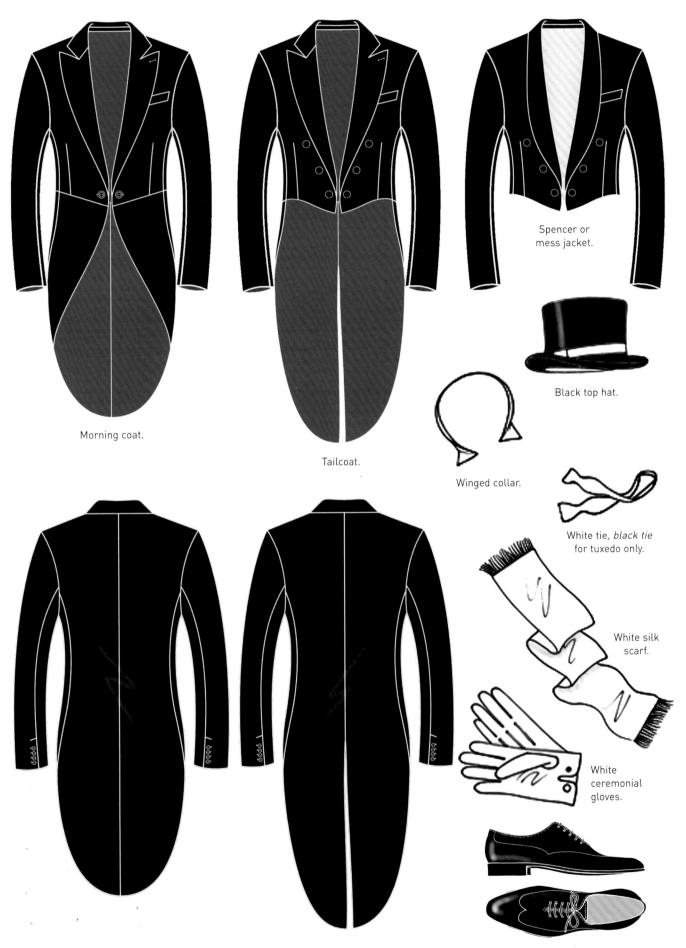

Morning coat.

Tailcoat.

Spencer or mess jacket.

Black top hat.

Winged collar.

White tie, *black tie* for tuxedo only.

White silk scarf.

White ceremonial gloves.

Black patent leather shoes with laces.

HACKING JACKET - RIDING JACKET

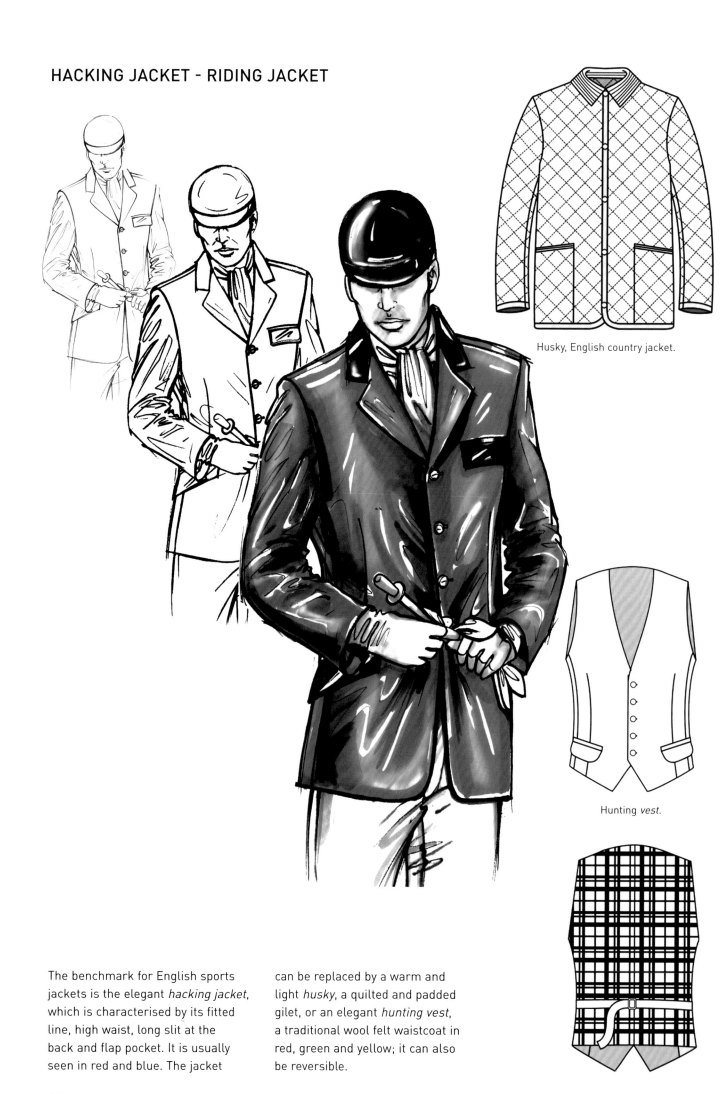

Husky, English country jacket.

Hunting *vest*.

The benchmark for English sports jackets is the elegant *hacking jacket*, which is characterised by its fitted line, high waist, long slit at the back and flap pocket. It is usually seen in red and blue. The jacket can be replaced by a warm and light *husky*, a quilted and padded gilet, or an elegant *hunting vest*, a traditional wool felt waistcoat in red, green and yellow; it can also be reversible.

TYPES OF WAISTCOATS

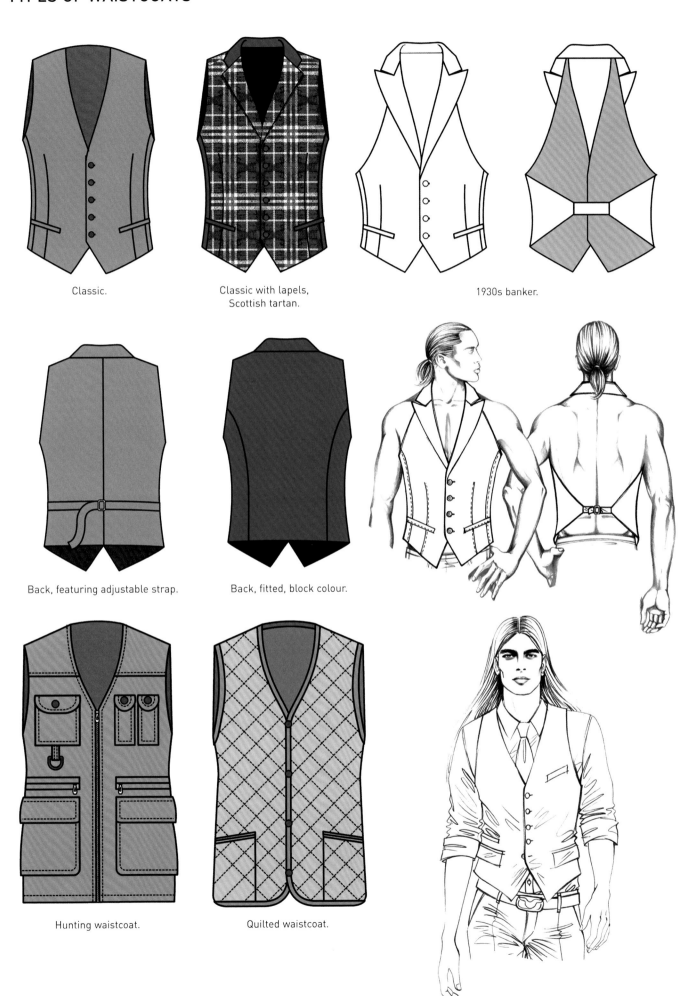

Classic.

Classic with lapels,
Scottish tartan.

1930s banker.

Back, featuring adjustable strap.

Back, fitted, block colour.

Hunting waistcoat.

Quilted waistcoat.

TIES AND STYLES

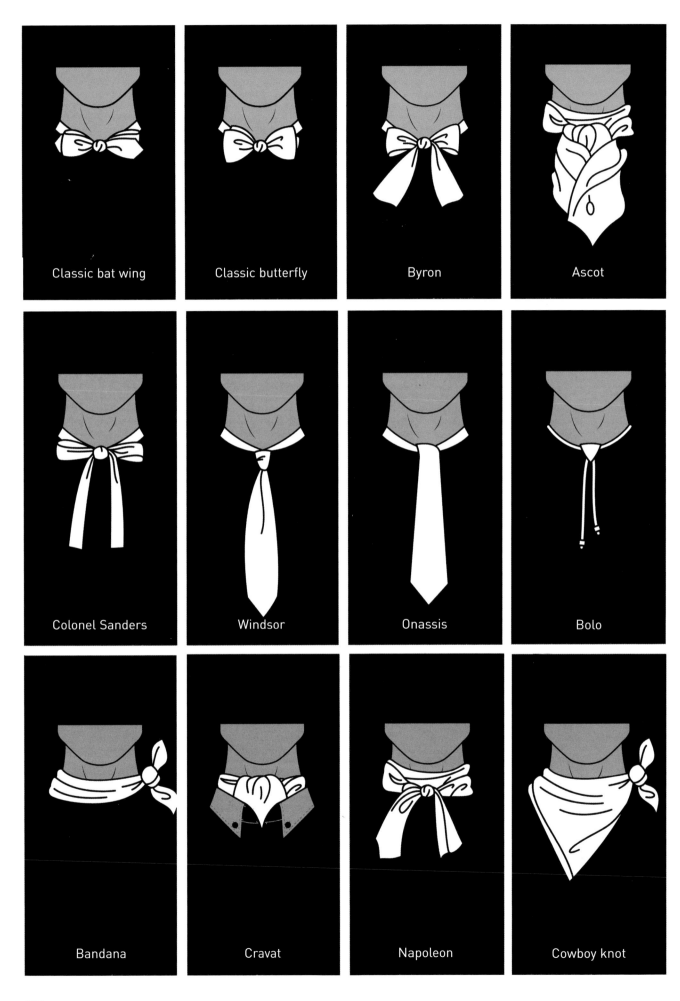

Classic bat wing

Classic butterfly

Byron

Ascot

Colonel Sanders

Windsor

Onassis

Bolo

Bandana

Cravat

Napoleon

Cowboy knot

THE SHIRT

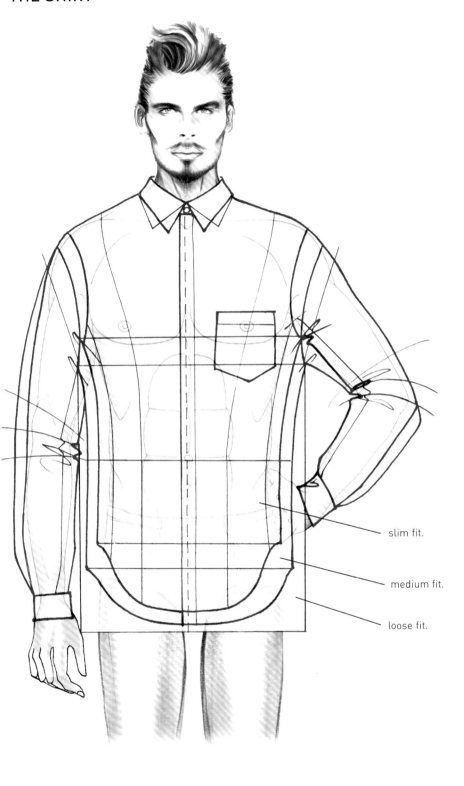

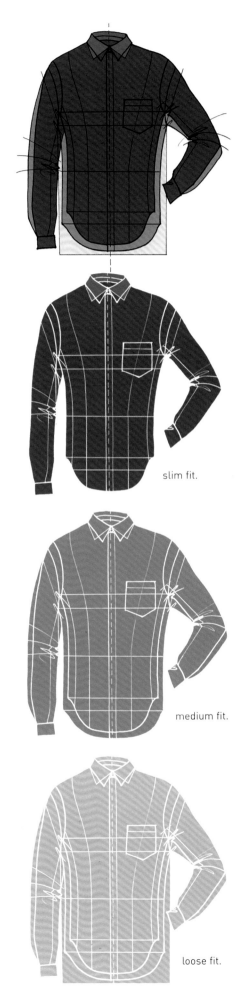

slim fit.

slim fit.

medium fit.

medium fit.

loose fit.

loose fit.

With or without a collar, with long or short sleeves and available in various widths and lengths, the shirt is a staple of the men's wardrobe.
Ties are made in various fabrics: cotton, fustian, velvet, silk, etc. Their many widths are shown in these drawings.

PARTS OF THE SHIRT

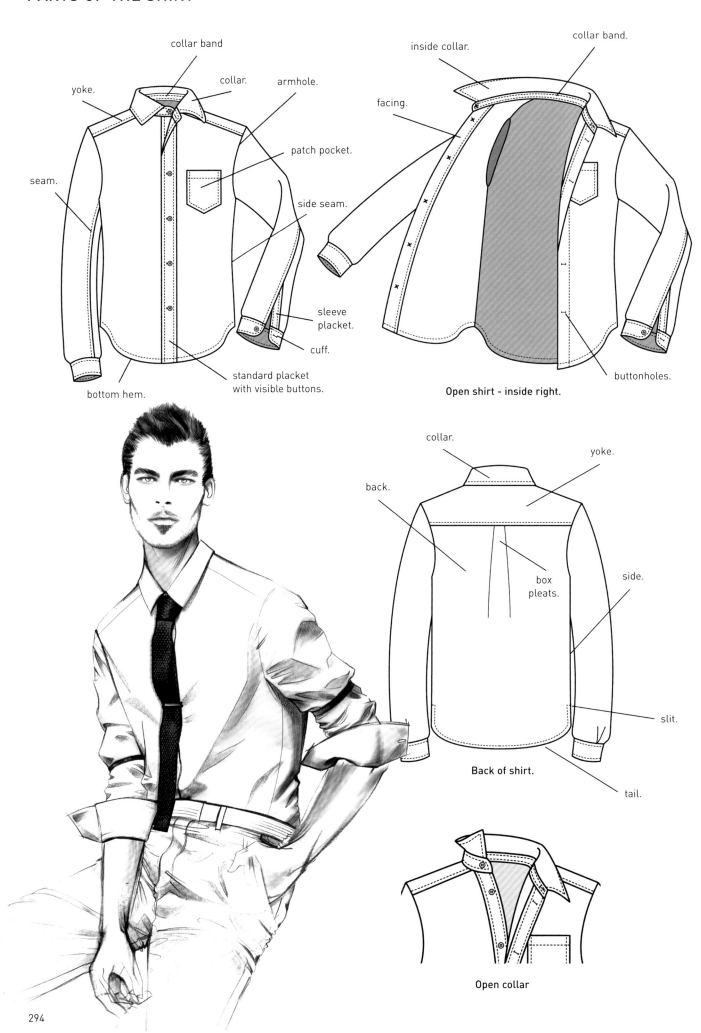

collar band

collar.

yoke.

armhole.

patch pocket.

seam.

side seam.

sleeve placket.

cuff.

standard placket with visible buttons.

bottom hem.

inside collar.

collar band.

facing.

buttonholes.

Open shirt - inside right.

collar.

yoke.

back.

box pleats.

side.

slit.

Back of shirt.

tail.

Open collar

ELEGANT SHIRTS

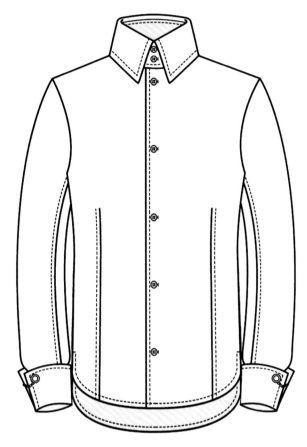

Elegant exposed stitching, straight
pointed collar, cuffs with cufflinks.

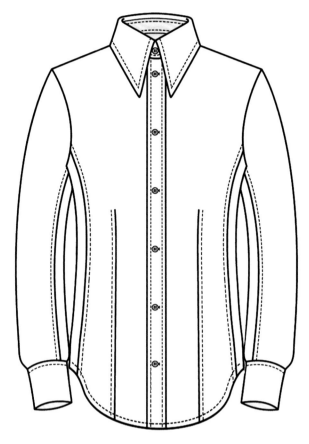

70's style, tight-fitting, long
pointed collar, wide cuffs.

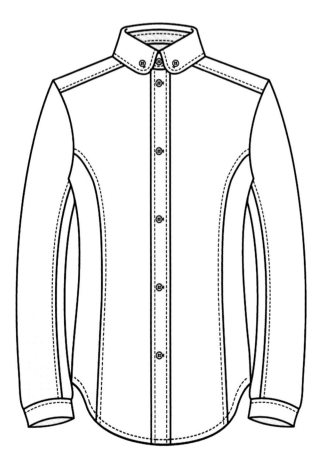

Fitted cut, featuring pleats
and small, buttoned collar.

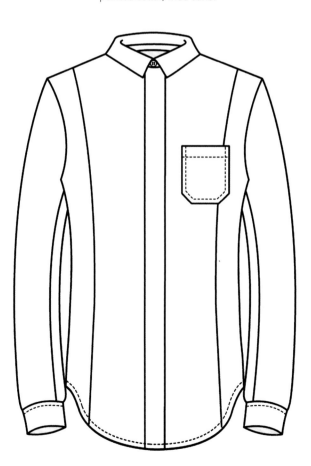

Fitted cut, featuring stitched
pocket, soft collar and pleats.

CASUAL SHIRTS

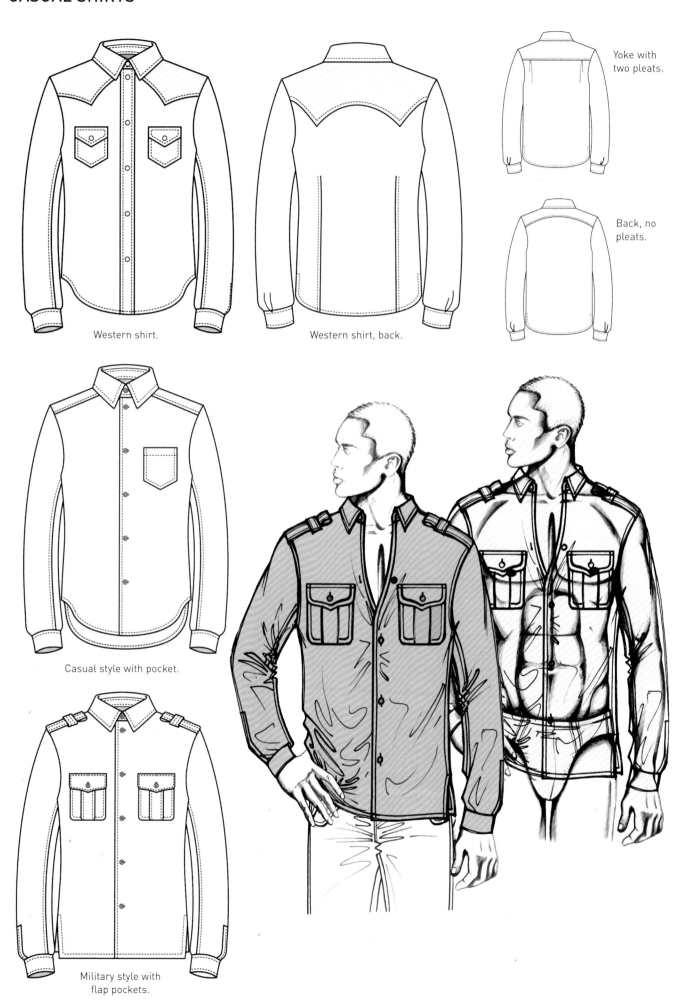

Western shirt.

Western shirt, back.

Yoke with two pleats.

Back, no pleats.

Casual style with pocket.

Military style with flap pockets.

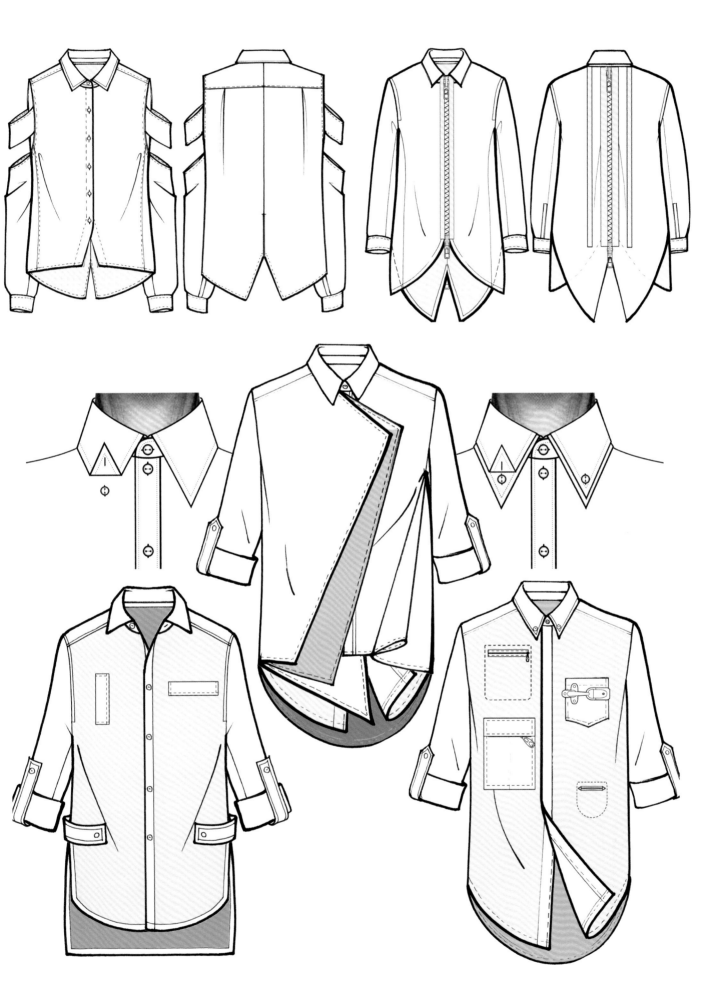

ELEGANT COLLARS

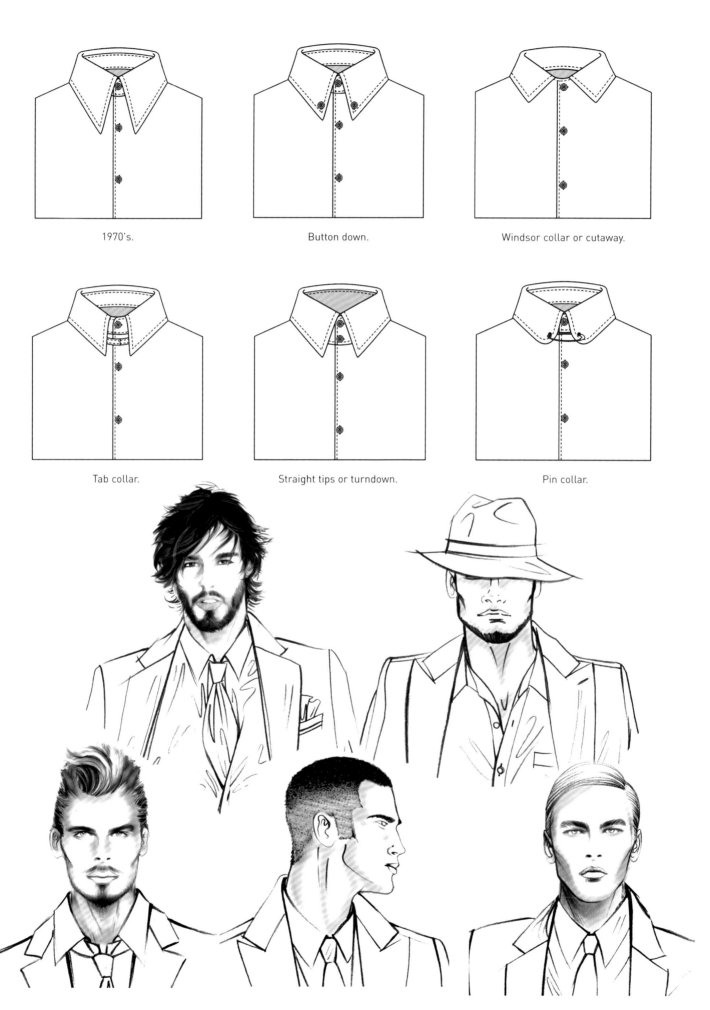

1970's.

Button down.

Windsor collar or cutaway.

Tab collar.

Straight tips or turndown.

Pin collar.

THE COLLAR SEEN FROM VARIOUS ANGLES

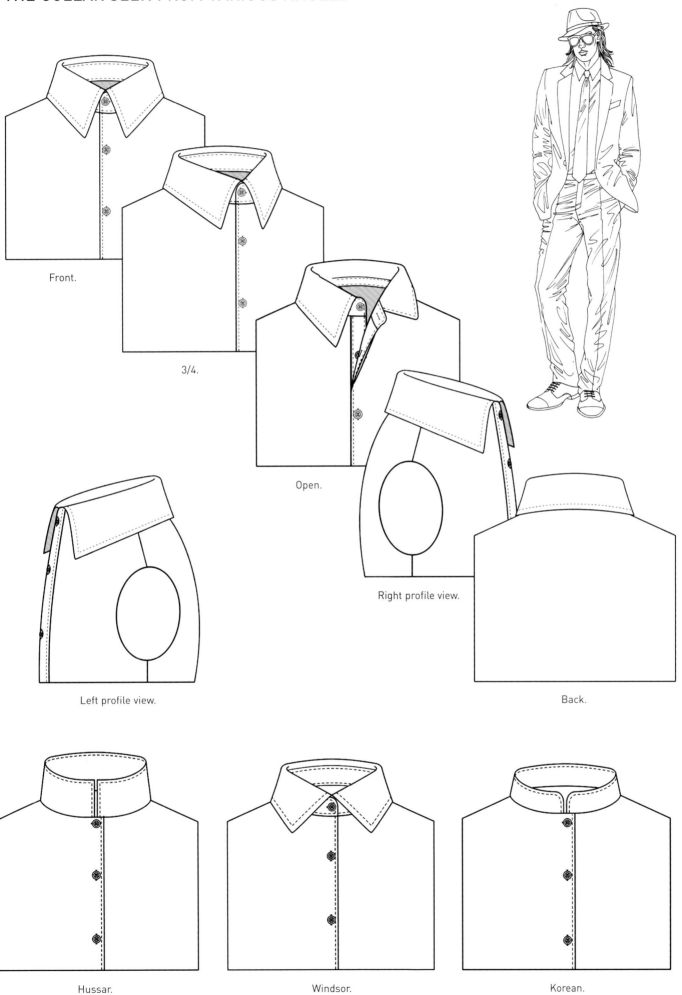

Front.

3/4.

Open.

Right profile view.

Left profile view.

Back.

Hussar.

Windsor.

Korean.

TYPES OF CUFFS

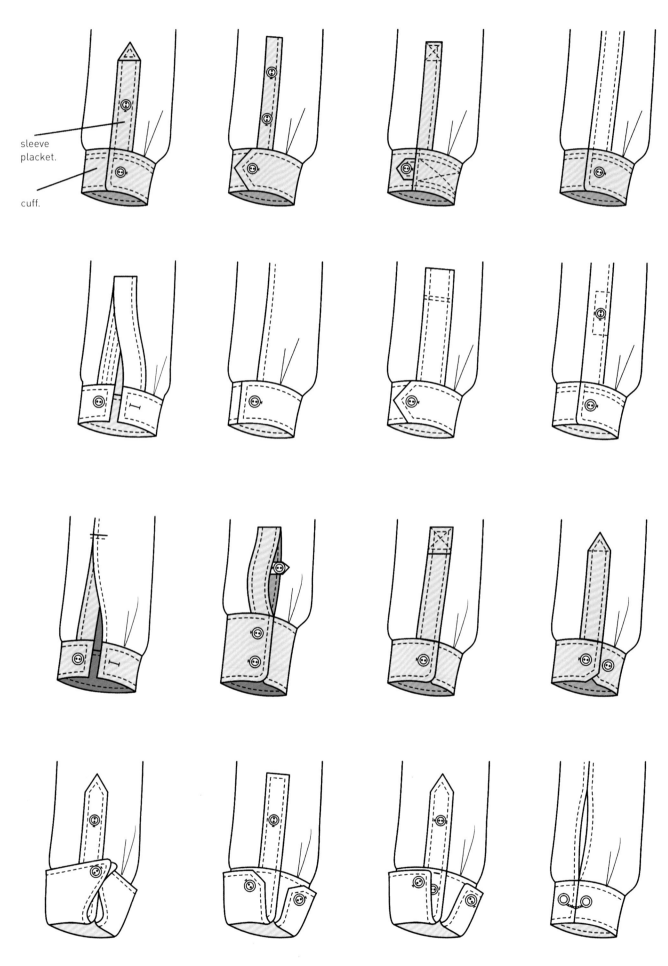

sleeve
placket.

cuff.

Elegant cuffs with cufflinks.

KNITWEAR

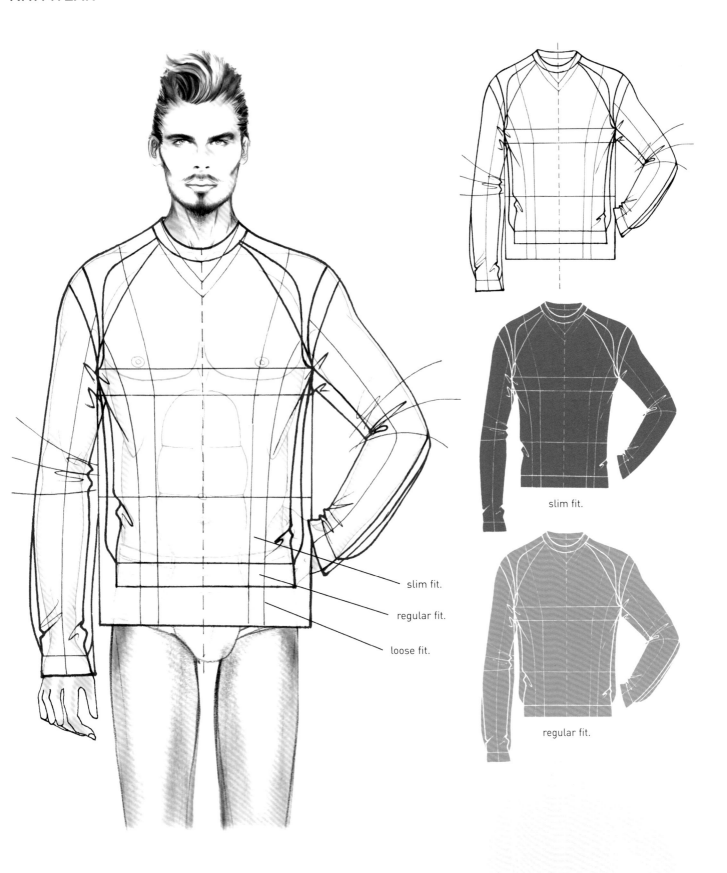

slim fit.

regular fit.

loose fit.

slim fit.

regular fit.

loose fit.

Knitwear refers to all knitted fabrics. It is classified into two types: light knit, which includes T-shirts, polo shirts, vests, light sweaters and other fine knit garments, and heavy knit garments such as jumpers, *pullovers* cardigans, thick sweaters, etc. These garments can be knitted or cut from knitted fabric, and can include formal, classic designs, or informal, casual designs.

SWEATSHIRTS

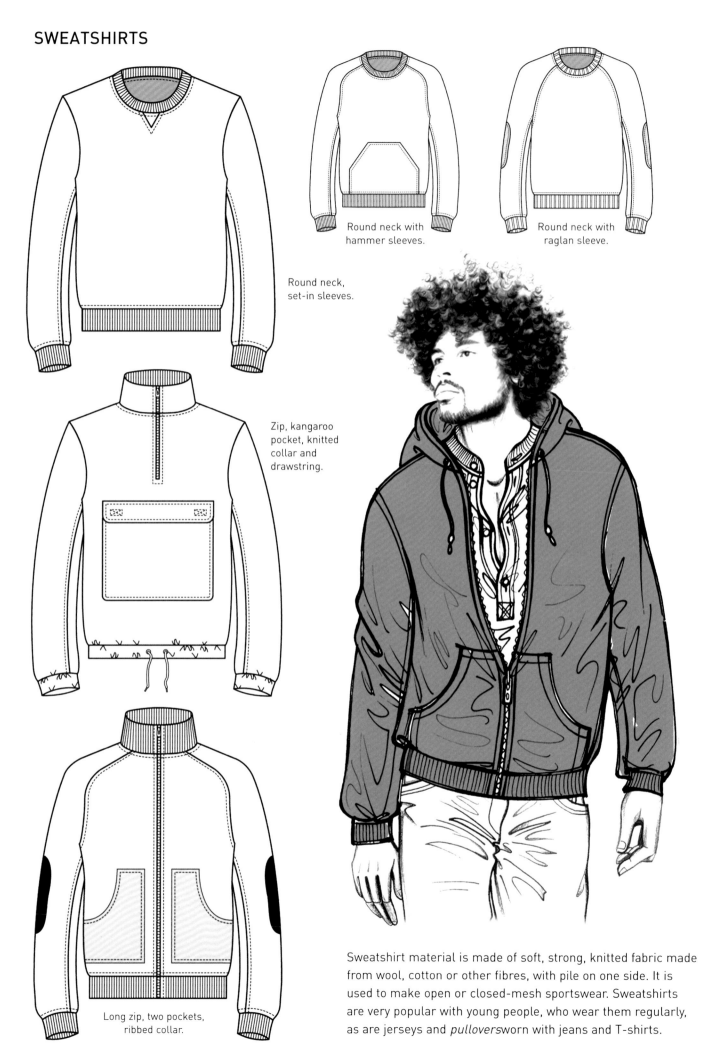

Round neck with hammer sleeves.

Round neck with raglan sleeve.

Round neck, set-in sleeves.

Zip, kangaroo pocket, knitted collar and drawstring.

Long zip, two pockets, ribbed collar.

Sweatshirt material is made of soft, strong, knitted fabric made from wool, cotton or other fibres, with pile on one side. It is used to make open or closed-mesh sportswear. Sweatshirts are very popular with young people, who wear them regularly, as are jerseys and *pullovers* worn with jeans and T-shirts.

HOODIES

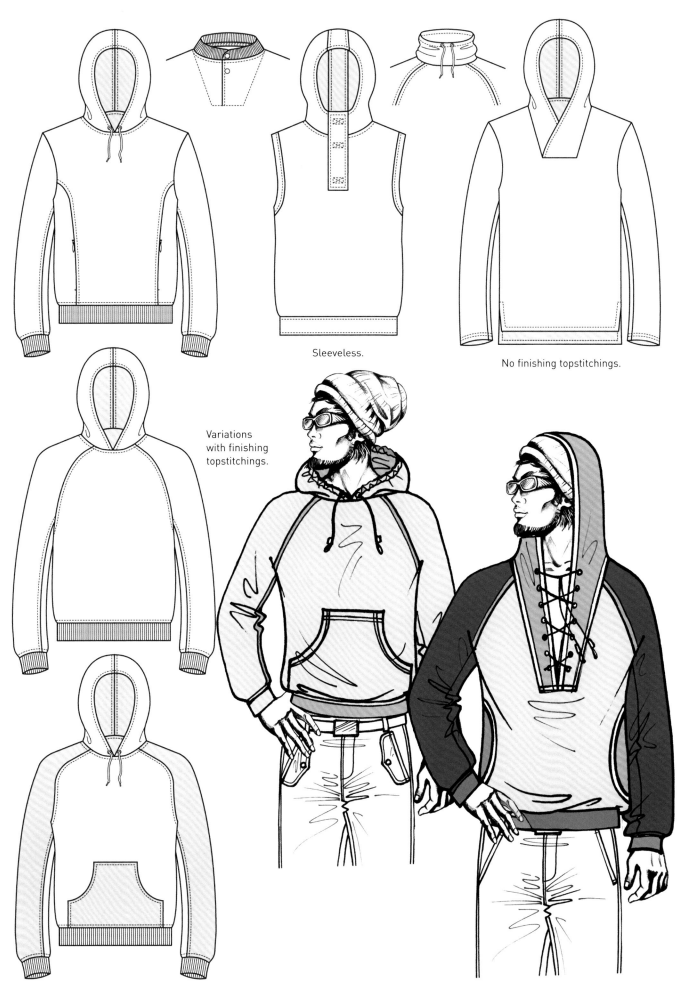

Sleeveless.

No finishing topstitchings.

Variations with finishing topstitchings.

HOODIES SEEN FROM DIFFERENT ANGLES

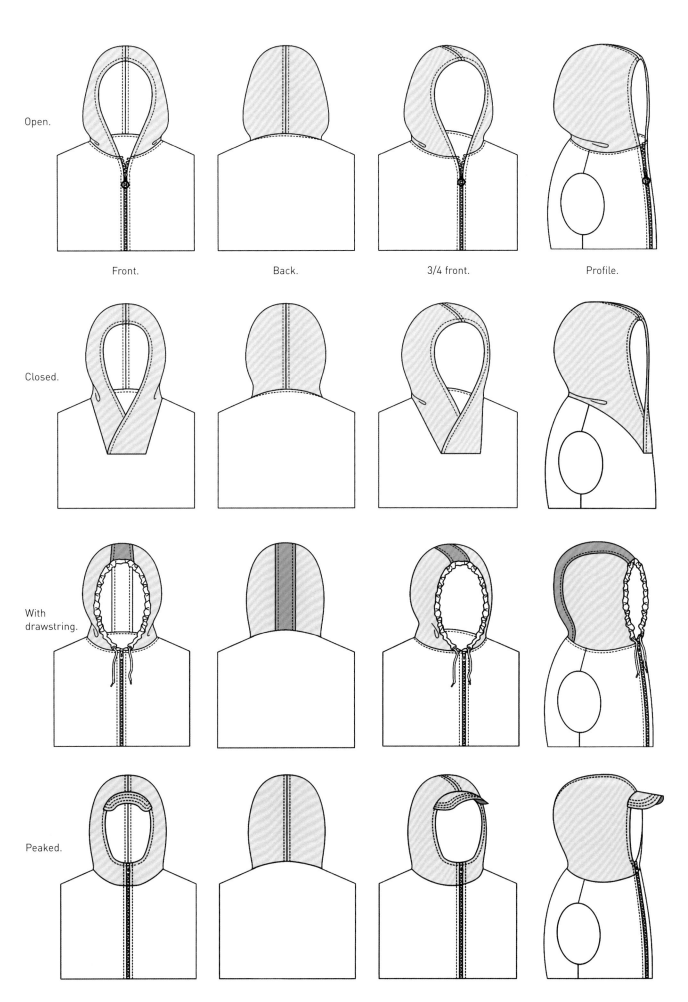

Open.

Front.

Back.

3/4 front.

Profile.

Closed.

With
drawstring.

Peaked.

POLO SHIRTS

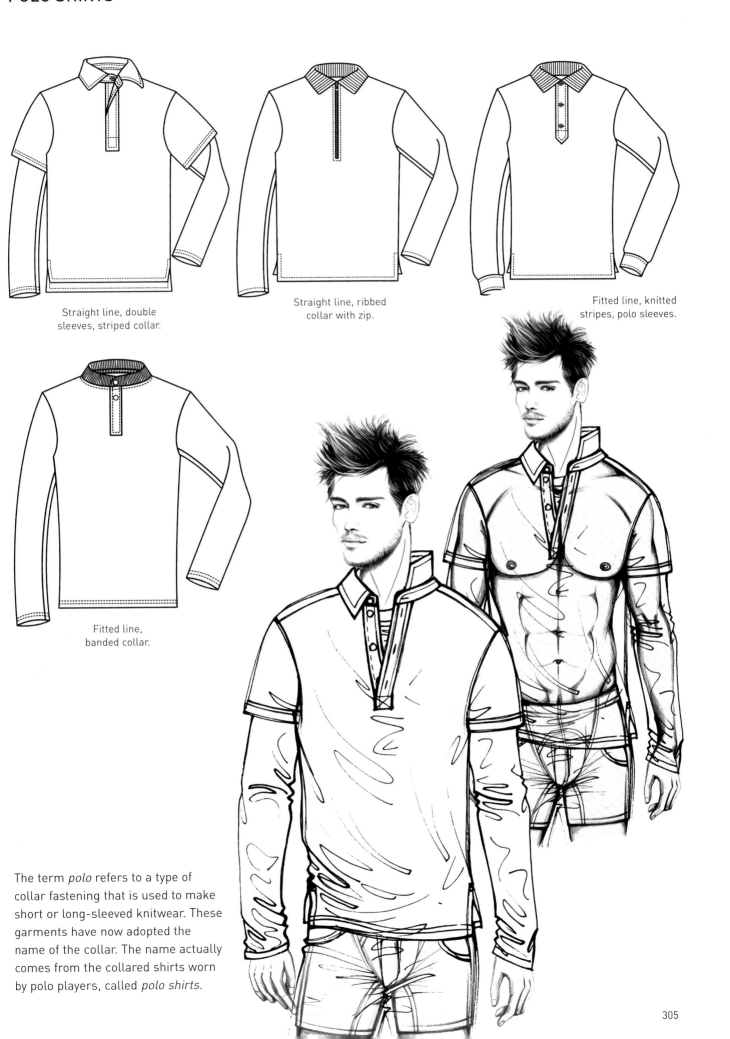

Straight line, double sleeves, striped collar.

Straight line, ribbed collar with zip.

Fitted line, knitted stripes, polo sleeves.

Fitted line, banded collar.

The term *polo* refers to a type of collar fastening that is used to make short or long-sleeved knitwear. These garments have now adopted the name of the collar. The name actually comes from the collared shirts worn by polo players, called *polo shirts*.

SHORT-SLEEVED POLO SHIRT AND VARIOUS COLLARS

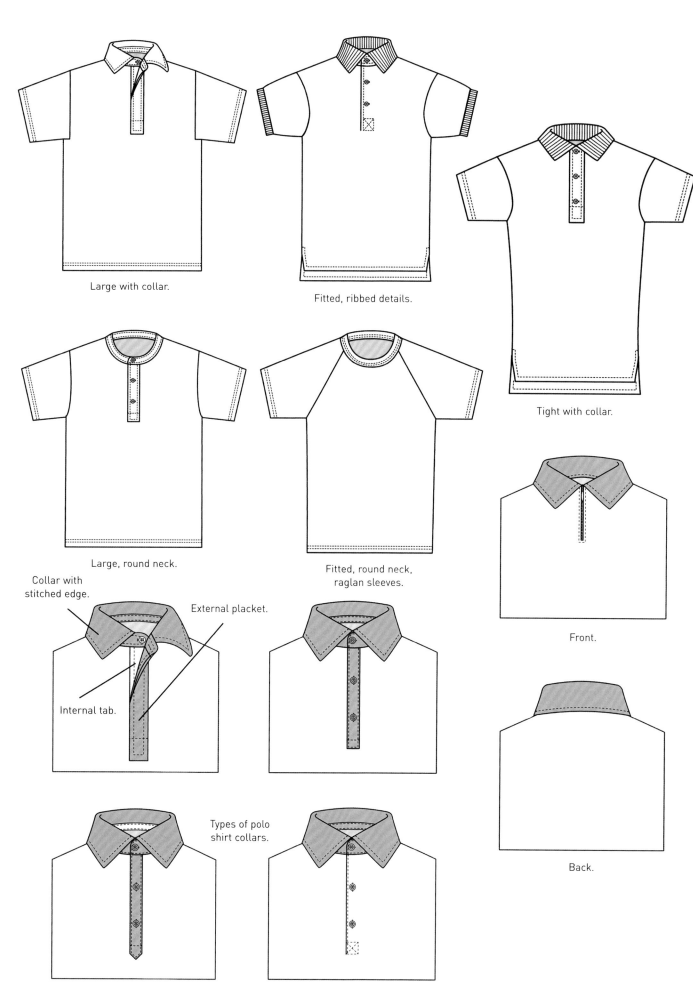

Large with collar.

Fitted, ribbed details.

Tight with collar.

Large, round neck.

Fitted, round neck, raglan sleeves.

Collar with stitched edge.

External placket.

Internal tab.

Types of polo shirt collars.

Front.

Back.

LIGHT KNITWEAR

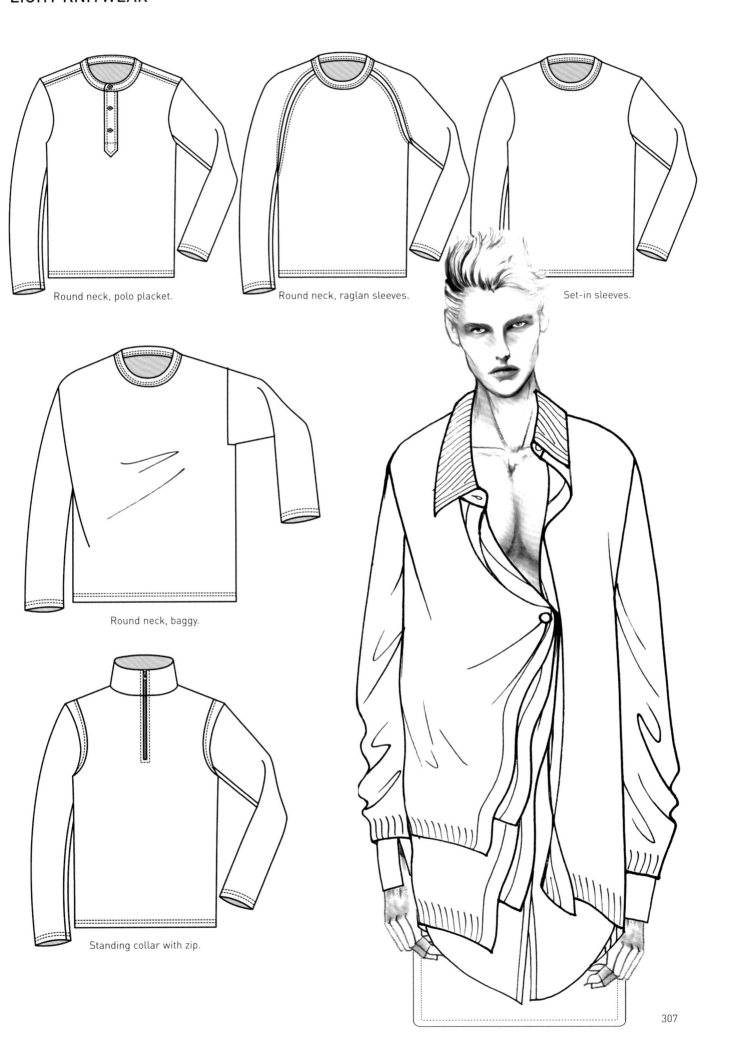

Round neck, polo placket.

Round neck, raglan sleeves.

Set-in sleeves.

Round neck, baggy.

Standing collar with zip.

VARIOUS TYPES OF KNITWEAR

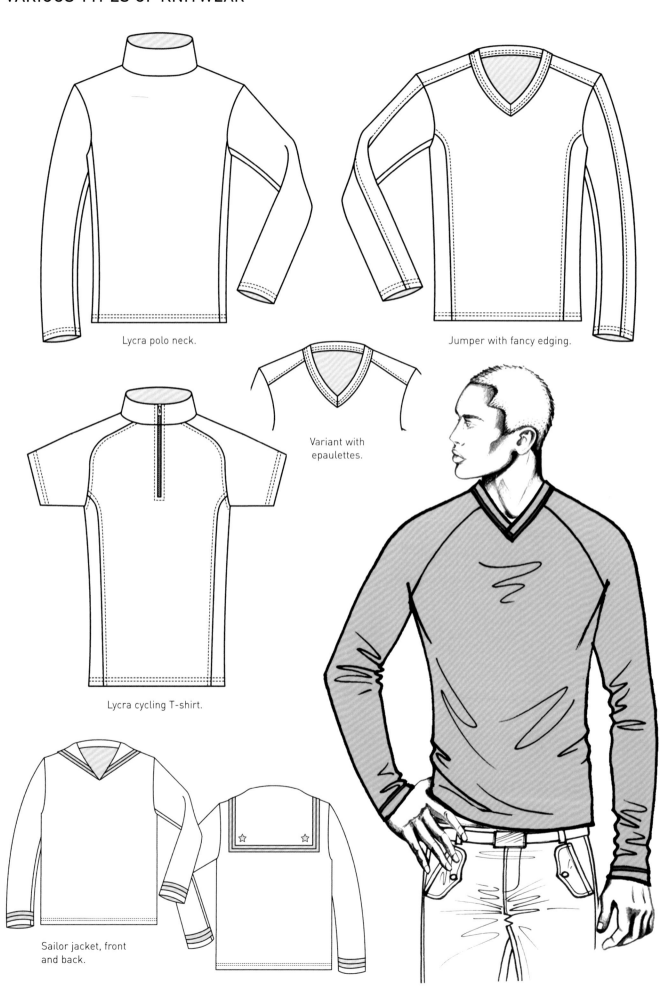

Lycra polo neck.

Jumper with fancy edging.

Variant with epaulettes.

Lycra cycling T-shirt.

Sailor jacket, front and back.

KNITWEAR - FINE YARNS

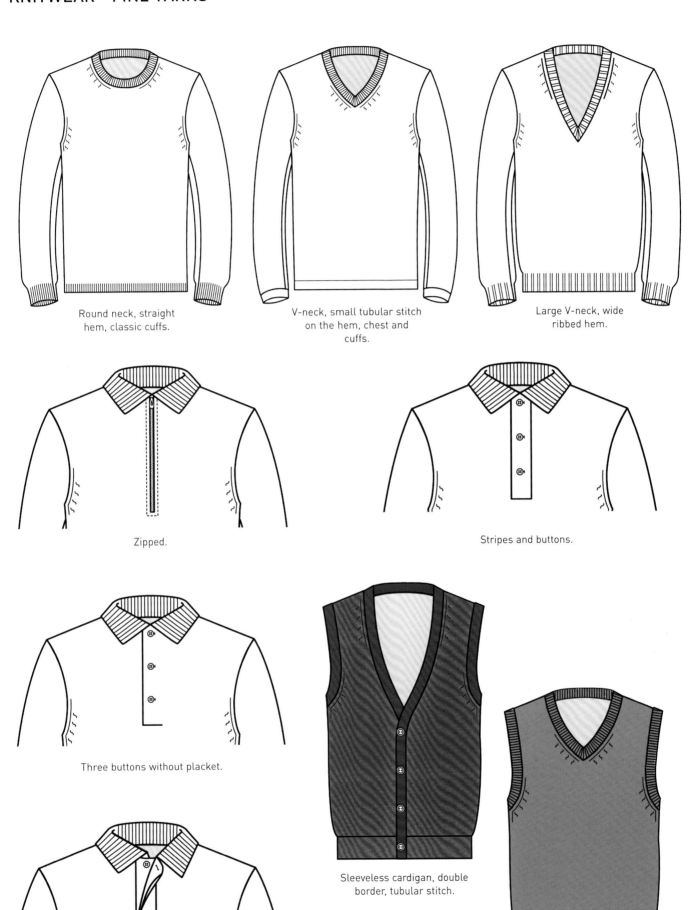

Round neck, straight hem, classic cuffs.

V-neck, small tubular stitch on the hem, chest and cuffs.

Large V-neck, wide ribbed hem.

Zipped.

Stripes and buttons.

Three buttons without placket.

Sleeveless cardigan, double border, tubular stitch.

Concealed placket and buttons.

Tank top.

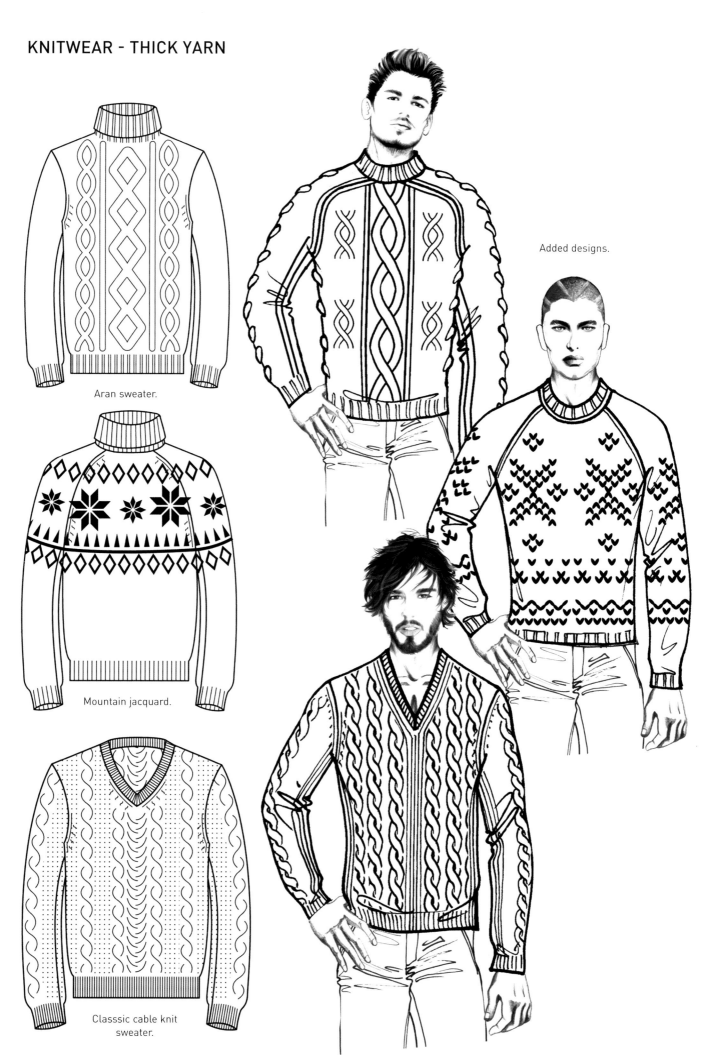

Aran sweater.

Mountain jacquard.

Classsic cable knit sweater.

Added designs.

CARDIGAN

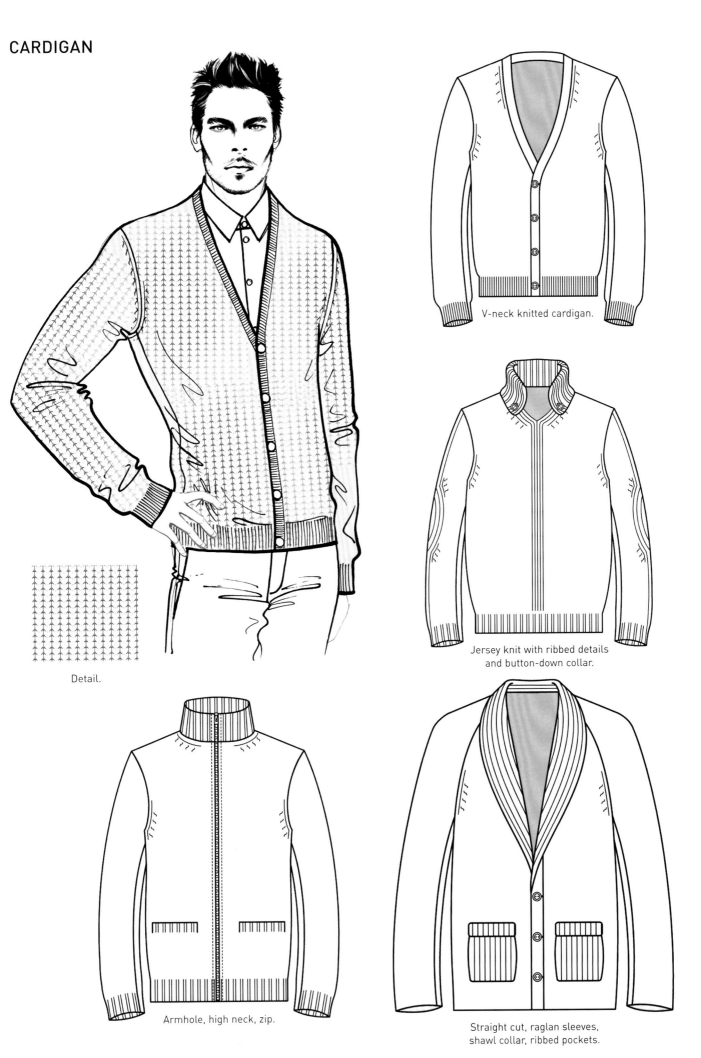

Detail.

V-neck knitted cardigan.

Jersey knit with ribbed details
and button-down collar.

Armhole, high neck, zip.

Straight cut, raglan sleeves,
shawl collar, ribbed pockets.

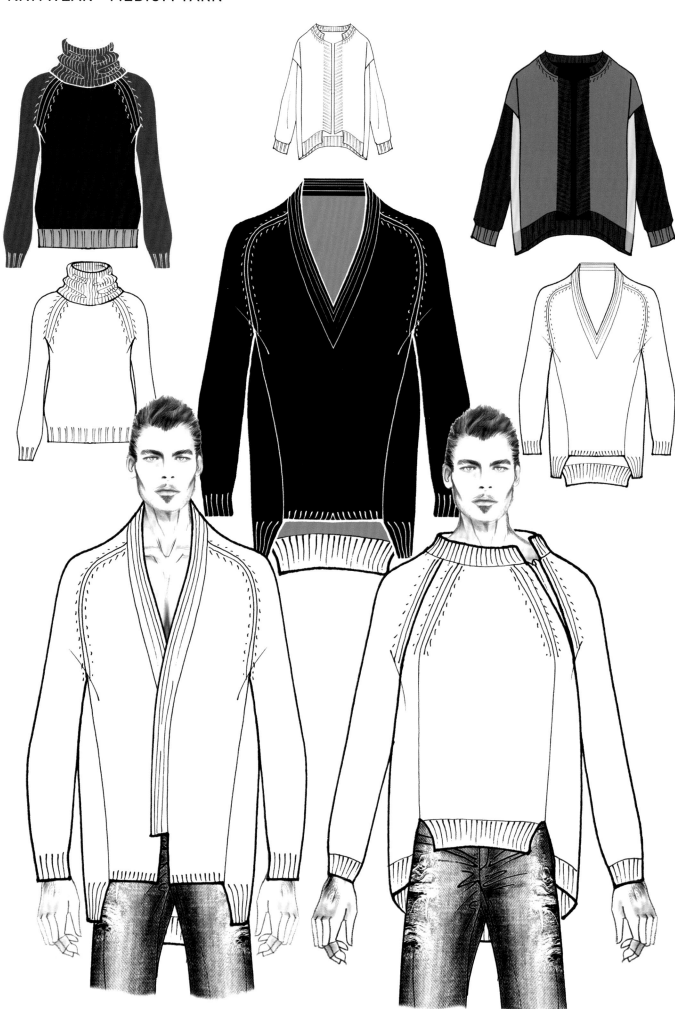

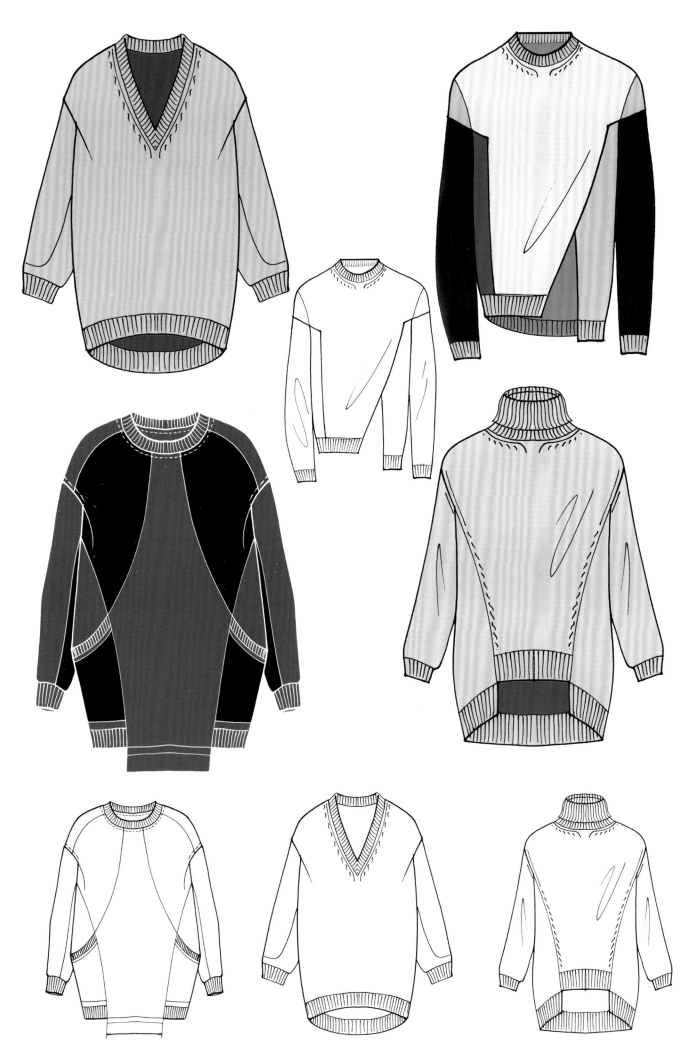

FANTASY KNITWEAR

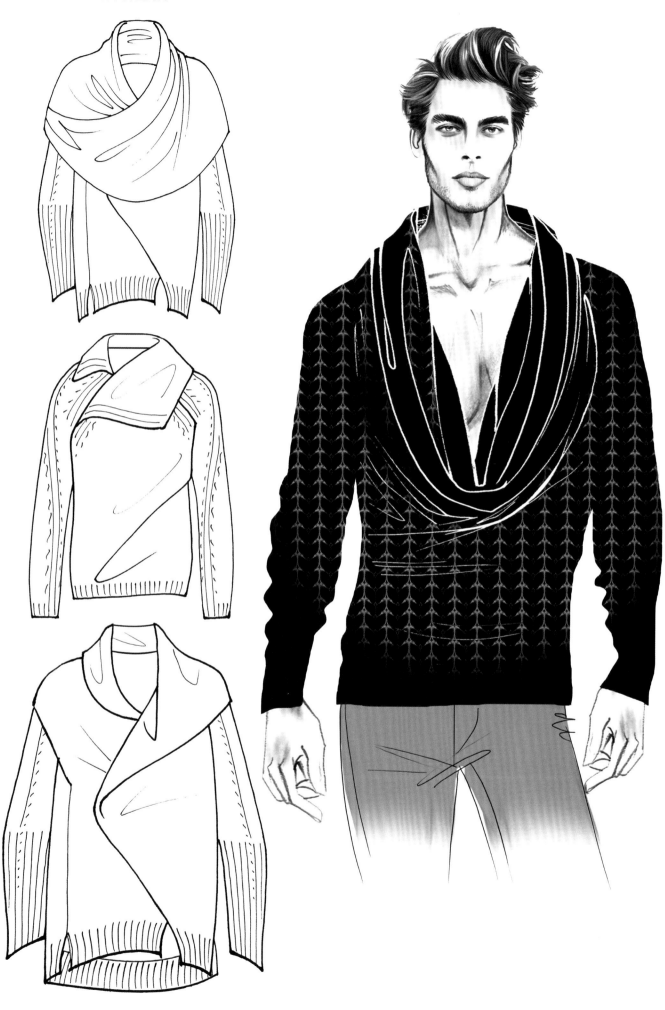

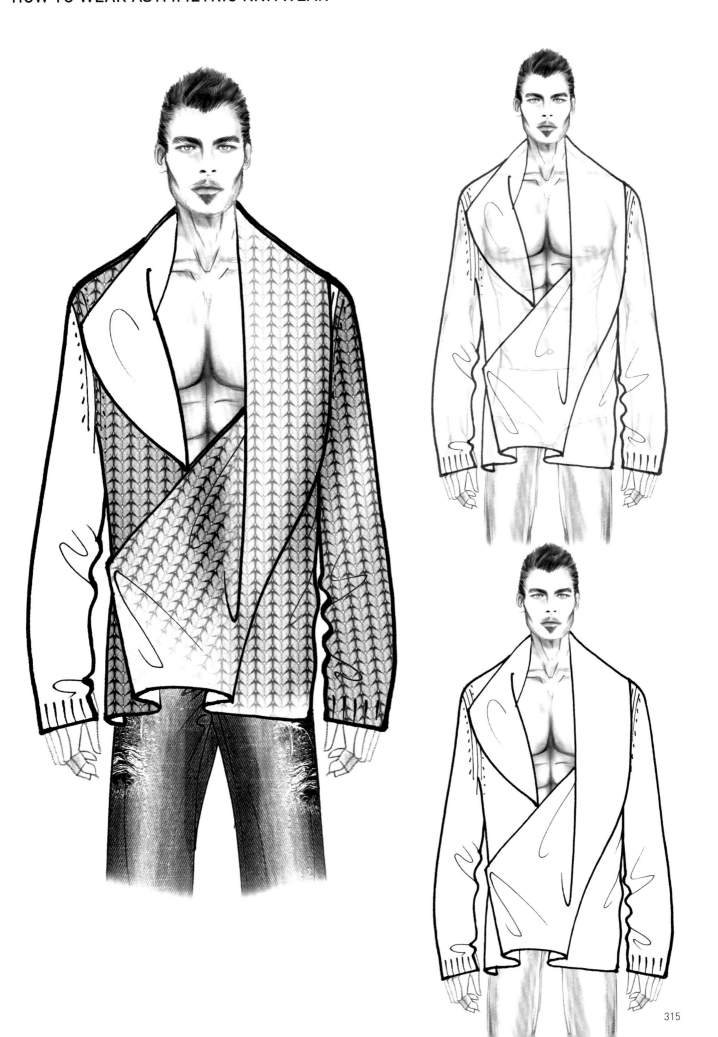

COLLAR TYPES FOR JERSEY GARMENTS

Polo neck.

Reverse roll neck.

Straight with zip.

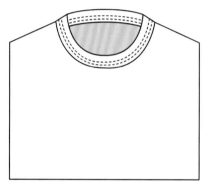

Round neck.

Standard V-neck.

Round neck with pointed placket.

Fitted, ribbed collar with zip.

Ribbed collar with placket.

With interior interlining.

Back, with topstitching detail.

Fitted collar with topstitching detail and concealed placket.

TYPES OF COLLARS FOR JERSEY AND KNITWEAR GARMENTS

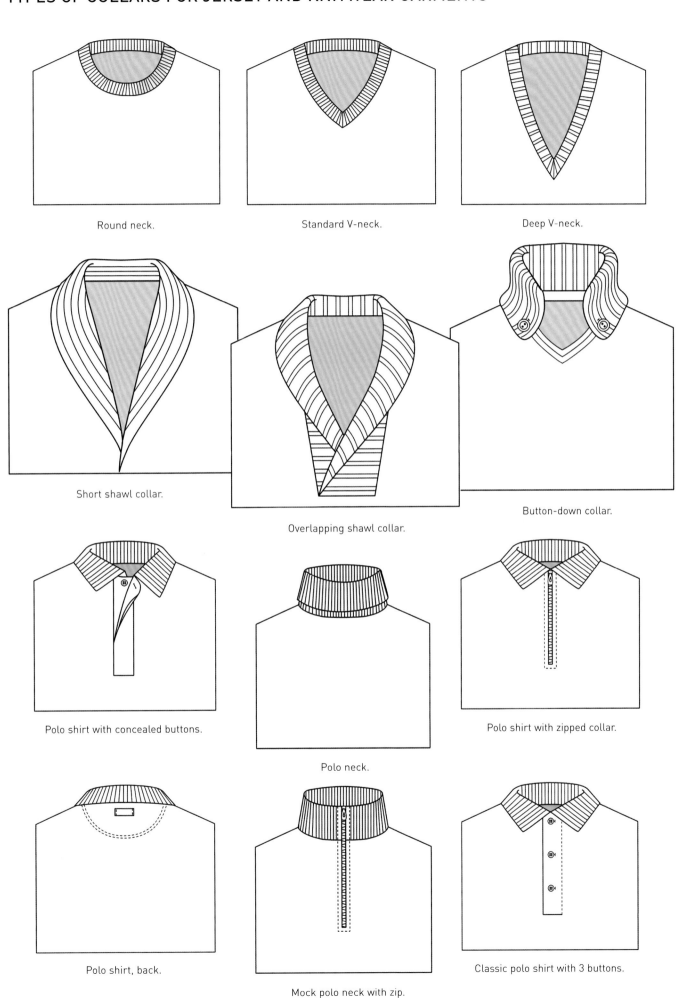

Round neck.

Standard V-neck.

Deep V-neck.

Short shawl collar.

Overlapping shawl collar.

Button-down collar.

Polo shirt with concealed buttons.

Polo neck.

Polo shirt with zipped collar.

Polo shirt, back.

Mock polo neck with zip.

Classic polo shirt with 3 buttons.

T-SHIRT

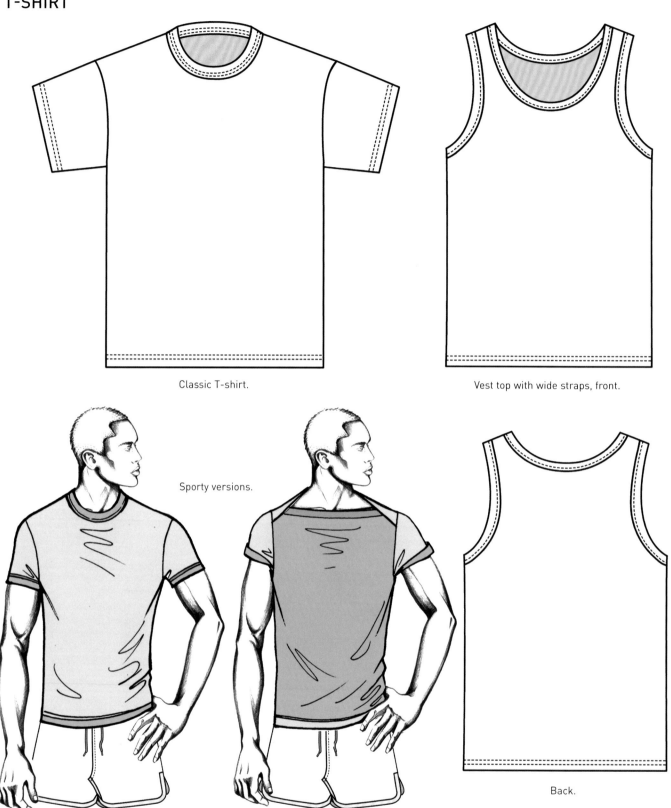

Classic T-shirt.

Vest top with wide straps, front.

Sporty versions.

Back.

The *T-shirt* type top is a cotton-knit garment with a round neck, originally with short sleeves, but they can also be made with long sleeves. The cut of the sleeves (particularly the short ones) gives it the characteristic T-shape that gives it its name. In fact, in the same way that its name and shape allude to the capital T, it has been known as a garment with a literary vocation. First appearing in the United States of America in the early 20TH CENTURY; its worldwide success began after the 1940s, when the US Navy incorporated the garment into the sailors' uniform. The popularity of the white T-shirt worn by US soldiers spread across Europe during World War II. A symbol of the angry youth of the 1950s and 1960s, it jumps onto the big screen with American films starring Marlon Brando and James Dean.

T-SHIRTS - VARIOUS DESIGNS

Vest top with thin straps.

Back.

Cap sleeved T-shirt.

Sleeveless.

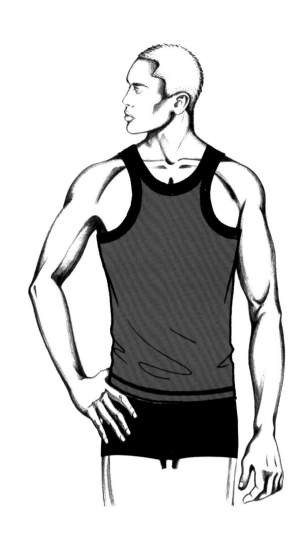

Being so comfortable, the *T-shirt* has replaced the shirt over the years, especially among young people. Thanks to its simple, youthful shape, and because it is worn over bare skin, the T-shirt becomes synonymous with rebellion and freedom, attitudes that are expressed more fully by decorative details or personal and social messages that can be printed onto it. Since the eighties, the T-shirt has become a veritable writing page on which famous music and poetry, song lyrics, slogans and diary entries can be showcased; many famous artists have contributed their written and graphic works, turning them into works of art that are sold in libraries and museums around the world. The *T-shirt* has given rise to countless fashion garments and industry products, to the point that the same name is used to refer to sleeveless, short and long sleeved tops made of cotton jersey, microfibre, Lycra and polyester, etc.

TROUSERS

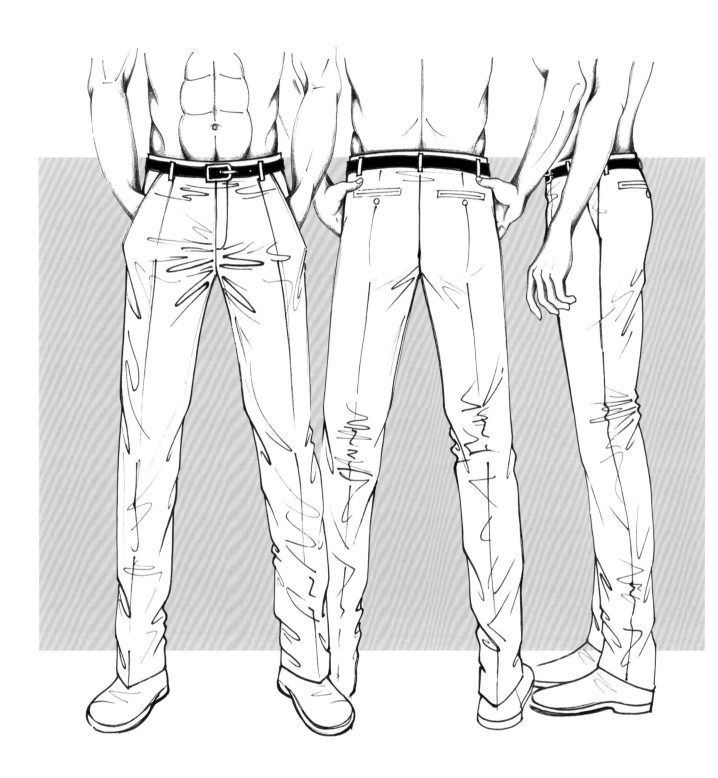

Made from a variety of fabrics in a range of designs, trousers are worn by males and females and dress the body from the waist to the ankles. Over the course of history, trousers have undergone many transformations, taking on the most diverse forms: high and low waist, long, flared, tight, wide, short, baggy, knickerbockers, pedal pushers, jodhpurs, tapered, adorned with ribbons, bows and prints and often covered with decorations and applications of all kinds. Men's classic trousers were first seen in England around 1830; the feminine version came about as a result of the student protests of the 1960s. This chapter presents the main styles that characterise this complex yet universal garment.

PARTS OF CLASSIC TROUSERS

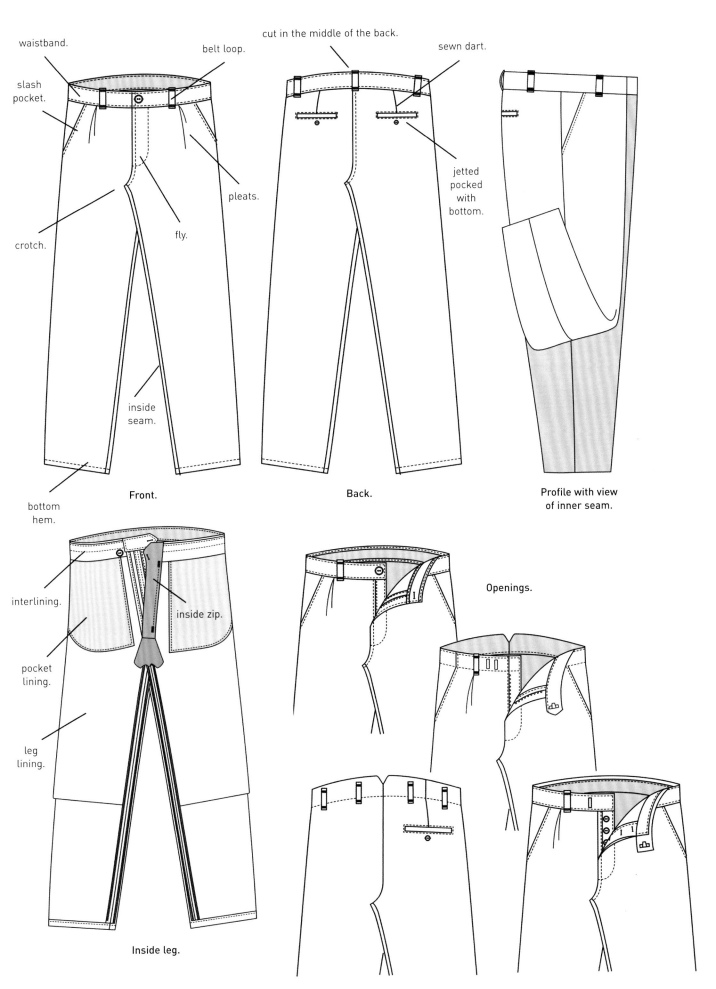

waistband.

slash pocket.

belt loop.

crotch.

fly.

pleats.

inside seam.

bottom hem.

Front.

cut in the middle of the back.

sewn dart.

jetted pocked with bottom.

Back.

Profile with view of inner seam.

interlining.

inside zip.

pocket lining.

leg lining.

Inside leg.

Openings.

DETAILS OF THE CLASSIC TROUSER

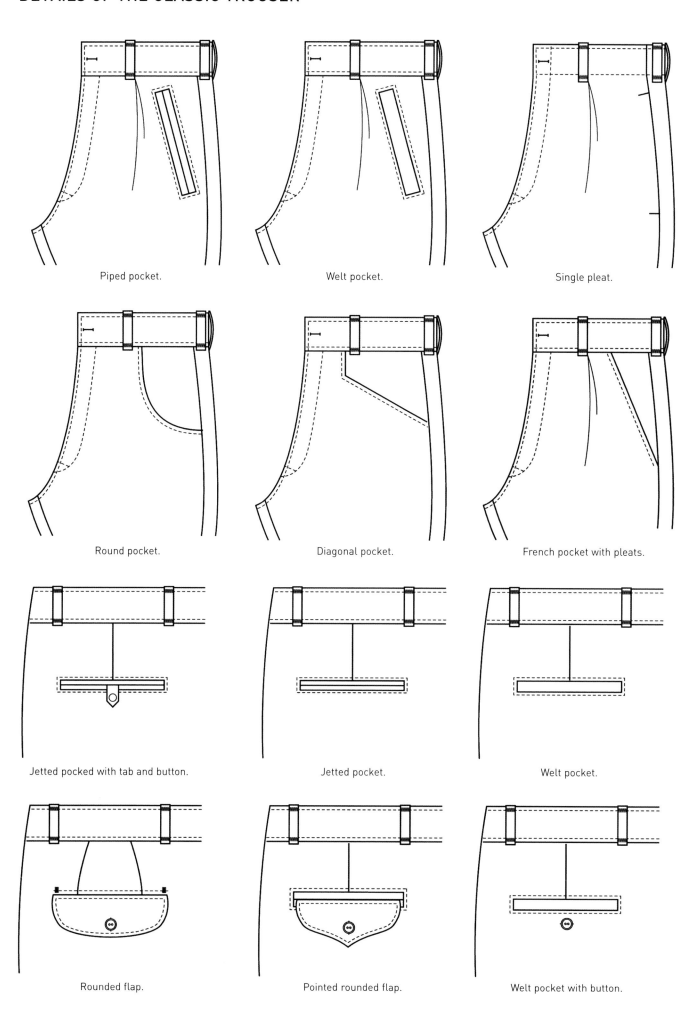

Piped pocket.

Welt pocket.

Single pleat.

Round pocket.

Diagonal pocket.

French pocket with pleats.

Jetted pocked with tab and button.

Jetted pocket.

Welt pocket.

Rounded flap.

Pointed rounded flap.

Welt pocket with button.

VARIOUS TROUSER DESIGNS BEING MODELLED

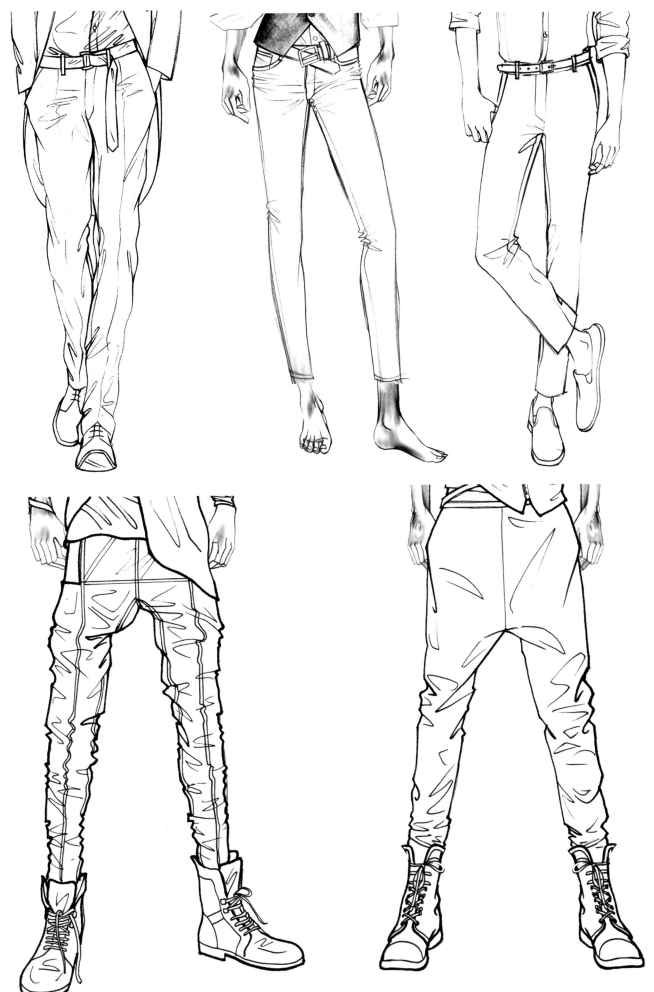

TYPES OF TROUSERS

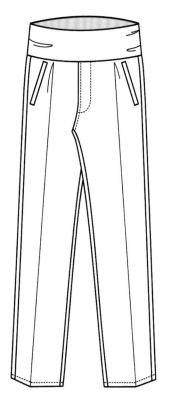

Black-tie trousers.

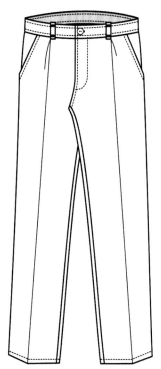

Trousers with
single pleat.

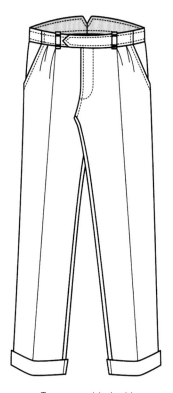

Trousers with double
pleat and turn-ups.

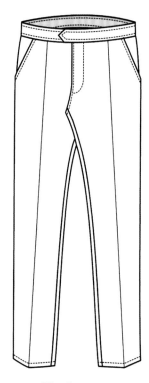

Slim-fit trousers
without pleats.

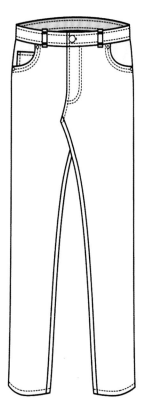

5 pockets, slim-fit.

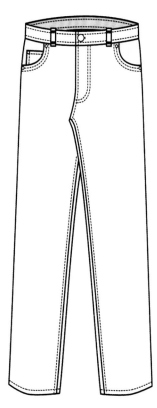

5 pockets, easy fit.

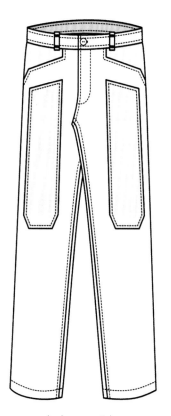

Jeckerson style.

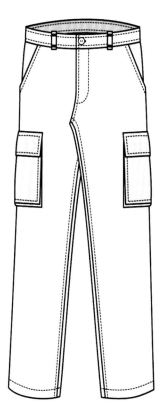

Classic military trousers.

CASUAL TROUSERS

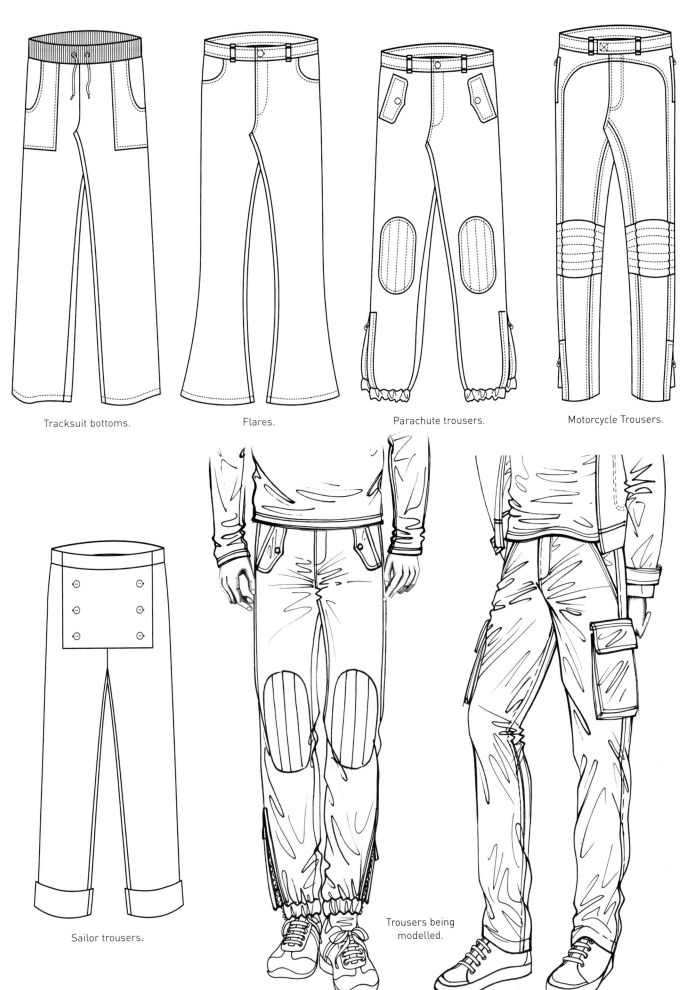

Tracksuit bottoms.

Flares.

Parachute trousers.

Motorcycle Trousers.

Sailor trousers.

Trousers being
modelled.

OTHER STYLES

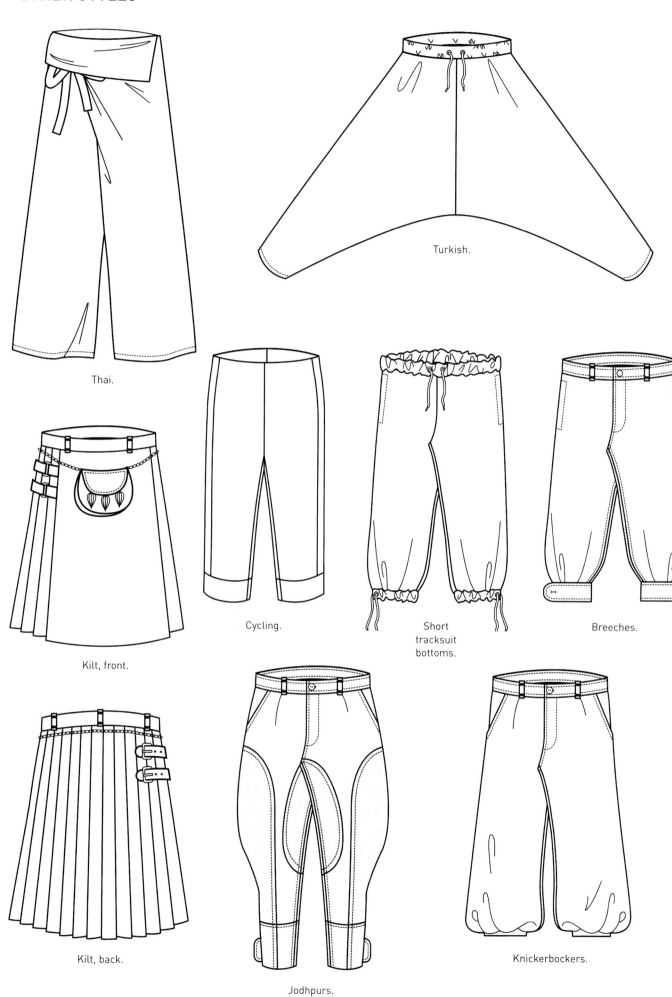

Thai.

Turkish.

Kilt, front.

Cycling.

Short tracksuit bottoms.

Breeches.

Kilt, back.

Jodhpurs.

Knickerbockers.

KNICKERBOCKERS

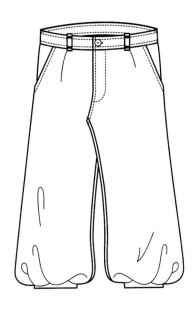

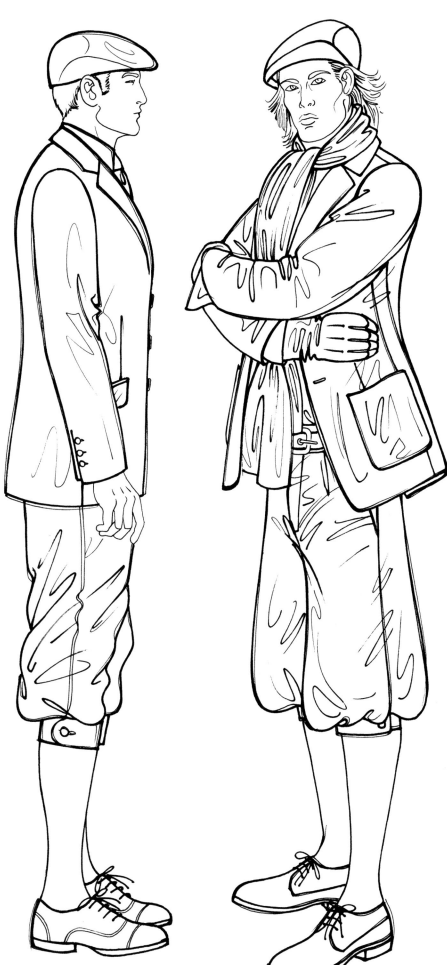

Knickerbockers, worn by the Dutch who emigrated to America in 1674, are short and long variations of the classic Zouaves, but looser under the leg. The longer version, also called *"plus four"*, drops eight centimetres below the crotch and is still used for golfing, while the shorter *"plus two"*, which drops four centimetres, is generally used for hunting. Knickerbockers are made from a checkered fabric that is similar to tweed, and are worn with a sports coat. The corduroy version is particularly suitable mountain attire.

BERMUDA SHORTS

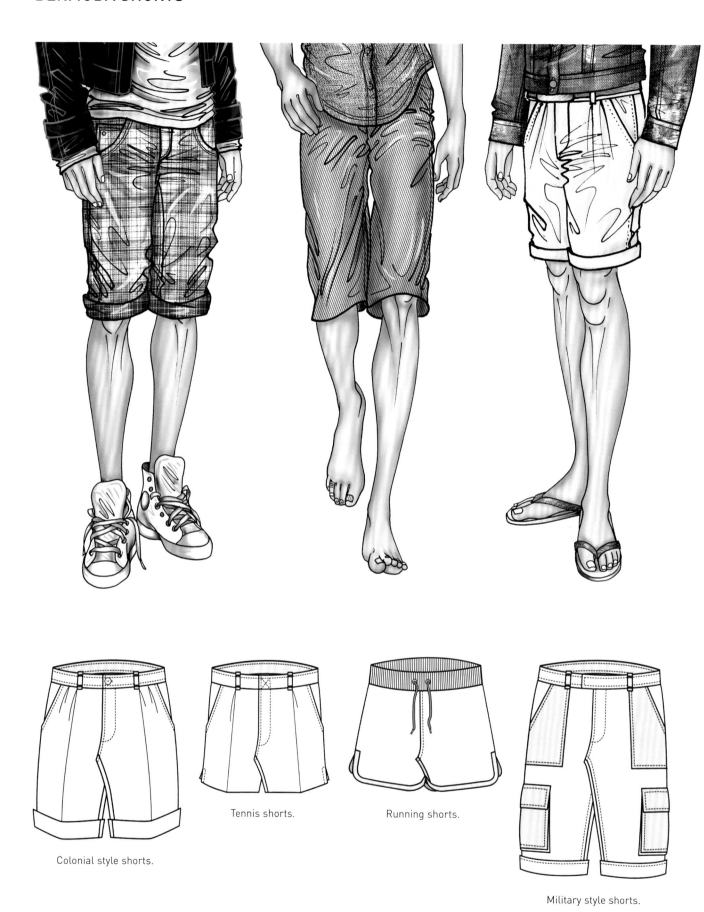

Colonial style shorts.

Tennis shorts.

Running shorts.

Military style shorts.

Bermudas shorts were often worn in English colleges in the late 19th century. These days, they are mainly worn when taking part in sport, on the beach or during other leisure activities outside of work places and hours. Bermuda shorts are available in different lengths and can be made in a variety of materials, depending on what they are to be used for.

JEANS

Denim is a robust cotton fabric that is most commonly used for making jeans.

Denim is also used to make many other garments for all ages, and every year designers include it in their original creations. One of the most influential fabrics to complement the clothing of our time, its terrific versatility, strength and reasonable price have contributed to making denim the most widely-distributed fabric in the world. Taking global communication into account, it is worth drawing up a summary of its history. The origin of *blue jeans* is indicated by the name: *blue dye* was commonly used in the past due to its cheap price, and the word *jeans* is derived from Genoa, where they were first made, which links them to the city's flourishing port activity and the ancient mediaeval cotton route. It is the history of fustian and other fabrics that were destined to be used by the general population.

This sturdy fabric, which was already in use in 16th century Europe, landed in the United States in 1850 along with the robust cotton fabric from Nîmes. Italian *jeans* fabric was used to make clothes for doing light work in, while the French *denim*, which was a bit tougher, was used to make working clothes that were worn on top of other clothes, for example, jackets, overalls and dungarees. The trousers that we know today as *jeans* were created more than 150 years ago by Loeb Strauss, Americanised as Levi Strauss, a German emigrant who in 1847 travelled from Bavaria to New York, where he dedicated himself to the textile trade. It all started with an order for a simple pair of trousers from a mining community at the height of the Californian gold rush. As a result, Levi Strauss began producing the indestructible *waist-high overalls or pantaloons*; to reinforce the areas of greatest traction and make

them more resistant and durable, in 1873, together with tailor Jacob Davis, he patented the metal rivets on the crotch and pockets: thus the legendary Levi's brand was born. Demand for these unique trousers increased with further orders from cattle breeders and workers on the new railroad network.

This is how, at the beginning of the twentieth century, miners, ranchers and railroad workers endorsed, and became the main beneficiaries of, *blue jeans'* success. These trousers' mythical vicissitudes and fortunate rise around the world is the stuff of history. We have seen them frayed and torn in student riots, featuring patches and holes to feign poverty, worn four sizes too big or extremely tight, and even embroidered with gold and trimmed with diamonds. A thousand faces for a thousand personalities: that is why the world of clothing is unimaginable without jeans.

PATCH POCKETS

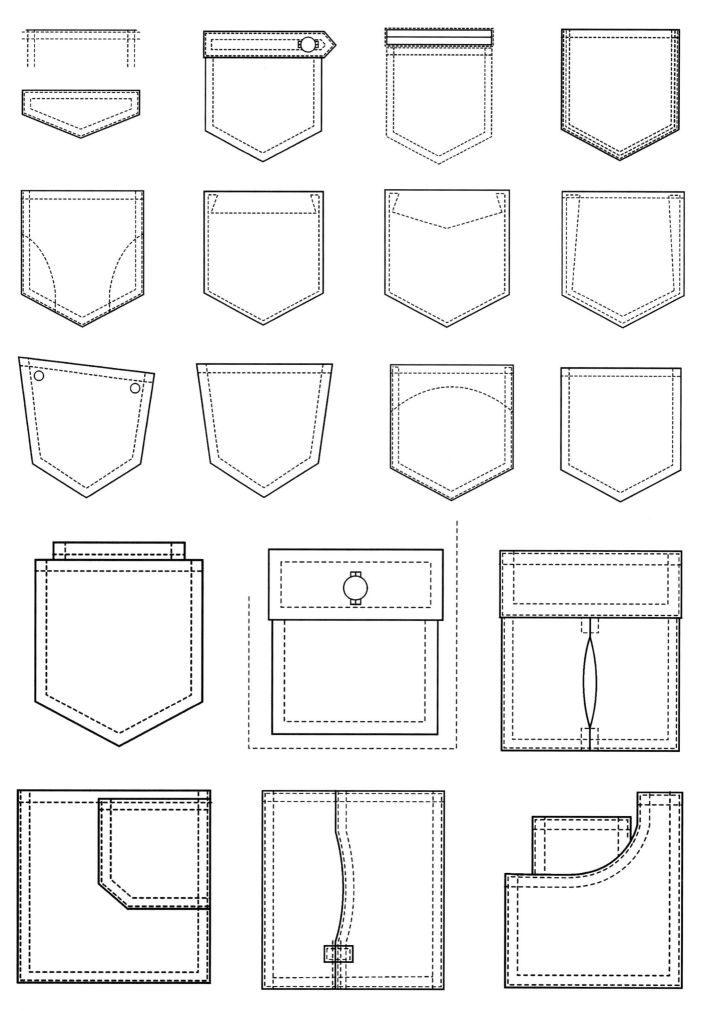

CLASSIC JEANS

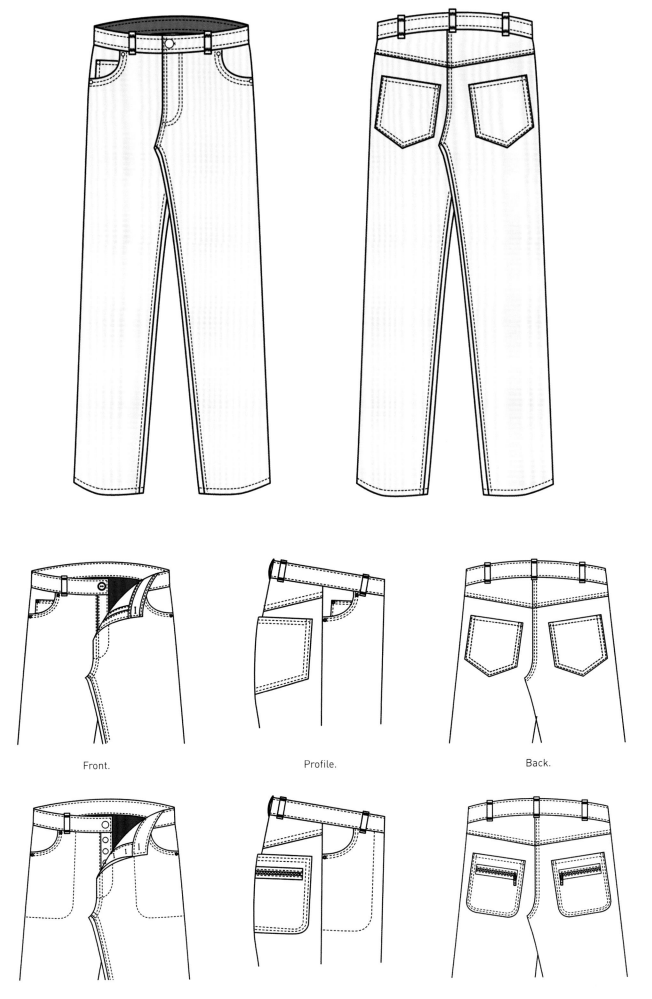

Front.

Profile.

Back.

TREKKING *TROUSERS*

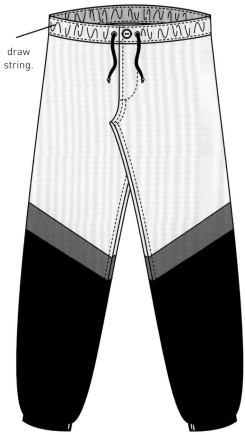

draw
string.

Front.

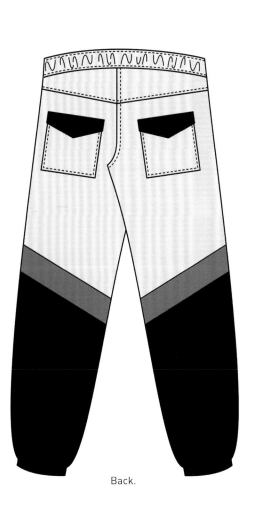

Back.

Closure variants.

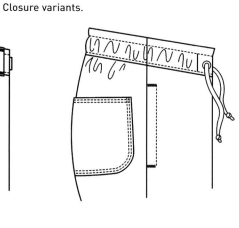

Various types of hemlines.

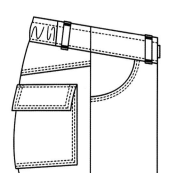

Drawstring.

Velcro strap.

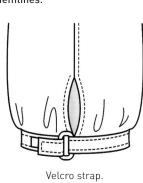

Stitched.

Elasticated cuff.

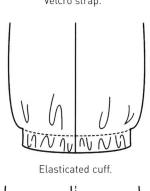

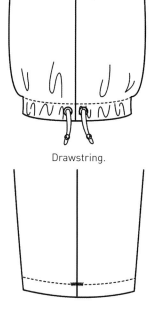

Ribbed cuff.

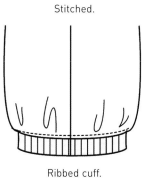

Adjustable strap.

HOME CLOTHING

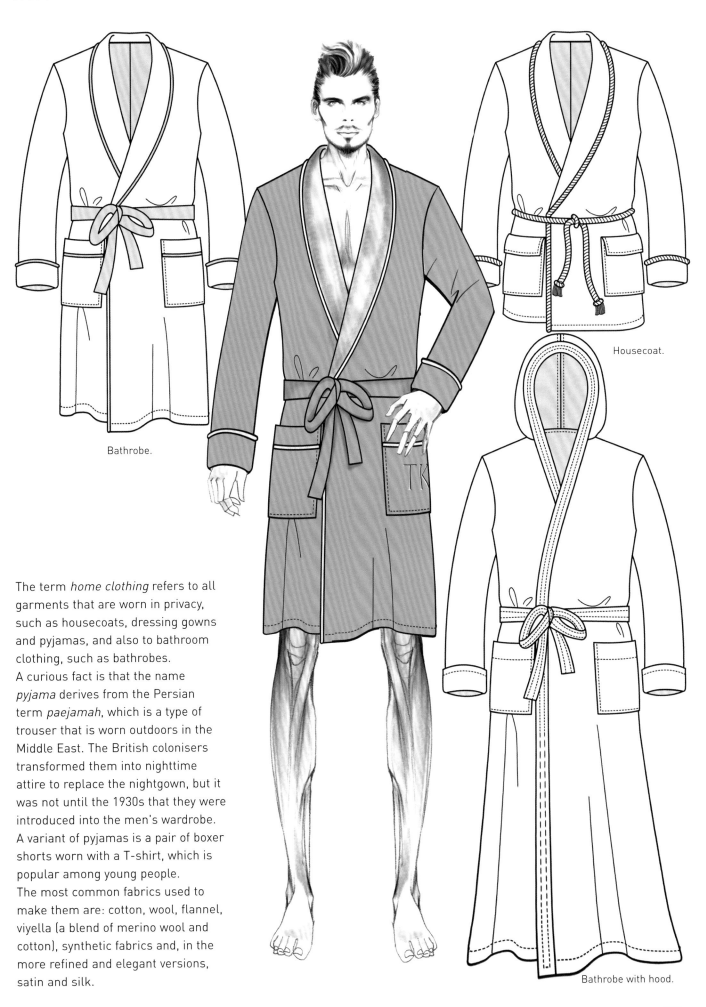

Bathrobe.

Housecoat.

Bathrobe with hood.

The term *home clothing* refers to all garments that are worn in privacy, such as housecoats, dressing gowns and pyjamas, and also to bathroom clothing, such as bathrobes.
A curious fact is that the name *pyjama* derives from the Persian term *paejamah*, which is a type of trouser that is worn outdoors in the Middle East. The British colonisers transformed them into nighttime attire to replace the nightgown, but it was not until the 1930s that they were introduced into the men's wardrobe.
A variant of pyjamas is a pair of boxer shorts worn with a T-shirt, which is popular among young people.
The most common fabrics used to make them are: cotton, wool, flannel, viyella (a blend of merino wool and cotton), synthetic fabrics and, in the more refined and elegant versions, satin and silk.

PYJAMAS

Summer T-shirt.

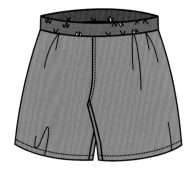

Boxer shorts.

Pyjama top.

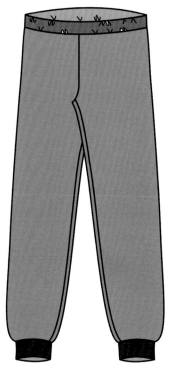

Pyjama bottoms.

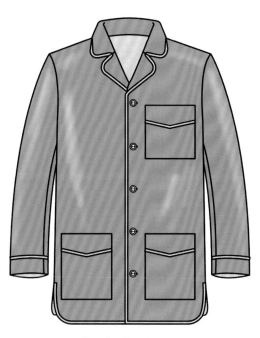

Classic silk pyjamas.

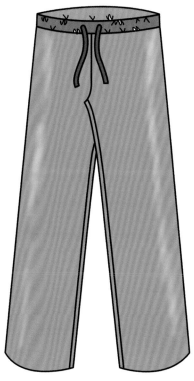

Bottoms in the same colour.

YUKATA

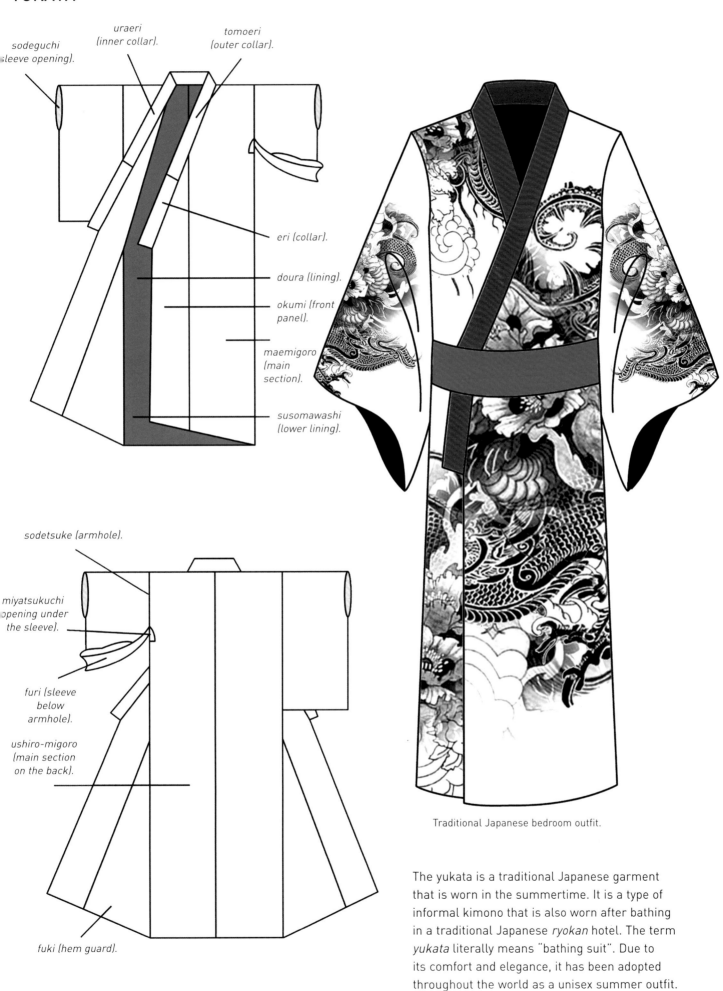

sodeguchi (sleeve opening).

uraeri (inner collar).

tomoeri (outer collar).

eri (collar).

doura (lining).

okumi (front panel).

maemigoro (main section).

susomawashi (lower lining).

sodetsuke (armhole).

miyatsukuchi opening under the sleeve).

furi (sleeve below armhole).

ushiro-migoro (main section on the back).

fuki (hem guard).

Traditional Japanese bedroom outfit.

The yukata is a traditional Japanese garment that is worn in the summertime. It is a type of informal kimono that is also worn after bathing in a traditional Japanese *ryokan* hotel. The term *yukata* literally means "bathing suit". Due to its comfort and elegance, it has been adopted throughout the world as a unisex summer outfit.

FLAT DRAWING FOR *FASHION BOOKS*

Flat drawings that depict *movement* are a valid alternative to traditional technical drawings. It is a great choice for those who love freehand drawing or who like to draw using a pencil in a liberal and evocative way. These simple drawings are also great for presenting collections or illustrating *fashion books*. In order to train in the technique, you can start by drawing or copying a photo of a garment in a fashion catalogue, picture book or anything else that uses still life as the main form of advertising. It is also possible to improvise photos with a simple *smartphone* and a little creativity.

Use Photoshop to enlarge the photo to the required size and print it off. Then use a brush to paint a soft, wavy line (fig. 2). The resulting drawing can be used several times as a template, on which you can modify or swap details such as edgings and pockets (fig. 3), pocket edgings and cuttings (fig. 4), button-down collars, pockets and cuttings (fig.5); it's easy to create a rich archive simply by photographing the most interesting items in our wardrobe. The only thing you need to do is to lie the garment out flat, leaving it loosely arranged, as you can see in the photo of the jacket. (fig. 1).

1

2

Traced image

3

Edgings and pockets.

4

Edgings, pockets and cuttings.

5

Pockets, cuttings. and collar.

Coated cotton cap

Collar featuring multi-seam detail

Vintage effect field jacket in mud-coloured canvas

Win needle top stitching

Pockets with placket & inverted pleat

Raw cut leather belt

Light stone washed 5-pocket loose fit jeans

Holdall bag with multiple pockets in brushed calfskin

Classic suede desert boot

topstitching

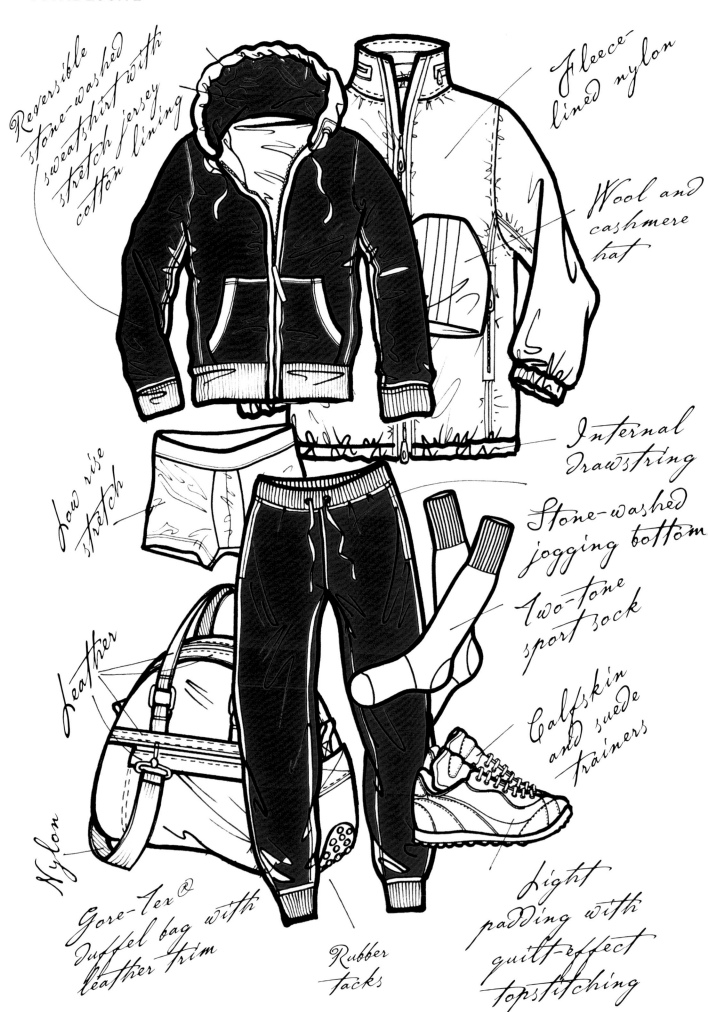

Reversible stone-washed sweatshirt with stretch jersey cotton lining

Fleece lined nylon

Wool and cashmere hat

Internal drawstring

Low rise stretch

Stone-washed jogging bottom

Two-tone sport sock

Calfskin and suede trainers

Leather

Nylon

Gore-Tex® Duffel bag with leather trim

Rubber tacks

Light padding with quilt-effect topstitching

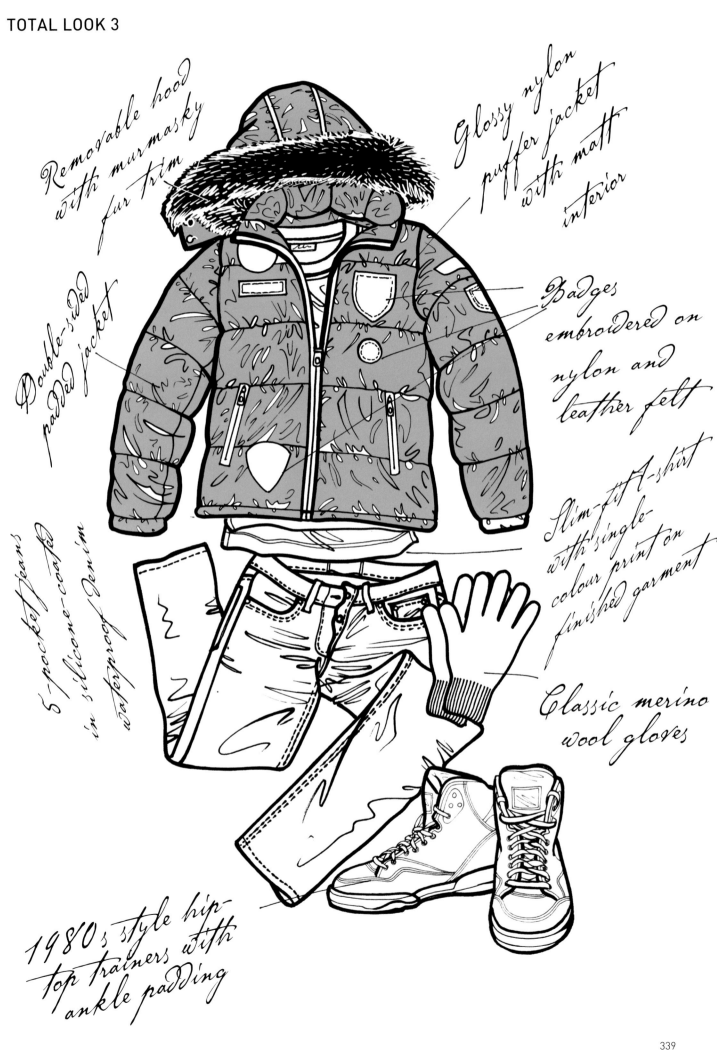

Removable hood with murmarsky fur trim

Glossy nylon puffer jacket with matt interior

Double-sided padded jacket

Badges embroidered on nylon and leather felt

Slim-fit T-shirt with single-colour print on finished garment

5-pocket jeans in silicone-coated waterproof Denim

Classic merino wool gloves

1980s style hip-top trainers with ankle padding

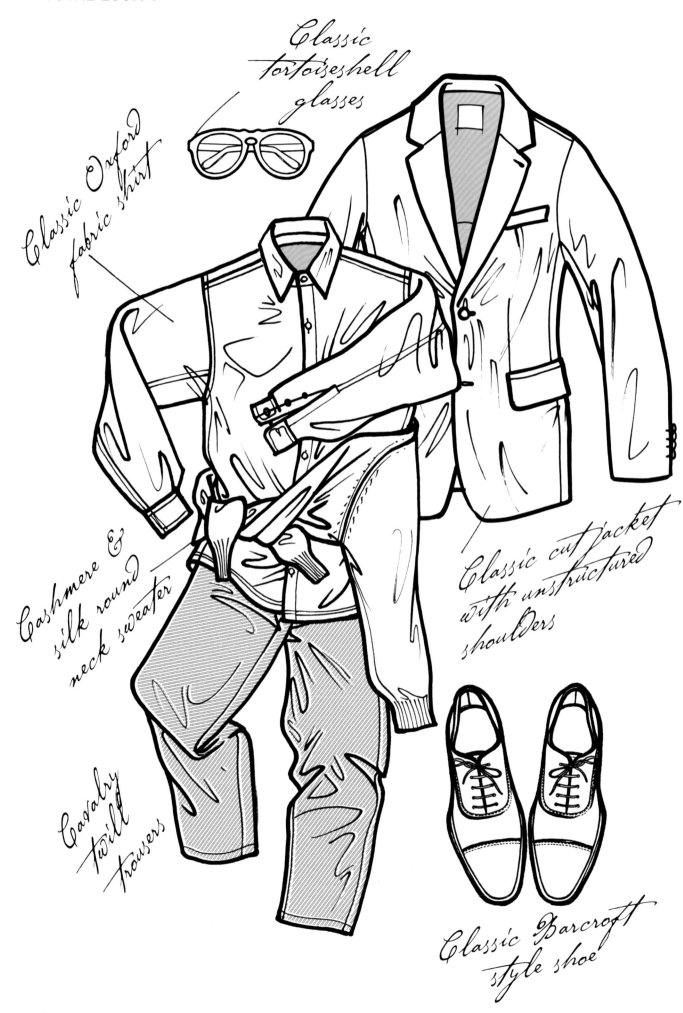

Classic tortoiseshell glasses

Classic Oxford fabric shirt

Cashmere & silk round neck sweater

Cavalry twill trousers

Classic cut jacket with unstructured shoulders

Classic Barcroft style shoe

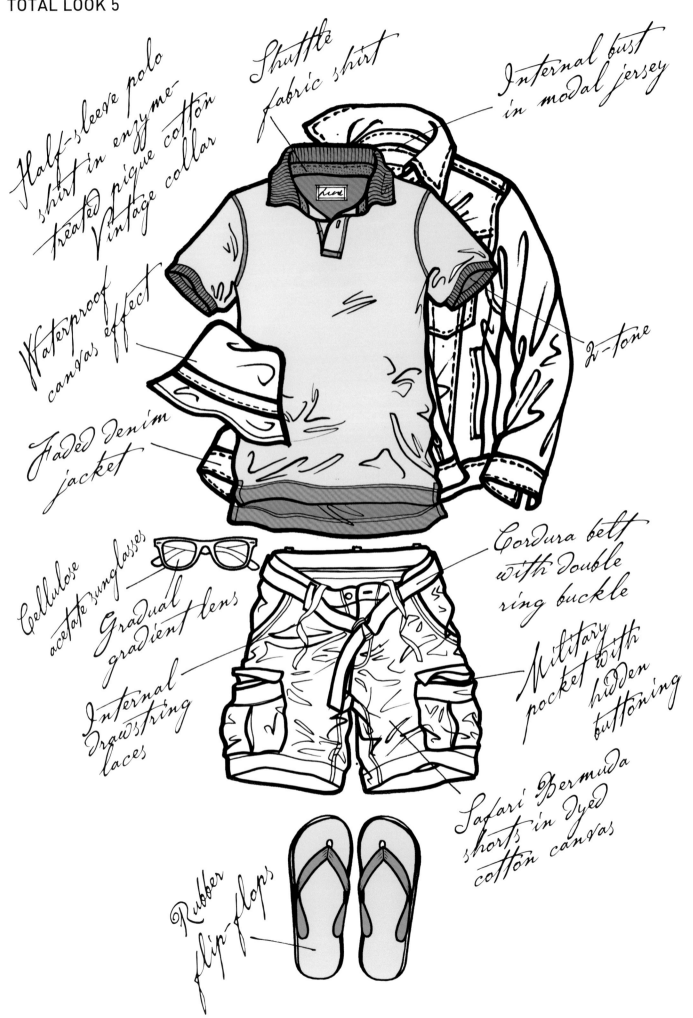

Half-sleeve polo shirt in enzyme-treated pique cotton

Vintage collar

Shuttle fabric shirt

Internal bust in modal jersey

Waterproof canvas effect

2-tone

Faded denim jacket

Cellulose acetate sunglasses

Gradual gradient lens

Internal drawstring laces

Cordura belt with double ring buckle

Military pocket with hidden buttoning

Safari Bermuda shorts in dyed cotton canvas

Rubber flip-flops

MEN'S FOOTWEAR

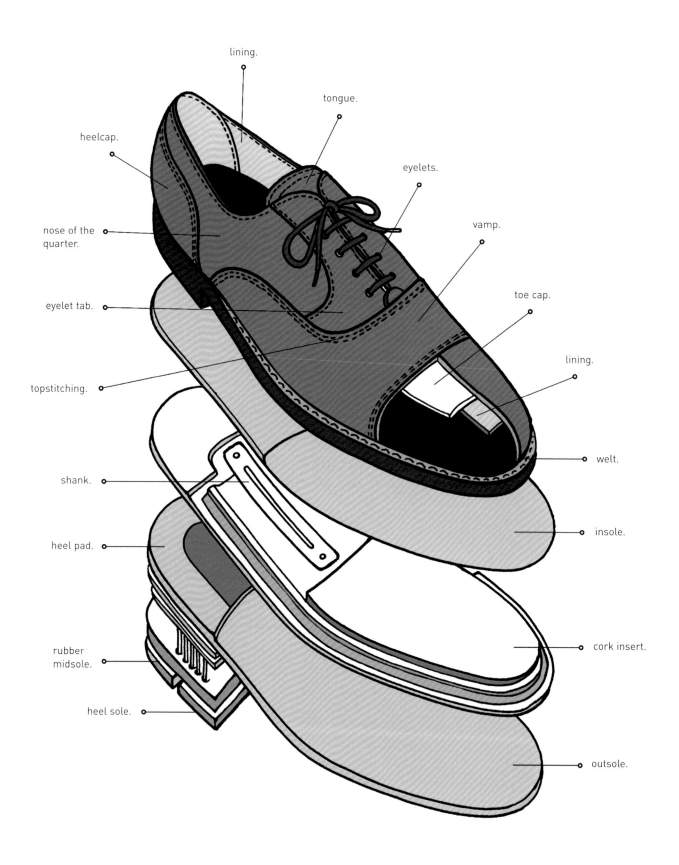

lining.

tongue.

heelcap.

eyelets.

nose of the quarter.

vamp.

toe cap.

eyelet tab.

lining.

topstitching.

welt.

shank.

insole.

heel pad.

rubber midsole.

cork insert.

heel sole.

outsole.

CLASSIC, ELEGANT AND SPORTS SHOES

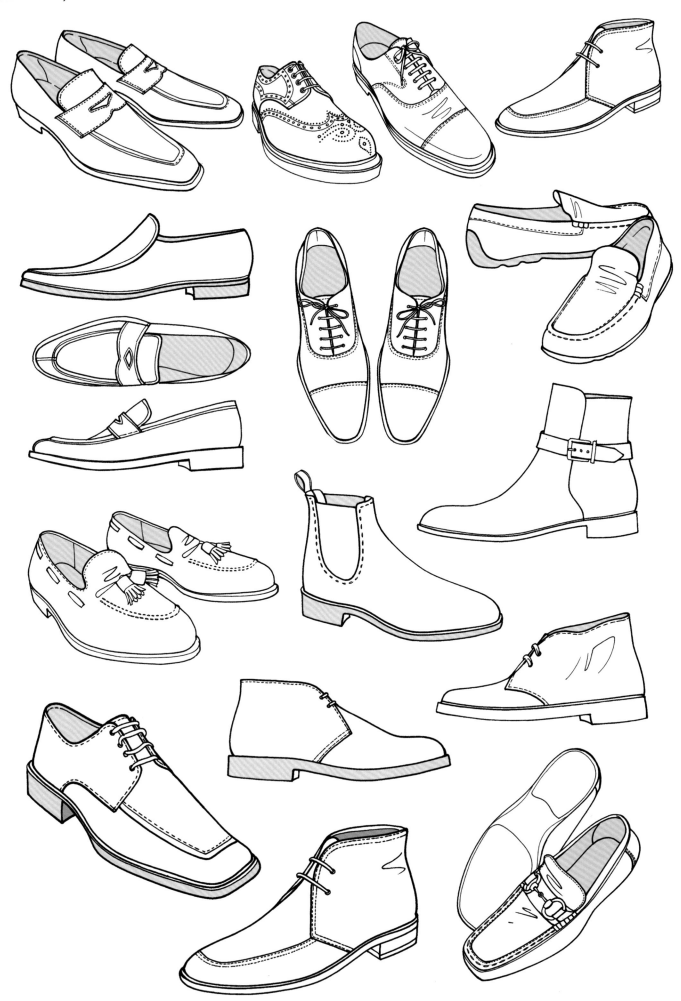

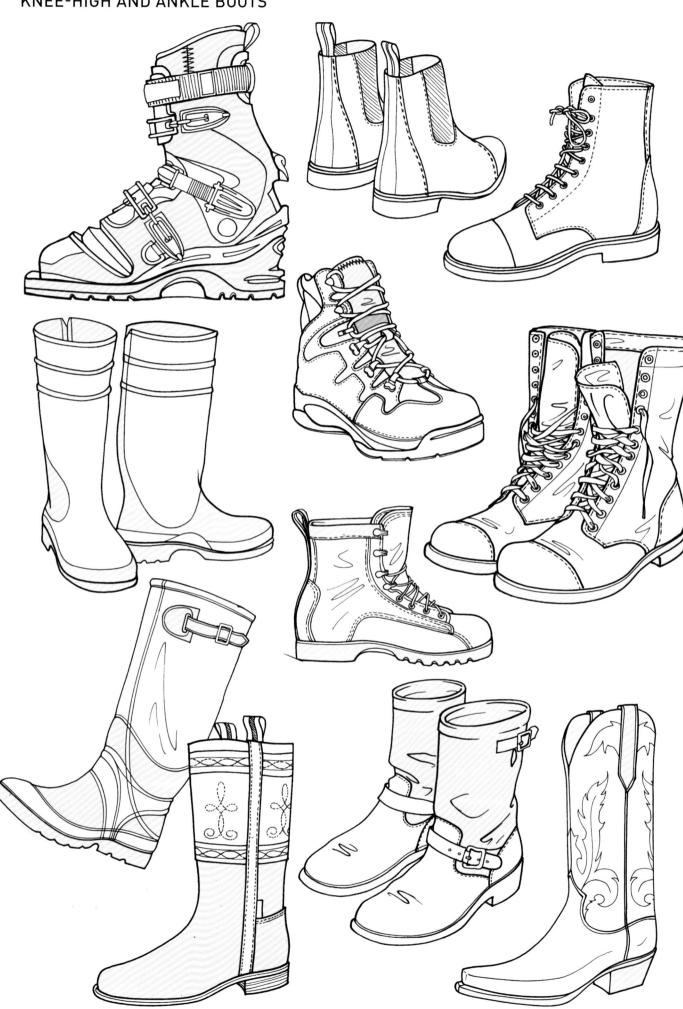

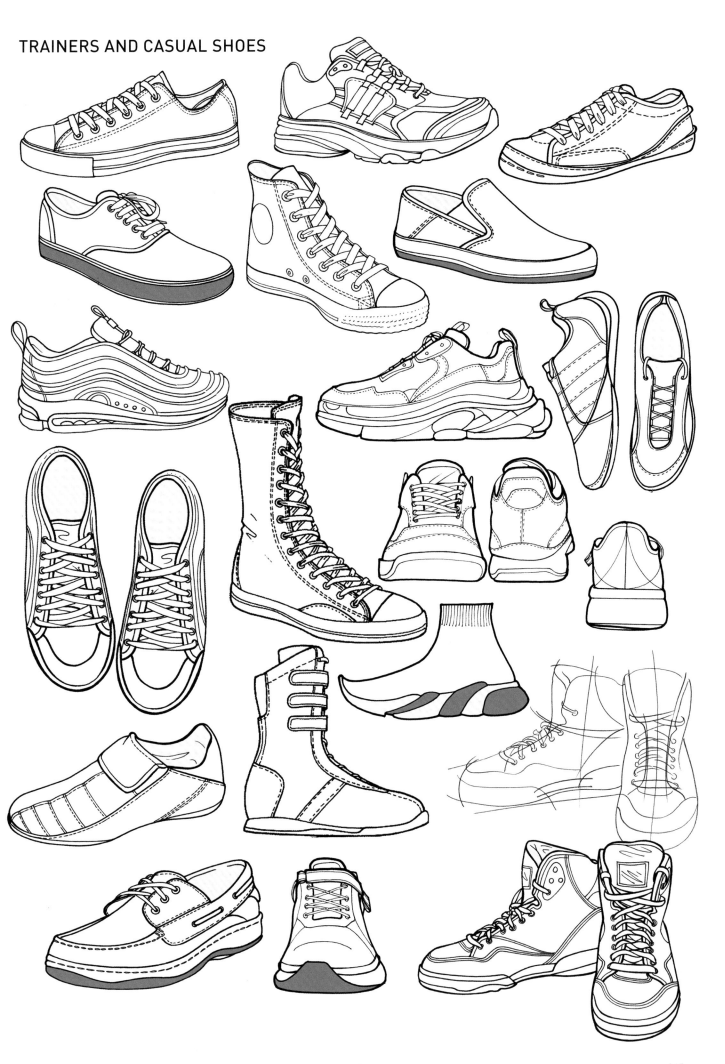

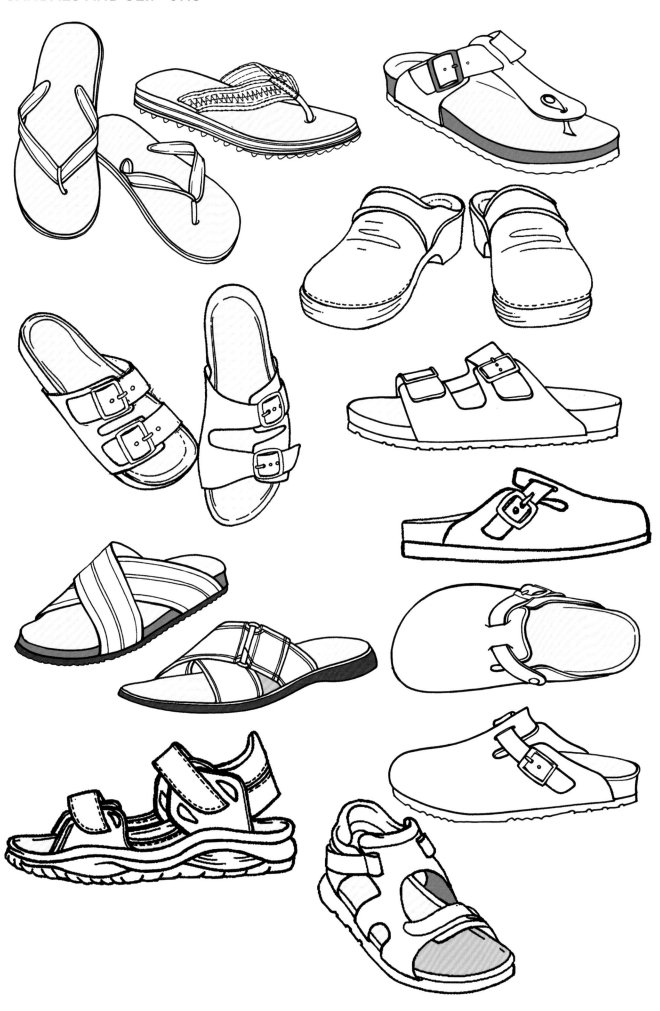

SLIPPERS

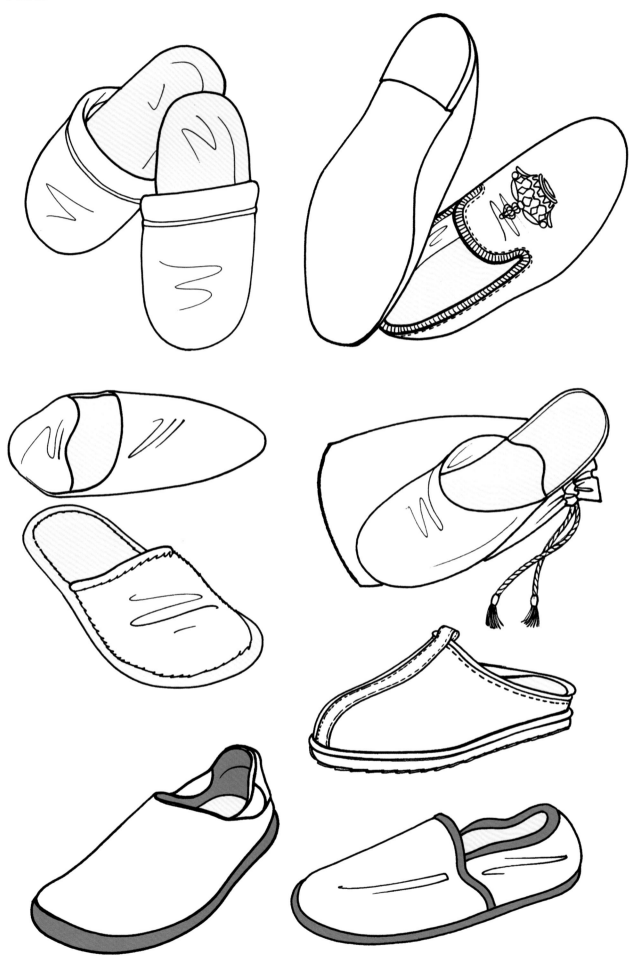

BIBLIOGRAPHY

Anatomy
Collana Leonardo, **Anatomia per artisti**, Vinciana Editrice, Milan 2004.
Collana Leonardo, **Le basi del disegno**, Vinciana Editrice, Milan 1994.
Paul Richer, **Artistic Anatomy**, Watson-Guptill Publications, New York 1971.

Clothing and fashion design manuals
Astess, **Cravatte e dintorni**, Arti grafiche Stibu, Urbania 1990.
Giuliano Angeli, Riccardo Villarosa, **Il guardaroba di lui**, Idea Libri, Milan 1993.
Vittoria De Buzzaccarini, **Abito di società**, Ed. Idea Libri, Milan 1986.
Antonio Donnanno, **La Tecnica dei modelli Volumi 1-2-3**, Ikon Editrice,
Milan 2002. English version **Fashion Patternmaking Techniques vol. 1, 2, 3.**
Promopress, Hoaki Books, S.L. Barcelona, 2015, 2016, 2016.
Elisabetta Kuky Drudi, **Fabric Textures & Patterns**, The Pepin Press BV,
Amsterdam 2008.
Elisabetta Kuky Drudi, Tiziana Paci, **La Figura nella Moda**, Ed. Ikon Editrice,
Milan 2006.
Kazuko Koike, **Issey Miyake**, Ed. Taschen, Cologne 2016.
Francesco Morace, **Real Fashion Trend**, Ed. Libri Scheiwiller, Milan 2007.
Museo del tessuto, **Jeans - Le origini, il myth americano, il made in Italy**,
Maschietto Editore, Florence 2005.
Bernhard Roetzel, **Il Gentleman**, Ed. Könemann, Milan 1999.
László Vass, Magda Molnár, **Scarpe da uomo fatte a mano**, Ed. Könemann,
Cologne 2000.

Colour
Johannes Itten, **L'Arte del colore**, Edizione ridotta, Ed. Il Saggiatore,
Milan, 2010.

Dictionaries and encyclopaedias
Francois Chaille, **Piccola enciclopedia della cravatta**, Ed. Rizzoli, Milan 2002.
Antonio Donnanno, **Modabolario - Dizionario tecnico - creativo**,
Ed. Ikon Editrice, Milan 2019.
Anna Evangelisti, **Enciclopedia della moda**, Ed. Meb, Padova 1990.

Trend magazines
CoolBook Sketch, Trend Book Man Shoes, Autumn / Winter,
Ed. Studio Fabrizio Fava, Potenza Picena 2019/20.
Collezioni Uomo n.94, Spring/Summer, Ed. Logos Publishing, Modena 2019.
Collezioni Uomo n.95, Autumn/Winter, Ed. Logos Publishing, Modena 2019/20.
Next Look Men, Trend Book Style & Colour, Ed. Overath, 2019.

SUMMARY

FASHION ILLUSTRATION & DESIGN ACCESSORIES
Shoes, Bags, Hats, Belts, Gloves and Glasses
Manuela Brambatti and Fabio Menconi

978-84-17412-64-7
210 x 297 mm. 264 pp.

The third book from this series on illustration and design focuses on the most popular accessories: shoes, handbags, hats, belts, gloves and glasses. Brilliantly illustrated by Manuela Brambatti, a key member of the Gianni Versace fashion house for nearly thirty years, and with the participation of the designer Fabio Menconi (senior designer for Escada and Armani, among others), the book guides readers through the fashion world's most iconic accessories, and it features practical information and technical advice on how to draw them to achieve a desired result.

FASHION ILLUSTRATION & DESIGN
Methods & Techniques for Achieving Professional Results
Manuela Brambatti

978-84-16851-06-5
215 x 300 mm. 240 pp.

This book reveals the technical essentials for understanding fashion figure drawings from the professional point of view, as well as the materials and tools needed for each style and each drawing element. It teaches readers to ably handle all kinds of pencils, brushes, watercolors, gouaches, inks, and pens and to use them to achieve their goals. The book covers all aspects of drawing figures for fashion, from the basic lines and the different types of figures to using color and recreating different fabrics, and it even reveals the secrets to designing and reproducing jewelry and accessories.

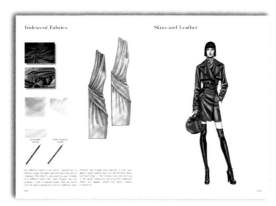

PALETTE PERFECT
Color Combinations Inspired by Fashion, Art & Style
Lauren Wager

978-84-15967-90-3
148 x 210 mm. 304 pp.

FASHION DETAILS
4,000 Drawings
Elisabetta Kuky Drudi

978-84-17412-68-5
195 x 285 mm. 384 pp.
Second Edition in 2020

COLOUR IN FASHION ILLUSTRATION
Tiziana Paci

978-84-16851-59-1
215 x 287 mm. 320 pp.

FASHION HISTORY
The Ultimate History of Costume from Prehistory to the Present Day
Stefanella Sposito

978-84-15967-82-8
195 x 275 mm. 256 pp.

PRINTED TEXTILE DESIGN
Profession, Trends and Project Development
Michaël Cailloux and Marie-Christine Noël

978-84-15967-67-5
215 x 280 mm. 192 pp.

COUTURE UNFOLDED
Pleats, Folds and Draping In Fashion Design
Brunella Giannangeli

978-84-16851-91-1
190 x 260 mm. 120 pp.

FASHION PATTERNMAKING VOL.1, VOL.2, VOL.3
Antonio Donnanno

210 x 297 mm.

ISBN vol. 1: 978-84-15967-09-5. 256 pp.
ISBN vol. 2: 978-84-15967-68-2. 256 pp.
ISBN vol. 3: 978-84-16504-18-3. 176 pp.

FASHION MOULAGE TECHNIQUE
A Step by Step Draping Course
Danilo Attardi

978-84-17412-12-8
195 x 285 mm. 192 pp.

FABRICS IN FASHION DESIGN
The Way Successful Fashion Designers Use Fabrics
Stefanella Sposito.
Photos by Gianni Pucci

978-84-16851-28-7
225 x 235 mm. 336 pp.